VISIONS OF BELONGING

VISIONS OF BELONGING

New England Art and the Making of American Identity

JULIA B. ROSENBAUM

Cornell University Press
Ithaca and London

For my parents

Publication of this book has been aided by a grant from the Wyeth Foundation for American Art Publication Fund of the College Art Association.

First published 2006 by Cornell University Press

Printed in the United States of America

Design by Scott Levine

Library of Congress Cataloging-in-Publication Data

Rosenbaum, Julia B.
 Visions of belonging : New England art and the making of American identity / Julia B. Rosenbaum.
 p. cm.
 Includes bibliographical references and index.
 ISBN-13: 978-0-8014-4470-8 (cloth : alk. paper)
 ISBN-10: 0-8014-4470-5 (cloth : alk. paper)
 1. Art, American—New England—19th century. 2. Art, American—New England—20th century. 3. New England—In art. I. Title.
N8214.5.U6R67 2006
709.74′09034—dc22

 2006023271

Cloth printing 10 9 8 7 6 5 4 3 2 1

Contents

Illustrations

Acknowledgments

Writing acknowledgments is a reminder that however monomaniacal a book project may seem, it is a thoroughly social affair. It is a great pleasure to acknowledge here the individuals and institutions that collectively have made this book possible. I feel fortunate to have studied with a group of professors as intellectually stimulating and generous as those in the art history department at the University of Pennsylvania, and I have benefited especially from the extraordinary teaching and support of Elizabeth Johns.

My research has been greatly facilitated by helpful archivists and librarians at the Corcoran Gallery of Art, Dartmouth College, the Florence Griswold Museum, the Historical Society of Pennsylvania, and the Metropolitan Museum of Art. Guy McLain at the Connecticut Valley Historical Museum and Library, John Dorsey at the Boston Public Library, and John Campbell at Harvard University deserve my explicit thanks for their assistance and their readiness to answer my steady stream of questions. Grants from the University of Pennsylvania, the Henry Luce Foundation/American Council of Learned Societies, and from Harvard University offered valuable financial assistance during the research and writing of this project. The College Art Association generously supported publication with a Wyeth Foundation for American Art Publication grant.

I am especially grateful to the scholars and colleagues who, through their example, advice, and support have made this a better book, among them Jeffrey Andersen, Sven Beckert, Thomas Bender, Donna Cassidy, Paula Lupkin, Sally Promey, Eric Rosenberg, and Andrew Walker. To Vivien Green Fryd I owe a special acknowledgment for she has been a remarkable mentor. My friends and colleagues at Bard College, and particularly Laurie Dahlberg, Laura Kunreuther, and Gregory Moynahan have offered invaluable encouragement and insights as this project evolved. To Melinda Gray, Danielle Lapidoth, Camille Lizarribar, Kathy Mele, and

Emily O'Brien, I happily remain in perpetual debt for their intellectual curiosity and companionship, their tireless reading, and their unstinting love and support through the years.

I thank Bernhard Kendler for first taking this book under his wing, and I am beholden to Alison Kalett, along with Nancy Ferguson and Candace Akins, for gracefully and ever so smoothly shepherding the book through production. I also greatly benefited from the eagle eye and deft touch of copyeditor Kay Scheuer.

In the sprint to completion, Jeanette McDonald and Heather Zavod provided calming critical assistance, and where would I be without Eva Hagberg, last-minute researcher extraordinaire and the ultimate "Hagdaughter." This book is dedicated to my parents whose deep love of learning and of life has always guided me. They, along with my entire family—immediate and extended—have made so much possible.

The best part of this project has been completing it in the company of Garry Hagberg, my husband. With him, this book has come home, and I have found my true sense of belonging.

VISIONS OF BELONGING

Introduction

For New England in its truest sense is more than a geographical entity.
It is the constant flame of a spirit, the fulfilment of a great principle, the worshipful
deification of a divine right. In fact, New England, in the deeper significance
of the words, is not a place at all; it is a state of mind!

WINTHROP PACKARD, "The New England Society in the City of New York"

Such grandiloquence published in *New England Magazine* in 1908 reveals something of the mania for the region of New England at the turn of the century. It gives voice to a distinctive way of understanding the shaping of identity in late nineteenth- and early twentieth-century American culture—one centered on the transformative power of place. In the paintings and sculptures of American artists, that conception took compelling form. Between roughly 1890 and 1920 depictions of New England landscapes and New England figures flooded the American art scene. Augustus Saint-Gaudens rendered statues of sturdy Puritan colonists. Intimate, bucolic scenes of rural Connecticut filled the canvases of American Impressionists John Twachtman and Julian Alden Weir, while Willard Metcalf and Childe Hassam featured views of quaint villages among verdant fields and Congregational churches that affirmed an Anglo-Saxon Protestant ethos. Such works of art did more than capture specific people or places. They became identified with social values: self-reliance, order, and respect for heritage and tradition. Audiences hailed these images as much for the ideals of community and nationhood projected by them as for their aesthetic qualities.

This book investigates the extraordinary appeal of these works of art. It seeks to understand the regionalist impulse animating artistic production at the turn of the century, and, more broadly, the interplay between art objects and the shaping of loyalties and identities. In the late nineteenth and early twentieth centuries, issues of regional identity and the relationship of the local to the national surfaced in debates about artistic representation. By following the direction of those debates about what to represent as well as how to represent it, I unfold a narrative of nation building, one that extends from American Impressionists to American modernists, from pictorial landscape to painterly abstraction. The region of New England and its representation

in this period provide a case study, a means to apprehend nationhood and the forging of a common culture it involves. I specifically examine how New England was imagined to fit into the nation as a whole, from its almost exclusive identification with national ideals to its reorientation as a region on equal footing with all others. As the geographer Yi-Fu Tuan has observed, abstract concepts like region or nation cannot be known directly but must be "constructed by symbolic means."[1] The works of art discussed here show one way in which that was accomplished.

The turn of the twentieth century marked a peculiar identification of people and place, of land and character. The unique role of New England in the founding of the country had distinguished it early on as a special place; already in the antebellum period, New England places, customs, and historical characters had been immortalized in literature and art. Interest in these subjects continued after the Civil War, particularly through the work of rural genre painters like Eastman Johnson. The images produced at the turn of the century, however, carried a new focus and consistency, and they coincided with a contemporary hunger in the Northeast and beyond for things New England. Organizations devoted to New England heritage such as the National Society of New England Women and the Society for the Preservation of New England Antiquities proliferated, as did a national network of so-called New England Societies that cropped up across the country to celebrate New England heritage and the region's contributions over two centuries to national life. Authors wrote novels, histories, and travel guides detailing New England's attractions while architects introduced the colonial revival style and collectors rushed for early American antiques—almost by definition made in New England.

This fascination with the region speaks to a search for roots, for a sense of belonging. As immigrant populations swelled, as new industries transported thousands to urban centers, and towns and cities sprang up from one coast to the other, Americans struggled to find common ground. National identity had long been bound up with the possibility of limitless expansion, but by the 1890s, with the borders of the country securely mapped out and land under continual settlement, wild and uncharted territory had largely disappeared. Thus could the influential historian Frederick Jackson Turner at the 1893 World's Columbian Exposition—or the Chicago World's Fair, as it was commonly known—cite the 1890 census report and declare the frontier closed. His pronouncement ushered in a new period in American history, one that required all the pieces of a matured country to coalesce.

In 1893, the dazzling visual spectacle of the Chicago World's Fair, from state buildings to state pavilions within the great exhibition halls, to the vast manufacturing, agricultural, and artistic exhibits, helped crystallize the terms and categories in which American visitors could think about the related but distinct parts of the country. The fair offered bases for comparison among states and regions and graphically illustrated the role they might play in national life. In 1893 and in the years following, cultural and political leaders, particularly those from New England, insistently made a bid for New England as an exemplar for the nation, an alternative to the model of western expansiveness and individualism and to Turner's view of the frontier as a powerful influence on national character. The fair, and the extensive literature it generated, provides a glimpse not only into the emerging tensions between eastern and western parts of the country but also into the growing debates about the relevance of the regional and par-

ticularly the relevance of New England for the nation. In the years after the fair, producers and consumers of art mobilized high culture and fashioned an intricate vision of New England, one they hoped could transcend ethnic, class, and other divisions and rouse a national spirit.

The specific ways critics, artists, and artworks negotiated and addressed the complex dynamic between local and national interests are the focus of this book. The visual preoccupation with heritage and community in this period arose, I argue, out of a nation-building project that placed distinct emphasis on the local, at both the state and regional levels. Such a focus marks a significant shift from artistic concerns especially in landscape painting in the antebellum years. In her 1993 book, *The Empire of the Eye: Landscape Representation and American Cultural Politics, 1825–1875,* the art historian Angela Miller found that a nationalist program in art largely depended on regional loyalties being subsumed.[2] By the turn of the century, however, intellectual and political figures encouraged, I suggest, the cultivation of state and regional loyalties as a necessary means to quicken nationalist sentiment. The late nineteenth-century historian Charles Adams underscored the importance of the local for a larger, national unity when in 1907 he wrote to a good friend, the Boston "Brahmin" Charles Eliot Norton, lamenting the weakness of American patriotism: "We in America, I am continually made to realize, give no weight to the traditional element which ought to figure so largely in the education of each rising generation. It is the root of all true patriotism,—that sentiment attaching to localities and the soil!"[3] Adams's comment underscores how an abstract concept like a nation is made more meaningful and real through a concrete sense of place.

For Adams, local traditions and histories were vital to a larger sense of belonging, and he and others believed these resources could best be found in the old and settled region of New England; the very typography of its landscape—its tended countrysides, lofty mountains, and rocky coasts and soils—seemed to mimetically reflect the sturdy character of the industrious men and women of earlier generations. Associated with an Anglo-Saxon Protestant heritage, New England was put forward through the turn of the century as the original national home. American artists did more than participate in this endeavor to promote the region; they gave it memorable and enduring form. Above all, the American Impressionists working in New England, through their efforts to frame the land and render it "scenic," succeeded in creating a landscape art acclaimed for being "native." The rootedness and connection Charles Adams yearned for in 1907, artists such as Childe Hassam and Willard Metcalf made visible on canvas.

Their successful delivery of a "native" art is not, however, the end of the story. Claims for New England as a national model or exemplar were easily perceived as illusory and misplaced, a deluded cultural imperialism, and did not go unchallenged; even within the region, a New England identity had never been securely or truly fixed. Going back to Nathaniel Hawthorne, there had always been American scholars, writers, and artists who had derided the region's Puritan ethics and heritage, and by the second decade of the twentieth century, that legacy had come under serious attack by a host of cultural figures, among them H. L. Mencken and New Englander Van Wyck Brooks; if, as they argued, New England's Puritan legacy had proven inadequate to meet the demands of the times, what cultural role could the region play at all? The violence and devastation of the First World War called into question still more dramatically the direction of modern life as typified by the industrialized Northeast and by a contemporary

emphasis on standardization, the urban, and the mechanical. The war galvanized a generation of American writers and artists to look beyond New England to other seemingly more pristine, less developed and less Europeanized parts of the country.

This book reveals the contours of a noisy regional discourse, from the Chicago World's Fair, which fundamentally helped highlight and define the distinct parts of the country, to the eclipse of New England's cultural prominence and the celebration of multiple regional identities as constitutive of a national ideal. By the 1920s and 1930s, art critics as well as literary and social critics were repeatedly calling for cultural expressions that embraced other parts of the country and that emphasized distinctive features of individual regions. Emerging across disciplines, the concept of Regionalism linked regional diversity with a heightened national consciousness. In the arts, an interest in place led painters to locales across the country. From Ernest Blumenschein and Robert Henri, the Ashcan school leader, to Marsden Hartley and Georgia O'Keeffe, realist painters as well as modernists connected with Alfred Stieglitz's circle flocked to New Mexico, for example. The so-called Midwestern regionalists, Thomas Hart Benton, John Steuart Curry, and Grant Wood, celebrated in their work midwestern rural figures and landscape.

The rise to prominence of artists and artworks focused on Taos, New Mexico, and the Southwest and the later promotion of the agrarian Midwest by Thomas Hart Benton and others effectively defied not only New England's claims for cultural dominance but in fact any hegemonic model, any region's claim to superiority or national preeminence. The trajectory traced here emphasizes not the obvious differences among the artists considered—those working in the impressionist mode, modernists such as Marsden Hartley, and narrative, realist painters like Benton—but rather the curious, and heretofore much less discussed, ties that unite them.

Turn-of-the-century landscapes and figurative artwork linked to the region of New England have received scant scholarly attention as a coherent group. Although many of the paintings and sculptures discussed here entered major American collections, because they cross boundaries of medium, genre, and style they have eluded thematic analysis. This book reclaims that unity. In so doing it reestablishes the central role this art has played in the shaping of American identity. Given my thematic focus, I have organized chapters around objects or groups of objects that I believe bring into relief most clearly and poignantly contemporary arguments about the relationship of local and national identities. In choosing to treat painting as well as public sculpture and exhibition displays, I aim to elucidate the movement of artistic ideals across media and across class and social boundaries.

In general, I take a social art historical approach in that I want to situate the works of art I discuss in a larger cultural context. The fundamental question, and the one I am most interested in answering, is how and why these images held meaning for viewers. To explore that, I look at the artwork itself along with artists' and patrons' private correspondence, exhibition records, and the contemporary press and literature. Ultimately, I blend formal and iconographic analysis with sustained inquiry into cultural context. The important studies and monographs

that have focused on biography, on stylistic development, or on the history of a particular artwork make such a contextual approach possible here.

National identity, although often talked about as if it were an easily graspable thing, is an elusive ideal, constantly shifting, evolving, and under negotiation. The constructed nature of this identity has been most deeply explored by historians and geographers, and their focus on the importance of memory and place has shaped my inquiry into turn-of-the-century artistic visions of American identity.[4] By applying their insights directly to artistic production, I have aimed to break down the monolithic concept of American nationhood, to show the struggles for unity and how artists and artworks participated in bridging the distance between the local and the national.

The term "New England," and its distinction as a region, deserve some elucidation: New England emerged as a geographic entity back in the 1600s. An English sea captain named John Smith coined the term "New England" in the early seventeenth century when, on an expedition in 1614–16, he mapped the coastline and called the area by its now long-accepted name. It served as a general designation for the territory stretching roughly from the Penobscot River in Maine to Cape Cod, Massachusetts, all of which was previously known as simply North Virginia. Through the British crown, commercial ventures that financed New World settlements parceled out various portions of this territory to colonizers; for example, the Virginia Company, essentially a London business corporation, put up the initial money for the Plymouth colony of Pilgrims. In 1629, the Massachusetts Bay Company was formed by a group of Puritans and secured a crown charter that gave it jurisdiction over much of what became the states of Massachusetts, New Hampshire, and Maine. Starting in the 1630s, colonies rapidly expanded and pushed into present-day Connecticut and Rhode Island; not only did the so-called Great Migration bring scores of new settlers, but political and religious differences like those that motivated Roger Williams to found a colony in Providence also increased the number and range of new colonies.

These disparate settlements acted quite independently of each other and often antagonistically. What united them were only their common British background and their mutual need for trade regulation and protection against the Indians, the Dutch, and the French, an interest formalized by four of the major colonies in 1643 with the establishment of the New England Confederation (or the United Colonies of New England). Political unity was also obtained for a short time in the late 1680s, when the British king James II attempted to establish royal control over a broad band of territory he made known as the Dominion of New England, which actually included the colonies in what are now New York and New Jersey as well. These loose early connections set the stage for the subsequent designation of the six northeastern-most states—Connecticut, Rhode Island, Massachusetts, Vermont, New Hampshire, and Maine—as a unit and prepared the way for a concept of the region of New England as a self-evident cultural entity.[5]

Intellectual and literary efforts through the early 1800s helped shape a consciousness of New England as both a specific region and a special place. The works of Jedidiah Morse (1761–1826) and Timothy Dwight (1752–1817), for example, mapped out not only the specific ge-

ography of the region but also its customs and moral sensibilities. Morse published *The American Universal Geography* in 1793, with subsequent editions in 1812 and 1819. Dwight's *Travels in New England and New York* appeared posthumously in 1821–22. Committed New Englanders, both authors, in their discussions of New England's physical and cultural terrain, worked to convey a sense of the region defined not only by its geographical boundaries but also by what the historian Joseph Conforti has referred to as the "steady habits" of its people.[6]

In the 1830s John Warner Barber, an engraver, combined text and image to give readers detailed views of the prospering towns of Connecticut and Massachusetts. His *Connecticut Historical Collections* and his *Massachusetts Historical Collections,* published in the late 1830s with second editions in the 1840s, offered, as the extended title suggested, "interesting facts, traditions, biographical sketches, anecdotes, &c. relating to the history and antiquities of every town" lavishly illustrated with close-up views of main streets or more panoramic vistas.[7] In *Connecticut Historical Collections* alone, Barber included 190 engravings. His picturesque scenes organized and gave shape to a landscape few had fully seen. They showcase neat and tidy town buildings as well as well-dressed villagers out for a stroll or taking in the view. That they are often visually anchored by the portrayal of a town's church or churches communicated a strong moral ethos that clearly accorded well with the depictions of capitalist productivity. Barber's imagery established an initial repertory of topographical motifs that turn-of-the-century artists such as Willard Metcalf and Childe Hassam fastened on and developed.

This book begins in 1893 with the opening of the Chicago World's Columbian Exposition, commemorating the four-hundredth anniversary of Christopher Columbus's expedition to the New World, and the exhibition displays created expressly for it. Previous scholarship has tended to treat American fairs, and particularly the 1893 World's Columbian Exposition, as singular expressions of "Americanness," easily set against European identities. But the United States exhibitions in 1893 were anything but uniform. Almost every state in the Union participated in one way or another, and the regional and state fair commissions that organized the extravagant displays considered themselves to be in an intense competition for recognition. They went well out of their way to distinguish their individual state or region from every other. The results led to some extraordinary visual spectacles, not to mention heated debate and commentary, revealing the tension particularly between eastern and western parts of the country.

In considering particular displays—from the state buildings to the major exhibition halls to one of the big attractions at the fair, Thomas Hovenden's painting *Breaking Home Ties*—I attempt to identify and illuminate the building blocks of national identity and the terms of the debate this visual material helped crystallize about the relationship of region and nation. In its emphasis on the local, the 1893 Chicago World's Fair provides an unusually clear view of the struggles and challenges to nation building at the turn of the century. The following chapters evolve from this discussion.

Throughout the 1890s and 1900s, artists and audiences grappled with what constituted New England identity and how to give this abstract concept appropriate visual expression. Chapter 2 considers the outdoor public sphere as a potent locus of debate, as well as a platform from which to proclaim civic mores. From this perspective, I examine the works of two of the coun-

try's most well-known and sought-after sculptors, Frederick MacMonnies and Augustus Saint-Gaudens. Their sculptures and the discussion surrounding them underscore the challenges of promoting and consolidating New England ideals within the region, let alone outside of it. MacMonnies's *Bacchante and Infant Faun* (1893) sparked fiery controversy when it was first unveiled in the courtyard of the Boston Public Library. Ultimately expelled from the city in June 1897, the three-quarter life-size bronze statue was held up by members of Boston's elite as a symbol of potential social anarchy and the dangers posed by lower-class, non-Anglo-Saxon, Protestant immigrants, who had not in their eyes been properly assimilated.

Saint-Gaudens's *The Puritan,* first dedicated in Springfield, Massachusetts, in 1887, was, on the other hand, praised as an embodiment of New England Anglo-Saxon values. In 1903, the New England Society of Pennsylvania commissioned Saint-Gaudens to do a second version of the statue, which became known as *The Pilgrim*. Dedicated in 1905 and positioned outside the entrance to the law courts of Philadelphia's City Hall, the statue provocatively stood as a monument to New England heritage outside of the region. Through these three examples, I show how civic leaders—many claiming New England descent—sought to use art not only to influence public morality but also to mold a robust and homogeneous national cultural identity.

Images of the land offered an alternative and powerful medium to disseminate regional ideals and assert the importance of local traditions and sites. By the 1890s, pastoral New England was becoming a popular destination for artists and travelers alike. New art colonies burgeoned and a tourist industry boomed, as Americans increasingly turned to the countryside for its scenic and "therapeutic" qualities. Landscape art memorialized these experiences at the same time that it presented New England as a place that could sustain and replenish an urban-weary, itinerant, and potentially drifting nation. The extraordinary appeal of landscape painting at the turn of the century occupies the third chapter. I focus on the life and art of the early American Impressionists Theodore Robinson, John Twachtman, and Julian Alden Weir. Not only did their work strongly associate an attachment to place with the New England countryside, but their personal biographies also exemplify larger cultural concerns about the pressures of industrial and urban development and the need to establish local connections and a sense of home.

The identification of a sense of home and belonging with New England took most powerful visual form in the works of Childe Hassam and Willard Metcalf. Widely reproduced, their paintings (and Hassam's etchings as well) were embraced for both their style and subject matter. Although their art was later eclipsed by the modernist drive for abstraction, these artists were especially renowned in their lifetimes, and their images helped to consolidate what I have termed an "iconography of belonging." Through their work, a classic image of New England materialized—orderly villages with white, steepled churches among verdant fields and forests. Chapter 4 analyzes these intimate, bucolic, and typically unpeopled canvases in the light of contemporary issues of ethnic difference and mass immigration. An Impressionist aesthetic as practised by Hassam and Metcalf, I suggest, functioned as a unique means to register the value of the land and the belief in the connection between soil and character. The positive response of critics to the work of these artists helped to firmly merge New England's local views with national visions.

Notions about rootedness and community continued to engage both artists and critics, regardless of aesthetic approach, through the interwar years. What shifted, however, were the dynamic between the local and the national. The final chapter explores the recasting of the relationship between region and nation and the consequent repositioning of New England. The emphasis on place, as articulated and advanced by regionalists of the early-to-mid-twentieth century from across the disciplines, promoted an intense interest in regions well beyond New England. On the art scene, Taos and Santa Fe, New Mexico, and their Native American cultures drew artists of all aesthetic stripes, and the midwestern states equally achieved a new visual prominence. In the artwork of Marsden Hartley among others, New England emerged again, but from a wholly new perspective. The art world's appreciation of this range of artwork can best be understood in the context of an expansive and broadened interest in place and region.

In 1937, Alfred Stieglitz, the photographer, dealer, and major proponent of modernist art, exhibited at his gallery, An American Place, new work by Marsden Hartley. The artist had traveled and painted abroad for many years, and the show was Hartley's attempt to recast himself as an American painter with authentic native roots. Hartley, who had grown up in Maine, filled the gallery walls with scenes of this northernmost New England region. Accompanying the exhibition was also a brochure with two of Hartley's writings, a prose piece entitled "On the Subject of Nativeness—a Tribute to Maine" and a poem, "Signing Family Papers." In that poem, Hartley closes with an image of a return to the familiar and the whole:

> . . . we at home at last, the un-conditioned flower
> blooming in a streak of sun, the several shapes
> of self in one—
> and here, the costly geometric
> signature, signed and sealed—
> heraldic images to be
> genuflective offerings to place.[8]

In those last seven lines, Hartley encapsulated the themes of identity, belonging, land, and place, themes that profoundly shaped his own experiences. But his evocation of union and integration resonates well outside the boundaries of his personal life. They are themes that engaged American artists and audiences throughout the late nineteenth and early twentieth centuries, and they are the principal themes that occupy this book. The works considered in the pages that follow, from the 1893 Fair displays to the paintings of American Impressionists to the work of Georgia O'Keeffe or Thomas Hart Benton, became precisely what Hartley termed in his poem "heraldic images." As "offerings to place," they had for patrons, collectors, viewers, and even the artists themselves a transfigurative power. And it is this which brings us back to Winthrop Packard, the author of the *New England Magazine* article. Taken together, the works of art discussed here transformed the country's impersonal geography into a communal "state of mind."

CHAPTER ONE

America on Display

In May 1893, the World's Columbian Exposition opened in Chicago, the first international fair in the country since 1876. Attracting over twenty million visitors, the fair offered a dazzling spectacle of human ingenuity and productivity. Fourteen major exhibition halls and countless smaller ones spreading over 686 acres documented the cultural and material achievements of countries from around the world (Fig. 1). An emerging industrial power, the United States not only played host but was itself on display. Never before had there been such an opportunity to show what constituted the nation. In the Exposition's parade of progress, commentators and social observers carefully took stock of the country's position, anxious to define the United States not only against its European counterparts but also internally as a singular balance among state, regional, and national loyalties. As Henry Adams recorded in his autobiography, "Chicago asked in 1893 for the first time the question whether the American people knew where they were driving." While Adams made no claim to know and doubted whether anyone could know for sure, he concluded "that they might still be driving or drifting unconsciously to some point in thought . . . and that possibly, if relations enough could be observed, this point might be fixed. Chicago was the first expression of American thought as a unity; one must start there."[1]

Following Adams's example, this chapter examines the World's Columbian Exposition (or the Chicago World's Fair) as a benchmark in the building of American nationhood. But in this case, I wish to depart from the traditional scholarship on the fair, which largely perceives an American national identity not only as monolithic but also in terms of what it is not—that is, as different from French, British, and other foreign nationhoods.[2] While this oppositional perspective occupied critics at the time and still offers a useful interpretive approach, my aim here is to shift the lens of inquiry and focus instead on how a sense of national identity was built from within the country. I argue for the constitutive forces at work in 1893, examining specif-

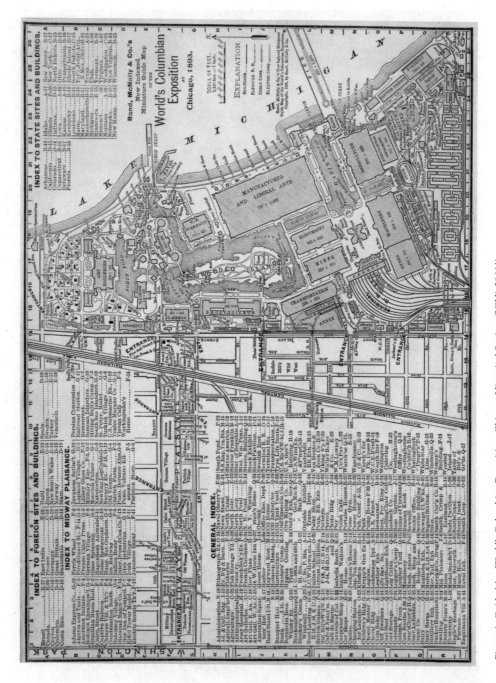

Figure 1. Guide Map, World's Columbian Exposition. Chicago Historical Society (ICHi-30461)

10

ically the composition of the American sections of the fair. These exhibits, prominently displayed throughout the major exhibition halls, helped visitors apprehend the notion of a "united states" and played a critical role in channeling local pride into national spirit.

Only three decades after the Civil War, the Chicago extravaganza was an unusual occasion when constituent parts of the country, namely states and regions, came together engaging in intense but friendly competition for recognition and distinction before a national audience. The fair provided a broad basis for comparison and contrast, and it did much to show the seams by which the country was stitched together. A fundamental question prevailed: how did individual states fit into the Union as a whole? What role did they play in national life? From pavilions to publications to parades, the exhibits at the fair attempted to reconcile the drive toward unity with the representation of distinct local traditions and pasts. Unlike previous or subsequent international fairs, organizers of and participants in the Chicago World's Fair fastened on state and regional identities, promoting and greatly expanding them as components to a larger nation-building project.

In these endeavors, the bid of the New England states for recognition stands out in particular. New England had once been practically synonymous with the United States. By the time of the fair, it had shrunk to one of several regions. Among all of the visual and textual materials produced by fair organizers, however, it was the New England states that particularly responded to late nineteenth-century struggles to achieve cohesion and forge a national identity. The vast American collections of art, industry, and natural resources at the fair ultimately served two purposes at the same time: they marked American against European progress and they made manifest the elements of "Americanness," the various and sometimes conflicting strands that composed the larger tapestry of nationhood. The first part of the chapter lays out the role states played in the display of material, focusing especially on modes of presentation, on how contributors organized and exhibited objects as well as on how viewers responded to what they saw. The subject of reception pertains especially to the Fine Arts Building and to the interest on the part of critics to isolate local and regional categories in the hope of defining a national art. The later section addresses specific artwork and the critical response that attempted to put forward New England as a model for the nation.

The Fair's World

Close to three years in the making, the World's Columbian Exposition transformed the scrub brush and sand of Chicago's Jackson Park, which stretched along the edge of Lake Michigan, into a gleaming utopia. In their mission to document cultural progress, the National Commission for the Fair succeeded not only in fashioning an extravagant visual spectacle but also in mapping a vision of the world onto the fairgrounds. The layout of buildings and exhibits narrated stories of development and ordered peoples and nations by their perceived contributions to human advancement. A set of colossal Beaux-Arts-style buildings grouped around a great lagoon formed the core of the fairgrounds (Fig. 2).

Designed by some of the most prominent architects of the period, among them Richard

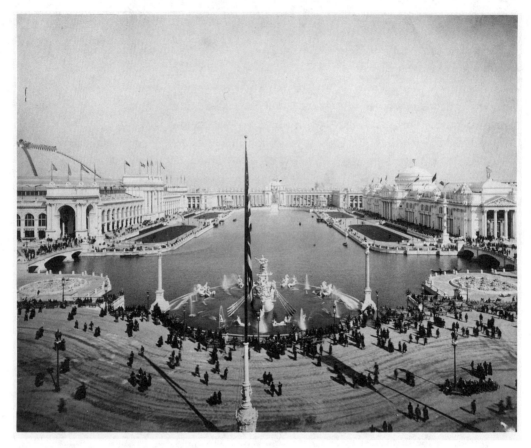

Figure 2. View of Court of Honor, World's Columbian Exposition. Courtesy Avery Architectural and Fine Arts Library, Columbia University

Morris Hunt, Charles F. McKim, Stanford White, and Henry Van Brunt, the "White City," as it was called, exemplified a union of architecture, sculpture, and the decorative arts. With its axial layout and brilliant white plaster facades, it projected order and harmony. To the north of the lagoon extended additional exhibition halls as well as elaborately designed state and foreign buildings. Jutting out like an extraneous spoke at the western edge of the park was the Midway Plaisance, a mile-long strip that featured the first Ferris wheel, concession stands, "exotic" amusements such as Turkish, Irish, and Chinese villages, and ethnographic displays of live peoples transplanted from Africa, the South Seas, and the Orient. Taken together, these two parts of the fair, the White City and the Midway, worked to juxtapose elements of "civilization" and "savagery," culture and commerce. The yardsticks with which organizers measured progress were material and artistic achievement, as evidenced by the exhibits of manufactured goods, agriculture, and machinery presented by countries from all over the world.

Through these elaborately ordered exhibits, the fair educated visitors and disseminated knowledge about the world's resources, both natural and cultural. But the impetus behind

world's fairs in general, manifested in their principles of organization, also established an atmosphere of peaceful rivalry. As M. H. De Young, second vice-president of the National Commission and member of the Board of Control of the World's Columbian Exposition, remarked of modern fairs in general, "No matter how urgently the utilitarian spirit of the age argues that it pays to hold such exhibitions, that is not their animating purpose. The overshadowing aim is to win glory by showing the progress made in the arts and industries, and not to sell the goods exhibited."[3] Another Chicago Fair commentator more directly addressed the notion of such expositions as serious international competitions. Speaking of the mining exhibit in particular, he wrote that it had "a higher mission than simply to draw up the states and nations in dress parade and furnish a novel entertainment for the multitude." Foreign countries, he continued, participated to maintain their rank in the industrial world; "the exposition afforded a battlefield upon which, at the time set, was to be fought out and settled future commercial supremacy."[4] The author might have added cultural supremacy as well. In breaking countries down into discrete, knowable units, the fair not only highlighted potential new markets for producers but also sorted out world leaders among the countries present.

For both American and foreign visitors, the extensive displays showed off the United States as an international player, a major industrial and cultural power. Acutely aware of Europe's great art historical traditions, American reviewers, for example, were thrilled by the United States exhibit in the Fine Arts Building because it visibly demonstrated artistic prowess and seriousness of purpose. If the 1889 Paris Exposition Universelle had set the gold standard for world showcases with its vast art displays and visual wonders such as the Eiffel Tower, Chicago promised to surpass all that. As one author remarked shortly before the fair opened: "We shall have an exhibition more dignified, beautiful, and truly artistic than any the world has seen. . . . It will convince all cultivated Americans, we repeat, of the vitality and vigor and independence of American art; and, we believe, its effect upon the vast public which will view it will convince them of the genuineness of the nascent American love of art."[5] The comparison of national displays at the fair, reviewers asserted, would not just confirm America's place in the world, it would stimulate Americans, spurring them to greater excellence and to a position of leadership. The architect Henry Van Brunt enthused: "They will for the first time be made conscious of the duties, as yet unfulfilled, which they themselves owe to the civilization of the century."[6]

The Civil War and its aftermath had inaugurated a new phase in American nationhood. If antebellum Americans had defined the Union as a convenient and voluntary association of states, the postwar period made any idea of secession, as the historian Carl Degler has argued, "intellectually unthinkable and politically impossible."[7] War and Reconstruction had spawned enormous new federal institutions and networks of communication, establishing a fundamental political framework for national cohesion, while the emergence of a bourgeoisie in cities across the country helped to consolidate social and economic interests.[8] The Centennial Exhibition of 1876, the first held on American soil and the only other such large-scale American exposition of the late nineteenth century, reinforced a growing sense of unity among the country's upper and middle classes. A prelude to the Chicago World's Fair, the much more modest Philadelphia Fair celebrated the country's founding. To mark the event, Philadelphia's

business leaders had organized displays of America's technological and material achievements set against those of other nations. Opening only a decade after the Civil War, the fair highlighted industrial progress, helping to unite Americans behind a common goal. The Corliss engine, the industrial marvel of the era that drew endless crowds of visitors, symbolized that collective purpose.

In 1892, the four-hundredth anniversary of Columbus's "discovery" of America offered new impetus to address the subject of national unity. The grand decorative features of the central Court of Honor in the White City and the rhetorical program for Dedication Day worked in particular to illuminate the concept of "united states." On the side facing Lake Michigan, fair architects designed a dramatic colonnade-like structure, 600 feet long, 60 feet wide, and 60 feet high, forty-eight columns in total, each representative of a state or territory; every column was to bear a different state coat of arms.[9] A freestanding sculptural scene of Columbus posed on a platform drawn by four horses in turn led by two female figures crowned the main archway of the Peristyle. This composite grouping suggested joint efforts and the coordination of independent actions, a visual gesture of collaboration echoed in one of the other major sculptural attractions of the Court of Honor, Frederick MacMonnies's *Barge of State,* also known as the Columbian Fountain (Fig. 3).

Positioned in the lagoon opposite the Christopher Columbus group and Daniel Chester French's allegorical *Republic* (a colossal 60-foot gilded female figure set on a base in the water), MacMonnies's equally mammoth galley showed, in the words of Benjamin Truman, a historian of the time, "an apotheosis of modern liberty."[10] MacMonnies's dynamic sculptural program featured the seated female figure of Columbia atop a central pedestal inscribed with the words *E Pluribus Unum* and supported by four kneeling cherub-like figures. The boat was guided by the male figure of Time, rowed by eight young female standing figures, understood as the Arts on one side and Science and Industries on the other, and led by a winged Victory or Fame. America personified, MacMonnies's work, like the peristyle with its statuary above, presented the nation as a union of elements. The grand scale and balance of these sculptures emphasized the virtues of coordinated effort and synchronized action.

The rhetorical program for the World's Fair Dedication Day similarly allowed for an elastic expression of common purpose. While architects drew up plans for the Court of Honor, James Upham and Francis Bellamy, editors of Boston's *The Youth's Companion* magazine, turned to prose. A longtime advocate of American flags in schoolhouses, Upham proposed a nationwide school ceremony to be accompanied by a salute to the American flag. The result was the "Pledge of Allegiance," the chant of generations of American school children to come. Upham and Bellamy aimed in this single ritual to give common cause and symbolic unity to a disparate population spread over thousands of miles. By effecting a shared experience, they sought to create, in Benedict Anderson's words, an "imagined community." The act of participation would help to make tangible the more abstract ideals of allegiance and unity. As *The Youth's Companion* intoned, "The same flag will be raised over every school, the same songs sung, the same ode read, the same sentiments uttered in every county of every State in the Union. . . . The entire nation will be helping with the same thoughts at heart, the same words upon the lips, to inaugurate the World's Columbian Exposition."[11]

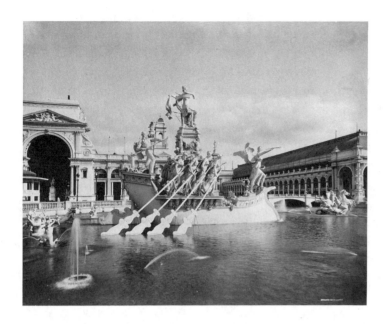

Figure 3. Frederick
MacMonnies, *Barge of
State,* 1893. Courtesy Avery
Architectural and Fine Arts
Library, Columbia University

Upham's inaugural flag celebration conjoined civic and federal interests. The Chicago
World's Fair Committee had readily endorsed the idea of nationwide school ceremonies, ea-
ger to make Dedication Day a national moment. Appealing to a patriotic spirit, Upham and
Bellamy eventually had also won the support of Congress and President Benjamin Harrison.
In the summer of 1892, the federal government issued a proclamation declaring October 21
a national holiday and sanctioning public school festivities across the country. At the appointed
time, students and teachers throughout the United States would rise, face the flag, raise their
right arms, and together repeat the following words: "I pledge allegiance to my Flag and
the Republic for which it stands: one Nation indivisible, with Liberty and Justice for all."[12]
Upham and Bellamy's pledge of allegiance fits with a growing regard in this period for the flag
as a sacred object, which increasingly appears as a political prop. The historian Robert Gold-
stein, for example, locates the origins of a "flag protection movement" in the 1890s, especially
around the 1896 presidential election when McKinley made a love of the flag a theme of his
campaign.[13]

The invention of this national ritual occurred precisely at the time when Americans had
begun to think of the country as finite and bounded. Earlier in the century, American iden-
tity had been associated with limitless expansion. But by 1893, the borders of the country to
the north, south, east, and west had been clearly established. Excluding Alaska and Hawaii, only
four territories—Arizona, New Mexico, Utah, and Oklahoma, all located in the interior and
well demarcated—had still to be admitted to the Union as states. The notion of the closing of
the frontier and the beginning of a new era of consolidation indeed first found expression at
the fair. Frederick Jackson Turner delivered his seminal paper "The Significance of the Fron-
tier in American History" to a group of fellow scholars at the fair's Congress meetings in July

1893. His talk was published shortly thereafter, and as Theodore Roosevelt, then governor of New York and future president, noted in an 1894 letter to Turner, it gave definite shape to "a good deal of thought which has been floating around rather loosely."[14] Turner had called attention to a new awareness not only of the physical limits of the country but also of its regional characteristics. In his focus on the westward movement and its importance to social, economic, and political development, he attempted to delineate national qualities and reflect on the salient features of American culture. In this sense, his discussion spoke to the same late nineteenth-century concerns that charged the ambitious project of the 1893 Exposition: to delineate the contours of a newly defined American nation.

Questions about American identity in part derived from the rapidly changing composition of society. The flow of immigrants into the country intensified in the late nineteenth century as well as shifted in its source. Earlier in the century, peoples from western Europe, especially Scotland, Germany, and Scandinavia, had typically constituted the bulk of immigrants. Despite their differences, they shared with the so-called native-born population a largely Protestant, Anglo-Saxon, Nordic background. By the late 1800s, however, eastern Europeans, Russians, and Italians, as well as a continuing stream of Irish, entered the country, and their different religious and ethnic customs exacerbated their strangeness. The perceived challenge to an Anglo-Saxon tradition stimulated a desire to express more clearly and concretely the nature of Americanness, its values and qualities.

Within the massive exhibition halls surrounding the Court of Honor, the United States displays helped to outline vividly the country's important features, from the physical to the cultural. As fairgoers wandered from building to building and display to display, the material, industrial, and artistic elements of the country unfolded before them, and the vast array of American exhibits helped focus the terms and categories in which they could think about national identity. The fair stirred a consciousness not only of America's new position in the world, but also of how all the pieces of the country fit together and in what order. In identifying its component parts, how they were related, and which were important, the fair aimed to foster shared values and attitudes.

Packaging Culture

The Chicago World's Fair of 1893 served and was intended as a showcase of human development in which different countries and cultures mapped the direction of this evolution. As Robert Rydell and other historians have argued, the fair, especially through the contrast with the exhibits of the Midway Plaisance, promoted a sense of Western superiority and dominance over supposedly less developed, more primitive societies. The combination of evolutionary and historical exhibits in the Anthropology Building and the living examples of human society on the Midway allowed for, in the words of one contemporary commentator, Hubert Bancroft, the "study of national types."[15] Throughout the fair, human culture was compartmentalized, compared, and contrasted, and differences or similarities, both between countries and within them, could be registered.

Comparison extended not only across space but also through time. Such an organization stressed the teleological nature of history by juxtaposing "savage" and "civilized" periods. The American section in the Anthropology Building, for example, featured an exhibit on early inhabitants of the American continent, followed by extensive documentation of American culture in the so-called modern era. Here were illustrated, as Bancroft noted, "special epochs and events, with portraits and busts of those of whose lives and achievements our history largely consists, but without allusion to the annals of the civil war, a theme entirely out of place in an exposition devoted to the arts of peace."[16] The fair organizers, through the lens of a select history, strove to keep in focus markers of social advancement and the importance of the United States as a model for civilized society.

The principles that guided the classification of knowledge and structured the presentation of objects at the Chicago World's Fair grew out of the tradition of great nineteenth-century fairs. Like them, the 1893 Fair charted development by breaking the world down into measurable units, whether mechanical, agricultural, scientific, or artistic. Manufactured products, raw materials, and every form of creative wizardry occupied its own separate space, filling over fourteen of the great exhibition halls of the White City. Visitors feasted their eyes, for example, on countless types of seeds, fruits, vegetables, or meat and dairy products in the Agricultural Building and marveled at the thousands of objects designed for human consumption in the Manufactures and Liberal Arts Building. Machinery Hall detailed the vast range of tools and devices, the Transportation Building the latest in locomotion. In the Palace of Fine Arts every nation displayed its artistic wealth—the prized works of its sculptors, painters, and watercolorists.

The taxonomic ordering in play at the Chicago World's Fair culminated a century of intense scientific investigation into natural phenomena and grew out of an Enlightenment focus on rational inquiry as well as on subsequent pedagogical theory that rooted learning first in observation, then comparison, and finally abstract reasoning.[17] Provincial European fairs in the 1830s and 1840s first put these concepts into visual practice. For London's Crystal Palace Exhibition held in 1851, Prince Albert had outlined three broad categories of objects, namely raw materials, the objects made from them, and the art used to embellish them. The great international displays in the following years featured ever more elaborate classification systems, incorporating not only classes of objects but their countries of origin as well, as Graeme Davison has noted. By the late nineteenth century, fair managers advanced an ideology of material progress and systems of classification to measure the range of civilization.

The Philadelphia Centennial Exhibition of 1876, drawing on these classificatory schemata, set the precedent for the ordering of cultural artifacts at the 1893 Chicago World's Fair. A special committee in 1876 had overseen the arrangement of objects. In a report published in 1874, its members emphasized that a classificatory system was more than just a means to establish order: "A classification goes further than this: it serves to indicate generally and specifically the nature of the exhibition; it is the organic basis or expression of the whole; it is the foundation of organization and effort."[18] Breaking the world down into its component parts offered a precise way to apprehend it; thus could both the 1876 and the 1893 World's Fairs help to explain and make the country of America comprehensible to viewers.

In 1876, the Centennial Fair Committee on Classification devised a general four-part framework that guided the rank and order of all objects. Natural products and those used for making goods came first, followed by the products resulting from them. Tools and machines to make such goods occupied the third level, and finally came "the resultant effects of such productive activity." Ten departments were created that charted the evolution from natural to manmade products. From raw materials—mineral, vegetable, and animal—one moved to products used to manufacture or process those raw materials. Separate categories existed for textiles and fabrics, for furniture and goods used in construction, as well as for tools and machines, motors and transportation devices. Products that increased or spread knowledge made up yet another grouping, and public works, architecture, and examples of engineering formed a distinct category, as did the plastic and graphic arts. The tenth and final department of goods included objects that related to the improvement of the intellectual and moral condition of humankind. The Committee on Classification further broke down these general departments into classes; they subdivided textiles, for example, into silks, woven wools, and goods made of vegetable or mineral materials.

When the Philadelphia Centennial opened, five principal exhibition halls—what was known as the Main Exhibition building, the Art Gallery (Memorial Hall), the Agricultural hall, the Horticultural hall, and the Machinery building—housed the vast quantity of collected material. Access to objects and constraints of space ultimately had forced fair organizers to compress the original ten departments into seven more comprehensive ones, suggesting the somewhat arbitrary or at least shifting possibilities for the categorization of knowledge. The compressed classification system nonetheless communicated the fundamental history lesson of the exposition. As a *New York Times* reporter exclaimed: "And so, from point to point, from landmark to landmark, the ingeniousness of the human brain was developed, and the march of progress shown."[19] In compartmentalizing culture, the fair not only had pegged human progress to production, it had provided a seemingly scientific basis for comparison between different groups, regions, or countries.

The World's Columbian Exposition of 1893 built on the lessons of the Centennial, reflecting both the industrial strides of the past decade and a half and an increasing belief in western European/Anglo-Saxon superiority. The categories for objects swelled. Organizers named fifteen separate departments—further divided into at least 172 distinct groups or classes—which ranged from agriculture to fish to mining to electricity to ethnology and archaeology. Housed in richly decorated structures, nearly every department occupied its own building. The scale and the visual and spatial order created by the structures of the White City made the World's Columbian Exposition unlike anything previously attempted. Reflecting on the fair in comparison to 1876, Benjamin Harrison concluded that it gave "a glorious vision of the growth in power, wealth, invention and art, which sixteen years have brought to the world."[20] For Americans specifically, the structure of the fair helped establish a blueprint for nationhood. The same principles that gave order to material objects could be applied to comprehending the vast territory of the United States.

Organizing America—1893

In keeping with the classificatory system that undergirded the entire fair, organizers broke the United States down into meaningful parts for comparison and contrast. Part of describing any entity requires clear definition of component parts, and states, as discrete political units, offered one of the basic organizing categories. Hubert Bancroft spoke to the important role individual states played and the seriousness with which they organized themselves: "Each of the state boards felt itself responsible for the good name of the community, stimulating rivalry among intending exhibitors, and often suggesting, arranging, and taking charge of their exhibits."[21] By opening day in May, most states had assembled impressive and elaborate collections for display in the major exhibition halls and in the official state buildings that ringed the northern end of the park.

The prominence of these state exhibits in 1893 stands out, especially when compared to the two important and influential international American fairs that bracketed the Chicago World's Fair, the Centennial World's Fair of 1876 and the Century of Progress Exposition of 1933. At both of those fairs, states played a largely secondary role in the ordering of artifacts. Designed as a commercial, industrial fair, the Philadelphia Centennial had relied heavily on manufacturing firms to organize displays. Unlike the 1893 Fair, individual states were only minimally represented; little effort went into either setting up pavilions in exhibition halls or erecting separate structures. In 1876 only about 22 of 38 states had built state buildings compared to roughly 40 of the 44 states represented at the Chicago World's Fair. Moreover, no overriding theme, historical reference, or style had guided the design or placement of the buildings in 1876. They functioned largely as meeting places for the use of state citizens, and as Bancroft remarked "were scattered almost at random throughout the grounds; for the idea was a new one, and there was no such cooperation between state and Exposition authorities as at the Columbian Fair."[22] By the 1933 Century of Progress Exposition, states had faded from public view and no longer even seemed to count as relevant organizing units; only three states erected separate buildings. Structures put up by business corporations filled the fairgrounds instead.[23] In the mid-twentieth century, corporate presence had superseded geographic entities.

The need in 1893 for an emerging nation to orient itself in time and space accounts at least in part for the emphasis on states at the Chicago World's Fair. State buildings and pavilions, as icons of local features, provided a basis from which to abstract national identity. Wherever they appeared—in exhibition halls or as freestanding structures—state exhibits served to distill the country into knowable and memorable parts. Their juxtaposition helped not only to structure local loyalties within a national context but to outline distinct features of American identity. The art reviewer Montgomery Schuyler alluded to this when he spoke of the importance of highlighting states' attributes: "It is manifest that a building which is a State exhibit ought to be as characteristic as it is possible to make it, and to suggest the history of the commonwealth which it represents." He added later: "Our point is that a State building should be, so far as possible, distinctive and racy of the soil, provided there be any elements of race and distinctiveness to be had, and in the case of the older States there is no question about that."[24] Records of the

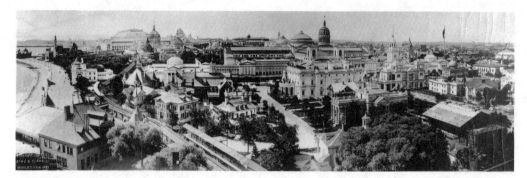

Figure 4. View from the south showing State Buildings, World's Columbian Exposition. Chicago Historical Society (ICHi-25143)

design and outfitting of state buildings suggest the considerable effort on the part of state organizers to take advantage of the independent sites put aside for such construction, and their awareness of how forcefully these separate structures could demonstrate the particular properties of a state's history and geography.

States creatively converted their small plots of land into distinctive buildings aimed to establish their uniqueness (Fig. 4). A number of states, for example, drew on historically important local sites. Virginia erected a replica of George Washington's Mount Vernon home; Massachusetts recreated Governor John Hancock's residence; Louisiana built a plantation house. Regional architectural styles inspired others. California's building resembled an old mission. Connecticut went colonial, while Kentucky modeled its building on the style of southern mansions. Many states also marked their structures through the use of indigenous building materials.

In the same way that the building's facade was supposed to capture a local essence, the interior decoration typically emphasized unique state features such as important historical events, distinctive industries, or products. In addition to providing comfortable reception rooms for the entertainment of visitors, the majority of state buildings set up special exhibition spaces. A number also included small galleries to show the work of local artists. Multiple states, among them California, Idaho, Kansas, and Washington, had such elaborate displays of local items that Hubert Bancroft described them as "a fair within a fair."[25] Pennsylvania, for example, featured a hall of portraits of distinguished citizens, a William Penn memorial exhibit, and the Liberty Bell. Massachusetts furnished its building with colonial antiques as well as portraits of New England authors. Iowa sported a huge grain mosaic that decorated the halls, ceiling, and wall panels of its building, while California pleased crowds with extravagant sculptures made of oranges.

In an effort to make an enduring impression, state exhibits reduced a geographic and social entity to its iconic or representative elements; Massachusetts, for example, fastened on its political leadership and its contribution to American literature in organizing materials, while California focused on its bounty of fruits and vegetables. Displays worked successfully when they

imaginatively fixed a certain vision of a state's resources in visitors' minds, as in the case of the state of Washington's building and its exhibit of stuffed animals, a miniature farm, and agricultural machinery. A *Cosmopolitan* reviewer was singularly impressed with not only the state's natural wealth but its enticing presentation, and declared that "Washington henceforth will mean something definite to me, and the name will call up a vivid mental image."[26] The 1893 Fair, like its predecessors, emphasized knowing through seeing, and the need to appeal to the eye pushed state promoters to articulate and fashion particular, if not spectacular, identities.

A gentle rivalry prevailed as states jockeyed for prominence, anxious to highlight what made them so integral to the nation. Contemporary commentators and fair organizers noted the importance of state pride as a motivating factor in displays. In 1891, with preparations underway, the *World's Columbian Exposition Illustrated* reported: "We read and hear of State pride, we note State competition, and are even informed of State jealousy, but all these elements will be forcibly, though pleasantly, illustrated at the coming world's fair, as it is now definitely assured that the different states and territories of the United States will vie with each other to produce not only state buildings but as well exhibits which will carry off the first prize for beauty, attractiveness and comprehensiveness."[27] Another author noted that local loyalty offered in some cases "the sole inducement to the exhibitor to expend his money and take upon himself additional burdens."[28] Competition for prominence of course had its commercial and political side; greater visibility carried the promise of increased economic development and greater influence in national politics. The governor of California alluded to this when he commended the efforts of the state's citizens that had "enabled California to derive more substantial and lasting benefits from the Exposition than any other State in the Union has received."[29] Whatever the ultimate results, the organization of the World's Columbian Exposition not only called attention to the relevance of the local but also suggested how much national unity depended upon the recognition of local differences.

The efforts to put together a comprehensive showing in the American section of the Agricultural Building underscore the importance of the local to the success of the fair as a national statement. According to Rossiter Johnson, a contemporary historian of the fair, letters requesting agricultural goods for each of the ninety-eight classes in the department had been sent out to various fair boards and commercial associations. The collection of all this material, however, proved difficult. Fair managers responded with a change in approach, deciding that they needed a "broader method" for obtaining exhibits. As Johnson observed, "the installation of agricultural exhibits as intended by the classification—by classes, without reference to State identity—while admirable in theory, is impracticable, and, with the experience of other expositions, it should not have been attempted. State loyalty and pride are two important factors on which reliance can be placed to secure State agricultural exhibits; but when the identity of the State is lost in a scientific or ideal installation interest ceases among its citizens, and failure is inevitable unless the entire exhibit is purchased."[30] Building an American national identity depended first on local loyalties, on citizens having a sense of belonging and where they fit into the larger whole. The state exhibits, especially in the Agricultural Building, helped visitors as well as organizers establish vivid, personal connections.

With almost all of the nation's forty-four states and four territories represented, the Agri-

cultural Building, more than any other exhibition hall, succeeded in condensing the expanse of the United States into a matter of acres. Visitors could literally walk the country, traveling from state to state, noting along the way the production of different areas and how their particular state contributed to the nation's agricultural richness. The state pavilions featured cornucopias of local grains, fruits, seeds, and vegetables. Elaborate labels accompanied all items. The managers of the Agricultural Building required, among other things, the name of the product, the producer's name, the character of the soil, the method of cultivation, and the yield per acre, the extraordinary detail of which provided visitors with the opportunity to compare and contrast the produce of different states. Many states in fact made such comparison explicit. Hubert Bancroft described the layout of Pennsylvania's exhibit as follows: "Worthy of note also are the charts and handsomely bound agricultural reports, in which is a statement of the agricultural and mining products, and the commerce of Pennsylvania as compared with the sisterhood of states."[31] In the systematic detail they employed, state exhibits packaged the country in a clear and immediately accessible fashion.

As with the state buildings, the exhibition hall pavilions created by state organizers resulted in visual confections, or what one guidebook referred to as "beautiful little temples."[32] Their efforts turned entire exhibits into spectacular artworks. Many states designed elaborate facades, archways, and pillars, often recalling heroic monuments. Illinois organizers, for example, collected local grain and covered the walls of their pavilion, pictured to the right of Ohio (Fig. 5)

Figure 5. Ohio and Illinois Pavilions, Agricultural Hall, World's Columbian Exposition. From Hubert Bancroft, *The Book of the Fair* (1893). Courtesy Avery Architectural and Fine Arts Library, Columbia University

with an intricate decorative mosaic. An imposing triumphal arch made out of local grains distinguished South Dakota's agricultural exhibit, while Kentucky erected a 33-foot high and 23-foot wide portal entirely of local coal in its Mines and Mining Building exhibit.

The artistic and sculptural decoration of pavilions minted emblems of a state's basic resources and the assets it and the region of which it was a part could offer the country at large. Pennsylvania, for example, played on the ideal of an agrarian republic. Its agricultural pavilion featured a keystone and a liberty bell made entirely of local seeds, grains, flowers, and fruits. These symbols of the state's role in the birth of the country stood in the central section of the exhibit along with a four-foot seed and grain reproduction of the state's coat-of-arms. Ohio's pavilion, assembled in the form of a Grecian temple whose columns were cast of glass filled with grain, made a similar allusion to agriculture as a pillar of democracy (see Fig. 5). It, too, asserted the importance of the state to the prosperity of the country's political system.

In the Mines and Mining Building, which featured about thirty-five state pavilions, several of the more newly incorporated western states turned to an allegorized female form to attract attention and underscore their legitimacy in the country. Montana capped off its large display of precious metals with a silver statue of Justice set in the center of its pavilion (Fig. 6). Guarded by two bronze lions at the entrance, this six-foot female figure, holding scales in one hand and a lowered sword in the other, stood on a silver globe supported by the outstretched wings of an eagle.

Idaho's exhibit also incorporated an image of Justice, which appeared on a shield made of marble and refined ores. Colorado and Louisiana, like Montana, similarly anthropomorphized their mineral wealth. Colorado displayed "The Silver Queen," a ten-foot figure crowned with ores and seated in a chariot, variously described as a goddess of mining or as a young girl the same age as the state of Colorado. Drawing on a biblical motif, Louisiana featured a statue of Lot's wife carved from a block of its rock salt.[33] Such statues literally gave a recognizable face to states that viewers either may have known little about or thought of only abstractly. Especially for those states in the so-called Wild West, invoking such values as justice suggested as well their civilized, cultured side. The use of the female form reinforced this by drawing on associations of the feminine ideal with virtue, righteousness, and domesticity.

As another opportunity to solidify their image, states also had their official day of celebration. These events regularly punctuated the fair calendar and typically involved dinners, fireworks, and speeches by notable state figures. For citizens from the celebrating state, the festivities provided entertainment and a source of pride. To fair visitors in general, State Days memorialized, like the pavilions, noteworthy qualities of a particular state and their significance to national life. New York Day, for example, fell on September 3 and opened with a series of addresses. As one state official concluded: "We [New Yorkers] are here with our arts, our agriculture, our manufactures, the products of our mines and our forests, the illustrations of our educational system and of our general progress, to explain to the other Commonwealths and to the world why it is that we enjoy and retain and will continue to hold the proud position of the Empire State of the American Union."[34]

The visual message of state and regional distinction had written reinforcement in the vast literature states generated for the fair. Almost all states published some kind of report or

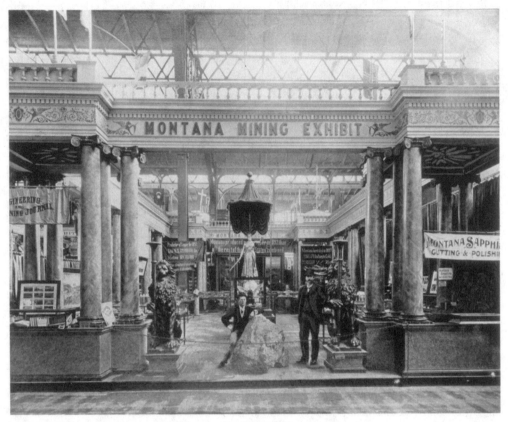

Figure 6. Montana Pavilion, Mines and Mining Hall, World's Columbian Exposition. From *The World's Columbian Exposition Reproduced* (1894). Courtesy Avery Architectural and Fine Arts Library, Columbia University

brochure, and like the State Day performances and the exhibition hall pavilions, these texts also advertised local specialness to affirm national relevance. Iowa, for instance, published a pamphlet with the title that began with *A Hand Book of Iowa . . . or* and went on to list a multitude of features including settlement, topography, agricultural productiveness, manufacturing advantages, healthfulness, government, and the excellence of the social and moral life of the state: the final part of the title read *The Brightest Star in the American Constellation*. An Idaho publication described in detail its state's history and resources, and included tables that compared Idaho's wheat production, mining, and healthfulness to those of its immediate neighboring states as well as to those in the East. The author concluded that "Idaho has fully proved herself one of the great natural treasure houses of the Nation."[35] Maneuvering for position within a larger whole, states claimed superiority not only for specific natural resources and manufacturing industries but for more intangible qualities as well. Pennsylvania's exhibits at the fair, one of its state books declared, should show the "taste, genius, production, and enterprise as will fill our people with increased love for the state, and improve the welfare of every line of manufacture and industry, and aid in placing Pennsylvania in its true light before the world, as one of the most moral, intelligent, wealthy, patriotic and progressive members of the

Union." In an article on the Liberal Arts Building, the author made a comparable declaration about Massachusetts's contributions to human betterment. One of the state books, *Massachusetts of To-Day: A Memorial of the State, Historical and Biographical,* echoed this point, singling out Massachusetts as the birthplace of political and social enlightenment. The introduction closed with the dedication: "To the States of the Union and to the nations of Christendom, Massachusetts pledges this book as a token of her undiminished zeal and ability in the furtherance of the arts of civilization and the happiness of the human race."[36]

The period's flair for rhetorical flourish and the bombastic only partially accounts for such declarations. State jockeying for prominence and distinction had at root a fundamental issue in the building of late nineteenth-century American nationhood; where did individual states fit in the Union economically and politically, and what role were they to play in national life? Materials published for the fair along with the exhibits themselves not only capture the struggle of states to negotiate their way between local conceit and national spirit but highlight tensions between different sections of the country. As much as the fair promoted individual state identity, it also forced considerations of regional affiliation and what bound or separated different states.

While the tensions leading up to the Civil War largely split the country into northern and southern parts, a fault line that emerged in 1893 cut the country along an east/west axis, between the newer, more agricultural parts of the United States and the older, more industrial ones, with each warily eyeing the other. California's fair commission in its final report, for example, recorded with great satisfaction that "Eastern and foreign visitors, for whose benefit the display [of California at the fair] was chiefly made, were not only astonished, but impressed in a practical manner that was most gratifying." The art gallery of the state building, which featured Californian artists, proved a special source of pride. In commenting on the response to the exhibit, the report explicitly revealed the tension surrounding a region's image: "While this may be considered the extreme of encomiums, the complimentary remarks usually made showed that the exhibit as a whole was a valuable object-lesson to visitors, demonstrating to doubting ones that California possesses all the elements of refinement and culture enjoyed by the older States in the Union, notwithstanding the fact that the State is comparatively new and hitherto known chiefly for her material products."[37] Ironically, for the older states of the Union, particularly those of New England, it was precisely the issue of natural resources that exposed sensitive nerves, and New England state fair managers responded by linking agricultural quality to the moral health of the country as a whole.

Eager to showcase Connecticut and demonstrate its agricultural vitality, Professor William Brewer of Yale University pressed for an extensive agricultural exhibit. He argued for the important role farming played in the state, stressing its vigor and health, despite reports in magazines and newspapers about the barrenness of portions of the land. While he admitted that no crop stood out prominently, he emphasized the abundant and varied harvests and especially the importance of quality over quantity, particularly in comparison to the bountiful midwestern states. He made a point of noting that "the value of production per acre is larger than in Illinois, Indiana, or Ohio."[38] Spurred on by Brewer, Connecticut set up a large display in the Agricultural Hall featuring its corns, grasses, and tobacco.

Like Connecticut, Massachusetts also reacted to perceived challenges from western parts of the country. Stressing the agricultural plenitude of the state, the director for the agricultural exhibit detailed his mission in his final report on the fair. Here he attempted to combat apparent references to the New England states as "a sterile region," "a good place to be born in and to emigrate from," erroneous allegations he saw coming from citizens of the middle and western states. The agricultural exhibits for Massachusetts under his charge were meant directly to counter those impressions:

> In the Massachusetts exhibit of farm crops I have tried to give expression and confirmation of my own belief that Massachusetts can and does produce all the fruits of a temperate clime in as great perfection and abundance as any State in the Union, and while she does not claim that her soil will yield profitable returns under niggardly and slipshod management, her intelligent, liberal and skilful farmers, being surrounded by industrious and thrifty communities of manufacturers and merchants and scholars and professional men, obtain better pay for their labor than their Western brethren, whose profits are heavily tolled by the freight agent and the middleman.[39]

Echoing Professor Brewer's claim, Massachusetts's agricultural director argued that what the state lacked in volume, it made up for in better value and social worth. The alliance of land and character surfaced as powerful trope for the New England states.

For their part, the southern states worked to recuperate a sense of belonging in the nation after a war that had isolated them. In a series of articles published prior to the opening of the fair, the *World's Columbian Exposition Illustrated* focused on the determination of the southern states to assert their presence and prove their worth. One of the magazine's southern authors concluded that "the World's Columbian Exposition of 1893 affords the South a conspicuous opportunity, possibly never again to be repeated, for a display of the resources hidden during the first century of our national existence, which it would be short sighted, if not criminal, to neglect."[40] Although less well represented in many of the major exhibition halls and rarely described as lavishly in the guidebooks as those of other states, the exhibits by southern states nonetheless marked their position on the national map.

Sensitive to regional affiliations as a way of displaying the country as a whole, fair managers made attempts to arrange state buildings geographically. Already in 1891, the *World's Columbian Exposition Illustrated* had recommended this type of ordering. As in the major exhibition halls, visitors here too could walk from state building to state building and figuratively travel the entire country. By 1892, the magazine had noted that with the erection of Vermont's state building the "New England group" would be complete.[41] An effective regional organization, however, depended on broad state participation, one reason perhaps that the scheme worked better with the state buildings than with the various exhibition halls, especially the smaller, more specialized ones. Only a small percentage of states were able to send exhibits for the Fisheries Building or the Anthropology Building, for example, and the arrangement of their displays appears random and tied more to space and size constraints. On the other hand, in major

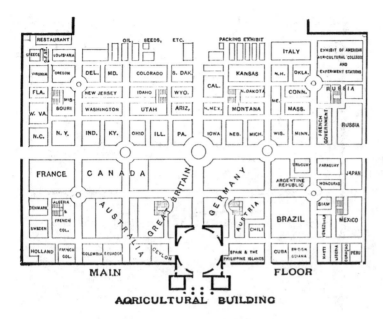

Figure 7. Plan, Agricultural Hall, World's Columbian Exposition. From *Rand, McNally & Co.'s Handbook of the World's Columbian Exposition* (1893)

halls like the Agricultural Building where almost every state could participate, fair organizers managed loose regional groups. Photographs and plans show the New England states clearly clustered together (Fig. 7), and in his chronicle of the fair, Bancroft explicitly noted how the agricultural displays fronting on the central nave were "divided among the middle, western, and southern sections of the country." In his section on the Mines and Mining Building, Bancroft carefully guided the reader around the hall describing the exhibits by regional groupings.[42] In roughly recreating the contours of the nation, the scheme allowed visitors, armed with statistics and categories of comparison, to apprehend the country's physical and cultural terrain, its breaks and bonds.

A particular solidarity emerged among the six New England states. Concerned about how they compared to the western states with their vast natural resources, Massachusetts, Connecticut, Rhode Island, and the others stressed in their materials for the fair their long and distinguished history. A collective pride centered on the quality of the region's citizenry. It stressed that character grew best on New England soil. From poem to pavilion, variations on the expression "crops of men" reverberated and united the New England states behind a common image. The exact term appeared in a poem about the Massachusetts building that concluded:

> Yet naught hath my imagination swayed
> Or stirred the high pulsations of my heart,
> Like this gray building, whose pretenseless wall
> Enshrines the honored names who live again,
> And in whose precincts shadowy footsteps fall.
> Let others bring earth's wealth before our ken;—

Figure 8. Connecticut Pavilion, Agricultural Hall, World's Columbian Exposition. From *Dream City: A Portfolio of Photographic Views of the World's Columbian Exposition* (c. 1893–1894). Courtesy Avery Architectural and Fine Arts Library, Columbia University

> The Ancient Mother, high among us all,
> Hath proudly garnered here her crop of Men.

Connecticut proclaimed this point even more forcefully. An arch mounted in the state's pavilion in the Agricultural Building bore the legend "Connecticut's Best Crop—Her Sons and Daughters" (Fig. 8).

A similar sentiment inspired a poem written for the festivities of Rhode Island Day, a portion of which read:

> Last of the thirteen, smallest of them all,
> What canst thou bring to this World's Festival,
> Where all thy sisters come with pride and power,
> And bring each one a Princess' generous dower
> Of gold and gems, and fruits, and precious woods,
> And joyous tribute of their costly goods. . . .

What can we bring? No outward show of gain,
No pomp of state; we bring the sons of men!

Elsewhere, reviewers commented on the wholesome and solid men and women of Vermont and Maine.[43] In asserting a link between character and environment, New England promoters invoked earlier nineteenth-century scientific theories about the relationship between climate and race; the geographer Friedrich Heinrich Alexander von Humboldt's research into the peoples and landscape of South America in particular had helped establish that connection. Humboldt's understanding of racial difference or types, as Deborah Poole has commented, "was framed in terms of culture and only secondarily as a problem in comparative physiology. If migration was to affect 'race' it would be, for Humboldt, less through the darkening of skin or the broadening of noses than through the ways in which culture and art had been altered by different climates, landscapes, and geologies."[44] In 1893, New Englanders looked at the distinctive features of their landscape and claimed a regional superiority. In associating the region's land with the propagation of hardy and enterprising citizens, the term "crops of men" secured the importance of New England to the nation.

From a region once practically synonymous with the United States, New England, by the end of the nineteenth century, had shrunk to one of several geographic areas. As the country had stretched to California, political, economic, and social power also shifted in that direction. The areas beyond the Mississippi opened up opportunities for business ventures and new careers. Those amassing great fortunes helped to build leading cultural enterprises, including educational institutions such as Stanford and the University of Chicago, as well as museums and libraries. The literary historian Martin Green has noted that, although the number of millionaires significantly increased in the late nineteenth century, New England claimed few of them.[45] Against these shifts in the balance of power generated by other regions—the West, Midwest, or the South—the New England states struggled to project a potent image of themselves and the region as a whole, one that would solidify their position as leaders among the united states. In *Massachusetts of To-day,* the memorial volume published in anticipation of the fair, the author commented on more than just the state of Massachusetts; indeed he embraced all of New England and summed up the region's claim for leadership when he wrote: "Evidences of that enterprise, of that integrity, and of that conservatism, qualities which seem to be almost indigenous to the soil of New England, are seen on every hand as one journeys through the country, and what perhaps is as interesting a fact as any other, is that nowhere is full credit denied to the spirit of New England,—that spirit which is generally and thankfully acknowledged as having had a very marked influence upon the nation's history."[46] The wide range of visual and textual material of the fair attempted to illustrate how that had been accomplished. Together, they put forth an image of the region as cultured and productive, the source of moral values and "solid and substantial" citizens.

Regional Representation and the Fine Arts Exhibit

The nearly 1,200 paintings, sculptures, watercolors, and engravings assembled for the American section in the Fine Arts Building seized the attention of viewers from home and abroad. The United States' showing not only garnered international recognition but also elevated the position of the arts in the country itself. Reflecting on the exhibition one year later, the art critic John Van Dyke enthused, "The book of our arts has just been opened, and no one knows what bright deeds of beauty may be written upon its pages in the years to come."[47] Yet just as the state exhibits throughout the fair had addressed the composition of the country, the American art exhibit stimulated questions about the nature of a national art and viable elements for its representation: on what themes, styles, or subject matter should American artists concentrate?

The organization of the Fine Arts exhibit extended the Chicago World's Fair spirit of competition into the aesthetic realm. To put together the American section, the chief of the Fine Arts Department, Halsey Ives, and his assistant Charles Kurtz had established advisory committees and juries of selection in the major art centers of the United States—New York, Philadelphia, Boston, and Chicago. In the year before the fair, each city had prepared to send its best representatives, eager to demonstrate the quality of its local artists. The friendly rivalries evident among states and regions in other parts of the fair appeared in this venue as well. Here too issues of regional identity and specifically New England's artistic contribution came into play.

Boston, the center of the New England art world, rallied in particular. In a call to action printed in the *Boston Transcript,* the editor of the paper spoke of the importance of a creditable showing of New England art and urged local artists to "unite in common cause" and show what they could do for the glory of their country. Massachusetts, the editorial cried, "whose legitimate boast it has always been to lead and not to follow the rest of the States in every movement where the honor of the country is involved, must not be suffered to straggle in the rear during this all-important campaign. There are some people who think there is no art in this Commonwealth worth talking about; and there will never be a fitter opportunity to open the eyes of these deluded folks than the year of grace 1893."[48] Several months later the *Transcript* reported on the effective efforts of the state and the region. Approximately 125 paintings had been forwarded to the fair's Fine Arts Department, including works by Edmund Tarbell, Frank Benson, Charles Davis, and Thomas Allen. John Enneking sent a number of pastoral landscapes, Frederic Vinton a host of portraits. The Boston-born artist Winslow Homer, whose work seems to have been selected by Kurtz himself and not by any local jury, attended the January viewing of the collection in Boston. As reported in the paper, Homer found it the "best-hung collection of paintings" he had seen in the country. The *Transcript* commented further that it had "a look of importance and dignity which is not often to be seen, even in the galleries of the Salon" and concluded that, based on Boston's fine showing, a "great and glorious triumph of American art over all competitors" seemed assured.[49]

Most critics concurred, seeing a new maturity and independence in the artwork presented in the American section. A sign of this coming of age was the combination of native subject

matter with technical quality, best embodied for some reviewers by the work of Homer. John Van Dyke singled out his pictures, which included a large number of New England coastal scenes, writing that they were "American without preface or apology. They breathe of the soil and the sea, tell of their place of origin, give the American point of view."[50] While full of praise, Van Dyke wished only to see more of these visible signs of locale. He cautioned that European influences still held too much sway, and representations of American life, although clearly in evidence, were still too few. As he noted, American art would never be truly successful without a distinct American approach and sensibility. Hubert Bancroft in his chronicle of the fair echoed this sentiment and pointed out that important American figures and events seemed better represented in some of the foreign sections. He quoted one distraught American: "After I had made a tour of the galleries, and compared the exhibits of European nations with our own, I felt like a man without a country."[51] Historical episodes, important civic leaders, identifiable local places—these particular aspects of an American scene struck Bancroft and other commentators as lacking in the exhibition, an impression generated perhaps by the actual arrangement of the collection.

Unlike exhibits in the other exposition halls, none of the work in the Fine Arts Building had been specifically created for the fair, and states played no role in the presentation of art objects. Instead, Charles Kurtz, who took on the responsibility for hanging the pictures, seems to have been guided largely by his preferences for color, size, and visual impact. While the Fine Arts exhibit revealed a flourishing art community, it displayed little effort to emphasize themes, styles, or types of subject matter that could be characterized as distinctly American. Winslow Homer's ten New England coast paintings, featuring images of hardy fishermen and Maine's rocky shore, were distributed, for example, across seven different rooms. Furthermore, as Carolyn Carr notes, painting genres—landscapes, portraits, and figure scenes—were freely mixed.[52]

Given the unthematized presentation of the United States art exhibit, what is notable in the contemporary discussions of the show are the attempts by reviewers to bring principles of organization to the imagery on their own. While many fastened on media and genre, highlighting the types of sculpture or landscape paintings in the American section, a number looked at the display in terms of regional artistic contribution. According to Bancroft, for example, "Pacific Coast art" hardly made an appearance and was best seen in the state buildings. But what truly impressed him was the work of artists who submitted from Boston, what he called the New England collection, and for the three main mediums—painting, sculpture, and architecture—he singled out the region's display. The critic William Howe Downes contributed a piece in the *New England Magazine* in which he similarly addressed the issue of regional contribution. Echoing concerns of the *Boston Transcript* earlier in the year about New England's role in the Fine Arts exhibit, Downes started his discussion with a question: "What share is New England to have in this peaceful international tournament?" He answered with reference to scale: "Many of the pictures are of great size . . . and while this is perhaps in itself no merit, it has a certain advantage, in that it will present an ensemble of important aspect, even of a sort of dignity, in the galleries of a great world's fair, where a collection of smaller works, however meritorious, would fail to attract an equal measure of attention at the first glance."[53] Downes's

perspective on the American section proves strikingly artificial, however, given that the so-called New England collection was dispersed throughout the American galleries and plenty of artists outside New England had submitted large-scale canvases. While he clearly sought to give an order to the great jumble of American artworks exhibited, he also wanted to make a claim about Boston and New England's cultural and artistic position. Through the sheer number and size of art objects presented, Downes argued, New England had shown itself to have an important place. Thus the region retained its stature even as the country had expanded and added other sections.

The Case of Thomas Hovenden's *Breaking Home Ties*

The response of reviewers not only to perceived groups of objects but also to individual paintings established and reinforced regional distinctions. The interpretation of the Pennsylvania artist Thomas Hovenden's *Breaking Home Ties* as a New England scene offers a compelling example of New England's enduring association with refined taste and moral sensibilities. During the fair, *Breaking Home Ties* (1890) earned the distinction as one of the most popular pictures in the Art Building. According to one newspaper account, engraved copies were available in almost every art store in Chicago and had sold briskly.[54]

Hovenden's scene of a young boy leaving his rural home and family to make his way in the wider world captured a certain vision of national destiny, growth, and promise (Plate 1). The work, as one critic had commented when the picture was first exhibited in 1891 at the Pennsylvania Academy show in Philadelphia, could be "considered as historic, and of national consequence, since it represents a turning of the tide in the affairs of men which leads on to fortune, not only personal but public, to the founding of private welfare and to the upbuilding of the State . . . and it is one of the significant elements of the situation that, being an American boy, we do not need any visible assurance written on his forehead that he is destined to succeed."[55] Although Hovenden may not have marked the boy's forehead, the structure of his painting communicated this message of stability and promised achievement. Overall balance and symmetry characterize the entire scene, from Hovenden's pairing of figures to the strong pyramid in the foreground, outlined by the mother's head, the dog on the left, and the chair at the right.

The composition revolves around the mother and son pair, a strong vertical accentuated by the mother's gleaming white apron. Four points anchor this core; the grandmother and daughter pair near the door balances the dog and daughter pair near the hearth, while the empty chair at the table offsets the chair in the foreground. Similarly, in the background, the open cupboard mirrors the open door across the way. Hovenden further unites the elements of the painting by an integration of foreground and background; the central pair forms a line linking the floor of the foreground to the wall in the background, a strategy echoed on either side of the painting. On the right, the foreground chair leads to the men at the doorway; on the left, the dog, the seated girl, and the back cupboard form another continuous line. Visually cued, every viewer could see, as the 1891 critic did, that this boy like many others was leaving home "to create new conditions, to acquire property, to marry well and establish another fam-

ily, to become good citizens and valued members of new communities, to develop that estate of American manhood which is the strength of the strongest nation in the world to-day."[56]

While Hovenden's generic statement about rural home values and the promise of youth lacked any clear geographic reference, commentators, especially many from western parts of the country, repeatedly identified *Breaking Home Ties* as a distinctive New England scene. Disregarding what they knew and even what they saw in the painting, they sketched in the missing details and mapped a specific local character onto the image. For them, the painting's exaltation of country ways evoked an imagined New England. Benjamin Truman, an author and western newspaper man who chronicled the fair, described Hovenden's work as "a simple study of the living room of an old New England farm house, showing the table set with quaint old china, the mantel adorned with pieces of glaze ware, the high-backed yellow chairs, and the ingrain carpet that every New Englander in the United States can remember if he looks back far enough." Hubert Bancroft, who hailed from Ohio and established a publishing house in California, similarly described the picture as "a simple and touching story of New England life in days not long gone by," seeing the china, the chairs, and the carpet as dearly loved and recognizable New England objects.[57] The fact that almost nothing about either the painter or the painting specifically pointed to a New England setting underscores the completely invented nature of this identification.

The painting's creator, Thomas Hovenden, spent little, if any, time in the New England area, did not claim Puritan ancestry, and by all accounts was considered a Pennsylvanian. Born in Ireland in 1840, he came to New York City in 1863, then left in 1874 for Paris to continue his artistic training. Upon his return to the United States in the early 1880s, he settled in Plymouth Meeting, Pennsylvania, the hometown of his wife Helen Corson, whose family were prominent descendants of the town's early Quaker settlers. As Hovenden's reputation grew, one newspaper even featured a story on him entitled "An Irish Quaker Artist."[58] Hovenden taught at the Pennsylvania Academy of the Fine Arts for a short period, and by all accounts, worked and resided exclusively in the Philadelphia area. Because he was considered a Pennsylvania artist, it is hardly surprising that those Philadelphia newspapers that bothered to note the identity of the farmhouse or the boy in *Breaking Home Ties* described them as Pennsylvanian. In an interview in 1891, Hovenden himself had pointed out that he regularly attended country auctions to find objects—furniture, mantels, rugs, and so forth—that he could incorporate into his paintings. As an example, he showed the interviewer the very rag carpet he had used in his painting of a boy leaving home.[59]

Even without Hovenden's statement about the provenance of the carpet, there is little evidence for reviewers' assertions of its inherent New England identity. Rag carpets were extremely common across the country, and their patterns and styles carried no regional distinction. As early as 1875, a midwestern publication, the *Prairie Farmer,* ran an article in its household section exhorting housewives to make and decorate their homes with rag carpets because they represented "real honest family life and love."[60] The chairs reviewers singled out in Hovenden's picture resemble typical Windsor-style chairs, which were widespread and popular through the 1800s. The Windsor was first introduced from England in the early 1700s and, if anything, had a reputation as a Philadelphia chair; the city's furniture makers were known

for their patterns and innovative designs. By the mid-1800s all types and shades of them—bow-backed to fan-backed to high-backed—could be found up and down the eastern seaboard and further inland and were produced throughout the various regions.[61] Critics' interest in finding New England elements in Hovenden's work and conflating Pennsylvania with New England underscored a view of the region as a site of strong familial values and traditions.

In reading Hovenden's painting as a specifically New England scene, Bancroft and other reviewers responded to, as well as promoted, evolving notions about national character. The regional interpretation of *Breaking Home Ties* called into play a loose association between New England on the one hand and rural life, moral values, and stability on the other. This to some degree was rooted in historical fact. Throughout the nineteenth century, New Englanders and people from the East in general had migrated westward, setting up new towns and bases of largely Anglo-Saxon culture. A conviction in Manifest Destiny, elaborated both in art and in literature, had spurred that vast enterprise and justified the means employed.[62] Hovenden may not have directly addressed the details of westward movement, but he articulated visually a sense of strong foundations, new beginnings, and future rewards. While some reviewers focused on the painting as a statement about rural versus urban values and specifically mentioned the city, a substantial number left the boy's destination more ambiguous and open-ended. As one commentator eloquently summed up the image of family in *Breaking Home Ties:* "The Home is the American Home, the unit of our commonwealth; the boy who is leaving it is the young State-builder, the type of that youthful energy that has gone out from Eastern households and reared up a score of great empires in the West."[63] Popular interpretations of Hovenden's young boy recall the claim of the New England states at the fair that the region's rocky soil grew hardy "crops of men," individuals with the strength and fortitude to prosper even under adverse conditions.

This emerging vision of the region as the cultural capital of the nation coincided with the work of the New England Societies, a network of social institutions that came into prominence in the 1880s and 1890s, spreading across the country and dedicated to celebrating the region. In 1890, for example, in a *New England Magazine* report entitled "New England and the West," focusing on the New England Society of St. Louis and its Forefathers' Day celebration, the editors opened with a proposal for a new map of the United States, "in which New England appears bodily lifted out of its far-off corner, and set down plump in the middle of the republic, a bright spot in a sorely shady and needy-looking country, to whose extremes she is radiating philosophy and art and the sundry excellent things, including capital,—whether religion, we do not remember."[64] The article went on to quote the entire speech given at the society by Charles Dudley Warner, which discussed the influence of the "Pilgrim spirit" on the West, making a special point early on to state that expansion did not mean the exhaustion of civilization in the East.

The reference to a potential drain on New England's resources alludes to regional prejudices circulating at the time and the difficulties of securing national cohesion in the face of disparate states and regions; the fair particularly brought out tensions between eastern and western parts of the country. As passionately as New Englanders attempted to claim a leading role for the region in the nation, residents elsewhere, and Westerners in particular, wondered what

New England, after sending forth its sturdy citizens, had left to offer for the twentieth century. Had in fact the region's energies been spent? As the manager for the Massachusetts agricultural exhibit had tartly noted, Westerners seemed to want to entertain the idea of New England as a sterile region, "a good place to be born in and to emigrate from." On the other hand, from their perspective, New England promoters would argue that whatever the region's economic and social difficulties, they were only exacerbated by the West and its exploitation of New England's labor and resources. An anecdote reported in *New England Magazine* concerning Vermont's state building at the fair summarized this bitterness. In addressing the reason for the comparatively small size of Vermont's structure, the author cited the following exchange: "A Vermonter born, whose milk of human kindness had curdled in Kansas thunderstorms, said to Superintendent Drew, 'Wal, Vermont don't seem to spread out very big beside some of 'em?' 'No,' replied Drew, 'but the building isn't finished yet.' 'Not finished? What more is to be done?' 'Oh, we intend to paper the walls of the large room with defaulted Western securities held by our people, as soon as we can get paste enough made.'"[65] In the context of particular difficulties within New England and the simmering tensions among regions, it is perhaps not surprising that the New England papers and magazines resisted identifying *Breaking Home Ties* as a New England scene. The *Boston Journal,* for example, clearly stated that the picture represented a Pennsylvania home.[66]

As much as Hovenden's painting helped to evoke New England as a wellspring of moral and social values, it also raised the specter of eventual depletion, a vision of the region that the New England states worked to battle at the fair both textually and visually. As Massachusetts asserted in one of its volumes published for the fair, "If we will but look around us, the conclusion is inevitable that Massachusetts has *not* deteriorated; on the contrary, she has but reached the full and rounded development of a noble and beautiful womanhood."[67] The Fine Arts Building offered another, albeit limited, venue to further that claim. Here, New England took form not only in the art assembled by the Boston jury, the so-called New England collection, but also in a number of works submitted by artists in New York and Philadelphia that featured historical New England figures as well as rural scenes. Charles Turner, for example, depicted New England's colonial past. Two of his canvases—*John Alden's Letter* and the *Courtship of Miles Standish,* which Hubert Bancroft described as "full of the atmosphere of New England life"—presented New England characters inspired not only by historic events but also by Henry Wadsworth Longfellow's poem. Set in realistic, detailed colonial interiors, the paintings, as Diane Dillon has pointed out, emphasized an Anglo-Saxon heritage.[68] Images of hard-working rural New England laborers captured the attention of Eastman Johnson, who depicted Nantucket cranberry harvesters.

But echoing John Van Dyke, local New England papers clamored for still more readily identifiable and presumably more contemporary local subject matter, images of the region that would seize the viewer and leave memorable impressions. The editor of the *New England Magazine* articulated this driving need to represent and celebrate distinction when he looked back on the New England collection at the fair: if one had to identify a defect in the exhibition it was that it wasn't representative enough. It needed to give a much more vivid sense of "New England life and thought and feeling." The question he posed was "What is there, with slight

exceptions, in the subjects treated or in the pervading spirit, to show that the exhibition represents New England rather than another quarter, American or not American, whose history, traditions and character are as unlike those of New England as Britain is unlike Brittany?" The artists, he continued, had neglected the riches around them so that there was "nothing to show that they live in the New England capital, that they visit the New England farm, that they read the New England poets, that they inherit the New England history and traditions, that they know their own neighbors, or are themselves New England men and women."[69] The author called for the region's painters to stand up and paint the world from their own window.

In doing that they would offer artists throughout the country a template for American subject matter. An article published in the *Boston Evening Transcript* that actually reprinted parts of the editorial (including the section quoted above) stressed the link between the local and the national. Style was not the issue, the author insisted: "We hope that the epoch-making World's Fair year will bring such [native] themes to the front, and that a free discussion of them may result in a real demand for American pictures of American subjects."[70] In folding in the *New England Magazine*'s concern for the local with its own appeal for a national art, the *Transcript* made one thing clear: American art required American subject matter, and New England had the means and the resources to supply it. The region offered a quintessentially American model.

American culture in microcosm, the Chicago World's Fair of 1893 was a symbolic moment in the definition of nationhood. Yet like the whiteness of the facades that obscured rougher structures underneath, the national unity the fair trumpeted muffled the sound of other voices that spoke to tensions and struggles within. In the years following the Civil War, a nation had re-emerged, a delicate balance among state, regional, and national loyalties. The fair addressed the growing consciousness of their relations. What economic, cultural, or political place, one might wonder, did states have in the grand national scheme, and what assets could they offer to the country as a whole? By the late nineteenth century, these questions proved especially acute for the New England states. Their exhaustively detailed displays pointed to potential avenues of distinction, cultural leadership among them. These self-conscious articulations worked not only to lay out the terms of a local/national conversation in the 1890s, but they also helped to solidify a vision of the region, one that would become instrumental in the shaping of national identity in the ensuing years.

CHAPTER TWO

New England in the Public Eye

Between roughly 1880 and 1920, legions of bronze and marble heroes, historical personages, and allegorical and mythological figures took up positions in cities and towns throughout the Northeast. Placed in prominent public spaces, this statuary gave an order to the urban landscape. It also projected specific ideals about the body politic, invoking such values as courage, moral rectitude, and self-reliance. Architects and sculptors, together with their patrons, shared a confidence in the ennobling and moral influences of art, and in turning to public commemoration they attempted to foster a common civic culture. Their interest coincided with the efforts of late nineteenth-century reformers to combat problems of urban growth and social dislocation brought about by shifting demographics and urbanization, by rapid industrialization, and by the unprecedented influx of immigrant groups.

Located at the intersection of personal vision and community taste, public art has often aroused passionate response. This chapter explores its expressive qualities for artists and audiences, focusing on the travails and travels of three statues based in New England—*Bacchante and Infant Faun* (1893) by Frederick MacMonnies; *Deacon Chapin/The Puritan* (1887) by Augustus Saint-Gaudens; and *The Pilgrim,* also by Saint-Gaudens (1905). Behind a seemingly decorative Bacchante or a commanding Pilgrim lurked a basic question: Whose civic values would shape public life in New England, as well as in the country as a whole? The sculpture embodied in particular a claim by social elites for New England's cultural leadership and national authority. This claim did not go uncontested. Turn-of-the-century public monuments, as the circumstances surrounding the making and reception of these works illustrate, played a direct role in struggles by competing classes and ethnic groups for social and political expression. For civic leaders, works of art offered an opportunity to establish in public an ideal image of civic and moral values.

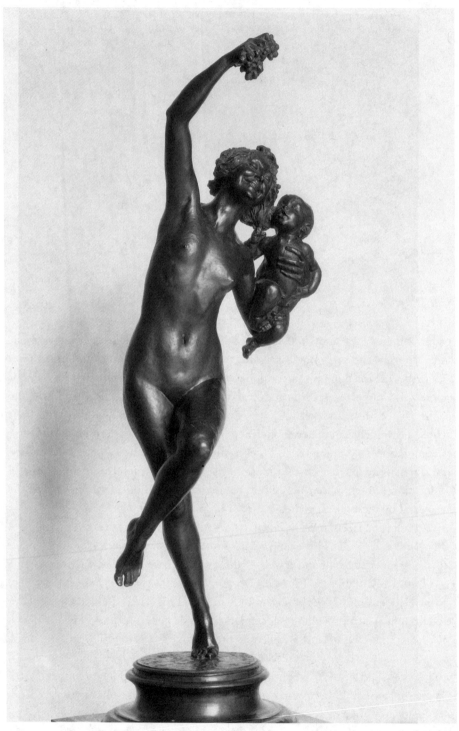

Figure 9. Frederick MacMonnies, *Bacchante and Infant Faun,* 1893, bronze, 83 in. All rights reserved, The Metropolitan Museum of Art, Gift of Charles F. McKim, 1897

Bronze Goddess or Drunken Nude

In the fall of 1896, a battle over public art erupted in Boston. The source of the fury was a bronze statue by Frederick MacMonnies, entitled *Bacchante and Infant Faun*—a three-quarter life-size female nude in mid-skip holding a cluster of grapes in one hand and a young child in the other, slated for the fountain in the courtyard of the Boston Public Library (Fig. 9). Charles F. McKim, the donor (as well as the widely respected architect of the library itself) had intended MacMonnies's work to unify the building with its courtyard (Fig. 10). Much to McKim's surprise, however, the statue was denounced as a memorial to "reckless abandon" and "the worst type of harlotry," debauched and offensive. In the end, the seemingly innocuous bronze succeeded only in dividing Boston society.

For over a year, controversy brewed as opponents fought to expel the American sculptor's skipping nymph from the city and supporters fought just as vehemently to keep it. One incensed opponent in a public talk entitled "Treason in the Boston Public Library" went so far as to accuse library trustees who defended the statue of "treason to purity and sobriety and virtue and Almighty God."[1] The trustees, like McKim and other Boston citizens, regarded such accusations as reactionary and uninformed. By November, the debate over the statue had reached a fevered pitch. As Thomas Sullivan, a Boston playwright, put it in his journal:

> Both cats have their backs well up, and the fur is likely to fly before the spring comes. . . . and we [Sullivan and other supporters] hope to overwhelm the howling dervishes by our numbers, if not by rational arguments. Against the group are arrayed President Eliot, H.U. [Harvard University], Professor Norton, Robert Grant, Barrett Wendell, and others, who regard it as "a menace to the Commonwealth." Their allies, the sensational clergy, go a few steps further, and declare that this begins a righteous crusade against the intolerable indecencies of the antique in the Art Museum. Verily, impropriety makes strange bedfellows![2]

Through the winter and spring of 1897, local citizens organized meetings for and against the statue, petitions and counter-petitions were filed, and newspapers in Boston and in cities across the country took positions on the subject. Articles on the latest developments in the uproar appeared regularly in papers from Los Angeles to Milwaukee to Philadelphia.

In the course of these exchanges, MacMonnies's statue assumed two distinct personalities. For the president of the library trustees, the *Bacchante* was "simply glorious, a beautiful work of art." Other supporters similarly described the statue as an innocent expression of grace and joy. But while they praised the *Bacchante* for its vital image of life and delighted in what McKim called the "spirit of joyousness and spontaneity," opponents denounced the statue as a wanton woman, "unclothed, unquiet, and vile." In the words of one expert appointed by the Boston Art Commission, the work portrayed no innocent joy but only "a drunken revel of debased civilization." Critics personified the statue so frequently she even acquired a voice of her own.

S

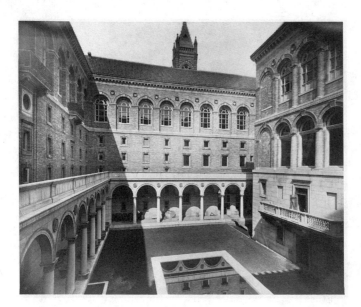

Figure 10. View of the Boston Public Library Courtyard. Courtesy of the Boston Public Library, Print Department

A New York paper imagined hearing the Bacchante's poetic lament: "Although I have a joyous air / I'm really feeling sad; / When I am so divinely fair / How can they call me bad?"[3]

But the endorsement of the library trustees, and later the Art Commission, as well as the groundswell of popular support was not enough to secure a place for the statue in Boston. The trustees had enthusiastically accepted McKim's gift in July 1896 when he offered the statue. Such acceptance was conditional, however, because all public works of art had to win the approval of the Art Commission. That summer, the trustees submitted a smaller model of the *Bacchante* to the commission for evaluation. After conferring with a committee of experts, the commission voted against the statue in October, citing concerns about artistic merit and the figure's appropriateness to the site.[4] The following month, they changed their minds and accepted it, prompting those opposed to the *Bacchante* to fight all the harder. Come June 1897, after a winter of bitter attacks, the commission moved once again to reject the *Bacchante*. Charles McKim reported to a colleague that "petitions were circulated by a certain element in the [Boston] community, which chose to find in Macmonnaies' [sic] masterpiece that which neither the Trustees nor the Art Commission were able to discover, and which Macmonnaies never intended."[5] Chagrined and dismayed by the references to the statue's unsuitability and degeneracy, McKim took back his gift to save himself and the library trustees any further humiliation. In June he offered it to the Metropolitan Museum of Art in New York City—which immediately accepted it.

What was it that so powerfully disturbed particular Boston citizens about the *Bacchante* and gave common cause to groups that otherwise had little to do with one another? Many critics at the time, especially those in other cities, ascribed the commotion to Boston prudery and primness, and they endlessly ridiculed Boston (their own apprehensions about the public display of nudity no doubt fanning the flames). As the *New York Sun* put it, "The people there [in

Boston] do not believe that such trifling with the terrible gravity of life as the *Bacchante* delighted in is proper. They don't do it themselves, and they object to anybody's doing it or having done it."[6] In a show of journalistic mud-slinging and regional rivalry, the *Boston Evening Transcript* of 24 October indignantly responded to what it called "blackguarding" by the *Sun:* "The Sun has been morally perverted and bent only on public mischief for more than twenty years. . . . So nobody knows whether or not the Sun is serious in a given matter and nobody really cares." Modern scholars have also tended to regard the incident as a less enlightened moment in Boston's relationship with the arts.[7]

But the battle over the *Bacchante* reveals more than this; it exposes fundamental issues about civic control and the organization of public space in the late nineteenth century. The furor the statue caused had less to do with squeamishness over nudity or overzealous sobriety than with competing claims to social legitimacy. The opposition to the statue expressed both by anti-vice religious organizations, typically of middle- and upper-class membership, and by key figures of Boston's Anglo-Saxon Protestant elite suggests deep anxiety over changing identities and shifting hierarchies within the city. These groups fought the statue not so much because they themselves found it offensive as because they feared its potential corrupting power over others. Perhaps more accurately, opponents of the statue saw in it a challenge to a moral and social hierarchy whose existence shored up their waning political power. Drunken nude, bronze goddess—such interpretations fit into a larger context of class and ethnic conflicts in late nineteenth-century America. By proposing to set the bronze in the Boston Public Library, McKim and his supporters unwittingly thrust the *Bacchante* into the center of contemporary debates over women's roles, the proper nature of leisure-class activities, and the position of an Anglo-Saxon Protestant elite in New England and in the country.

McKim's Gift

From the beginning, McKim thought he had presented to the city of Boston a splendid gift. The *Bacchante*'s sculptor had an established reputation, having won numerous awards and commissions, including the dramatic *Barge of Liberty* fountain at the Chicago World's Fair of 1893. In designing the Boston Public Library, McKim had planned a courtyard fountain as a memorial to his recently deceased wife. When he received the statue from Frederick Mac-Monnies—a thank you for the architect's generosity in helping finance a European trip—McKim rejoiced, believing he had found the perfect complement to his Renaissance, palazzo-style building (Fig. 11).

Artists and audiences found much to applaud in MacMonnies's conception. When it first went on display in Paris at the Salon of 1894, the work met critical acclaim. Impressed with the *Bacchante,* the French government contacted the sculptor about purchasing it for the Luxembourg Museum—a singular honor for an American artist. (Having already promised the statue to McKim, MacMonnies made a replica for the Luxembourg.) Encouraged perhaps by the reception in France, MacMonnies began making reductions of the *Bacchante* in 1895, which were exhibited and sold in the States. The American art critic Royal Cortissoz singled out the

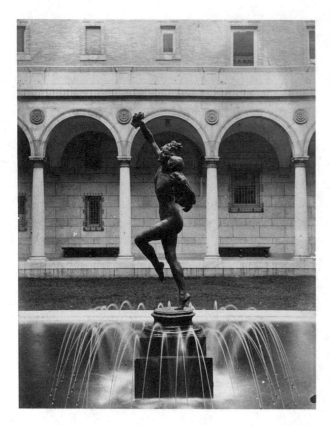

Figure 11. Boston Public Library
Courtyard with *Bacchante and Infant
Faun*. Courtesy of the Boston Public
Library, Print Department

statuette for praise, declaring after a New York showing: "It is deft, compact, a little triumph of concision, yet it has all the expansive grace, all the intimations of endless movement, which belong to a dancing figure."[8]

Two of America's most prominent sculptors, Daniel Chester French and Augustus Saint-Gaudens, greatly admired the statue. Saint-Gaudens, writing to a French friend after seeing the *Bacchante,* spoke of the deep impression it had made on him and proclaimed it a masterpiece, "the *dernier mot* of grace and life. No one has ever done better. No one will ever do better."[9] Solicited by the Boston Art Commission for their expert opinions, Saint-Gaudens and French both sent letters of support. They wrote again in the fall after the Art Commission's initial rejection of the statue, expressing dismay at the decision and urging reconsideration. They emphasized that the name "*Bacchante*" and its allusion to Greek mythology and the god Bacchus should not prejudice the commission.[10]

In employing a mythological theme, MacMonnies's work drew on compositions by nineteenth-century French artists. To demonstrate the *Bacchante*'s distinguished genealogy, Saint-Gaudens had specifically mentioned in his June letter to the commission a series of Pompeiian bronzes by various sculptors from France. *Bacchante and Infant Faun* echoes, for example, the pose of Hippolyte-Alexandre-Julien Moulin's *A Lucky Find at Pompeii* (1863), which won a

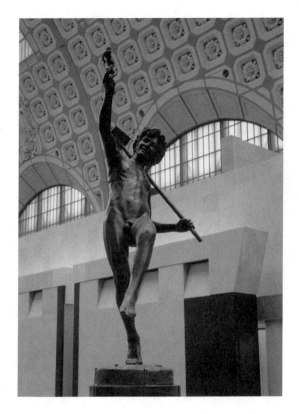

Figure 12. Hippolyte-Alexandre-Julien Moulin,
A Lucky Find at Pompeii, 1863, bronze, 74 in.
Réunion des Musées Nationaux/Art Resource,
New York, Musée d'Orsay, Paris

medal at the Salon of 1864 (Fig. 12), as well as the *Hunting Nymph* exhibited in 1884, 1885, and 1888 by Alexandre Falguière, one of MacMonnies's teachers in Paris.[11]

Like Moulin and Falguière, MacMonnies avoided a strictly columnar or vertical composition in favor of a more open and lively one with the extension of limbs and counterpoint balance: the *Bacchante,* on tiptoe, arches slightly backward and to the side, left leg bent, right arm outstretched. Like Falguière, MacMonnies also explored mythological subjects in his work; his *Diana* won him an honorable mention at the Salon of 1889. In the 1890s, he executed not only *Bacchante and Infant Faun* but also *Pan of Rohallion, Running Cupid,* and *Young Faun with Heron,* a laughing boy wrestling a large heron that MacMonnies made for Joseph Choate's estate in Stockbridge, Massachusetts, and showed in the salon of 1890 (Fig. 13). In their emphasis on movement and playfulness, these works recall a French tradition of light-hearted sculptural figures such as those with a fisherboy theme by François Rude, François-Joseph Duret, and Jean-Baptiste Carpeaux.

It was the vitality of the work that struck advocates of the *Bacchante* as its great charm, the feature that made it a highly decorative and desirable addition to the courtyard of the Public Library. As one critic observed in 1895, McKim and MacMonnies "will give Boston one of the few admirable examples of imaginative sculpture in public places in America."[12] Although

Figure 13. Frederick MacMonnies, *Young Faun with Heron,* 1890, bronze, 27¼ in. All rights reserved, The Metropolitan Museum of Art, Gift of Edward D. Adams, 1927 (27.21.8)

the courtyard was shielded from the street, large windows on the upper floors of the library looked out onto the grassy inner sanctum. Visitors could also stroll into the courtyard either directly from the carriage entrance on Boylston Street or through the Grand Staircase via the Dartmouth Street doors to stretch their legs, relax, read, and enjoy the outdoor pool and fountain (Fig. 14).

Approval for the *Bacchante* ran high among Boston citizens on the whole despite the statue's expulsion. At the first viewing on 15 November for the commission and invited guests, Thomas Sullivan recorded that the majority, which included many "intelligent women," appreciated the beauty and artistry of the statue and hoped it would remain. The distinguished gathering, he wrote, also recognized how well the figure complemented the courtyard design; the statue's scale was in perfect harmony with the surrounding arcade.[13] The statue went on public display the following day, and those who came to see it liked what they saw. The local papers, from the *Boston Evening Transcript* to the *Boston Herald* to the *Boston Post,* all reported that among the great number of viewers at the library nobody appeared to be offended. "'Not so bad after all!' sighed the crowd, rather disappointedly," one reporter for the *Boston Record* noted.[14] According to the *Herald,* many who came "prepared to see a figure that was inappropriate for the courtyard of the Public Library were struck by its beauty and fitness for the fountain."[15] A local poll reported widespread acceptance, and some began to question the judgment of the Art Commission altogether. Cries for a democratic procedure in deciding the fate of the

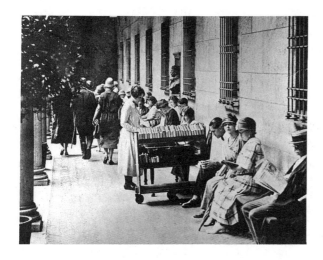

Figure 14. Summer reading in the Boston Public Library Courtyard. Courtesy of the Boston Public Library, Print Department

statue resounded. Starting in November, the *Boston Traveler* urged a referendum and even printed coupon ballots that readers could send in to the newspaper's art editor. In a letter the following month, one outraged reader commented: "Majority rule is the foundation of our government. If the majority of Boston's citizens want the Bacchante, as they seem to, they should have her, undisturbed by the quibblings of fractious children."[16] But once the Art Commission had reversed its original decision and accepted the statue, those against it fought all the harder. For these Bostonians, the *Bacchante* represented nothing less than "a menace to the Commonwealth."

Players of the Opposition

Leading the battle against the *Bacchante* was a formidable set of Boston figures, among them Harvard president Charles W. Eliot, Harvard professor Barrett Wendell, Judge Robert Grant, congressman and author William Everett, and Harvard art history professor Charles Eliot Norton. All were men of impeccable social status, perfect examples of Boston Brahmins—a relatively homogeneous, Anglo-Saxon Protestant elite that had perpetuated itself over generations through family ties, old money, and multi-faceted involvement in the political and cultural institutions of the city. By the late nineteenth century, one of the strongest bulwarks of Brahmin power was Harvard University. Statistics underscore the close relationship between Harvard and Boston's upper strata. Of forty individuals identified as *the* Brahmin leaders of the era by historians, at least 93 percent held Harvard degrees.[17]

Despite the large percentage of Harvard graduates among the Brahmin group, the Harvard experience did not stamp out hundreds of socially equal men. In fact, Harvard produced a multi-layered student body, and constituted, in the words of the historian Ronald Story, "as much a civic institution as a college and as much an engine of class as an entity of culture."[18] In his book *The Proper Bostonians,* Cleveland Amory describes Harvard as having a caste sys-

tem even stricter than that of Boston society. In the middle of the eighteenth century, students had an official ranking that determined their place in such school rituals as marching in procession, chapel meetings, and class recitations. Such official ranking eventually was abandoned. Harvard's clubs, however, took over the role and already were playing this important function when Charles W. Eliot became president of the college in 1869. Amory identifies the Hasty Pudding Club as the great "sophomore sifter" and notes that even at the time he is writing—the 1940s—"the Proper Bostonian looks to his listed clubs and refers to the man's Pudding rating as confidently as a credit bureau turns to Dun & Bradstreet. If the man is listed as 'Hasty Pudding—Institute of 1770' followed by the letters 'D.K.E.,' the Proper Bostonian knows that he was a 'Dickey' or one of the first forty-five sophomores elected to the club and hence very definitely a social somebody."[19]

The men most opposed to MacMonnies's statue could all be considered quintessential Brahmin figures. Charles W. Eliot, like the others, descended from an old Boston family. He also matriculated at Harvard University; was a member of its most prestigious social club, the Porcellian; and held the college presidency for forty years. Barrett Wendell, referred to as "the Brahmin of Brahmins,"[20] not only lectured and taught at Harvard, but also wrote a column for the *Boston Transcript*. Like Wendell and Eliot, their colleagues Grant, Norton, and Everett moved in high-society circles and figured prominently in the Harvard administration and faculty. Everett's father had been a Harvard president. Robert Grant served on Harvard's Board of Overseers and held membership in Boston's Somerset Club, said to correspond to Eliot's Porcellian Club in social status. Through their extensive ties to Harvard and Boston society, these men wielded a social and political clout that set them apart as leaders within the Brahmin elite.

The elevated status of these individuals distinguished them from those who supported the *Bacchante*. Compared to the Eliot-Norton group, supporters had less august family lineages, maintained few ties to Harvard College, and less frequently walked the halls of the most exclusive social clubs.[21] Art Commission or library trustee members favoring MacMonnies's statue included, for example, Boston's former mayor, Frederick O. Prince; Francis A. Walker, the president of the Massachusetts Institute of Technology (who initially voted against the statue but after seeing the full-scale version changed his mind); Edward Robinson, a curator at the Boston Museum of Fine Arts; and several Boston architects. Among others in the community who defended the *Bacchante,* Thomas Sullivan, the playwright, had no Harvard connection at all, and few if any of the individuals who wrote letters to local papers appear in social registries.

For that small and influential group of Brahmins committed to the collective well-being of their class or status group, the statue stirred deep concerns. Their opposition, however, as Barrett Wendell and the others emphatically maintained, had nothing to do with nudity. Indeed, they could grow quite perturbed when people tried to draw this conclusion. Wrote Robert Grant in his autobiography: "Needless to say, among those who knew us, the nakedness of the figure was not a factor in our conclusion. Could one clothe bronze or marble? Yet we had to bear—Barrett and I especially at the Tavern Club—the brunt of being bracketed with prudes and that portion of the clergy who associate indecency with the nude in art—especially when Bacchanalian."[22] Rather, as Grant summarized in another of his writings, the statue was ob-

jectionable because of "the artistic unworthiness of the entire composition as a keynote to the [library]—a place in an educational sense sacred, and which should be reserved for a work of art intrinsically noble."[23] The ennobling mission of the library, in other words, required equally uplifting visual models.

This "want of sympathy" between the statue and its library setting, specifically the disruption of an aesthetic structure, greatly disturbed Wendell, Norton, and Grant. They repeatedly referred to the statue as inappropriate and unsuitable, although no one clearly defined what that meant. A statement by Norton printed in the *Boston Record* on 16 November suggests, however, a link between inappropriate and potentially dangerous. Norton warned that "to a public, who look not always from an artistic standpoint, more harm is apt to be worked than good."[24] What people would see in the statue, its undisciplined deportment, its carefreeness, could affect, he implied, their behavior and by extension civic order.

The conviction that the act of looking had the power to transform human behavior similarly characterized the other major anti-*Bacchante* bloc, the religious and anti-vice organizations such as the Watch and Ward Society, the Woman's Christian Temperance Union (WCTU), and the Congregational Club, an association of clergy and church workers. These groups, and especially the WCTU, attracted a middle- and upper-middle-class constituency, largely Protestant and native-born.[25] But where the language of Boston's most prominent points to an anxiety, above all, about the preservation of social order and hierarchy, these groups voiced concerns that focused more on morality. Unlike Norton or Wendell, they condemned MacMonnies's sculpture for its nakedness and supposedly brazen drunkenness. As the New England Watch and Ward Society president asserted, the statue represented lust and impurity: "if it means anything, it is the glorification of that which is low and sensual and degrading."[26] Seeing the *Bacchante* as degenerate and debauched, these groups worried about its message. Letters in the *Transcript* asked about the kind of moral instruction the statue imparted. A *Boston Post* article, "Honors Immorality, Library No Place For It," quoted the objections of various temperance activists, all to the effect that the statue, if placed in the library, would inevitably be a bad influence.[27] In short, to install the statue in the courtyard would have meant for some the collapse of cultural and civic order. An article in the *Boston Globe* expressed it most bluntly: "Vices which fill our prisons should not be exalted in our library."[28]

Social Roles / Social Distinctions

The cries against female nudity by Boston's anti-vice and religious organizations provoked a barrage of criticism from newspapers, particularly ones outside Boston. They took delight in mocking what seemed to be rank hypocrisy. New York's *Evening Sun* summed up the situation, declaring that "these Bostonians have never been inside their library. For if they had been surely they could never have missed seeing that shockingly naked statue, the Venus de Medici, which occupies a prominent place in one of the corridors, and which is much more calculated to 'debase the standards and tempt the eyes,' &c., of the Bostonians than poor Mr. Macmonnies's work." Another article cited the two completely nude and (in the author's

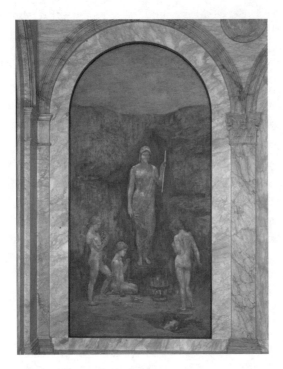

Figure 15. Pierre Puvis de Chavannes, *Chemistry,* 1896, 171¼ × 86⅜ in. Grand Staircase mural, Boston Public Library. Courtesy of the Trustees of the Boston Public Library

opinion) ungainly figures that adorned the seal of the Boston Public Library—a seal reproduced on all library publications and stationery. A picture of the seal, under the headline "Prudish Boston and Her Library Seal," accompanied the newspaper's text.[29] The French painter Pierre Puvis de Chavannes's large mural cycle in the Grand Staircase of the library illustrating the realms of human knowledge also depicted a partially nude female figure identified as *Chemistry* (Fig. 15).

Charges of hypocrisy by the press point, albeit crudely, to contemporary debates about the role of women and the display of the female body. The figure of Chemistry decorating the staircase, like the Venus statue, constituted a traditional and acceptable representation of the female form: nudity cloaked by allegorical context. *Chemistry* personifies scientific endeavor and the pursuit of knowledge for human betterment. An image of civilized society, she represents rational, empirical inquiry and humankind's successful efforts to domesticate natural forces. The deployment of the figure—solid, columnar, and balanced—underscores that control. This sense of discipline was equally true for other nude statues like those of Venus that graced the library halls. The *Venus de Medici,* prominently placed in a corridor to the Children's Room, had a contained pose: feet together, arms modestly placed before her body, gaze averted. By contrast, MacMonnies's *Bacchante* portrays female nudity without the shield of edifying allegory.

The statue's lighthearted air strained against Victorian notions of public female behavior, according to which a good woman was modest and responsible. The lively composition makes no pretense toward modesty or restraint; the statue's open arms, her wide grin and her head

thrown back express pure delight. MacMonnies's naturalistic rendering of the head further distances the statue from the safe haven of the idealized world. Not only does she sport a loose, unstyled hairdo, but her face appears realistic, so much so that newspapers consumed much ink speculating about the identity of the model.[30]

Free spirited and exuberant in her nakedness, the statue touched nerves made raw by changing women's roles. Temperance unions such as the WCTU saw women as defending one of the bastions of moral society, the home, and viewed the abuse of alcohol as a serious threat. Drinking squandered precious family funds and disrupted family relationships in part by encouraging greater sexual freedom. The WCTU consequently centered its temperance activities around "home values," or what it called "the white life." An attempt to consolidate women's authority both inside and outside the home, living the white life meant, as the historian Barbara Epstein has noted, "elevating the position of women by placing restraints upon sexuality, supposedly a primarily male interest, and valorizing the moral role of women in family and society."[31] The statue, in the eyes of its opponents, left too much open to individual interpretation. The grapes the statue holds, as well as its pose and even its title, do not necessarily convey drunkenness or sexual licentiousness, but the image as a whole does not strongly counter such associations. Once envisioned as a drunken woman, the *Bacchante* transgressed moral boundaries, making a seeming mockery of the domestic role of women.

In challenging ruling mores, the statue also threatened to collapse boundaries between elite and mass purviews. Beneath the Brahmin charge of inappropriateness lay fears about upper- and lower-class roles and the absorption of alien groups into prevailing social structures. Beginning in the 1870s, in response to populist political assaults on Brahmin institutions and the flow of immigrants into the city, Boston's elite had attempted to strengthen itself by erecting cultural barriers. The elite had created a network of charitable organizations, museums, and societies, making the city a center for historians, poets, educators, and philosophers. It was in the seventies, for example, that the Museum of Fine Arts and the Boston Symphony Orchestra were founded. Unlike upper-class elites in New York and Philadelphia, which concentrated less of their money and efforts on cultural enterprises, Boston leaders, as the sociologist Paul Dimaggio has written, "retreated from the public sector to found a system of non-profit organizations that permitted them to maintain some control over the community even as they lost their command of its political institutions."[32]

The challenge to Brahmin political hegemony came above all from the Irish. Poor, Catholic, and culturally distinct immigrants, they started flooding into Boston in the 1840s. Middle- and upper-class perceptions of the Irish focused on their propensity to be without money and on the supposed inability of even American-born Irish to be productive. Magazines such as *Atlantic Monthly* and *Century Magazine,* for instance, circulated reports about the degeneracy of second-generation immigrants.[33] At the height of the *Bacchante* controversy, the *Boston Evening Transcript* printed, for example, an article arguing for a correlation of alcohol consumption with crime, pauperism, and insanity.[34] In listing the statistics for each category, the report broke down figures into "citizen-born" and "alien"; percentages ran significantly higher for the latter. Estimates put the Irish population in the city by 1895 as high as 60 percent, a figure that most likely includes first- and second-generation Irish as well third and fourth generations.[35]

As their presence grew, they increasingly exercised their electoral muscle, gaining a bigger piece of the political pie. In 1884, for the first time, an Irishman became mayor; from 1900 on, the Irish would consistently control the mayoralty. In the face of the Irish move into civic life, many of Boston's Anglo-Saxon elite felt themselves and the values in which they believed under assault by an alien people. The remarks of *Bacchante* opponent Charles Eliot Norton just after the statue's expulsion registered the level of tension and unease particularly among Boston's Brahmins. Norton declared in an 1897 letter, "I fancy that there has never been a community on a higher and pleasanter level than that of New England during the first thirty years of the century, before the coming in of Jacksonian Democracy, and the invasion of the Irish, and the establishment of the system of Protection." For many of Boston's elite, the Irish continued to be viewed as outsiders, dangerous and impossible to assimilate. Norton concluded his thoughts with a question: "Are we too big territorially, and too various in blood and tradition ever to become a nation? I should like to come back some centuries hence and see."[36]

The 1890s were particularly destabilizing, a result of a severe economic crisis and the continuing transfer of political power to the Irish. Earlier tenuous alliances between Irish-Catholic Democrats and upper-class Bostonians had ruptured, and from 1900 onward, the Irish consistently controlled the Boston mayoralty. Henry Adams reflected on the dislocation a number of years later, writing that "New England standards were various, scarcely reconcilable with each other, and constantly multiplying in number, until balance between them threatened to become impossible. . . . New power was disintegrating society, and setting independent centres of force to work, until money had all it could do to hold the machine together. No one could represent it faithfully as a whole."[37]

By the turn of the century, Boston's upper class had moved not only to stem the erosion of elite strongholds but also to consolidate their forces. In this context, signs of unconventional behavior and non-traditional mores required swift and forceful action. In 1896, they fought against what appeared as yet another assault—MacMonnies's *Bacchante*. As Grant had averred, the statue's nudity and supposed drunkenness, in and of themselves, were not disturbing. Rather, Brahmin leaders found threatening the possibility that an unsophisticated mass public might see in an officially sanctioned image that broke the bounds of convention and freed inhibition a license for any kind of irregular behavior. To immortalize in bronze and enshrine in a public space—a public library, no less—a statue that members of a Brahmin elite saw as legitimating social anarchy was tantamount to backing their own demise. The fight over the *Bacchante* revolved ultimately around what it meant to be a good New Englander at just the time the region was being held up as a model for the nation.

A cartoon from the *Boston Journal* in November 1896, captioned "Bacchante Skip Will Be The Rage: The Lame, The Halt and The Blind will Make This Their Fad Now That the Statue Has Been Accepted," illustrates the possible chaos and loss of control that the statue could inspire (Fig. 16). A crudely drawn *Bacchante* lurks in the left corner of the cartoon. Imitating her pose, Boston citizens from all walks of life prance down the street, arms thrown above their heads, legs kicked out in front of them. Even the animal kingdom gets mixed up in the potential anarchy, as the little dog on the right suggests. Only the small child—an allusion perhaps to future generations—who is held in the arms of a young woman, cries unhappily.

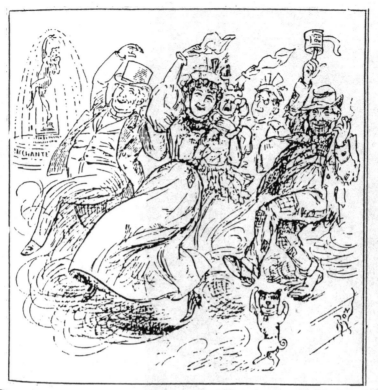

The Lame, the Halt and the Blind Will Make This Their Fad Now
That the Statue Has Been Accepted.

Figure 16. "Bacchante Skip Will be the Rage: The Lame, the Halt and the Blind Will Make This Their Fad Now That the Statue Has Been Accepted." Cartoon from the *Boston Journal* (18 November 1896). Reproduced in Walter Whitehill, "The Vicissitudes of *Bacchante* in Boston," *New England Quarterly* 27 (December 1954)

Another Boston newspaper cartoon, this one entitled "A Suggestion for a Pedestal for the Bacchante," suggests how deeply the debate over the statue tapped into contemporary class and ethnic conflicts (Fig. 17). Although ambiguous in its stance toward MacMonnies's statue, the cartoon categorized types of alcohol to set up a clear visual hierarchy. With the harder alcohols at the bottom of the pedestal is Irish whiskey. In contrast to the rustic kegs, four books occupy the middle tier. With titles such as *Vintner's Guide, How to Mix Drinks,* and *The Art of Brewing,* they suggest people of more refined taste and standing, as well as a certain self-reliance or motivation. A layer of lush grape leaves, a reference perhaps to a natural order, leads to the top of the pedestal. Above stands the Bacchante herself, holding a cluster of grapes, the union of art and discriminating taste that could be interpreted as representing an upper-class elite. The stratification the cartoon depicted suggests the importance of cultural and social distinctions in New England's capital city.

An incident involving the Boston Public Library before its move to the new building in

A SUGGESTION FOR A PEDESTAL FOR THE BACCHANTE.

HOW TO GET A LICENSE · VINT-NERS GUIDE · HOW TO MIX DRINKS · THE ART OF BREW-ING

BOURBON IRISH OLD MEDFORD

Figure 17. "A Suggestion for a Pedestal for the Bacchante." Cartoon from newspaper clippings scrapbook, Trustees Library, Boston Public Library. Reproduced in Walter Whitehill, "The Vicissitudes of *Bacchante* in Boston," *New England Quarterly* 27 (December 1954)

1895 further illuminates the reliance of Boston citizens on class codes and their sensitivity to social identities. Several local papers reported in 1892 that the library had no plans for housing in a separate space the collection of popular books and magazines located in the old library's "Lower Hall." The *Boston Globe* reported that Lower Hall readers—largely the working poor—would suffer if they had to go "into the [new] enormous Bates Hall along with everyone else, and rub elbows with the Beacon st. [*sic*] swell, the teacher, and all the varying classes of people who are now accommodated in the [old] Bates Hall, upstairs, and are away from the plain people, who are glad to avail themselves of the 'lower hall.'"[38]

Although library officials proceeded with their plan for one main hall, the *Boston Globe* report underscores the role public space played in regulating social interaction. The art that shaped such space became part of that process, and in the social environment of 1896, both a Brahmin elite and temperance and anti-vice organizations saw danger stalking in the form of a bronze Bacchante. Interest in affirming their own social position and identity, as well as prescribing a cultural model for alien, lower-class groups, made issues of appropriateness and abstinence particularly significant. Alone, the crusade organizations might not have been enough to banish MacMonnies's statue. But the union of moral mission and social authority translated into clout. By the summer of 1897, enough pressure had been exerted to convince McKim to abandon his vision for the courtyard fountain.

In opposing the statue, a Brahmin elite asserted itself as an arbiter of appropriateness and a purveyor of good taste. Their vehement response culminated a pattern stretching back to the 1870s of upper-class efforts to stake out high cultural ground and resist the increasing democratization of public life. A telling event of the *Bacchante* incident is a postscript to the uproar. Some years after the controversy, a Boston collector purchased a bronze replica of the statue and presented it to the Boston Museum of Fine Arts. No one raised the slightest fuss. In the confines of an elite institution, dedicated to artistic taste and high culture, the *Bacchante*'s blissful abandon could cause no harm.

Public Space and Public Interests

A broad educational mission, however, distinguished a public institution like the library. By the late nineteenth century, public libraries were heralded as an instrument for social reform. Members of the public library movement, underway since 1876, looked to this public venue as a potential solution to pressing social problems such as alcoholism, penury, and the assimilation of diverse ethnic groups. As Frederick M. Crunden, an active member and a president of the American Library Association, noted in 1906, "plague spots cannot exist here and there without affecting the health of the whole body politic. As pain in a tooth or a toe affects the comfort of the whole body and the action of the brain, so does society suffer from even a modicum of vice and poverty; and the evil effects of these diseases are most keenly felt where population is densest and extremes meet."[39] In this sense, libraries, and particularly city libraries, extended the work of public schools, and librarians assumed the role of literary shepherds guiding their flock to the wholesome pastures of the written word.

Stocked with collections of good reading material and fine art, libraries provided patrons with resources to improve themselves, to become better, more responsible citizens. Investments in public libraries, as Crunden had written some years earlier, "would be returned in the superior skill and increased productiveness of our mechanics and artisans, in the lessening of crime and disorder among us, in the influx of the most desirable classes of citizens, in the greater sobriety, industry, order, morality, and refinement throughout the community that must necessarily result from the reading of ten times as many books by ten times as many people." Another prominent librarian echoed that sentiment even more forcefully, proclaiming: "Free corn in old Rome bribed a mob and kept it passive. By free books and what goes with them in modern America we mean to erase the mob from existence."[40] For library proponents and Boston Brahmins, the "public" in public institution did not imply an open place in which to congregate or bring together heterogeneous groups as we might think of such a site today. What mattered was not fulfilling an individual desire but absorbing prescribed communal values (in this case determined by a political and social elite).

Spurred by a belief in public libraries to mold an edifying civic culture—or, as the art historian Sally Promey has noted in her study of the library's John Singer Sargent murals, to promote democracy through education—Boston city officials in the late 1880s had drawn up plans for a grand new building.[41] Their efforts resulted not only in one of the largest public

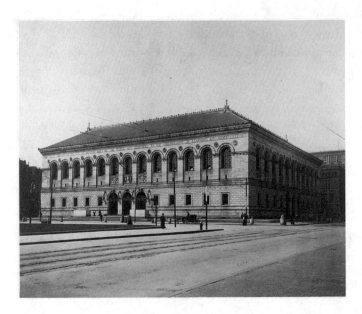

Figure 18. Boston Public Library.
Courtesy of the Boston Public
Library, Print Department

libraries in the country but in an impressive union of architecture, painting, and sculpture: an environment to inspire both heart and mind (Fig. 18). The inscription on the Dartmouth Street side, which read "The Public Library of the City of Boston Built by the People and Dedicated to the Advancement of Learning," beckoned visitors, who entered the Renaissance-style structure through massive bronze portals that opened onto a marble staircase guarded by two sculpted lions (Fig. 19). An imposing barrel-vaulted reading room, 218 feet long, 42 feet wide, and 50 feet high, served library patrons. Throughout the building, elaborate mural cycles by some of the era's most prominent artists decorated the walls and ceilings. Puvis de Chavannes's set of murals, which included the personification of "Chemistry," ran along the walls of the Grand Staircase, for example. John Singer Sargent depicted the history of religion in the vaulted hall of the third-floor gallery, while the legend of the Holy Grail by Edwin A. Abbey ornamented the Book Delivery Room.

In its union of texts and images, the library was meant to offer a complete aesthetic experience. Frederick Crunden, in his article on the public library and civic improvement, elaborated: "Is not its mere beholding educative and inspiring? Can the thousands who see it every month fail to imbibe a truer taste for beauty? And is not a pervading love of beauty one of the corner stones of civic improvement?" In the library, faith in the power of good books to redress social problems united with a conviction in the power of art to transform human behavior. When the new Boston Library opened its doors in 1895, Mariana Van Rensselaer described it as a "civic monument." Of the courtyard in particular, she wrote that it was "a place owned by the public of a great city, where hours or even moments of repose or study will be doubly fruitful, feeding the most careless or unconscious eye with the food of high artistic loveliness."[42] Dubbed a "palace for the people," the library could equally have been termed a tem-

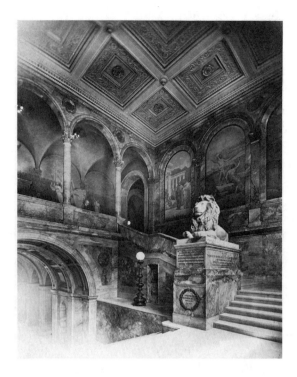

Figure 19. Grand Staircase, Boston Public Library. Courtesy of the Boston Public Library, Print Department

ple of refinement, a secular counterpart to the church. The institution's backers had high hopes that the library would counter what they perceived as the dangerous influence of establishments such as the saloon. Concerns about the use of alcohol and leisure time indeed made the *Bacchante* controversy all the more explosive.

In the bourgeois world of the late nineteenth century, the library and the saloon represented opposing moral and social poles. Associated with alcohol and often called the "workingmen's club," the saloon was essentially a stronghold of immigrant as well as lower-class culture. By the 1890s, middle- and upper-class temperance groups such as the WCTU, Boston's Citizens' Law and Order League (founded in the 1880s), and the Anti-Saloon League (which came into force in the mid-1890s) launched a frontal attack on places of drink, using the law to regulate alcohol consumption and leisure time. Battles over the saloon's existence, as the historian Roy Rosenzweig has noted, "often took on aspects of a 'class war' over the recreational world of the industrial working class."[43] Although saloons provided certain amenities such as toilets, clean water, warmth, and socializing space that were not readily available elsewhere in public, from a temperance perspective saloons meant alcohol and alcohol was a scourge. Middle- and upper-class ideals about leisure time and family life clashed directly with the circumstances of immigrant life and lower-class uses of urban areas.

For proponents, libraries offered social comforts but without the alcohol. In the civilizing space of the Public Library, patrons imbibed culture, not booze. That libraries and bars met exactly the same social needs and could be easily exchanged, and would be by those given the choice, was presumed. Frederick Crunden, the passionate and vocal spokesman for the library

association, explicitly described the library's role as antidote to the saloon: "It is fair to assume," he wrote, "that saloons and resorts of a demoralizing character all over the city are nightly frequented by men and boys who would go to a free reading-room, if one was found in the neighborhood. Prohibition will not do: substitution is the true remedy."[44] The library, envisioned as a structure of enlightenment, and the saloon, a site of iniquity, thus stood at opposite ends of the cultural spectrum. To place what temperance activists saw as a vice-ridden figure in the central courtyard, the heart of the public library, contravened every principle for which they were fighting. If in fact one saw the Bacchante as a drunken woman, then the statue's worst offense, as one pastor claimed, was that it represented "a half truth": it failed to show "the true wages of sin," the "blasted lives, wasted opportunities, shrunken energies."[45] The mixing of classes in the library's new Bates Hall had confused established social propriety in an architectural sense. Four years later the *Bacchante* threatened to do far worse in art. To install the *Bacchante* in the courtyard would have meant the symbolic transfer of the saloon into the library.

Ways of Seeing

The *Bacchante* incident speaks to divergent ways of seeing and the mediation through art of social tensions. Opponents described the statue as representing intoxication, but sympathetic viewers, including a library janitor who had helped to display the statue, saw nothing of the kind. A columnist who was favorably inclined toward the statue, for example, pointed out a logical fallacy in the argument of the opposition: "No one, it would seem, who has made the slightest study of the outward symptoms of inebriety could charge this Bacchante, who is standing on the tip of one toe and carrying a baby safely and comfortably on one shoulder, could accuse the Bacchante of being under the influence of the bunch of grapes which she dangles over the baby's mouth."[46]

Indeed, a letter to the *Boston Evening Transcript* rejected the charge of drunkenness altogether. The author had overheard a woman say in front of the statue, "If there's anything in the world more innocent than a young mother dancing her baby and holding up a bunch of grapes before it, I should like to know what it is? We may object to wine, but there, nobody objects to grapes!"[47] As tensions mounted, the issue of what the statue depicted spilled over even to what the term "bacchante" meant. Already back in October 1896, as the controversy heated up, Augustus Saint-Gaudens and Daniel Chester French had written to the Art Commission asserting that the statue's name held no deep significance and conveyed only a classical reference or ideal.[48] Newspapers, however, devoted entire articles to defining precisely both the word and the nature of the god Bacchus. Here too, depending on what both readers and writers wanted to see, they oscillated in identifying a bacchante as a joyous nymph or a "drunken wanton."

These conflicting visions outline fundamental issues about civic control and the organization of public space. The efforts by both a Brahmin elite and temperance and anti-vice groups to consolidate their own social positions, as well as prescribe a cultural model for alien, lower-class groups, made issues of appropriateness and abstinence—and by extension the *Bacchante* itself—symbolically loaded. In the final analysis, the *Bacchante,* while artistic, had failed to edify or uplift enough.

In February 1896, a little more than six months before MacMonnies's *Bacchante* set Boston on edge, Charles Eliot Norton published an article entitled "Some Aspects of Civilization in America." His impassioned essay revolved around the question of whether the moral and intellectual attainments of the waning nineteenth century could survive the rampant spirit of individualism of the dawning twentieth. Deeply troubled about the quality of the American character, Norton elaborated in grand style on fundamental national dynamics—dynamics to which the local controversy of the *Bacchante* would soon point. An unrestrained spirit of independence and the possession of power without a corresponding sense of responsibility led, Norton maintained, to disrespect for authority. This "unrestraint of expression" and lack of discipline could appear in every class and have a deleterious effect even in the most civilized or settled parts of the country. But the further west one went, Norton was convinced, the worse the effects. To buttress his argument, he went on to quote Owen Wister's story about the hostile attitude of Westerners toward United States soldiers: "He [Wister] says: 'The unthinking sons of the sage-brush [in Arizona], ill tolerate a thing which stands for discipline, good order, and obedience. . . . I can think of no threat of more evil for our democracy, for it is a fine thing diseased and perverted,—namely independence gone drunk.' The threat, under another aspect, exists no less in New England than in Arizona."[49]

As Norton's diatribe makes clear, the controversy he would face in his own backyard that fall in the form of a bronze Bacchante represented a much larger threat. In the opinion not only of Norton but also of his colleagues Barrett Wendell and Robert Grant, the country as a whole stood on the brink of social chaos, and in their minds the West as a region and its values only exacerbated the impending crisis. The "spirit of individualism" that had fueled westward expansion, compounded by the influx of alien immigrants (especially into New England) was tearing at the country's social fabric. Rejecting any glorification of the West, Norton proclaimed that region and the character traits it advanced to be the root of the nation's problems. The drive to push west into unsettled new territory had created a host of "pioneers," a population in Norton's view that was largely undisciplined and unsocialized. "Such virtues as their conditions may develop are not the civic virtues," he wrote and continued: "Of mere necessity they become ignorant, rude, careless of social obligations, lawless in disposition, and of dull moral sense. They react upon the civilization which advances upon the border line, and imprint upon it something of their own characteristics. Its standards are lowered. And thus we are brought face to face with the grave problem which the next century is to solve,—whether our civilization can maintain itself, and make advance, against the pressure of ignorant and barbaric multitudes."[50]

Norton posited a dramatic contest of regional wills engulfing the country. The civilized East—New England together with New York—lined up against the savage West, which meant essentially everything beyond the Alleghenies. At stake was the nature of national character. This Manichean vision, in disavowing the West's cultural legitimacy, stood Turner's famous frontier thesis of 1893 on its head. Turner had held up the frontier as a positive force, indeed, the prime causal factor in Americanization: it promoted a specifically American, as opposed to a European, identity, and united the different sections of the country. Above all, the frontier fostered a hardy democratic character. "That coarseness and strength," Turner had written, "combined with acuteness and inquisitiveness; that practical, inventive turn of mind, quick to

find expedients; that masterful grasp of material things, lacking in the artistic but powerful to effect great ends; that restless nervous energy; that dominant individualism, working for good and for evil, and withal that buoyancy and exuberance which comes with freedom—these are the traits of the frontier."[51] For Charles Eliot Norton and certain of his Brahmin peers, however, it was precisely these features, and particularly their elevation and their influence, that boded ill for the future.

The nation's best hopes for defense lay in the cultivation of common purpose, civic responsibility, and a flourishing culture, and Norton knew exactly where the wellspring of such ideals could be found. New England, particularly in the period of Emerson, Lowell, and Longfellow, constituted in his opinion the fullest and most positive expression of American character. In an article from 1893 mourning the deaths of James Russell Lowell and George William Curtis, Norton had made this linkage between region and nation explicit. Curtis and Lowell, he declared, "most truly represented the ideals of American culture and citizenship. I say *American* culture and citizenship, because the type which they displayed was in certain marked respects novel, the product of conditions peculiar to our national institutions and life. . . . They were 'new births of our new soil,' and their virtue drew nourishment from New England principles and New England practice."[52] New England's strength, for Norton and his peers, lay in its leadership qualities and its heritage of cultural achievement. Such sentiments echoed the assertions of the World's Columbian Exposition organizers in 1893. Anxious to demonstrate the importance and contribution of the New England states to the nation as a whole, state managers had emphasized the historic quality of the region's citizenry, their patriotic and civic accomplishments. If other regions, they argued, mined precious metals or raised excellent crops, New England produced superior men and women.

Both Norton and Wendell fretted, however, about New England's ability to sustain its position of cultural vigor. Writing of the recent deaths of several close friends, Wendell bleakly reflected in 1893: "It is significant that among his [Bishop Brooks] contemporaries and the younger generation in New England there are no figures of eminence left. And when I came here to live we had Longfellow, and Lowell, and Whittier, and Emerson, and half a dozen more, as well as Dr. Holmes, who survives alone. We are vanishing into provincial obscurity. . . ."[53] Mindful of New England's earlier preeminence, a Brahmin elite struggled to secure in the aesthetic realm some kind of privileged role—not only for its class but for the region as well. That required drawing sharp distinctions between different types of cultural expressions and maintaining clear boundaries between the preserves of art and everyday life. From Wendell's perspective, Isabella Stewart Gardner, the art collector and Boston socialite, triumphed when she completed her private museum at Fenway Court, an impressive collection of medieval and contemporary works of art. He wrote to her in 1902 to say how deeply moved he was by her actions and sense of purpose: "More and more it seems to me that the future of our New England must depend on the standards of culture which we maintain and preserve here. The College, the Institute, the Library, the Orchestra—and so on,—are the real bases of our strength and dignity in the years to come. . . . I wish thus to express to you how deeply I am grateful to you, as a citizen of New England, who loves his country."[54]

The institutions Wendell enumerated kept in place a cultural network he prided himself in

heading. In the debate over MacMonnies's sculpted nymph, Boston's Brahmin leaders, like the temperance groups, sought to mold a public in their own image, and they turned to art and culture to transmit and inculcate the values they esteemed. Their leadership depended on a compliant people, desiring guidance. For Charles Eliot Norton, Barrett Wendell, and many of their generation and status, true democratic spirit implied a patrician rather than a popular democracy; those of social stature, with education and culture, bore the burden of leadership. Making themselves available to the people, they took the reins of public office and expected that those without such background would defer respectfully to this stewardship. As Norton remarked, "each man has the opportunity and is consequently under the responsibility to make the best of himself for the service of his fellow–men."[55]

The growth of democracy that Frederick Jackson Turner depicted, linked as it was to individualism, troubled Norton greatly. While he believed in equal opportunity, as he discussed in his 1896 *Forum* article, universal suffrage represented to him a "distinct source of moral corruption" and a threat to civilization; he saw too many individuals unenlightened and insufficiently trained. The principle of one man–one vote in America had not brought peace and civilization. Rather, for Norton, it meant "the rise of the uncivilized, whom no school education can suffice to provide with intelligence and reason. . . . I fear that America is beginning a long course of error and of wrong, and is likely to become more and more a power for disturbance and for barbarism."[56]

By the end of the nineteenth century, patrician dominance in Boston was yielding to democratization and new forms of cultural expression. For men such as Norton and Wendell, a political and social hierarchy that had stood for decades—and in which they had flourished—was suddenly crumbling beneath them. No longer did it seem that they would inherit the mantle of cultural leadership bequeathed by Emerson, Lowell, and Holmes, those intellectual giants of the preceding generation. An awareness of that loss escaped neither of them: "I can understand the feeling of a Roman as he saw the Empire breaking down, and civilization dying out," Norton had bitterly remarked in 1896. The difficulty, Wendell observed, with perhaps slightly more distance in 1908, was that their generation, raised to believe in the notion of a gentlemen class and its commitment to social duty, had to confront the new era equipped largely with the ideals of the old.[57] And they had to do this, he might have added, in a nation that extended far beyond New England, both territorially and demographically, larger than ever before.

As Norton and Wendell feared—and the *Bacchante* incident seemed to demonstrate—New England values and traditions as they knew them might not prevail against mounting challenges. The statue's placement in the courtyard of the Boston Public Library carried the struggle to an aesthetic field. In transgressing strict principles of artistic sensibility, the statue seemed to collapse the division between mass art, more literal in its depictions, and the realm of refined, idealized high art. *Literary World,* a journal published in Boston, argued as much during the controversy. How, it asked, could Boston, which proclaimed itself one of the country's foremost sites of culture, set up such a vulgar work of art in a building as ennobling as the Public Library? Cities around the nation, the article implied, were watching to see how Boston responded to this challenge of authority.[58] With the rejection of the statue in 1897, Barrett Wen-

dell could claim, as he did to Isabella Gardner, that for the moment New England had preserved "the standards of culture."

In the climate of 1896—a time of deepening recession, extreme labor unrest, the rise of a populist movement in the West, and agitation for a silver standard that galvanized the presidential election debates that year—signs of unconventional behavior and nontraditional values proved especially intimidating. MacMonnies's *Bacchante* arrived in the city at a moment when the terms of "the public" were being challenged and reconstituted. A Brahmin elite found itself struggling to maintain some element of cultural leadership within both New England and the nation as a whole. The statue, by seeming to flout values held dear, impelled a small but influential circle of social leaders to marshal their forces and fight for its expulsion.

Puritan Deacons and Ideals

In 1887, the prominent American sculptor Augustus Saint-Gaudens made for the city of Springfield, Massachusetts, a bronze statue of the city's founder. Over eight feet tall and staring grimly ahead, his early Puritan colonist, Deacon Samuel Chapin, strides purposefully forward, a staff in one hand, a large Bible in the other. But unlike many statues of its time, the bronze deacon remained neither immobile nor provincial. Over the course of almost twenty years, it journeyed both spatially and culturally. First dedicated in 1887, it moved location in 1899, was reformulated in 1905, then re-sited yet again around 1920. The statue's travels through public space succeeded in transforming a local identity into a statement about national character. To do so, a primarily religious figure had to be transformed into a secular, historical one. If, for influential members of Boston's elite, MacMonnies's *Bacchante* came to symbolize everything New England should not stand for, Augustus Saint-Gaudens's work, which became known as *The Puritan,* crystallized into the *Bacchante's* opposite, a moral exemplar. For many critics and viewers, this public monument came to embody a proper vision of New England values.

Augustus Saint-Gaudens, in his memoirs, records that an unidentified nineteenth-century citizen of Springfield had, at some point, proposed erecting public monuments to each of the three founders of the city, among them seventeenth-century Puritan deacon Samuel Chapin.[59] In the early 1880s, Chester W. Chapin, a descendant of the deacon and president of the Boston and Albany Railroad Company, acted on the plan, commissioning from Saint-Gaudens a statue of his ancestor. The result of the sculptor's efforts was an impressive, larger than life-size sculpture. Captured in mid-stride, Saint-Gaudens's Puritan colonist stares fixedly into the distance, lips pursed (Fig. 20). His tunic, partially buttoned and tightly stretched across his chest, suggests the mass of the man. The flowing cloak around him further emphasizes that weightiness. Indeed, the entire image, from hat to cloak, forms a unified and imposing pyramidal composition. In his dedicatory address on 25 November 1887, Reverend A. L. Chapin from Wisconsin (and another descendant of the first Chapin) eloquently described the sculpture's power, seeing in the figure a "physical health and vigor—a manly stature—a well-developed, well-

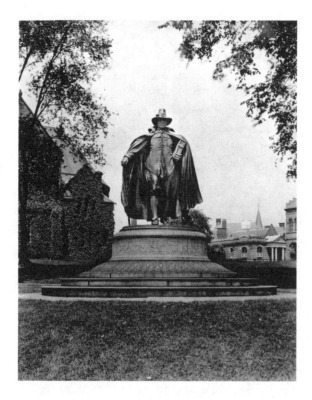

Figure 20. Augustus Saint-Gaudens, *The Puritan,* 1887, bronze, over life-size. Springfield Picture Collection of the Connecticut Valley Historical Museum

proportioned frame, strung with nerves to give it activity and force. These features reveal a mind within, balanced and clear—a judgment, cool, candid, and positive;—a heart tender, susceptible, inspiring yet poised by reason—and a will resolute and strong."[60]

Saint-Gaudens's conception of an old Puritan leader possesses no clear antecedents. The weighty presence he gave to the deacon in fact contrasts dramatically with the aura projected by the most prominent Pilgrim sculpture extant at the time, John Quincy Adams Ward's *The Pilgrim* completed in 1884 and installed in New York City's Central Park with considerable fanfare. The work of one of the country's best-known artists, that statue would have been familiar to Saint-Gaudens, but unlike *The Puritan,* who firmly plants his walking stick, Ward's pilgrim sedately rests his outstretched right arm on the muzzle of a musket (see Fig. 24). Although depicted with an instrument of far greater destructive power, *The Pilgrim* cuts a humble figure next to Saint-Gaudens's imperious work. Standing frozen in place, unanimated, Ward's statue conveys less a sense of monumentality than an appreciation for the details of costume, the wrinkle of leather, and the large boot tops turned down. A number of critics in fact came to question whether the statue even depicted a Pilgrim at all and commented on the statue's lack of personality. A contributor to *Scribner's Magazine,* for example, remarked in 1902 that "one would enjoy getting rid of the excessive call upon his attention made by the costume part of it, and getting at the man, with the hope of finding there the kind of human na-

ture out of which the real Mayflower Pilgrim was made, to the almost complete exclusion of the clothes which invested that pilgrim."[61] Such sharp criticism of Ward's statue might have owed its inspiration in part to the brilliance with which Saint-Gaudens had tackled the Puritan deacon of Springfield.

Artists and audiences alike uniformly agreed that the sculptor had captured in bronze an element of the human spirit. They hailed the work as the finest embodiment of Puritanism, a monument to personal conviction and determination. In 1900, Saint-Gaudens's statue received the Grand Prize at the Exposition Universelle in Paris. At least twenty-four reductions of the statue were made and sold, one of which went to Theodore Roosevelt, then governor of New York, as a gift from his staff.[62] Saint-Gaudens's deacon, critics readily noted, transcended mere portraiture to give life and form to an abstract ideal. It captured, as Charles Lewis Hind wrote in 1908, "the spirit of a world-moving movement." Elsewhere, an anonymous writer described the sculptor as a psychologist: what other artist, he asked, "has résuméd, as he has in his Deacon Chapin, all New England!"[63] Although originally titled *Deacon Samuel Chapin,* the work by the turn of the century became known as *The Puritan,* an appellation that would prove a double-edged sword.

For city officials and speakers at the dedication ceremony held on Thanksgiving Day, 1887, the statue possessed only positive qualities, a commemoration of the courage and hardiness of Springfield's early settlers. In his statement of thanks for the gift, Mayor E. B. Maynard proclaimed the importance of art as a model for behavior. For him, the Puritan deacon showed not only the triumph over privations that the early settlers had endured, but "the inspiration those pioneers had, the God-like life they led and the liberty of worship which they had secured." Reverend Chapin reminded his audience that "poverty and crime have hardly had a place among his [Deacon Chapin's] descendants." Most of them, he noted, constituted a part of the middle class: "may we not say the happiest and best—the good and substantial citizens who . . . form the strength and glory of the nation." On a note similar to the mayor's, he added later: "Such men [as the Puritan deacon] are needed in this wicked world. They are the salt of the earth. May the setting of this monument lead many who look upon it to imitate the example of him whom it represents!"[64]

Stearns Park, located in downtown Springfield, was the site of the unveiling (Fig. 21). Although Chester W. Chapin died before Saint-Gaudens could complete the figure, other members of the Chapin family worked with the sculptor and the architect, Stanford White, to create an appropriately distinguished setting. Substantially redesigning the grounds of the park, White accented the statue with an arboreal framework. Opposite *The Puritan,* he installed an elaborate fountain, featuring a bronze globe surmounted by dolphins and encircled by four turtles. The ensemble met with city approval, and officials pronounced the park "one of the most artistic in the city."[65] Twelve years later, however, the site despite its artistic merits was deemed inadequate.

By 1898, city officials wanted *The Puritan* relocated. The problem lay not in the appeal of the statue but in the relative obscurity of the site. Largely commercial by the turn of the century, the area around Stearns Park now stood at the edge of the city's center. Civic buildings such as the post office and the new theater, according to one of the local newspapers, had been

Figure 21. Stearns Park, Springfield, Massachusetts, c. 1899. Springfield Picture Collection of the Connecticut Valley Historical Museum

erected elsewhere downtown. Instead of monumental architecture, shabby buildings occupied by poor families ringed Stearns Park, and their children often used the park as their playground, playing ball and occasionally stopping up the fountain.[66] Just as the city had grown, so had Saint-Gaudens's reputation and the renown of the statue. In a 23 January feature article, the *Springfield Republican* declared Stearns Park unsuitable for "the city's finest work of art." Local officials and concerned citizens sought a more prominent location, and they urged moving the statue to Merrick Terrace, the entrance to a cultural complex of institutions for the spirit and the mind that included the recently established art museum, the Springfield Public Library, and Christ Church Episcopal cathedral.

Concerned citizens noted that Merrick Terrace, a grassy, tree-shaded knoll situated on the east corner of State and Chestnut Streets, not only provided a more dignified and dramatic setting, but had considerably more traffic—so many more people would see *The Puritan* and be inspired by it. The January article in the *Springfield Republican* on the statue's move included a letter to the editor that addressed the civic importance of the sculpture. The decisive factor in the relocation of the statue, one local resident named E. C. Gardner declared, was the important "moral inspiration" it imparted. Gardner identified the Puritan figure as "one of the founders of the great nation that is moving forward more rapidly than any other on the earth," and he heartily endorsed the placement of the statue in a thoroughly visible and accessible site in the city. This way, he argued, it would have the opportunity to influence as many people as possible because it would be seen "by men and women who in their feverish haste to reap the

material benefits made possible to them by this same old Puritan, are prone to forget their ob-
ligations, not alone to him individually, but to the principles of rectitude and that unflinching
response to the call of duty for which he forevermore stands."[67] Support for the relocation of
the statue echoed through the *Springfield Republican*'s reports. In 1899, without controversy or
incident, the city finally transported *The Puritan* to the more stately setting of Merrick Terrace.

From a more commercial site, the statue moved to a powerful cultural one. A model of the
"principles of rectitude" and civic responsibility, *The Puritan* now stood flanked by a house of
God and an institution of learning. Through the efforts of a national Public Library Move-
ment, libraries in this period were celebrated civic bodies, charged with serious educational
and social purpose. Like the art in the museum immediately behind the statue, books and the
repositories that housed them had the power to influence behavior: "good books," supporters
of public libraries like Frederick Crunden and Josephus Larned repeatedly noted, led to bet-
ter citizens. As the *Springfield Republican* had affirmed back in 1890: "The liking for a good
book is of vastly more consequence to youth and manhood than a knowledge of the equation
of payments or adverbial elements of the third form." A diet of bad literature, such as yellow
journalism or dime novels, on the other hand, threatened social order. As "The Editors' Table"
of *New England Magazine* noted, a boy who fed on wild adventure stories "will have his brain
filled with notions of life and standards of manliness which, if they do not make him a men-
ace to peace and good order, will certainly not tend to make him a useful member of society."[68]

Springfield Public Library officials, like their counterparts in Boston and elsewhere, aimed
to staunch the spread of social ills (from vandalism to alcoholism) and to foster instead an up-
lifted and educated electorate. For John Cotton Dana, the head librarian, the library provided
an instrument for the promotion of common ideals, common standards, and "the common
aims which make us a nation."[69] Saint-Gaudens's purposeful and resolute Puritan now stood
just outside the door. From this position it offered a complementary vision, a three-dimen-
sional and dynamic illustration of the social values presented in far more diffuse fashion by the
library's collection. Standing at the gateway to all three buildings—the church, the museum,
and the library—the statue accented the connection among piety, art appreciation, and civic
responsibility. As powerfully as MacMonnies's *Bacchante* had represented to certain of Bos-
ton's citizens social dissolution incarnate, Saint-Gaudens's old Puritan deacon, with the Good
Book in hand, made not only an aesthetic statement but also a statement about community tra-
ditions and heritage. While ethnic tensions in Springfield seem never to have been as acute as
those in Boston, immigrant groups such as the French Canadians, the Irish, and the Italians
made up an increasingly significant portion of the city's population by the turn of the cen-
tury and asserted more political control. In 1899, Springfield elected its first Irish-American
mayor.[70]

That same year marked not only the statue's relocation but also a major exhibition at the
Art Museum in Springfield commemorating the tercentenary of the birth of the Puritan leader
Oliver Cromwell. The show drew up to 150 people a day.[71] An admirer of Cromwell, and him-
self of old New England stock, Dana the librarian had organized the event. It is in fact possi-
ble that Dana and other library officials may have lobbied for the move of *The Puritan* to nearby
Merrick Terrace to coordinate with the exhibition. In his preparatory notes, Dana commented

that Cromwell had been unfairly stigmatized as a usurper or tyrant and cited him instead as a man of the people like George Washington or Abraham Lincoln.[72] Together the relocation and the show not only highlighted the positive qualities of New England's Puritan legacy but also emphasized Puritan ideals as the basis for civic principles in the region and the cultivation of a New England spirit. Perhaps more important, they reinforced the notion of Puritan ideals as fundamental to national values and the political underpinnings of the country.

The Puritan/Pilgrim Heritage

What had started out in 1887 as a monument to a prominent family member and town founder, through its move in 1899, had become associated with civic leadership and responsibility. The work of public sculpture to visualize New England ideals inspired cultural leaders again in 1905 but this time far from Springfield, Massachusetts. Interested in representing itself to the city of Philadelphia, the burgeoning fraternal organization known as the New England Society of Pennsylvania decided to make a donation of a public statue, and in 1902 commissioned Augustus Saint-Gaudens to make another version of *The Puritan,* which they would later retitle *The Pilgrim* (Fig. 22).

By the late nineteenth century, New England Societies had sprouted all over the country, from Philadelphia to St. Louis to Madison to San Francisco. Drawing their membership from the ranks of transplanted New Englanders and their descendants, the societies raised to an art form the celebration of the New England heritage as a positive and integral force in contemporary American life.[73] The *New England Magazine,* in a series of articles, identified the societies as "among the most efficient carriers and radiators of the New England light" and praised them for keeping "vital and influential everywhere the true New England spirit."[74] The earliest societies dated back to the first decade of the nineteenth century; a society had opened in New York in 1805 and in Philadelphia in 1816, although the latter dissolved in 1827 (later to be reformed). These antebellum organizations brought together and supported communities of relocated New Englanders. Many focused their efforts on charitable purposes, providing economic assistance for widows or those who had fallen on hard times. By the late nineteenth century, however, New England Societies enjoyed a new popularity. By the mid-1880s, their number had doubled, and by 1897 seventeen societies flourished across the country. Members came from a highly educated business and professional elite and included such personalities as John Wanamaker, J. P. Morgan, and John D. and William Rockefeller. As a Philadelphia paper proudly noted in 1885, "our Philadelphia New Englanders are a solid set of our best men, the advanced leaders in many of Philadelphia's best enterprises."[75]

The main event on the calendar of New England Societies across the nation was the annual Forefathers' Day festival, which honored the spirit and legacy of the original Puritans. Members and invited guests gathered for a grand banquet late in December, typically featuring traditional New England foodstuffs, treats such as cod, oysters, baked beans, and pumpkin pie. Prominent cultural, political, and financial leaders were invited to participate and give addresses. A list published by the Pennsylvania chapter in the early twentieth century boasted a

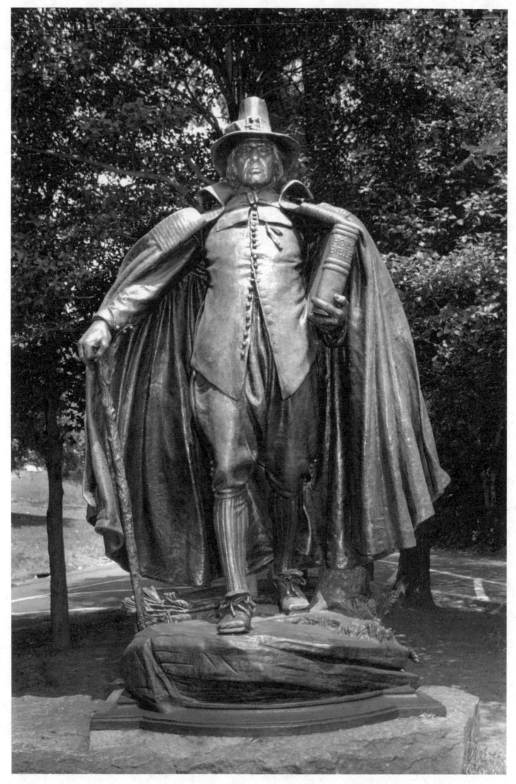

Figure 22. Augustus Saint-Gaudens, *The Pilgrim,* 1905, bronze, over life-size. Courtesy of the Fairmount Park Art Association. Photograph: Gary McKinnis © 1992

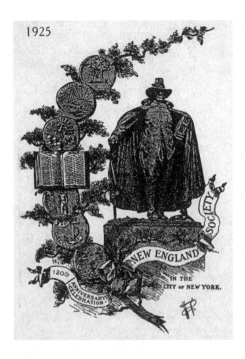

Figure 23. New England Society in the City of New York,
Annual Report cover, 1925

distinguished array of speakers, among them United States presidents and vice-presidents,
statesmen, cabinet officers, writers, college presidents, and governors.[76] Bearing titles such as
"The New Englander as a Citizen" (1897), "New England in Pennsylvania" (1900), "The Yan-
kee in the Far West" (1900), "New England in the Senate" (1902), "The Puritan's Part in the
American" (1904), and "The New Englander at Home and Abroad" (1904), they sounded the
importance of the New England Puritan heritage to the vitality of the United States as a whole.

Over the years in Philadelphia, more and more participants attended these annual celebra-
tions. One hundred seventy people, for example, graced the banquet tables in 1885, about 280
in 1894, and over 350 by 1902. Promoting the ideals of an Anglo-Saxon Protestant ethos, the
societies encouraged a consciousness of New England's historic importance. The Puritan her-
itage was part and parcel of this celebrated New England spirit. By the turn of the century,
that heritage had come to be best personified by Saint-Gaudens's 1887 statue. Most New En-
gland Societies had adopted the likeness of a Puritan—depicted almost exactly as Saint-Gau-
dens's statue—as their emblem and proudly sported the figure on the covers of their annual
reports (Fig. 23), as the New England Society in the City of New York did.[77]

The move to give three-dimensional form to this legacy began in 1885, when the current
secretary of the New England Society of Pennsylvania, Charles Emory Smith, had proposed
to fellow members that they consider erecting a statue or memorial to honor "a worthy an-
cestry." Twelve years elapsed before the society acted on Smith's suggestion. In that time, both
Augustus Saint-Gaudens and *The Puritan* had achieved renown. Their success may partially ac-
count for the society's decision to entrust Saint-Gaudens with the commemoration; James
Beck, an assistant attorney general and the president of the society at the time, wrote the sculp-

tor in 1902 asking him to make a replica of his "noble" statue. Beck also reiterated the society's desire for a monument embodying "the spirit of New England."[78] Saint-Gaudens accepted the commission but declined to execute an exact replica. In his memoirs, published in 1913, he explained that he had wished to make "several changes in details." The society requested for its part that, given its focus on heritage, the statue be renamed *The Pilgrim* in order to emphasize the historical rather than religious significance of the subject—a somewhat disingenuous gesture given the religious reasons for the Pilgrims' immigration to America.[79] The society's insistence on renaming the work presumed Protestant ethics as secular and therefore of national import.

The site ultimately selected for the statue was none other than Philadelphia City Hall. Although Saint-Gaudens had suggested Fairmount Park, a 9,000-acre bucolic stretch of public lands and gardens in the northwestern part of the city, and the Fairmount Park Art Association—chartered in 1872 to promote the erection of statuary along Fairmount's drives and walkways—had readily agreed, various society members favored a more accessible and conspicuous site, closer to the center of the city.[80] The heart of local government, Philadelphia City Hall, a massive Second Empire–style edifice, stood at the intersection of Broad and Market, down the street from the Academy of Music and the Stock Exchange. The building featured a colossal statue by Alexander Milne Calder of Pennsylvania's founder, William Penn, which had been installed in 1894 at the top of the Hall's multi-storied tower. On 25 April 1905, the New England Society's *Pilgrim* took up residence at the base.[81]

The Pilgrim and the "Spirit of New England"

At the dedication ceremony for the statue, Charles Emory Smith of the New England Society of Pennsylvania declared that *The Pilgrim* joined the ranks of Philadelphia's heroic sculpture, offering a visual expression of New England political and cultural ideals worthy of national emulation: "It symbolizes conscience, and a high resolve, unfaltering love of liberty and unswerving devotion to law." Smith grouped the pilgrim figure with such illustrious leaders of the country as George Washington and Abraham Lincoln, who already had statues in their honor in the city. If they typified "a great race," *The Pilgrim,* Smith declared, brought to the urban landscape "a racial figure that typifies great men." He was a figure that embodied "the moral and mental attributes of the immortal forefathers who on the stern and rock-bound coast of New England planted the seeds of liberty which ripened into an immeasurable harvest of greatness. Let it stand forever as the perpetual monument of a great principle, a glorious ancestry and a priceless heritage."[82] Saint-Gaudens's monument seemed to capture the society's image articulated by former president James Beck as "the spirit of New England." In the figure's erect, striding form and stern features, the society saw the virtues of hardiness and determination and the personification of time-tested values. Those values, as Smith made clear, were understood to be singularly Anglo-Saxon Protestant attributes. By declaring New England's heritage vital to the nation, Smith thereby claimed its importance to Philadelphia. With

the erection of the statue at City Hall, a vision of a Puritan past took its place alongside an image of the city's Quaker roots symbolized in the figure of William Penn.

Yet the seriousness with which the New England Society of Pennsylvania viewed its heritage contrasted with a growing ambivalence, especially in intellectual circles, about the meaning and viability of the Puritan legacy. What composed the so-called spirit of New England and the role it played in the nation had become increasingly debated despite the fervid claims of New England Societies across the country.

In the aftermath of the Civil War, historians had focused on the origins of the country, specifically the colonial past. Seeking to apply new "objective" standards of scholarship, they subjected New England and other regions to "scientific" methodology on the rise at the time. This meant taking leave of anecdote and narratives of heroic figures, and instead recording cause and effect and detailing economic and political facts. The New England Puritan tradition did not fare well through this. Puritans increasingly emerged as a narrow-minded, idiosyncratic sect, riven by internal dissension. In a 1906 literature review entitled "The Scientific Historian and Our Colonial Period," the historian Theodore Smith noted that in the current social climate Puritanism no longer possessed the cultural currency it once enjoyed. Why that was, he surmised, had to do with people neither liking Puritanism nor respecting it: "It is more remote from the present, more difficult to appreciate than the spirit of the discoverers, the explorers, or the buccaneers. Probably no more difficult task is imposed upon the historical imagination than that of representing the Puritan state of mind in the seventeenth century without caricature or repugnance."[83]

An earlier generation of historians—George Bancroft, John Gorham Palfrey, and even John Fiske—had exalted Puritanism, viewing it as the source for a full and rich development of the nation. By contrast, the new histories, among them *Massachusetts: Its Historians and Its History* (1893) by Charles Francis Adams and *The Colonization of New England* (1903 and 1904) by Bartlett B. James, dismantled the halo that topped the heads of the Puritan fathers. As Jan Dawson has written, "historical and literary scholarship showed Americans a side of the Puritan tradition that, although it might have been accepted or occasionally even respected as having once been historically necessary, made the Puritan impulse seem very much a product of a bygone era."[84] The glance backward was more critical and less sentimental, and it rooted the Puritan colonists and their institutions in a particular time and circumstance.

Members of the literary world wrestled with their inheritance as well, questioning what, if anything, the Puritan tradition could offer turn-of-the-century creative imaginations. A host of scholars and writers, among them George Woodberry and Barrett Wendell, continued to assert the spiritual power of New England's legacy and its modern relevance. But others, such as Van Wyck Brooks and Henry James, dismissed it as bankrupt. Brooks's socratic essay "The Wine of the Puritans," published early in his career in 1908, tackled the issue of the state of American culture and American letters in particular. Articulating a growing disillusion with New England Puritanism, he pronounced that tradition incapable of responding to the demands of modern life. Indeed, Brooks maintained, the more his generation struggled to preserve Puritan/Pilgrim ideals, the harder it would be to solve the era's social problems since Puritan ideas

had emerged from a specific and temporary set of conditions: "For, as we have said, the virtues of the Pilgrims were not those racial virtues which are always relevant because they have grown out of an antiquity which held in embryo all the later problems of the race. They were the virtues, negative and narrow, of a small colony."[85] Among intellectuals such as Brooks, parochialism and provincialism weighted down the Puritan heritage and prevented it from rising to the challenges of new times.

This ambivalence, if not hostility, had even reverberated in critical reviews of Saint-Gaudens's sculpture of Deacon Chapin. Art critics could proclaim the sculptor's *Lincoln* or *General Sherman* heroic national images without hesitation, but they equivocated on the meaning and relevance of *The Puritan*. Kenyon Cox, a New York artist and critic, for example, alluded to a legacy of intolerance when he wrote of the 1887 statue that year: "Surely those old searchers for a 'liberty of conscience' that should not include the liberty to differ from themselves could not fail to recognize in this swift-striding, stern-looking old man, clasping his Bible as Moses clasped the tables of the law, and holding his peaceful walking-stick with as firm a grip as the handle of a sword—surely they could not fail to recognize in him a man after their own hearts." Similarly, Charles Caffin, in his 1904 review of Saint-Gaudens's art, pronounced the bearing of the statue dour, militant, and aggressive: "The figure grasps a Bible and a staff, and looks ready to enforce its interpretation of the one by cudgeling with the other; no pleasant figure, but to be reckoned with; a force as inevitable in its progression as time, as unyielding as granite."[86] The one thing reviewers did agree on was how well Saint-Gaudens had captured a state of mind.

Nonetheless, when Saint-Gaudens accepted the New England Society commission for a Philadelphia statue in 1902, he had insisted that the figure was inadequate as a symbol of Puritanism, and he had agreed to the society's request for a replica of *The Puritan* only on the condition that he first undertake several changes. Dissatisfied with the execution of certain details, he modified, for example, the position of the left hand and the way the old colonist's cloak fell. He also reoriented the position of the book so that its spine confronted the viewer with the words HOLY BIBLE and there could be no mistaking what the figure was carrying. All this was nothing, however, compared to the alterations Saint-Gaudens made to the face. As he recorded in his memoirs, he now found Chapin's visage too "round and Gaelic in character." "I changed the features completely," he wrote of the Pennsylvania version, "giving them the long, New England type."[87] The sculptor's reasoning makes little sense, especially given that Saint-Gaudens had used a direct descendant of Deacon Chapin to model for the original statue.

Indeed, he may not have meant these words entirely in earnest. Rather than reflecting a narrowing of his views on race and character, his comments point instead to a broadening of his artistic wit, to a subtle mockery of his patrons. In the 1887 statue of Deacon Chapin, Saint-Gaudens had effectively delineated Puritan austerity. With the Philadelphia commission, his new "New England type" pushed that austerity to the limit. In the latter statue, Saint-Gaudens set the lips more grimly than in the 1887 version and elongated the face, adding more hollows. Overall, he crafted a far more severe and harsh countenance, carrying his creation past psychological portraiture and into the realm of caricature. The 1902 commission seems to have

unexpectedly offered the French/Irish sculptor an opportunity to engage in a little ethnic satire and ever so subtly mock his patrons and their seeming fixation on New England and Protestant Anglo-Saxon pre-eminence.

Saint-Gaudens in fact had employed wry humor in his art before. In small paper sketches as well as in the more august medium of bronze, he had poked fun at friends and relatives. A small medallion for his good friend Henry Adams from 1904, for example, features Adams's head attached to the body of a porcupine on one side and to angel wings on the other. Suggesting the two aspects of Adams's personality, Saint-Gaudens inscribed across the bottom the words PORCVPINVS ANGELICVS HENRICVS ADAMENSO.[88] Another medallion caricatured his painter friend and fellow golfer James Finn, showing him in a strong man's pose wearing golf clothes.

Reports about the renovations Saint-Gaudens undertook to his Cornish, New Hampshire, house further suggest his undisguised disdain for New England Puritan traditions and his readiness to act on his contempt. On the whole, Saint-Gaudens had found inspiration for his art in Italian Renaissance models. This stylistic interest extended to architecture and landscape design and was especially manifested on the grounds of the art colony he had helped organize in Cornish. Devotees of a classical European past, affiliated artists actively reshaped the surrounding landscape, gardens, and residences according to classical and Renaissance models. Saint-Gaudens, who had been eager to stay in the area close to the colony, purchased an old farmhouse in Cornish in the mid-1880s. He records in his memoirs, however, that he could not abide living in the house, so averse was he to its New England heritage. "My dwelling first looked more as if it had been abandoned for the murders and other crimes therein committed," Saint-Gaudens wrote, "than as a home wherein to live, move, and have one's being. For it stood out bleak, gaunt, austere, and forbidding, without a trace of charm. And the longer I stayed in it, the more its Puritanical austerity irritated me, until at last I begged my friend Mr. George Fletcher Babb, the architect: 'For mercy's sake, make this house smile, or I shall clear out and go elsewhere!'" Babb did his best to transform the house into something more tolerable. Speaking of the renovation, Saint-Gaudens quoted one of his friends who had quipped that the new house looked "like an austere, upright New England farmer with a new set of false teeth," and another who thought it looked "more like some austere and recalcitrant New England old maid struggling in the arms of a Greek faun."[89]

Saint-Gaudens's personal background may have stoked his interest in Puritan parody. The sculptor had been born in Dublin, although his Irish mother and French father immigrated to the United States shortly thereafter. Charles Caffin, in his 1904 article on Saint-Gaudens's statuary, pointed to the presence of a Latin/Celtic temperament in Saint-Gaudens and to its complete lack in the Deacon Chapin statue. Most telling are the remarks by Saint-Gaudens's son, Homer, who edited his father's autobiography just before the First World War. In an early edition of the *Reminiscences* Homer noted that his father had been much influenced by Joseph Wells, "who though of Puritan blood, took delight in satirizing Puritan ancestry, and accordingly suggested to Saint-Gaudens that he almost caricature the typical Puritan in the statue of Deacon Chapin. It was only my father's tolerant discernment and standard of art that prevented

him from accentuating, even more markedly than at present, Puritan sternness and single-mindedness."[90] From the looks of the statue Saint-Gaudens executed for the New England Society, Wells perhaps had a greater influence on him than Homer chose to admit.

In 1917, in fact, an anonymous critic would speculate on why *The Pilgrim* looked as it did and query Saint-Gaudens's true feelings toward New England's Puritan tradition. The pose of the statue's feet, he wrote, "expresses the rigidity of his views concerning other forms of Protestantism. . . . But it is the face that tells the story first and foremost, with its massive features, stern eyes and closely pressed lips. . . . Nothing kindly or mellow, genial or humane about this face! Perhaps the Frenchman and Irishman in Saint-Gaudens caused him to accentuate in this work the qualities that are most abhorred by them."[91] The author did not pursue his point further.

New England in the Nation

Certainly the New England Society of Pennsylvania failed to see any irony in the statue delivered by Saint-Gaudens. Society members, like their cousins across the country, maintained an unwavering belief in the Puritan heritage and rejected the pessimism of Van Wyck Brooks and others. Speakers at the annual festival dinner of the Pennsylvania chapter in 1897, for example, asserted, as if in direct anticipation of Brooks, that while scholars might question the direction of Puritan ideas and poets might sigh at the lack of imagination, the Puritan New Englander had to be seen in the larger perspective. In his unique combination of heart, head, and conscience, he represented one of the truly great historical figures, one who had shaped the destiny of Western civilization.[92]

Addresses at New England Society dinners had for the most part consisted of variations on this theme, as had the dedication speeches for the statue itself. But speakers and society devotees were always careful to position the local within the national. Their assertion of pride in New England's past did not eclipse a larger loyalty to the nation. Speakers stated and restated their firm national allegiance. The president of the Pennsylvania chapter affirmed at the annual dinner in 1897, for example: "We have not grown more clanish [*sic*] and sectional by these meetings, as some feared that we might, but through them our patriotism has been deepened and our Americanism has been intensified."[93] Addressing the issue of New England's position in the Senate several years later, Senator Orville Platt maintained that the region was in fact the least sectional part of the United States. The South, New York, the Great West, or the Middle States were always asking for action on their behalf. But who, he asked, "ever heard of a New Englander saying that anything must be done simply because it was for the interest of New England?" Its senators, he declared, "have felt that they were Senators of the United States from the State which they represented. They have had a broader vision, a more comprehensive idea of their duty than to represent simply a section or a State. I think it is this that has given New England what I may call its proud pre-eminence in the Senate of the United States."[94] For Platt, the region's physical existence, its specific location, was incidental to its general purpose; it pursued a larger mission, the welfare of the country as a whole.

New England Society members fastened on a specific interpretation of the colonial past as a means to transcend sectionalism and promote a collective national spirit. The revitalization of a Pilgrim/Puritan type provided a critical bridge between such regional and national loyalties. The societies relied, one could say, on the transitive property, as did a speaker at the New York Society in 1890. Exhorting fellow members to be New Englanders yet remember that they were Americans, he went on to say that the best thing one could do was "to universalize the New Englander. When the New England merchant goes West, when the New England capitalist goes South . . . he steps into a larger mission. By the New Englander, I mean the Puritan, and by the Puritan I mean the man who has the spirit of the Pilgrims, no matter where you find him; and Puritanism is the salt of the American earth."[95] In another attempt to clarify the relationship of the American nation, the New Englander, and the Puritan, a Pennsylvania member explained five years later that the society's purpose was not to honor the region alone or New England's superiority because what mattered was more than place or a specific geography. Instead he stated: "We honor an idea; we celebrate a principle; we reverence that Puritan spirit which beginning in New England has largely moulded the nation."[96] The speaker thus attempted to censure regional partisanship, making the region, in this case New England, important only as a carrier of a universal impulse.

New England Society members repeatedly argued for concentric, not competing, loyalties. From this perspective, national allegiance, far from contradicting regional loyalties, required their amplification. At the level of the region, specific local traditions and abstract national principles could meet through representations of values common to both. What especially characterized this universal impulse or "Puritan spirit" and made it of national interest was respect for law. Society members pronounced this quality "the safeguard of morality," and of singular relevance for a society grappling with the profound consequences of demographic, industrial, and economic expansion. The essayist and editor Charles Warner, for example, in his Forefathers' Day address of 1889, noted that "if we maintain one of our inheritances from the Pilgrim incorruptible and unshaken,—his respect for law," the country would emerge strong and "unharmed."[97]

Such a directive seemed to have direct applicability to the city of Philadelphia. Not long before Saint-Gaudens's statue was dedicated at City Hall, the *Atlantic Monthly* ran an article that questioned why the city and the state in general seemed bedeviled by political corruption. The author, identified only as "A Pennsylvanian," compared Pennsylvania to the state of Massachusetts, supposedly much less corrupt although similar in demographics, political tendencies, and economic bases. Dismissing the Republicans and the problem of immigration as causes, the author focused instead on a historical reason. He claimed that the Quakers, who had settled Pennsylvania, had lacked the indomitable resolve of the Puritans, which to the current day had kept the social order in Massachusetts, even in the face of a large non-Puritan population. If the Quaker colonists, the author argued, "had had the spirit of the Puritan fathers, Pennsylvania might have been held steadier to the moorings of civic decency." But instead they had reached a point "where they were tolerating intolerance. Put in a minority by the unrestricted immigration of less worthy people, and lacking the strenuous, dominating spirit of the Puritans, the early Quakers soon let the control of the colony pass into the hands

of the less desirable elements; and there it has always remained."[98] The lesson of the article: embracing the Puritan spirit ensured the healthy future of the country.

An indignant Quaker responded some months later, saying that his denomination could not be held responsible for Pennsylvania's problems. The author, however, did not take issue with the idea of the Puritan as a fitting standard for civic duty.[99] The sentiments of both contributors suggest that the New England Society's gift to Philadelphia struck a resonant chord among viewers. For at least a certain segment of the city's population, Saint-Gaudens's Puritan figure, striding forward resolutely and supported by divine law in the form of the Bible, heralded an appropriate model for social order and a timely vision of political responsibility.

The association between the Puritan/Pilgrim and civic order was graphically underscored by the installation of Saint-Gaudens's statue in April 1905 on the South Plaza of Philadelphia's City Hall. The sculptural decoration of the south facade of the building revolved around the allegorical theme of justice. From above, in the form of a keystone head, the lawgiver Moses gazed down. Seated figures of Law and Liberty graced the walls, and the spandrel held the figure of Executive Power checked by Judicial Power. The entranceway itself led into the law courts. Like a sentinel at the gates of Philadelphia's seat of government, *The Pilgrim* monument sternly exhorted respect for law.

From a range of available colonial types, the New England Society of Pennsylvania had selected the Puritan figure as embodied by Saint-Gaudens's 1887 statue. It appealed to the organization not only because it distilled abstract principles into a concrete example, but because it also offered an image of members themselves. Unlike critics who denounced Puritan intolerance, dogmatism, and narrow-mindedness, those members, largely businessmen and social leaders, saw in Saint-Gaudens's colonial re-creation attributes of perseverance, self-reliance, self-discipline, and motivation. It was these qualities, Forefathers' Day orators repeatedly declared, that turned "the rocky coast and shore of New England into a garden that has blossomed and the fragrance thereof has swept around the world,"[100] and that now proved integral to the continued development of an industrial economy. In the late nineteenth century, the proselytizing mission of the Puritan/Pilgrim figure metamorphosed to enterprising zeal and fidelity to the capitalist creed. Loosened from its religious roots, the statue could lead the way toward cultural redemption.

From a memorial by a wealthy individual to his ancestor and town founder, Saint-Gaudens's bronze figure had evolved over the years into an emblem of social leadership. The transfer of the statue in 1899 to the complex of educational institutions in Springfield transformed its specific identity as Deacon Chapin into a personification of civic duty and moral rectitude. In translating the statue to a site outside the region, the New England Society of Pennsylvania set forth the Puritan/Pilgrim figure as an image worthy of national emulation. Though preserved and nurtured in New England consciousness and history, this ancestral image, as the society maintained, transcended its provincialism to exemplify the standard for civic order and cultural well-being.

Saint-Gaudens's *Puritan/Pilgrim* and MacMonnies's *Bacchante* represented two sides of the same coin. On the one side, the Puritan obverse, stood a bronzed image of civic order; on the

THE PURITAN FOR THE BACCHANTE—A WAY OUT FOR BOSTON'S PRUDES.

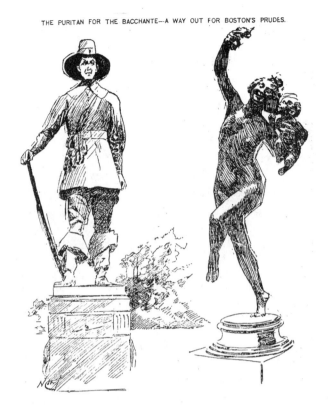

Figure 24. "The Puritan for the Bacchante—
A Way Out for Boston's Prudes." Cartoon
from *New York World* (31 May 1897).
Frederick MacMonnies Papers

other, the *Bacchante* reverse, a vision of social dissolution. The *New York World* suggested just such a pairing in an 1897 article satirizing the *Bacchante* controversy. Citing not Saint-Gaudens's statue but Ward's *Pilgrim,* the anonymous author proposed a trade; if Boston found the lively *Bacchante* unacceptable, they could have its opposite, Ward's sterner statue that stood in Central Park, and New York would take the *Bacchante*.[101] In an accompanying cartoon, "The Puritan for the *Bacchante*—A Way Out for Boston's Prudes," one statue confronted the other, their antithetical poses underscoring the difference in the social values they manifested (Fig. 24). The columnar and rigidly posed Pilgrim seems to stare disapprovingly at the open, freeform stance of the *Bacchante,* delicately balanced on one foot. In an ironic twist, one month after the *New York World*'s cartoon, McKim indeed packed up the *Bacchante* and sent it to New York.

The travels through public space of both the *Bacchante* and *The Puritan* expose a host of expectations and tensions about the direction in which New England and American society as a whole should move at the turn of the century. What would be the guiding ideals, and who was best qualified to lead? Convinced of the didactic potential of art and its ability to inspire human behavior, civic leaders in Boston, Springfield, and Philadelphia transposed particular social mores to a visual medium, an aid to organize and structure public space. The controversy over the *Bacchante* in Boston involved a struggle for leadership within New England. A Brahmin clique, in alliance with religious and anti-vice organizations, attempted and ultimately suc-

ceeded in instating a specific civic vision, if only for a short time. In both Springfield and Philadelphia, the severe, purposeful comportment of *The Puritan / Pilgrim* held out a model for lawful, orderly society, one rooted in New England's past but capable of nourishing the entire country. With the installation of *The Pilgrim* in Philadelphia, this ancestral image, preserved and nurtured in New England consciousness and history as the New England Society maintained, moved beyond its provincial roots. So-called New England principles momentarily held cultural sway outside the region.

Yet the attempt to secure these principles through public aesthetic display proved challenging. As Saint-Gaudens's own response suggests, the choice of a Puritan to represent the region's heritage provided a target for those questioning that heritage, its ideals, and its authority. The impetus to assert a privileged role for New England through the use of figurative public sculpture faded as the new century wore on. World War I also brought a host of new concerns into focus. At the same time, American writers and thinkers, following in the steps of Van Wyck Brooks, repeatedly pronounced New England's Puritan legacy bankrupt and incapable of steering the country through the twentieth century. As Barrett Wendell had observed, his generation seemed caught between an old and a new era; by the second decade of the twentieth century, most of that generation no longer survived. Different groups, who pinned fewer hopes on the transformative powers of art, claimed control of public space. The historian Stuart Blumin, among others, has argued that by the 1920s "the urban upper class, once so evident a part of the social landscape, began to lose visibility and force, receding from public view especially rapidly after Americans turned to more specialized celebrities in aviators, film stars, and athletes."[102] Without the support of an urban, upper-class audience, public statuary also retreated, turning away from three-dimensional exhortation to other aesthetic concerns.

These changes were manifested in the ultimate re-sitings of both Saint-Gaudens's and Mac-Monnies's statues, perhaps the most striking announcement of the eclipse of the values that endowed those sculptures and their former sites with meaning in the first place. In October 1920, the city of Philadelphia removed the New England Society's *Pilgrim* from City Hall Plaza to Fairmount Park, which by the early twentieth century featured a large collection of outdoor statuary. The permanent placement of the statue had always been somewhat of an open question. In a 1903 letter to the head of the Fairmount Park Art Association, the president of the New England Society had said that some society members favored the park, while others wanted a site closer to the center of the city. Saint-Gaudens delivered the statue before the matter was resolved and before funds for the permanent pedestal were available.[103] For fifteen years, *The Pilgrim* had stood its ground as political symbol at the city's center of government. As a New England type it had been aggressively cultivated and promoted as a model for an emerging and diverse new nation. The relocation to Fairmount Park highlighted instead the artistic mastery of one of the country's leading sculptors. It effectively emptied the statue of its political and historical resonance, rendering it for the first time truly immobile.

In the case of the *Bacchante,* Boston officials never installed any other artwork in the courtyard of the Public Library. MacMonnies's statue, out of sight, faded from the public mind. Nearly a century later, in 1992 in celebration of the library's 100th anniversary, the Boston Arts and Humanities Commission and library trustees decided to welcome the statue back to its

originally proposed site, the library's courtyard. Commissioner Bruce Rossley stated, "We want to erase an error of 100 years ago and fulfill McKim's courtyard vision."[104] With renovations to the courtyard and fountain pool completed, a casting made from the original statue at the Metropolitan Museum of Art was formally installed in 2000. In a world where its ethnic associations have faded, the statue no longer serves to demarcate an Anglo-Saxon Protestant superiority. Like *The Pilgrim,* MacMonnies's *Bacchante* carries for a twentieth-first-century audience strictly aesthetic significance—the crowning feature of a grand architectonic design. Boston today wonders what all the fuss had been about.

CHAPTER THREE

The Aestheticization of Rural New England and the Spirit of Place

In 1894, Theodore Robinson, an American artist raised in the Midwest and trained in Europe, journeyed to Vermont in search of new landscape scenes. Taken with the countryside there, he believed that he had finally reached his artistic home. As a fellow artist, Will Low, commented in his reminiscences, it was "a desire to identify himself with his native land" that brought Robinson to the hills of Vermont, and there he "had found his ideal country."[1] Although Robinson, an early proponent of Impressionism, died before he could realize his artistic ambitions, his fervor for the region was matched by two other well-known early practitioners of Impressionism in America, John Twachtman and Julian Alden Weir, who equally turned to New England scenery for inspiration. Like Robinson, their colleague and friend, they found an ideal country in which to live and paint.

People and place, land and character became peculiarly identified at the turn of the century. As Charles Adams remarked in 1907, a patriotic spirit depended on "that sentiment attaching to localities and the soil."[2] Robinson (1852–96), Twachtman (1853–1902), and Weir (1852–1919) used their art to convey such attachment. They located in the New England countryside a distinct sense of home. This chapter focuses on their relationship to place and its visual expression. In choosing not only to settle in the region but also to frame it aesthetically, Twachtman and Weir initiated a landscape art that strongly identified New England as a site of communal values and the source of an ideal national character.

The growing taste for images of the New England countryside connected to broad sociopolitical agendas. At the turn of the century, Americans increasingly looked to rural New England for its scenic and "therapeutic" qualities, inspired partly by the "Back-to-Nature" and "Country Life" movements, which advocated the active engagement and preservation of nature and the world outdoors. Tourism and flourishing art colonies such as Old Lyme, Connecticut, and Ogunquit, Maine, promoted the area's unique qualities. Writers, too, aided this

cultural reassessment of the region, bringing to public attention not only the resources and potential of New England but also its vital connection to the nation as a whole.

Both texts and art of the period were preoccupied with the spirit of place, with finding it, spending time in it, and absorbing it. The landscape as a locus of personal and cultural identity was an enduring perception and one only enhanced by the increasing growth of cities at the expense of rural environs through the 1800s. As the twentieth-century social critic Lewis Mumford commented in his book *The Brown Decades: A Study of the Arts in America, 1865–1895:* "With the coming of 'civilization,' that is to say, trade and manufacture and organized cities, the land is supposed to diminish in importance. As a matter of fact, the importance of the land increases with civilization: 'Nature' as a system of interests and activities is one of the chief creations of the civilized man."[3] Turn-of-the-century images of the land offered an alternative and powerful medium to disseminate regional ideals and assert the importance of local traditions and sites. In considering the transformation of landscape aesthetics from the grand and sublime to the intimate and bucolic, from Thomas Cole to the early American Impressionists, this chapter addresses not only the act of taking a natural scene and making it "scenic," or worthy of representation, but also the preference for particular types of landscape scenes by the turn of the century. How authors in magazines, essays, and books in this period talked about what they saw in the natural world elucidates the importance of Theodore Robinson, John Twachtman, and Julian Alden Weir to the identification of New England as a special place. Their initial artistic efforts helped to bring the local into more immediate view. As they gained increasing recognition, these artists and their works also gave expression to larger cultural concerns about the role of the New England region in national life.

From the Sublime to the Intimate

Thomas Cole's artistic success in the late 1820s helped establish American scenery as a subject of aesthetic and cultural interest. Signaling a departure from previous painters who had used their canvases largely as topographic records, Cole's work transformed the landscape into an artistic object. His panoramic views of the Hudson River Valley, the Catskills, and the Connecticut River Valley established an appreciation for nature and a visual aesthetic that set a model for later generations of landscape painters. While Cole drew on British landscape tastes and theories of the picturesque, he effectively translated them into an American idiom. As William Cullen Bryant remarked in an address delivered to the National Academy of Design in 1865: "I vividly remember the interest with which his works were at that time regarded. It was like the interest awakened by some great discovery. . . . Here is the physiognomy of our own woods and fields; here are the tinges of our own atmosphere; here is American nature and the feeling it awakens."[4] Cole's paintings highlighted the magnificent and sublime aspects of American scenery. In *The Falls of Kaaterskill* of 1826, the viewer stares up at steep cataracts rushing down the mountain face. The darkened, roiling sky, the brilliantly illuminated red leaves of the trees in the foreground, and the strong vertical orientation of the scene convey the drama of nature. *Schroon Mountain, Adirondacks* from 1838 creates a similar effect; rays of sunshine

break through black, threatening clouds and reveal the lofty summit of Schroon Mountain set in the center of the canvas. Cole's paintings worked to elevate the genre of landscape in the country and cultivate an attitude toward the land as spiritually valuable and connected to national well-being.

Cole was among a growing number of artists and critics in the early nineteenth century who conceived of the land as shaping both America's destiny and its moral character. In 1835, he wrote a lecture entitled "Essay on American Scenery" that celebrated the American landscape as a blank page on which to write the story of national achievement. According to Cole, the scenery did not speak "so much of the past as of the present and the future. . . . Where the wolf roams, the plough shall glisten; on the gray crag shall rise temple and tower—mighty deeds shall be done in the now pathless wilderness; and poets yet unborn shall sanctify the soil."[5] In nature lay the promise of American civilization. Cole, however, was not blind to the potential degradation implicit in the environment's transformation. Further on in his landscape essay, he agonized about the rampant deforestation he saw around him. On canvas, Cole also registered his apprehensions, as Angela Miller and others have shown. In his *View from Mount Holyoke, Northampton, Massachusetts* from 1836, also known as *The Oxbow* (Fig. 25), elements of the painting throw into doubt the ultimate direction of progress. Cole employed a divided composition—wilderness on one side, bared agricultural land on the other—and he positioned the river into the form of a question mark, with storm clouds hovering at the left and the rural scene eerily devoid of inhabitants.[6] Even more programmatic and polemical statements of his concern appeared in such apocalyptic visions as the two painting cycles *The Course of Empire* and the later *Voyage of Life*.

But for most of Cole's contemporaries, including Asher B. Durand as well as a successive generation of landscape painters such as Jasper Cropsey and Frederic Church, the course of American progress provoked less ambivalence and more gratification. While they employed many of Cole's compositional techniques such as the broad, all-encompassing view, realistic detail, and framing devices, their paintings tended to hallow the activity of settlers and their development of the land. Durand's *Progress* from 1853, for example, parallels the format of Cole's *Oxbow;* a central waterway splits the canvas between settlement on the right and a wilderness framed by trees on the left. Similarly, a panoramic vista and a low horizon line leave room for the expressive qualities of sky and clouds. In contrast to Cole's image, however, Durand's painting is suffused in warm yellow light and conveys no sense of foreboding; rather, purposeful enterprise animates the scene. The artist pictures both industrial and pastoral pursuits, from the bustling port in the middle ground to the herder with his cattle in the foreground. Buildings and roadways are nestled in the surrounding nature, emphasizing their harmonious coexistence. And, leading the viewer into the scene, a row of telegraph poles that resemble crosses suggests the sanctity of the activity below.

This visual confirmation of the blessings of progress would become increasingly important as the population pushed westward, developing the wilderness and displacing native inhabitants. While painters such as Durand, Cropsey, and Church registered the encroachment of towns and cities on the land, they generally smoothed over the invasive aspects of American settlement. Through composite scenes that took in a wide expanse of scenery, they made room

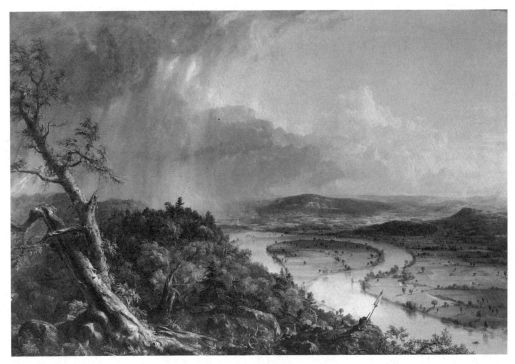

Figure 25. Thomas Cole, *View from Mount Holyoke, Northampton, Massachusetts, after a Thunderstorm (The Oxbow)*, 1836, oil on canvas, 51½ × 76 in. All rights reserved, The Metropolitan Museum of Art, Gift of Mrs. Russell Sage, 1908

for both the land and its inhabitants, and their paintings, often purchased or commissioned by developers and industrial entrepreneurs, offered assurances of an abundant nature that could support limitless enterprise. In Durand's *Progress,* Church's *Mt. Ktaadn* (1853), and Cropsey's *Starrucca Viaduct, Pennsylvania* (1865), a pastoral nature softens human development and moderates its spread. These paintings and others like them portrayed America as an Eden, regenerative and bountiful.

But it was not only material rewards that came from contact with nature. For Cole, Durand, and fellow artists, it also brought one closer to the divine, as they made clear in their writings. In a series of articles entitled "Letters on Landscape Painting" published in 1855 in one of the new art journals, *The Crayon,* Durand made explicit this association of God and nature. Gazing on the beauty of the natural world, he asserted, convinced a viewer "that the Great Designer of these glorious pictures has placed them before us as types of the Divine attributes, and we insensibly, as it were, in our daily contemplations, 'To the beautiful order of his works / Learn to conform the order of our lives.'" Landscape painting, he concluded in a subsequent letter, "will be great in proportion as it declares the glory of God." Cole similarly presented the natural world untouched by man: "the consequent associations are of God the creator—they are his undefiled works, and the mind is cast into the contemplation of eternal things."[7] Such commentaries helped not only to give a boost to the genre of landscape painting and the artistic profession in the United States but also to link the natural world with moral virtues. Art-

works provided a visual and even more accessible counterpart. Durand's images, which proved even more popular than Cole's, reached a large audience as a result of engravings. Together, Cole and Durand helped to secure a perception of nature and the American landscape as a source of moral truths.

The ideals of this early group of American landscape painters endowed the land with a cultural significance that operated on several levels. As a manifestation of the divine, nature provided inspiration for individuals as well as social uplift and enlightenment. This notion, echoed in the writings of Henry David Thoreau and Ralph Waldo Emerson, embraced the landscape as a place of contemplation and recreation, the source of transformative experiences. Already in the 1820s and 1830s, sites such as the Catskills, Niagara, and the White Mountains had become known for views described as picturesque or sublime, and functioned as popular tourist destinations.[8] Excursions to the mountains of New York and New England proved an appealing entertainment for those with wealth and leisure eager to cultivate their aesthetic sensibilities.

With its unique qualities and potential, the American landscape also stood out as a source of pride and a basis for national cohesion. Its peculiar natural wonders, its breadth and variety, not only distinguished it from Europe but also seemed to confirm the specialness of the country, and by extension those who occupied the land. As Angela Miller has remarked, "nationalists found in the country's geographic scale a measure of their own cultural merit."[9] In the early to mid-1800s, the scenery of the Northeast and in particular New York state, given its accessibility to major metropolitan areas, provided the most promising visual model for the portrayal of collective identity. Artists celebrated the splendors of these areas through the use of panoramic perspective, the juxtaposition of bucolic and sublime elements, and attention to topographic detail.

Increasingly through the century, the country's wilderness and its manifold natural wonders were singled out and celebrated as distinctly American. Durand's "Letters on Landscape Painting: Letter II," which had appeared in *The Crayon* in 1855, called for artists to find their material in the "untrodden wilds" of the country. That same year the journal also ran a series of articles extolling close contact with nature. This excitement for the natural world spurred the publication of mid-century album books concerned with the value of American scenery, among them *The Home Book of the Picturesque* (1852) and *The Scenery of the United States Illustrated* (1855).[10] In the art world, one of the biggest sensations occurred in 1857 when Frederic Church exhibited his new painting *Niagara* (Fig. 26), a view of the falls that focused dramatically on the rush of waters with little reference to the surrounding environment. Commentators at the time hailed it as the spirit of American nature incarnate.

In his panoramic vista, Church placed the viewer at the very edge of the cascading waters, hovering just above the fall rather than looking up at it or down from a bird's eye perspective. Accentuated by the realistic detail of the water as well as the horizontal span of the canvas—seven and half feet in length compared with three and half—the vantage point creates an immediacy, a complete immersion in the drama portrayed. Church, unlike most other painters of Niagara, also positioned the viewer behind the fall, right before the water crashes over the precipice. The perspective emphasizes motion, dynamism, and impending power. In conjunc-

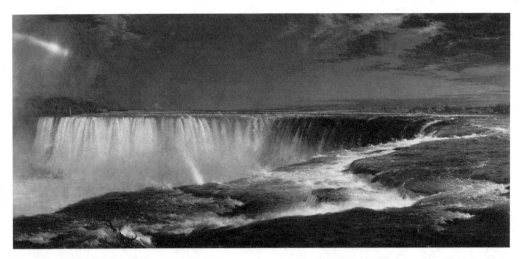

Figure 26. Frederic Edwin Church, *Niagara,* 1857, oil on canvas, 42½ × 90½ in. Corcoran Gallery of Art, Washington, DC, Museum Purchase, Gallery Fund 76.15

tion with the rainbow breaking through the clouds at the left, audiences reassuringly read the scene as a metaphor for the nation's lustrous future. A contemporary writer, for instance, in an essay on American art and its development, described Church's painting as one of the country's finest pictures because it embodied a vibrant American spirit. He went on to link the fall and its depiction to "a true development of the American mind; the result of democracy, of individuality, of the expansion of each, of the liberty allowed to all; of ineradicable and lofty qualities in human nature."[11] In 1860, Frederic Church again won enthusiastic response from critics for his *Twilight in the Wilderness,* an image that delighted in the expanses of pristine woodland. As in his earlier *Niagara,* Church eliminated all reference to human activity, making the wilderness, as the art historian Franklin Kelly has noted, a subject in its own right.[12] Such scenes of nature's wonders and largesse held out the promise of economic, social, and spiritual rewards.

Through the mid-1800s, nationalist-minded painters chose most of their subjects from the landscape of the Northeast. With the continuing push of populations westward and the coming of the Civil War, however, the western territories offered ever more dramatic spectacles of nature and enduring evidence of the country's greatness. Not only were the wonders of the western territories becoming well known through settlement and scientific exploration, but the region geographically as well as politically was more removed from the differences that locked the North and South in bloody confrontation. In the 1860s and 1870s, artists and audiences found in the Far West a new, seemingly purer source for American cultural identity. The region could be imagined as a primordial natural world beyond the limits of human time and human history.

Although Lewis and Clark had followed the Missouri River out to the Pacific in 1804, through the 1820s and 1830s the Far West largely represented a vast uncharted territory. John Charles Frémont's exploration of the Rocky Mountains and Oregon in the early 1840s pro-

duced substantial maps and a well-publicized account of his travels and first helped to give a literal shape to the region. In the following decades, a host of scientific expeditions sponsored by the United States government meticulously gathered all kinds of geological, botanical, and anthropological data. Most survey teams brought along artists and photographers to document visually the peculiar and spectacular features of the landscape. Albert Bierstadt and Thomas Moran, both of whom accompanied such expeditions, excelled in translating for eastern audiences topographical views into western visions.

Bierstadt's and Moran's heroic, large-scale canvases (many were over five feet in length and width), while realistic in detail, imaginatively condensed a variety of actual scenes from nature. Both artists typically painted panoramic sweeps of a terrain that through the effects of color and light was rendered both awesome and majestic. As in Bierstadt's *In the Mountains* (1867) and his well-known *The Rocky Mountains, Lander's Peak* from 1863—a canvas almost six by ten feet—luminous clouds suffuse the lofty peaks in the distance while rays of sunlight brighten the more gently sloping rocky outcrops at the base of the mountains. Framing elements such as a cliff wall or stands of trees work to moderate and contain for viewers the unfamiliar wildness and the vast open spaces represented. Such compositional devices echo the picturesque aesthetics practiced by artists associated with the "Hudson River school." At the same time, in these paintings, the spectacular cloud effects, lurid sunsets, and breathtaking expanses of rock formations dramatized the natural wonders of the West. The extraordinary features of this landscape provided Americans, eager in this period to distinguish themselves from European culture, with examples of distinction. A *New York Herald* article spoke to this pride of place when it asked: "Why should we go to Switzerland to see mountains, or to Iceland to see geysers. . . . The Yo Semite [*sic*], which the nation has made a park, the Rocky mountains and their singular parks, the canyons of the Colorado . . . form a series of attractions possessed by no other nation."[13]

Much of the West's perceived cultural value lay in the geologic antiquity of its mountains and chasms. Seeming to rival Europe's historical monuments, these natural monoliths of ancient time imparted a venerable "history" to the United States and helped make the West in the words of the late nineteenth-century art chronicler Henry Tuckerman an "eminently national" subject.[14] Artists such as Bierstadt and Moran who vividly captured these western scenes for audiences hungry to see, enjoyed great success. Praising Bierstadt's *The Rocky Mountains, Lander's Peak* when it went on view at the New York Sanitary Fair in the spring of 1864, the historian George Bancroft reveled in the primordial antiquity presented before him: "In this noble work, the artist transports us to the almost eternal solitudes of nature: the mountains and river and lake and forest, as they have existed for untold ages; glorying in their unblemished grandeur, rich with the shining of the sun, which is as old as their oldest peak; and at the foot of the mountain, near the transparent water, on the green sward, you see the village of the wild people who, like the mountains, are of unknown antiquity, and like them are basking in the light." For William Cullen Bryant, the region's trees seemed to have so great an age as to date back to the Trojan War.[15] Artists and audiences responded especially to those natural elements—arches, peaks, rock piles—that evoked the more familiar icons of age such as cathedrals, towers, or ruins. Even more so than Bierstadt, Thomas Moran featured in his paintings

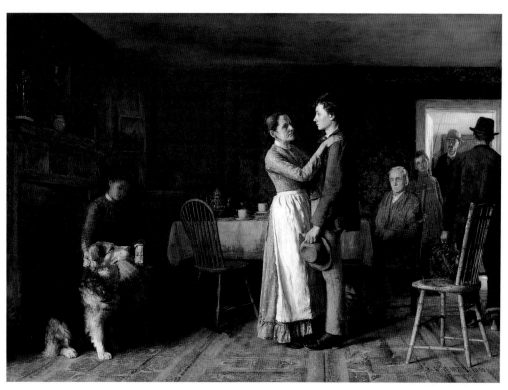

Plate 1. Thomas Hovenden, *Breaking Home Ties*, 1890, oil on canvas, 52 1/8 × 72 1/4 in. Philadelphia Museum of Art, Gift of Ellen Harrison McMichael in memory of C. Emory McMichael, 1942

Plate 2. Julian Alden Weir, *The Laundry, Branchville,* c. 1894, oil on canvas, 30 1/8 × 25 1/4 in. Weir Farm Heritage Trust, Wilton, Connecticut

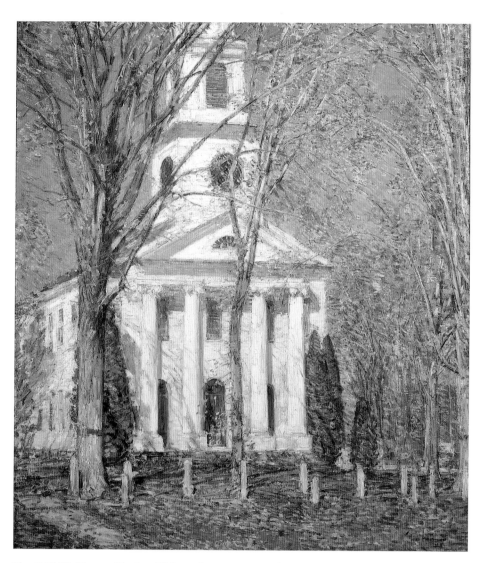

Plate 3. Childe Hassam, *Church at Old Lyme, Connecticut,* 1905, oil on canvas, 36 1/4 × 32 1/4 in.
Albright-Knox Art Gallery, Buffalo, New York, Albert H. Tracy Fund, 1909

Plate 4. Marsden Hartley, *The Last of New England—The Beginning of New Mexico*, 1918/1919, oil on cardboard, 24 × 30 in. Alfred Stieglitz Collection, The Art Institute of Chicago

of Arizona these types of geologic forms, records of millennial time. In *The Chasm of the Colorado*, for example, advancing light plays off the colors of exposed earth as the viewer looks out through the veil of a passing storm onto a vista of megalithic buttes carved by time and water.

Through the national prominence they achieved, Bierstadt and Moran helped to extend western landscape across the country. Bierstadt in particular assiduously promoted his work, seeking out all kinds of venues to display his canvases. Like Church, he exhibited many of his paintings as "Great Pictures," a public exhibition venue that drew on the conventions of the popular moving panorama. Such events featured special advertising, explanatory pamphlets, and tours. Bierstadt's much heralded *The Rocky Mountains, Lander's Peak* not only made the "Great Picture" circuit, but was also exhibited at the fairs held by the United States Sanitary Commission during the Civil War in major cities including Philadelphia, Chicago, and New York. As an added draw for the New York fair, Bierstadt organized a show of performing American Indians (Tuckerman's ancient "wild people") along with an eclectic assortment of Indian objects.[16] To give his work a still wider audience, Bierstadt also had engravings made of many of his paintings. Moran's work, too, reached a large audience through publication in national magazines. His images specifically helped to popularize Yellowstone. In 1871, the editor of *Scribner's Monthly* commissioned illustrations for a feature article on the area, allowing Moran to join the U.S. geological survey team led by Frederick Hayden.

Preoccupation with the western wilderness reached a climax in 1872 with the declaration of Yellowstone as a national park (Yosemite had been under the protection of the state of California since 1864). The act gave the United States government the role of protector and caretaker of the West's resources. Solemnizing that commitment, Congress purchased Thomas Moran's *The Grand Canyon of the Yellowstone*, a grand summation of his field sketches from the previous year. Two years later, Moran's *The Chasm of the Colorado*, painted after his 1873 visit to Arizona, was bought as a pendant piece. Prominently displayed in the Capitol, Moran's huge canvases—approximately seven by twelve feet—transported the world of the West east, metaphorically bringing the two ends of the country together. The enshrinement of both paintings in the political heart of the nation marked the success of the expansionist ideology inherent in Manifest Destiny.

Public appetite for the awe-inspiring wildness of nature shaped landscape aesthetics through much of the nineteenth century, privileging the grand panoramic scene such as those of Frederic Church or Thomas Moran. By the late 1800s, however, the compelling power of large, dramatic canvases and western vistas had waned. Instead, artists and patrons sought out scenes that focused on the less monumental, more restrained side of nature. This shift in aesthetic preference, which could be characterized as a shift from the majestic to the domestic, was accompanied by a geographic shift in the locus of landscape painting from west to east.

Nowhere was this clearer than in the American Fine Arts section of the 1893 World's Columbian Exposition. In place of the panoramic vistas of pristine nature and the heroicizing images of the West, pastoral images abounded, from depictions of gentle rolling hills and wooded glens to farm animals and rustic laborers like those of Eastman Johnson's cranberry pickers. Scenes invoking cycles of nature—a season or a time of day such as twilight or dawn—were especially common. With titles such as "Autumn Day," "End of the Shower," and "Octo-

ber Twilight," such paintings stood out less as portraits of places than as evocations of mood. As the American display underscores, the juries of selection and the Fine Arts Department organizers Halsey Ives and Charles Kurtz favored highly emotive, atmospheric landscapes often rendered in a tonal mode.[17] Celebrated by the art world—and collected by the well-known New Yorker Thomas Clarke—George Inness alone was represented by fifteen landscapes. Other artists working in a similar mode who also showed an unusually large number of works included Dwight Tryon and Alexander Wyant, with fourteen and ten landscapes respectively. One of the other important art displays at the fair, a loan exhibition, "Foreign Masterpieces Owned in the United States," emphasized Barbizon work and included a large number of Millets and Corots.[18]

Throughout the American section of the Fine Arts Department, the intimate held sway over the spectacular, cultivated nature over mountainous wilderness. Aside from two of Moran's Grand Canyon paintings, landscapes highlighting natural wonders and rugged western terrain were almost entirely absent. Bierstadt had declined to submit any works, and while his decision in part resulted from political skirmishes about the New York jury selection process, it also suggests the decline in popularity of his style and subject matter. Already back in the early 1880s Bierstadt's reputation had started faltering; at the Boston auction of Alvin Adams's art collection, his paintings sold for significantly less than they once had, and in the following years, Bierstadt struggled with sales. A big disappointment came in 1889 when the American jury for the Paris Exposition rejected the one work he had submitted, *The Last of the Buffalo,* reputedly because it was "too big."[19] By the time of his death in 1902, Bierstadt had fallen into relative obscurity. Moran continued to exhibit work, but in addition to western scenery, he also had started painting an increasing number of pastoral landscapes, woodland scenes of Montauk and East Hampton, Long Island. In 1884, after several summer trips to the area, he established a studio and a home and increasingly painted there.

Alternatives to a wilderness aesthetic expressed through grand, panoramic scenes of natural wonders had already started to appear in the works of various mid-century artists, among them John Kensett, Sanford Gifford, and Martin Johnson Heade. Characterized by what Angela Miller has called the domestication of the sublime, their paintings focused on the quieter, more subdued side of nature, and their canvases correspondingly tended to be smaller with their subject matter less grandiose. They also placed greater emphasis on the space between forms than on the external elements of nature characteristic of Church and others; the attention to light and atmosphere, for example, led one reviewer to describe Gifford's landscapes as attempts to paint the color of air.[20]

Through the 1880s, the artworks of a succeeding generation of landscapists—George Inness, William Morris Hunt, Alexander Wyant, and Homer Dodge Martin among others—increasingly portrayed intimate views of rural landscapes, often gently touched by human activity. Scenes of pastures, farms, and meadows that emphasized subtle moments in nature such as early morning light and lingering mists after rain, as opposed to cataclysmic events, characterized their work. Writing for *Harper's Magazine* in 1878, George Inness voiced this alternative landscape aesthetic when he declared that the civilized landscape is "more worthy of reproduction than that which is savage and untamed."[21] Like Inness, Hunt and Martin eschewed a strict

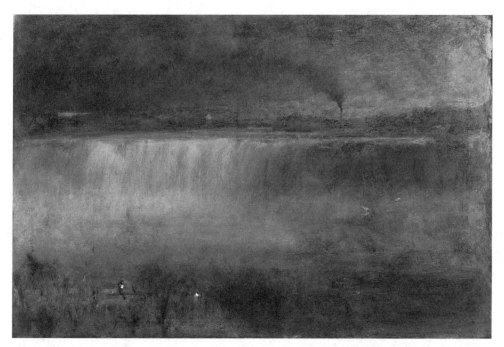

Figure 27. George Inness, *Niagara,* 1889, oil on canvas, 29⅞ × 45 in. Smithsonian American Art Museum, Gift of William T. Evans

transcription of the landscape, emphasizing instead an emotive over an analytic approach. They reveled in the effects of light and shade on form as well as the harmonious combinations of color. Bathed in veils of atmosphere, their late works especially have a diaphanous, translucent quality to them.

Rather than creating a pictorial experience of nature through confrontation with its awe-inspiring effects as Cole, Church, or Bierstadt had typically done, these artists worked to immerse the viewer in the poetic qualities of the landscape. The comparison of Church's *Niagara* with George Inness's renditions, especially those of 1885 and 1889, epitomizes the shift in attitude (Fig. 27). Inness downplayed the spectacular descent and raw power of the falls by flattening depth to focus instead on the screen of vapor and mist generated by the water and the prism of colors reflected there. Where Church had all but eliminated reference to human activity, Inness introduced grassy shores, figures, and signs of industry. Where Church attempted a literal transcription, obscuring the hand of the artist, Inness exploited the surface of the canvas. In its built-up layers of paint and expressive marks of his brush, the painting registered Inness's own personal impression and response to the falls.

The subject matter and bearing toward nature of paintings like those of Inness's resembled the quiet, pastoral images of French Barbizon artists such as Jean-François Millet, Théodore Rousseau, and Charles Daubigny. Exposure to this style of French painting had come about in

the 1850s as American artists ventured abroad; Inness visited the Fontainebleau area briefly, while Hunt had gone to study with Millet. As their subsequent work suggests, both Hunt and Inness found the idea of an artistic communion with nature appealing and once back in the United States had encouraged its pursuit. Hunt not only started teaching Barbizon methods in Boston but also promoted the work of Barbizon artists among collectors and dealers. By the end of the nineteenth century, American "nature-poets," as the art critic Charles Caffin referred to them, had garnered broad acclaim from reviewers and patrons. Caffin especially, in his 1907 account of American painting, celebrated the spiritual achievements of this new generation of landscapists, taking to task artists such as Bierstadt, whose paintings in his opinion marked an emotional distance from nature. While Bierstadt (and similarly Moran) gave viewers, according to Caffin, "a sense of nature's impressiveness," their images did not "conclusively impress." Because of the absence of the painter's own emotions toward the scene, their paintings, Caffin determined, fell short: "We are conscious of no condition of feeling but one of purely intellectual comprehension; we are pretty well assured what the scene looks like, but not what it feels like. It is almost exclusively a view."[22] These reviewers eschewed a scientific, topographic approach to the natural world, privileging instead the expression of a personal, individual relationship.

By the 1880s and 1890s, the work of Inness, Tryon, and Martin visualized as well as promoted a reorientation toward seeing nature less as an embodiment of the sublime and a statement of divine will than as a place for immersion in the natural order. Inspired in part by French practice, American landscapists increasingly moved their studios outdoors, one means of allying the act of painting with the cycles and rhythms of the natural world. Given its focus on capturing transitional or ephemeral moments, *plein-air* painting also implied an openness to commonplace scenes; the object of sight mattered less than the emotions it stirred. The artist Birge Harrison characterized this artistic aim as "true vision," the ability to grasp an "*essential beauty.*" In his early twentieth-century book on landscape painting, a compilation of essays he both delivered and published over the course of several years, he described landscapes as having a soul as well as a body. The physical earth, its fields, rocks, rivers, and seas constituted the latter, while one found the soul more in the atmospheric effects of nature and in the play of light. Painting physical features alone made for a fine craftsman, but the true artist, Harrison wrote, "is he who paints the beautiful body informed and irradiated by the still more lovely and fascinating spirit—he who renders the *mood.*"[23] If Moran and Bierstadt had concentrated on transcribing the splendor of geologic forms, Harrison and his fellow artists sought access to nature's less visible powers. Through a more intimate, personal approach to the natural world, the artist sought to catch, as Charles Caffin phrased it, "a whisper from the universal."[24] Even Winslow Homer's dynamic paintings of the Maine coast from the 1890s and the early 1900s partake of this interest in a close communion with nature. More invigorating than spectacular, his close-up scenes of rocks and breaking waves situate a viewer near the water's edge, inside the forces of nature rather than looking on from a distance. For Caffin, Homer's ocean paintings in fact closely compared to those of the landscapists he admired; they too breathed that spirit of the universal and, in Caffin's opinion, showed "traces of the Barbizon influence."[25]

The desire to engage with nature, evoke a mood or a spiritual essence, motivated landscape

artists through the turn of the century. Although specific painting techniques distinguished, for example, Tonalists from Impressionists—from Henry Ward Ranger to John Twachtman or Julian Alden Weir—the search in general for a reflective, familiar relationship with the natural world conditioned a landscape aesthetic. Increasingly, artists, patrons, and critics sought access to nature's more contemplative sites. As suggested by the display of American art at the Chicago World's Fair, depictions of western wilderness were increasingly devalued, and instead bucolic eastern scenery, and particularly that of the New England countryside, became a source of inspiration, a type of locale appreciated over others. The very grandiosity of landscape settings such as those of Yellowstone and Niagara that had so inspired nationalist viewers earlier in the century appalled certain artists and writers by 1900. Typical of the new reaction among landscape painters against the awesome and monumental was Theodore Robinson's sharp disapproval in 1896 of his friend John Twachtman's Yellowstone Park paintings: early in his career, on a trip out west, the Connecticut painter had experimented with a number of canvases of western landscape scenes.

Critics were equally vocal in their distaste for the grand. Like Robinson, John Van Dyke, an art critic and educator, and the popular naturalist John Burroughs favored the restrained and humble landscape. In his *Nature for Its Own Sake,* a book of essays on various landscape elements including sky, water, and foliage first published in 1898, Van Dyke disdained the grandiose and sublime. In his chapter on water, for example, he extolled the modest waterway, exemplified in his opinion by the little waterfall or the New England brook. The transformation to anything bigger such as a cataract not only lost all charm for him but also registered as an affront to his senses. His description of dramatic cascades is filled with loathing and condemnation. The waterways of the West such as those of Yellowstone and Yosemite, for example, conjure only images of violence. Rather than a grand descent, Van Dyke envisioned their waters as "blown out" and "shattered." Niagara particularly struck him as disastrous, and he referred to it as "a great horror of nature like a lava-stream pouring into the sea, or a volcanic explosion like that of Krakatoa. Grand it is in its mass, and sometimes beautiful in the coloring of the rising spray shot with sunlight; but its chief impression is one of power unrestrained and catastrophe unavoidable. It is nothing less than nature committing suicide."[26] For Van Dyke, such spectacles of nature and the unleashing of raw force appeared a breakdown of order, an example of uncivilized events.

Van Dyke's way of seeing, his aversion to the grandiose and "unrestrained," echoed in the writings of John Burroughs who, though based in the Catskills, traveled widely. *Far and Near,* a book he published in 1904, described his journey by train to Alaska in 1899 and cast in sharp relief distinctions between rural and untamed landscapes, associated in his writing with eastern and western scenery. Even as he marveled at the wonders of the Rocky Mountains, the plains, and the desert, Burroughs, like Van Dyke, embraced the contained and modest landscape. As children like to sit on their parents' laps, so too, he wrote, do "we love the lap of mother earth, some secluded nook, some cosy corner, where we can nestle and feel the sheltering arm of the near horizon about us."[27] In the first chapter of *Far and Near,* he repeatedly juxtaposed images of the wild against the settled, the unformed against the mature.

Burroughs recoiled from the open and untamed expanses of western terrain. In an almost

complete turn-around from a previous generation's perception of the Rocky Mountain region as representative of great antiquity, he was struck by what he saw as the "youthfulness" of large sections of the Far West, youthfulness in his mind associated with the unseasoned and intemperate. The plains, which reminded him of the faces of beardless boys in their lack of trees and forests, contributed to this impression, and so too did the miles of eroded earth, especially in Wyoming. They gave the landscape a sense not just of youthfulness but of newness, making it in Burrough's eyes, "raw, turbulent, forbidding, almost chaotic. The landscape suggests the dumping-ground of creation, where all the refuse has been gathered." The entire terrain seemed to him transitory. He described the area's mountain ranges as "newly piled earth . . . carved by the elements, as if in yesterday's rainfall." Coming upon the Bad Lands of Utah, Burroughs explicitly linked the newness with violence. Clearly overcome by the vista before him, he perceived the earth as being "flayed alive," "vivisected, anatomized, gashed,—the cuts all fresh, the hills looking as new and red as butcher's meat, the strata almost bleeding." Against this depiction of turbulence and savagery, Burroughs immediately conjured up an image of eastern scenery, a respite from the raw western landscape: "How *staid and settled and old* Nature looks in the Atlantic states, with her clear streams, her rounded hills, her forests, her lichen-covered rocks, her neutral tints, in contrast with large sections of the Rocky Mountain region."[28] It was precisely the quiescent, tempered quality of the landscape that Burroughs admired. In his esteem for eastern over western landscapes, he recalls Charles Eliot Norton and the distinctions he drew between the two halves of the country. In contrast to a riotous West characterized by the "unrestraint of expression," Norton had pictured an orderly, refined, and experienced East.

The appealing landscape, as writers such as Van Dyke and Burroughs implied, embodied a sense of tempered history; peaks smoothed out by the processes of time, rocks old and worn down enough to sustain vegetation. Nature in the East, however rough, rugged, and invigorating, could be distinguished by these markers of slow, steadying forces. It was the mature, composed, and orderly settings of nature and not the vast stretches of raw, unstructured wilderness that anchored a turn-of-the-century landscape aesthetic. Van Dyke alluded to this again in his discussion of lower mountain ranges, which in their horizontal and rolling lines he judged far more pleasing than the "jagged, saw-like effect" of high peaks with their sharp diagonal and perpendicular lines. "How very beautiful these [the lower mountain ranges] are in their undulation, as they join ridge upon ridge in rhythmical sequence! They twine and intertwine, curve and intercurve . . . along the sky and through the valley, until the whole fabric of the hills seems like a precious decorative pattern of green and purple embroidered on a blue-gray ground."[29] Increasingly into the early twentieth century, eastern audiences and critics responded to the small over the expansive, the intimate over the panoramic, the cultivated over the wild, all of which could be summed up by the term "countryside" with its implied proximity to human habitation and settlement. Wooded glens, birch stands, bubbling brooks, meadows and pastures accordingly constituted a repertory of landscape motifs. In these perceived expressions of beauty and harmony, the countryside offered a sense of repose and serenity.

The Restorative Countryside and Its Cultural Context

Turn-of-the-century perspectives on the relationship of urban and rural environments offer a context in which to understand the appeal of artists who focused on the New England countryside and the landscapes they painted. The works of John Twachtman and Julian Alden Weir, and later those of Childe Hassam and Willard Metcalf, grew out of a specific reorientation to the natural world that increasingly identified the countryside as a place of refuge, ultimately a sacred preserve of social (interpreted as Anglo-Saxon) values. With large percentages of the population concentrated in industrial and commercial centers, the countryside was perceived as a spiritual haven, away from the crass materialism and the stress of city living.

In 1896, Hamilton Wright Mabie, a literary editor and cultural critic, published *Essays on Nature and Culture.* Representative of its time, it argued that the release of the human spirit came about through contact with the generative and harmonious forces of nature. Stepping into the flow of nature's order restored the balance and vitality strained by daily urban life. As Mabie wrote: "To the mind fatigued by constant and rapid readjustments to different subjects and to diverse tasks, the quiet and seclusion of the woods are like a healing balm."[30] Mabie's contrasting worlds speak to the recurring opposition of country and city, with the former conceived as an antidote to the latter.

Like other cultural commentators of the period, Mabie feared the effects of urbanization on the physical as well as moral health of the country's citizens. Already by the 1850s, cities had become associated with social disorder, vice, and corruption, an image that was only enhanced in the decades after the Civil War with the increase in labor conflicts, the influx of immigrant groups, and the growing congestion of urban environments. In 1869, the New York physician George Beard addressed the psychological toll of city life when he coined the term "neurasthenia" to describe a host of nervous conditions afflicting upper-class urban inhabitants. Concerns about the ill effects of modern industrial society—from its materialism to its sedentariness and dissipation—intensified through the turn of the century. Theodore Roosevelt, among others, championed strenuous recreation, specifically physical exercise and athletics, as well as simple living, as an antidote to the demands of city life.[31] Urban reformers and educators also stressed the importance of cultivating peace and serenity through intimate connection with the elements and cycles of the natural world. The types of therapeutic activities they advocated included building country homes, gardening, and excursions to the country and to the farm. One magazine featured, for example, an article written by the chief chemist of the U.S. Department of Agriculture entitled "Plow and Pitchfork versus Pills and Powders." In it, the author prescribed a dose of rigorous country life for "that man who has broken down altogether under the strain of city work, and for whom dyspepsia, neurasthenia, or kindred ills have made life no longer worth living." The caption under the accompanying photograph of a man plowing a field read: "The actual work of the farm is what the tired city worker needs, not loafing on a hotel piazza."[32] While the city provided wealth and material comforts, country supporters envisioned rural nature as food for the spirit.

The so-called back-to-nature phenomenon originated in the East and was nurtured particularly by eastern intellectuals and urban reformers, but its widespread discussion in the press

and in books gave it national exposure. Readers encountered a flurry of publications. *Outlook* magazine in 1903 commented on the proliferation of volumes on flowers, trees, birds, and animals and on nature in general. Writers such as Mary Crawford, Clifton Johnson, Wallace Nutting, and E. P. Powell published their numerous guides and narratives about walks on country roads and village life, especially of the Northeast. In 1901, Doubleday, Page and Company began publishing the periodical *Country Life in America.* In the belief that "nature-love" was of general interest and associated with things that were "clean and true," the magazine devoted itself to discussing all aspects of country living from horticultural and breeding instruction to homebuilding to the pleasures of communing with nature. Other new journals to treat these subjects included *The Craftsman,* an illustrated monthly magazine for the "simplification" of life, in 1901 and *Rural Manhood* in 1910, while established journals such as the *Atlantic Monthly, Ladies Home Journal,* and *The Nation* ran countless articles on the healing powers of the outdoors.[33] The reading public took their enthusiasm to the road as well. Tourism boomed as coastal towns and country villages capitalized on the urban dweller's search for accessible nature and respite from the heat and intensity of city life. By the turn of the century, new train links and the automobile had opened up the rural valleys and waterways of the Northeast and especially New England. Despite their difference in style and subject matter, Homer's scenes of the rocky shores of Prout's Neck, Maine, and countryside landscapes like those of John Twachtman and Julian Alden Weir encapsulated this attitude toward the land as therapeutic, and critics enthusiastically responded to what they found refreshing, restorative, and soothing works of art.[34]

The emphasis on country experiences and the importance of rural areas to the health of urban dwellers precipitated concern about the quality of rural life itself. The so-called Country Life movement targeted actual farming communities across the country with the aim to invigorate agricultural development. Led largely by urban educators and reformers, the movement promulgated the Jeffersonian ideal of the yeoman farmer as the backbone of democratic society. Describing farming as "full of interest, responsive to intelligence and skill, building health, manhood, and independence," N. O. Nelson, author of the foreword to Edward P. Powell's *How to Live in the Country,* underscored the power of the farmer image when he commented: "We know from history that a country's yeomanry is its strength and the city rabble its destruction."[35] For Liberty Hyde Bailey, the well-known spokesman of the Country Life movement, the increasing dominance of cities and the end of readily fertile land to move onto made the revitalization of farm life all the more urgent. Official recognition came in 1908 when President Theodore Roosevelt appointed the Commission on Country Life to take stock of farmers' conditions and promote rural progress.

In both the Country Life and Back-to-Nature movements, the countryside was repeatedly invoked as the bulwark against the perceived evils of the city such as unbridled materialism and political corruption. By the late nineteenth century, urban centers also readily brought to mind southern and eastern European immigrant groups whose large numbers and alien customs made them seem unassimilable. For country life proponents such as Bailey and Roosevelt, strong rural communities ensured the health and stability of the nation. As Bailey commented, "In the accelerating mobility of our civilization it is increasingly important that we have many anchoring places; and these anchoring places are the farms."[36] A strong nation,

from the perspective of Roosevelt, Bailey, and others, literally grew out of the soil, an idea visualized, for example, in Thomas Hovenden's *Breaking Home Ties*. Although America depended on the city for energy and enterprise, a robust countryside safeguarded the proper cultivation of moral values and strength of character. Without the spiritual vitality supplied by rural populations, urban centers would deteriorate.

Particularly in the 1890s, social commentators such as Josiah Strong, citing the views of sociologists, contended that city populations could not sustain themselves without replenishment from country sources. In discussing this delicately balanced relationship between the country and the city, an article in *The Craftsman* addressed the subject of rural decline. Holding up New England as a warning, the author commented: "We have drawn too heavily upon the fundamental sources of our power, and we have not paused to replenish. We have bred too close, letting the human stock from which our best have come stagnate a little through lack of the stimulating ozone of outside intercourse, new blood, and fresh ideas and interests." The concern over New England's supposed decline or its decadence went beyond economics; it involved the region's rural moral health and its implications for the future prosperity of the nation.[37]

Beginning in the 1880s and 1890s, the popular press ran stories describing visitors' travels, particularly in New England, through a countryside dotted with deserted homes. The so-called abandoned farm phenomenon affected many of the older agricultural sections of the country including New York, Pennsylvania, and Ohio. But it was the neglected fields and unoccupied farmhouses in New England that attracted the most attention and the most hand-wringing. The *Saturday Review* in London, citing the concern in the American press about the fate of rural New England, commented: "If the State of Indiana were to develop some grave and unforeseen defect, and half of its people were to deport themselves into Colorado, no one would very much care except the remnant who were compelled to cling to the sinking ship. But the desertion of the old homesteads of New England appeals most strongly to the sentiment of all Eastern Americans, and an American upon a topic of this kind is the most sentimental of living men."[38] The possible imperilment of the yeoman farmer ideal in one of the oldest inhabited regions of the country caused alarm because of what it portended not only for other sections of the United States but also for the development of American character.

A flood of articles poured forth on the status of rural New England, ranging from grim emotional predictions of the future to considered examinations of the state of the region's agriculture, its difficulties and potential remedies. While rarely as dire as their titles suggested, a steady stream of warnings such as "The Doom of the Small Town," "Broken Shadows on the New England Farm," "What Ails New England?" and "The Decadence of New England" tended to give the impression that large parts of the region were besieged and in danger of collapse.[39] Concerns about the agricultural viability of the soil overlapped with fears about its transformation into an alien land.

New England's rural communities were perceived as bastions of a "native" population defined as Anglo-Saxon and Protestant. By the 1880s, large numbers of immigrants had moved not only into the cities but into the region's countryside as well. Predominantly Catholic and often southern European, groups of Italians, French-Canadians, Irish, and Poles settled on small

farms. Their arrival signaled to some, such as Francis A. Walker, president of the Massachusetts Institute of Technology, and Harvard professor of geology Nathaniel Shaler, a displacement of the native stock by what Shaler identified as a servile, alien folk and the inevitable corruption of democratic principles and social order. As another writer exclaimed, "We have allowed aliens to come in and steal our birthright."[40] Others took a less apocalyptic position on foreign residents, more troubled by what they saw as the problems in rural decline including the isolation of country villages, protective tariffs, inbreeding, and the drain of the bright and ambitious to the cities.

Indeed, there was a kernel of truth to the claims about fundamental changes in the region. Many rural areas, especially the hill-country of the north, had to face severe population shifts and economic hard times; not only were large numbers of immigrants moving into the countryside, particularly in Connecticut and Massachusetts, but the development of large-scale industry in the cities and the lure of employment opportunities outside of the region promoted heavy out-migration among the native-born to urban centers and to the West and forced changes in farming practices. Nonetheless, small towns and villages appeared to have adjusted. Recent studies actually suggest the relative ease of assimilation and the overall stability of the agricultural economy at the time and in many cases the increased prosperity among farmers who adapted to new technology and to new types of practices such as dairying.[41] Even many journalists at the time expressed cautious optimism, dismissing claims of agricultural decline as exaggerated and focusing instead on positive signs of the regeneration of country villages. The reputed degradation or potential health of the region, however, is less relevant here than what the profusion of articles demonstrates about the power of the countryside in the cultural imagination.

Rural New England and Calls to Home

Rural New England at the turn of the century with its meadows and brooks and its picturesque markers of steady habitation held out spiritual and social rewards. Among regional boosters and back-to-nature enthusiasts, empty farmhouses in particular represented golden opportunities; not only could they offer urban dwellers transformative rural experiences, they could bring economic and commercial benefits and thus help to maintain country life. The magazine *Country Life in America* published multiple articles celebrating the successes of new farmers and offering models and practical advice for the return to the countryside. Part of a larger series on how to make a living from the land, an article entitled "Going Back to the Old Farm: the story of a college professor who could not resist the charm of his boyhood home—how he is reclaiming a New England farm and winning a living from the soil which his ancestors tilled" typified a genre of urban farmer stories that repeatedly stressed the superiority of New England farms over those in the West. Eager to participate in the country home and urban farmer market, many of the New England state boards of agriculture published pamphlets advertising unoccupied houses and their sale at low rates.[42]

The promotion of New England and its countryside found institutional expression in the

so-called Old Home Week celebrations. Within five years of their introduction in New Hampshire in 1899, all of the New England states had organized them. The brainchild of Governor Frank Rollins of New Hampshire, they were ostensibly designed to increase interest in the state by encouraging visitors to the hosting town. Local associations compiled lists of former residents and then sent out invitations. The multi-day event included speeches, compilations of town histories, and displays that highlighted attractions of the area. Organizers arranged parades featuring a town's oldest members as well as marked historic sites, old buildings, and the birthplaces of prominent men and women. State politicians and municipal governments welcomed the celebrations as economic opportunities and infusions of resources into struggling towns. Governor Rollins commented in one of his addresses that "it is our intention to make our state so attractive that you will all be glad to return to it permanently instead of as summer guests."[43]

The program of Old Home Week, however, tapped into a complex set of sentiments and purposes. While most contemporary commentators stressed the practical benefits of Old Home Week, many also reflected on its role in generating a collective spirit. Responding to concerns about the moral and social decline of country communities, the celebrations worked to stimulate local civic pride by venerating the town's heritage, from the heroic actions of early colonists to more recent agricultural and social achievements. As one writer noted, that was important for two groups of citizens. Not only did the festivities remind sixth-generation local residents, for example, of their hardy and honorable roots, it also demonstrated to newer arrivals (foreign immigrants) what roots they should appreciate. Intended for those both inside and outside of New England, Old Home Week commemorated shared memories and a common past. The young age of the country made historical sites and past patriotic events that much more precious as one writer, Herbert Gleason, implied when he found it impossible to imagine Pittsburgh or Chicago celebrating an Old Home Week. For Gleason, only the region of New England possessed enough of a genuine history to be of national value. The problem, he argued, was that "outside of these [Bunker Hill, Faneuil Hall, and Plymouth Rock] and a few other memorials of ancient days and heroes, how little we really have, in comparison with old world countries, to serve as rallying centres for our higher sentiments! We are absolutely devoid of folk-music, that flower of national spirit which in turn is one of its strongest cementing ties; and our myth-maker is Mother Goose!"[44] The program of Old Home Week sought to build patriotic "rallying centres" and invoke a sense of history through an appeal to personal pasts.

Attempting to inspire interest in history and the past, advertisements for Old Home Week events cultivated the sentiments of childhood and home. Calls to come home to mother and images of little red school houses and oaken buckets became standard motifs, as the historian Dona Brown has pointed out.[45] A new and immediately popular literary form, Old Home Week verse such as the following tugged on similar heart strings:

> Bring from the garden the corn and the beans,
> Let old songs be sung while the succotash steams,
> Let Sally and Patience be shelling the peas

> While John gathers fruit from the bountiful trees.
> Sing the old songs that we sang long ago—
> 'Wait for the Wagon' and 'Old Uncle Joe'
> 'O, that will be Joyful,' 'Coming Thro' the Rye,'
> 'Hurrah for Old New England,' 'When the Swallows Homeward Fly.'[46]

In capitalizing on the notion of family bonds to draw those outside of the region back, Old Home Week dramatized the idea of a homeland or, as Gleason put it, the "fatherland instinct." Like the Pledge of Allegiance, though on a significantly smaller scale, it attempted to ground an abstract ideal of nationalism in a concrete, local experience. Asserting filial ties over the space of the country, Old Home Week promoted New England as the heart of the national body, the home to everyone.

Robinson, Twachtman, and Weir and the Importance of Place

The call to home, to the familial landscape, found a strong visual counterpart in the work of Robinson, Twachtman, and Weir. For these artists, the New England countryside offered a special sense of belonging, and they located their physical and aesthetic homes among its pastures and woods. Not only had a network of train routes opened up wide sections of the region but the qualities of the landscape itself also held special interest. Henry Ward Ranger, a Barbizon-influenced artist who in 1900 gathered together a community of artists in Old Lyme, Connecticut, commented that he had been drawn to the area because it bore the marks of both human cultivation and undisturbed nature.[47] New England's history-laden yet rustic settings spawned numerous art colonies that, despite variations in painting techniques and styles, all celebrated the rural landscape. Quiet seaside towns such as Cos Cob, Connecticut, and Gloucester, Massachusetts, which preserved remnants of pre-industrial activities, proved particularly appealing as did bucolic woodland sites, among them Old Lyme; Ogunquit, Maine; Cornish, New Hampshire; and East Hampton, New York, just south of Connecticut across the Long Island Sound.

In their emphasis on intimate pastoral scenes, Robinson, Twachtman, and Weir expressed visually the late nineteenth- and early twentieth-century preoccupation with immersion in the natural world. Reviewers came to appreciate their landscapes precisely for this quality, finding in both the subject matter and the impressionist mode a sense of immediacy and connection. Eager to demonstrate the evocative power of one of Weir's orchard pictures, a critic appealed to his readers' sense not only of sight but of smell and sound as well: "You can smell the blossoms. You can scent spring in that dominant note of exquisite green. It is Mr. Weir bursting into pictorial melody after his first day back on the farm after a winter in New York." Critics had also likened Twachtman's landscapes to musical interludes and spoke of his work as an "emanation of Nature's spirit," one that soothed the soul.[48] Compositionally, their works followed the lead of Barbizon-inspired artists such as William Morris Hunt, George Inness, and Homer Dodge Martin in focusing on the intimate, the personal, and the poetic dimensions of

the landscape rather than the panoramic and dramatic. In their ability to evocatively transport the countryside to the canvas, Twachtman and Weir not only offered viewers a serene and embracing nature but also posited New England as its vital source

Of the three artists, only Robinson recorded his thoughts on paper. More than his few surviving paintings from the last year of his life, his diaries articulate the attachment to the land he felt. His comments and perceptions also provide a context for reading the work of Twachtman and Weir, both of whom were far less vocal about their interests. In contrast to Robinson, their large bodies of work provide a better sense of their attitudes toward nature and the New England countryside. Together, the art and the biographies of these three artists allow one to trace the development and expression of the spirit of place at the turn of the century.

Theodore Robinson discovered the potential for New England's landscape only after a number of years studying and teaching abroad and in New York. Although he had been born in Vermont, Robinson's family moved to Wisconsin when he was three. He had first studied art in Chicago before attending the National Academy of Design in New York City, and then, like many in his generation, he had left for Paris for more academic training, working in the ateliers of Carolus-Duran and Gérome. His second extended visit to France—after several years employed as a decorative artist in New York and Boston—exposed him to a range of landscape styles including Impressionism. For about three summers starting in 1884, he painted at Barbizon, and then in 1887, along with several other painters, more or less stumbled upon Giverny. Over the next five years, he returned for months at a time and formed a close friendship with Claude Monet. In an 1892 article for the well-known American publication *Century Magazine,* Robinson expressed his enthusiasm for Monet's work and the impressionist approach to nature through light and color. He also argued for the important influence of Monet on the future of landscape art, concluding that "the coming landscape-men [will] use the impressionist discoveries of vibration and the possibilities of pure color, and, while careful to 'hold fast that which is good,' will go on to new and delightful achievements."[49]

A desire to help bring about those new achievements at home may have inspired Robinson's permanent return to the United States in December 1892. His journal entries stress the need to convey the impressionist aesthetic in an American idiom, to create in Robinson's words "a native American art." Robinson reports in his diary that Harrison Morris, the managing director of the Pennsylvania Academy of the Fine Arts, encouraged him, commenting that the artist would do "an immense service by sticking to this leading idea." With this in mind, the two had talked about Robinson putting together a display of "virile American pictures."[50] In 1895 when Robinson recorded this exchange, he had just started painting Vermont, that "native" landscape for which he had been searching. In an interview with the author and critic Hamlin Garland shortly before a fatal bout with asthma, Robinson declared that finally he had begun to paint "subjects that touch me." All of his earlier work in retrospect seemed to him "cold and formal" compared to what he was currently trying to do, "express the love I have for the scenes of my native town." Robinson seemed to have taken to heart Garland's encouragement of American painters to find subject matter they truly cared about.[51] In rural New England, Robinson believed he had found not only a connection to familial roots but also the source for a national landscape art.

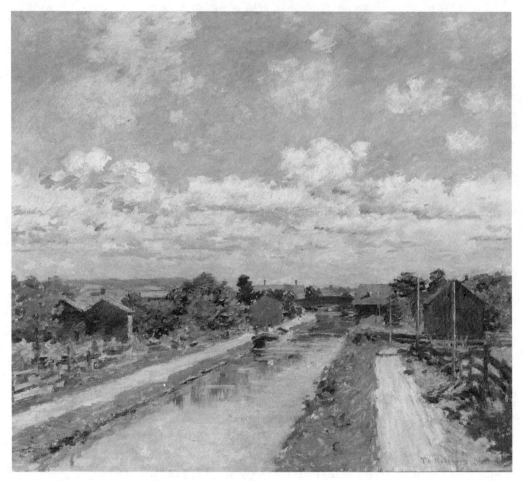

Figure 28. Theodore Robinson, *Port Ben, Delaware and Hudson Canal*, 1893, oil on canvas, 28¼ × 32¼ in. Courtesy of the Pennsylvania Academy of the Fine Arts, Philadelphia. Gift of the Society of American Artists as a memorial to Theodore Robinson

Although Robinson had regularly been painting images of countrysides, up until the last year of his life he had moved restlessly through a variety of northeastern locales. In 1893 he spent the summer teaching and painting in Napanoch, New York, on the Delaware and Hudson Canal. Extending his stay through the fall, he concentrated on the more scenic views of the waterway. Rather than depicting laborers or the activity of the barges, he favored scenes of the canal itself and the surrounding landscape. Robinson's *Port Ben, Delaware and Hudson Canal* of 1893 (Fig. 28), later purchased by the Pennsylvania Academy is, for example, as much a study of sky and clouds as a view of the terrain below—the canal, the towpaths, and the fences and houses that line the water's edge.

Another painting, *The Lock* (1893), provides a close-up view of the water rising in the wooden bay. As Robinson records in his journal, he endeavored to isolate concrete motifs of the landscape before him. When he finally left Napanoch, he regretted not painting more of

the box-shaped houses near the canal because they were typical of the area, regardless of how "ugly" they might have appeared to some. Robinson repeatedly urged himself to uncover the flavor of local landscapes, to capture distinctly American material. He wrote of the importance of emancipation from "old formulae and ideas of what is interesting or beautiful from the European standpoint." His canal scenes seemed to him a step in the right direction, but that fall he considered his attempts to capture the local spirit of the land unsuccessful.[52]

The following summer his search for new painting ground brought him to Cos Cob, Connecticut, close to the homes of John Twachtman and Julian Alden Weir. The landscape there strongly appealed to him, and he was drawn especially to the shoreline; his canvases from this period offer intimate views of small moored boats and stretches of harbor. Their quality was not lost on reviewers, who found much to admire in them. A brief trip by train to western Connecticut near Danbury and New Milford earlier in the year had exposed Robinson to some of the region's potential. He noted at the time that it was a "very fine country, almost mountainous—a great deal of character." That summer, and later in the fall, he also made a couple of trips to New Jersey, but it appealed to him far less. Although he found what he called characteristically American motifs—fences, church spires, and frame houses—they did not fully engage his attention.[53]

It was in the spring of 1895 that Robinson finally found a countryside with which he could emotionally and aesthetically identify. He made an exploratory trip to the village of Townshend in Windham County, Vermont, in April, and by May relatives of his mother welcomed him for the summer, providing household help and company. Like western Connecticut, the Vermont landscape immediately affected him. He appreciated the atmospheric effects of the early mornings with their play of light and color. He was struck not only by the area's quiet beauty and serenity but also by the ruggedness of the region and its inhabitants, and he entered in his journal: "Altogether a tough race and hard working to settle such a country and make a living and fortunes." Excited by the number of "fine motifs" he was finding and the idea of putting together a show of Windham County landscapes, Robinson planned to return that winter and the following summer to continue painting.[54]

His enthusiasm sparked, he threw himself into New England subject matter, not only plotting new canvases but collecting guidebooks, literature, and histories of the area from friends and on his own. In his diary, Robinson notes that August Jaccaci, the art editor of *Scribner's Magazine,* supplied him with a volume entitled "New England Roads," as well as sending an inquiring letter about what his friend meant by "getting all this New England literature—'stuff.'"[55] Of particular interest to Robinson was Harriet Beecher Stowe's *Oldtown Folks* (1869), a novel that celebrated the culture and spirit of post-Revolutionary New England, and to which Robinson favorably compared his own experience of rural Vermont. The artist's full-blown excitement about the region prompted his friend Jaccaci to declare, as Robinson records in his diary, that he had clearly found a place in America that moved him and quipped that he was "the right age for atavism to make itself manifest."[56]

Given his midwestern upbringing, Robinson, in reality, could claim Vermont as his "native" country only because his parents and some of their ancestors had lived there. Yet whether real or imagined, these familial ties helped to secure an attachment to place. Part of his fascination

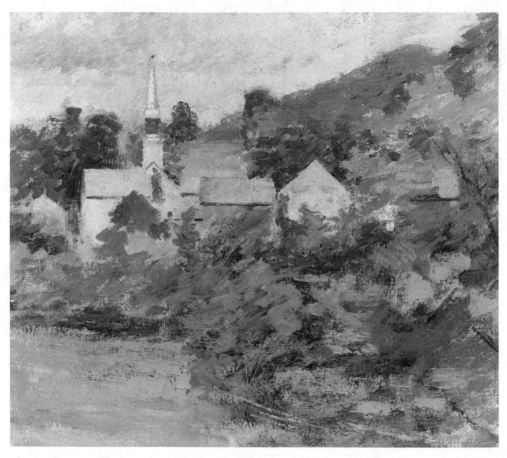

Figure 29. Theodore Robinson, *A Townshend Church,* 1895, oil on canvas, 13½ × 16 in. Private Collection. Courtesy Baltimore Museum of Art

with New England stemmed precisely from its history and its long record of Anglo-American settlement. In the few finished paintings from this final period in his life, Robinson emphasized these features of the area. The village of Townshend, nestled in the hills with several church spires piercing the treeline, for example, and the local river that he fancied as a man-made canal especially struck him. In *A Townshend Church* (1895) the white facade and steeple of a church stand out from the whirl of foliage that reaches straight to the edge of the canvas, creating a sense of immediacy and intimacy (Fig. 29). A large canvas entitled *West River Valley Vermont* (1895) depicts a scene of habitation; the two prominent hills that extend across the background of the canvas thrust attention on both the houses dotting the valley and the winding road that runs through the foreground.

For Robinson, features of the New England landscape seemed particularly iconic and emblematic of the region's—if not the country's—culture and history. He was particularly drawn to New England's barns. While in Vermont he glowingly wrote of them: "We should paint them as in the Old World one paints cathedrals or castles. Weir has done this—Twachtman as

well."[57] The motif, in his opinion, not only characterized an American as opposed to a European identity but also stood out as a monument to the country's past. Robinson drove this point home in a statement he made shortly before he died. He had just gone to see several paintings of Yellowstone Park that Twachtman had completed. Robinson was singularly unimpressed, especially with Twachtman's subject matter: "it is a country," he wrote, "I shouldn't care for—it is not enough *in time*."[58] Against the West and geologic or natural time, Robinson juxtaposed the East and human or social time. The two halves of the country marked the extremes of a scale calibrated by human industriousness and achievement; it was the mark of human time over natural time and the degree of historical continuity that determined the quality or value of a landscape. From this perspective, New England and Vermont in particular scored high. The intimate connection of the region with the flow of human history gave it, in Robinson's mind, the significance and authority to represent American landscape.

In the last year of his life, Robinson had found a place that gave him a strong sense of belonging, both as an artist and as an American. Aesthetically, the Vermont landscape resonated with interests shaped by his exposure to the Barbizon mode of painting and Monet's impressionist principles. His journey to Townshend also brought him into contact with his putative roots. And in that return to a "native land," Robinson had found a subject he deemed of national import. The desire to convey visually these sensibilities nonetheless proved challenging; Robinson struggled through the summer to capture the exact effects of the landscape on canvas. The thought, however, that he could return after the winter to a part of the country to which he felt deeply connected lessened his frustration. Unfortunately, in April 1896, a deadly attack of asthma cut short those plans.

The search for sanctuary and a feeling of belonging also motivated John Twachtman. Like Robinson, Twachtman grew up in the Midwest but found in New England his true home. For several years he had studied in Europe, returning finally to the United States around 1886. He taught and worked in a number of areas including Chicago and New York, and then, eager to settle in one place where he could both live and paint, he started looking for a home in southern Connecticut, familiar to him from visits to Julian Alden Weir. A seventeen-acre farm outside of Greenwich captured his heart, according to his friends. While easily accessible to New York by train, the Round Hill property, as it was called, with its old stone fences, small brook, fields and forests, offered the seclusion and tranquility of the countryside. Shortly after moving in with his wife and children, Twachtman wrote to Weir of his comfort and contentment: "I feel more and more contented with the isolation of country life. To be isolated is a fine thing and we are then nearer to nature. I can see how necessary it is to live always in the country—at all seasons of the year."[59] Immersed in nature, Twachtman found constant inspiration for his painting. The still and simple elements of the landscape such as frozen pools, gently sloping snow banks, and winding streams consistently drew his attention. More than Robinson, Twachtman emphasized the restorative, nurturing properties of nature. The motifs he returned to over and over again—Horseneck Brook, the pool below it, and his home—manifest his association of the Connecticut countryside with a place of refuge.

The critic Eliot Clark found "a feeling of home" in his paintings, "of a country well-beloved." The "peculiarly intimate charm" that he noticed Twachtman conveyed to viewers in

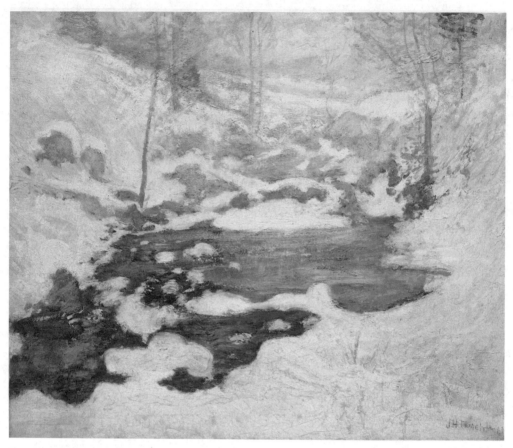

Figure 30. John Twachtman, *Icebound,* c. 1889, oil on canvas, 25¼ × 30⅛ in. Friends of American Art Collection, The Art Institute of Chicago

his Connecticut landscapes not only through his choice of modest subject matter but also through the compositional structure of his works. By concentrating attention in the center of the canvas through high horizon lines, as well as with framing devices and a strong feature in the middle ground, he encourages immersion in the portrayed scene. A *New York Times* reviewer looking at Twachtman's paintings described the experience as being "plunge[d] into their light tones," finding "fresh points of interest to seize."[60] In images of Horseneck Brook including *Winter Silence* (c. 1890–1900) and *Icebound* from c. 1889 (Fig. 30) the receding diagonal lines of the snow banks pull the viewer's eye to the partially frozen water in the middle. The slender tree trunks on either side of the water and the undulating outline of the brook serve to anchor one's gaze there. Twachtman creates delicate patterns out of forms and color tones that lend an air of repose and focus, a sensation enhanced by his flattening of the image through the layering of paint. This blending of hues and the thin washes of color, as the art historian Kathleen Pyne has noted, envelop the viewer in an atmosphere of mist and haze.[61]

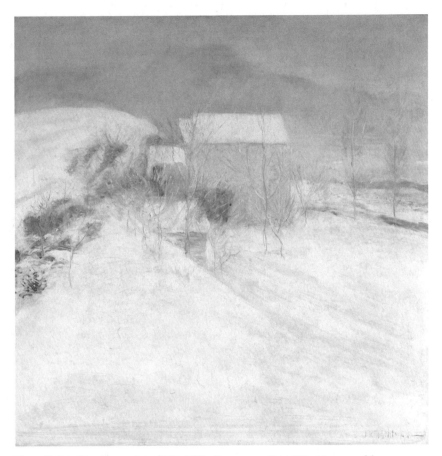

Figure 31. John Twachtman, *Snow*, 1895–1896, oil on canvas, 30 × 30 in. Courtesy of the
Pennsylvania Academy of the Fine Arts, Philadelphia. The Vivian O. and Meyer P. Potamkin
Collection. Bequest of Vivian O. Potamkin

In multiple images—among them *Round Hill Road* (c. 1890–1900), *From the Upper Terrace*
(c. 1890–1900), *Snow* (1895–96), featuring his barn, and *Summer* (late 1890s)—Twachtman's
focus on the Round Hill property communicated his deep attachment to home and the land.
A contemporary critic noted in an article on the poetic vision in his work: "His house at
Greenwich, Connecticut, often appears a dream among snows, his own humble Fuji Yama, not
less sacred than the Japanese mountain."[62] Similar to his images of Horseneck Brook or Hem-
lock Pool, Twachtman's abode is the centerpiece of these compositions. Receding lines of trees
or paths typically lead back to the house. In many of the snow scenes, the central house breaks
the stretches of whiteness in the foreground. But far from dominating the landscape, Twacht-
man's buildings nestle in the curves of hills and earthen banks and are embraced and framed
by nearby trees. In *Snow* (Fig. 31), for example, although the barn has a more material pres-
ence than in an earlier version entitled *Winter*, a delicate pattern of tree branches encircles the
structure and screens it from total view. Twachtman consistently sheltered the built environ-

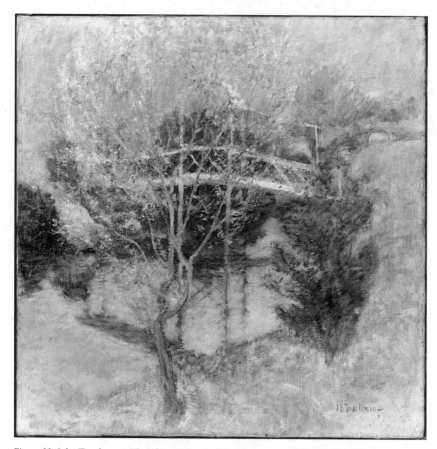

Figure 32. John Twachtman, *The White Bridge,* c. 1895, oil on canvas, 30¼ × 30¼ in. The Minneapolis Institute of Arts, Gift of the Martin B. Koon Memorial Fund

ment in nature's expanse through the use of extended foregrounds, rooftop views, as well as the blurring of shapes and colors. These devices make it impossible to tell where the natural world ends and the human begins.

Two paintings of a small white footbridge Twachtman built on his property epitomize his emphasis on harmony and connection with nature. Using square canvases (of about two and one half feet in length and width) for both images, Twachtman positioned the bridge centrally in the midst of lush vegetation. Like many of his home scenes, the potency of the natural elements temper the marks of human presence, represented here in the horizontality and whiteness of the bridge. The ends of the bridge in *The White Bridge* (Fig. 32), for example, dissolve in clumps of bushes and trees. The outlines of the bridge itself are obscured by the saplings in the foreground, whose branches and leaves create a weblike pattern that extends to the top of the painting. Through his blurring of boundaries between forms and the echoing of shapes as in the latticework of the railing and the crisscrossing of small branches, Twachtman suggested the intimate relationship and delicate balance between the manmade and natural worlds. His interest in harmony extended even beyond the canvas. In 1905, *Country Life in America* ran an article on the

architectural additions and modifications Twachtman had made to his Connecticut house, holding it up as a model for a place that had, in the author's words, "cooperated with Nature."[63]

Like his house, Twachtman's paintings signify communion with nature. Charles Caffin remarked that Twachtman had "absorbed the facts of his surroundings so completely that their very spirit had entered into him." The delicate tones of his work, the interlacing of form and color gave visual form to that spirit of the landscape. Often described as visions of the soul of nature, his canvases communicated to viewers a serenity and peacefulness.[64] In their ethereality and their ability to induce reflection, they accorded with the contemporary interest in a spiritual experience of nature. Twachtman's pictorial celebration of his Connecticut home grounded that experience in the subtle features of the rural landscape—rambling brooks, still ponds, and gently rolling pastures—and directly associated such elements with the southern New England countryside. As Julian Alden Weir commented shortly after Twachtman's death in 1902, in his images of the region "one is made to feel the spirit of the place."[65]

The character of the New England countryside inspired Weir himself. In 1882, he had acquired a 155-acre property in Branchville, Connecticut, in exchange for a painting and over the years grew deeply attached to the area. Over the front door of his house he had inscribed: "Here shall we rest and call *content* our home."[66] While Weir never stopped painting figures, increasingly through his life he turned to the land for his subject matter. In January 1899 he wrote to a friend of the appeal of landscape painting, commenting: "It seems to me that a great lover of one truth cannot but feel that wonderful something that the landscape in nature suggests, somewhat like the soul of a human being. . . ." Several years later, he wrote again of his eagerness to get to know nature "more intimately."[67] In New England's pastoral qualities, Weir found a landscape with that desired intimacy.

It was in part the tempered, settled quality of the region that proved so inviting. Weir's Connecticut property included an old farmhouse that became his home, as well as stone walls and rocky pastures, all of which suggested a history of working with the land and the continuity of human presence. In *The Laundry, Branchville* from about 1894 (Plate 2), Weir celebrated these features of country life. Set as if on a brilliant green pedestal, his red house crowns the hill, with the tree in the center drawing immediate attention to it. Human presence is marked not by great activity or by imposing objects. Weir's house does not dominate the painting; rather it is stretched almost the width of the canvas, an effect that emphasizes its integration into the natural environment. The crisp whiteness of the laundry hanging outside and bounded by three trees both reinforces that accord and makes the landscape familiar and personal. Weir's image recalls his brother's early advice to cherish the Branchville farm: "Keep it trim and untrammeled and you will find it a haven of refuge. . . ."[68]

The sense of sanctuary Weir associated with his property extended to other New England sites conjured in his landscapes. The air of consonance and equanimity characteristic of these paintings stands out especially in scenes incorporating local industry, a subject not readily associated with calm or quiet. In Weir's four major works on the theme—*The Willimantic Thread Factory* (1893), *The Red Bridge* (1895), *The Factory Village* (1897), and *Building a Dam, Shetucket* (1908)—although he makes the industrial site the center of the work, he contains and tempers modernity with elements of the natural world. His canvases achieve a compositional or-

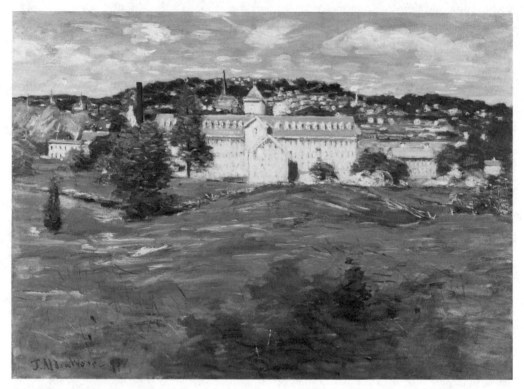

Figure 33. Julian Alden Weir, *Willimantic Thread Factory,* 1893, oil on canvas, 24⅛ × 33½ in. Brooklyn Museum. 16.30. John B. Woodward Memorial Fund

der and stability not only through the deployment of strong vertical and horizontal axes, but also through an impressionistic technique. Particularly in the 1908 image of the Shetucket dam, Weir's short fractured brushstrokes meld industrial equipment into tree limbs and leaves. Similar to Twachtman's blurring of boundaries through a single dominant tone and the repetition of shapes, Weir transmutes wisps of bluish smoke into bits of sky and turns wooden poles at ground level into vigorous saplings up above. The impressionist dematerialization of form helps to reconcile seemingly opposed elements such as factories and fields, or machinery and foliage.

Weir's industrial scenes highlight the capacity of the New England countryside to assimilate and sustain productive enterprise. In the *Willimantic Thread Factory* (Fig. 33), for example, Weir sets the white factory in the center of the middle ground; the building backs up against a hillside town and is distanced from the viewer by a wide stretch of meadow filling almost half of the canvas. The shadows that play across this foreground field echo the white of the manmade structures toward the back. Along with the use of unifying colors, the repetition of similar shapes throughout the image accentuates the congruence of the industrial, spiritual, and pastoral; the square forms of the houses that dot the hillside mimic the dozens of windows in the factory building, while the one smoke stack, pictured free of emissions, makes the same vertical mark as do the multiple church steeples of the background and the three trees on the

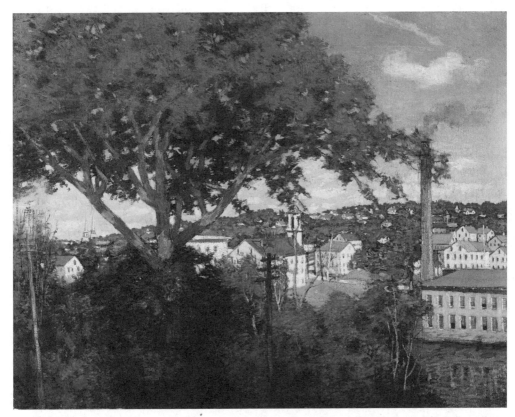

Figure 34. Julian Alden Weir, *The Factory Village,* 1897, oil on canvas, 29 × 38 in. All rights reserved, The Metropolitan Museum of Art, Gift of Cora Weir Burlingham, 1979, and Purchase, Marguerite and Frank Cosgrove Jr. Fund, 1998

left side of the painting. By containing the factory between the swath of meadow and the wooded hill of the background, Weir balances built and natural environments, an effect he similarly achieves in *The Red Bridge.* Here he transforms a view of an iron railroad trestle into a play of geometric patterns anchored by the trestle piling in the center and its reflection in the water. The interweaving of the lines of the bridge with the branches of trees from the foreground, the echoing of forms in the water, and the use of cool blues for both sky, water, and stone create a surface design that neutralizes the impact of the imposing metal form. Weir not only places foliage on either side of the bridge but also pushes the trestle up high on the picture plane, actually cutting it off in the upper right corner. In a way typical of his other industrial images, Weir frames a social structure within a natural order.

In pictures such as *Willimantic Thread Factory* or *The Factory Village,* identified in 1901 as *New England Factory* by the *New York Sun* (Fig. 34), any reference to New England's industrial decline, a topic of contemporary concern, is banished. Through the use of greenery and natural growth, Weir not only harmonizes his compositions but evokes a sense of stability and regional vitality as well. In *The Factory Village,* the town occupies a slice of middle ground balanced

between the screen of trees at the bottom of the canvas and the wide umbrella of leaves at the top. Its containment reinforces pastoral ideals and creates, as one contemporary reviewer noted, a sense of repose and equanimity. Such an environment, the same author suggested, naturally led to quality production: "One might be inspired here to splendid craftsmanship, to the making of exquisite laces, or the precise instruments of science, or the substantial furniture of our ancestors, undisturbed by the cheapening influences of horrid commerce; but the spirit of work is not even intimated." Weir achieved a grace and refinement in his landscapes that appealed to critics at the same time that they presented New England manufacturing as robust and of superior quality. Paintings such as *The Factory Village* were often read by reviewers as examples of a dignified and elevated human spirit.[69]

In two large exhibition canvases, *Noonday Rest* (known also as *Midday Rest in New England*) from 1897 and *Ploughing for Buckwheat* (known also as *New England Plowman*) from 1898, Weir incarnated that spirit in scenes of farm life, an equally important feature of New England's economy. Like the factory images, these paintings also portray a balance between natural and social orders; their focus, though, is on the worked land. In *Noonday Rest,* bright sunlight illuminates the tools of labor—a mallet and a sawhorse—at the center of the painting, as man and beast take a break in the shade. In *Ploughing for Buckwheat* (Fig. 35), Weir depicted a farmer in the process of plowing his fields accompanied by a small child who sits on the ground. The activity takes place in the lower half of the canvas and is emphasized by both the farmer's gaze out toward the viewer and by the screen of clouds, trees, and boulders that cuts off access into the distance. Critics praised the painting, seeing in it, as one reviewer remarked, an "epic picture of the American farmer amid soil and sky."[70] In Weir's presentation, the farmer becomes almost one with the land, his legs planted in the exposed earth, his humility effected in part by his placement slightly to the left of center and his modest size especially compared to the oxen. The child in the foreground, who clearly is too small to plow, instead rehearses the act, playing with the scattered stones and making them into his own furrows, a seeming promise of the future and the endurance of the yeoman farmer ideal.

By the early 1900s, Weir increasingly painted scenes that focused on the land itself. As in his earlier works, their orderly compositions, warm, delicate tones, and harmonious colors underscored the comfort of the countryside. In many of these paintings, including *Afternoon by the Pond* (c. 1908–09) and *The High Pasture* (c. 1902), Weir blocked a distant view with a high horizon line or a screen of foliage in the background. Similar to Twachtman's technique, Weir's efforts to center attention in the middle and foreground of the canvas enclose the landscape, enhancing a sense of comfort and familiarity. In *The Spreading Oak,* a tree typically associated with strength and age, an umbrella of leafy branches in the foreground extends across most of the canvas (Fig. 36). The narrow view in the center onto a strip of sunlit field and a wedge of blue sky focuses attention, and in this intimate space, the viewer is sheltered by the surrounding blend of lush green foliage, from oak leaves to pasture grasses.

Weir also stressed the domesticated or humanized qualities of the New England landscape, including in *Spreading Oak,* for instance, a split wood fence at the left. The same effect characterizes *Upland Pasture* (c. 1905), in which sheep graze at the top of the hill, as well as *Border of the Farm* (c. 1909), where a stone wall runs across the middle of the canvas. Human activity—

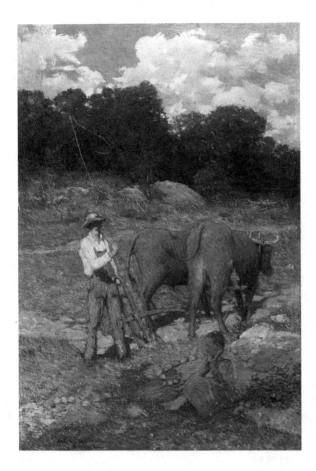

Figure 35. Julian Alden Weir, *Ploughing for Buckwheat (New England Plowman)*, 1898, oil on canvas, 48 × 33 in. Carnegie Museum of Art, Pittsburgh; Purchase

when represented, as in the small, shadowy figure of the wood gatherer in *Border of the Farm*—always appears as an integrated part of the larger natural universe.

Weir found in the Connecticut countryside a congruence of social and natural orders, and that portrayal on canvas earned him critical acclaim. As they had responded to Twachtman's work, reviewers prized what they saw as Weir's evocation of purity and character. Using *Ploughing for Buckwheat* as an example, Guy Pene du Bois wrote in 1911 that Weir's pictures revealed "the soul of a modest American who intuitively shuns the vulgar side of materialism and yet makes of its most successful models vivid symbols of the spirituality of the world." Weir and his work represented to many critics of the period the height of dignity and refinement, and several of them designated him as "one of the aristocrats of American art." The association of this quality with an Anglo-Saxon (and by extension New England) heritage was suggested by one reviewer in 1906 when Weir's portrait entitled *A Gentlewoman* went on exhibit at the annual show of the Ten; the reviewer remarked that although the figure was not beautiful, she clearly possessed "an inherited tradition of good breeding," which in 1924 the critic Catherine Beach Ely actually identified as Anglo-Saxon.[71] To contemporaries, Weir possessed the gift

Figure 36. Julian Alden Weir, *The Spreading Oak,* n.d., oil on canvas, 39 × 50 in. Portland Art Museum, Oregon, Gift of Col. C. E. S. Wood in memory of his late wife, Nanny Moale Wood

of a seer in his ability to capture the essence of things. Art critic Newlin Price lauded Weir's paintings for their "eternal verities," declaring that because Weir's "devotion to the beautiful and true burned like some sacred fire before an altar, his art will forever be an inspiration to all those who are also stirred by beauty and by truth." The warm reception of Weir's paintings and especially his Connecticut landscapes rested in their depiction of harmony and balance. At a time of increasing cultural heterogeneity, which many social commentators perceived as threatening and disruptive, Weir portrayed, in the words of Eliot Clark, a "scheme of relations rather than contrasts," a formal mode of beauty harmonized within the structure of the paintings. This "beauty of relations," as Clark called it later in his article, maintained a semblance of stability and order.[72]

The enthusiastic promotion of suburban locales and country retreats by social critics among others derived in part from concerns to balance the inherent conflict between material and spiritual needs. Turn-of-the-century social critics increasingly juxtaposed the congestion, frenzy, and corruption associated with cities with rural space, quietude, and purity. In the re-

sulting country/city dialectic, the urban world advanced material values while the country-side safeguarded spiritual and moral principles. For many of the period's writers and commentators, getting in touch with the natural order not only benefited the personal health of individuals but ensured the well-being of society as a whole. Echoing Hamilton Mabie and other nature proponents, John Van Dyke concluded *Nature for Its Own Sake* with the admonition: "If you would cry out, go to the forest; if you would moan, stand on the prairie; if you would implore, look up at the sky and the sunlight. Learn from these. The law is written on them. Through all the ages of the earth's endurance that law has not failed to teach obedience, patience, peace."[73]

In turning to the countryside, John Twachtman and Julian Alden Weir, like others of the time, found sanctuary and spiritual rejuvenation. The visualization of their experiences, however, not only reinforced rural ideals but also helped to associate them specifically with the region of southern New England. Critics, eager to locate an American art, encouraged American Impressionist painters to stay local. Giles Edgerton in a review of a show at the Pennsylvania Academy of the Fine Arts in 1907 thought the finest room was the Impressionist one in which he found largely New England–inspired canvases. Royal Cortissoz praised the work of Weir and Twachtman for its harmonious qualities as well as for its distinctiveness, its local feeling. Looking back on Weir's career in 1921, he remarked: "When he painted one of those landscapes of his, he gave it the delicate visionary loveliness of a dream, yet he left the picture the unmistakable portrait of a place."[74] Chromatic contrasts, play with light, and fractured brushstrokes—elements of an American Impressionist aesthetic—brought to the canvases of Weir and Twachtman the passion and sincerity of an attachment to place. They helped to sharpen a perception of the New England landscape as vital to the nation at large, an important spiritual resource.

Childe Hassam, Willard Metcalf, and the Production of a "Native" Landscape

With the death of Theodore Robinson in 1896, John Twachtman in 1902, and Julian Alden Weir in 1919, Childe Hassam (1859–1935) and Willard Metcalf (1858–1925) became the two artists most readily identified with New England and the New England landscape. Their early twentieth-century paintings and etchings immortalized the region as a place of verdant countrysides and productive labor. In their work, a distinctive New England identity emerged, one that offered an enduring vision of community and nationhood.

Hassam's and Metcalf's scenes of church spires, winding meadow brooks, and villages set in orderly fashion among trees and fields portrayed a domesticated nature. Intended to enfold rather than awe a viewer, these images suggested an easy balance between the natural and social orders. Henry Ward Ranger, the founder of the well-known Old Lyme art colony, spoke in 1914 of his attraction to this Connecticut spot, commenting that he had been drawn to the area because it highlighted both immovable nature and the marks of human cultivation. He perhaps best expressed the appeal of the New England landscape for artists and audiences when he envisioned it as animated by the spirit of the New England colonists: "I never get into a farmer's back-fields," he mused, "with their ridges of rock, recurringly stripped of timber, without feeling what a race of unconscious heroes the pioneers must have been." This quality of the land, its testament to human achievement and character, gave Old Lyme, he felt, an aesthetic value. "A landscape to be paintable," Ranger declared, "must be *humanised*. All landscapes that have been well painted are those in which the painter feels the influence of the hand of man and generations of labour. I think this is one reason why no man has made a success in painting outside his own country. For no matter how well he knows a foreign land superficially, he must still remain an alien."[1] Ranger's words implicitly establish a set of oppositions or ways of seeing. He distinguishes native from alien, humanized from wild and untamed, ancestral from rootless. Ranger invokes a vision of belonging, and it is this vision, I shall argue,

that needs to be seen in the work of two of the most prolific and renowned American Impressionist artists, Childe Hassam and Willard Metcalf.

In the pursuit of community—and the struggle to define it—Ranger was not alone. The influx of alien, non-Anglo-Saxon immigrants, the shift of populations from the country to the city, and the official closing of the frontier had generated urgency at the turn of the century not only to define "Americanness" but also to engender it. Efforts to rouse a national consciousness inaugurated the ritual of the "Pledge of Allegiance" back at the 1893 Chicago World's Fair and sparked a profound interest in general in the region of New England as a source of history and heritage. This interest found expression in cultural media from social organizations such as village improvement societies and genealogical groups to drama and literature to architectural styles and artistic subject matter.

The 1893 Fair, in its grand display of resources meticulously categorized and parsed, had attempted to make the United States known through a sense of the local and the specific. The focus on the identities of states and regions not only offered participants the opportunity to see the country and grasp what it meant to be American; it helped break down an abstract political entity and endow it, to use the German historian Celia Applegate's words, "with the emotional accessibility of a world known to one's own five senses." Hamlin Garland at the time had touched on just this relationship between the national and the local when he wrote about Impressionism and the development of a national art, noting that "art, to be vital, must be local in its subject."[2] Garland championed the impressionist mode of expression after seeing examples of French and Spanish impressionist art at the fair, and admiring its radical stylistic innovation. Here was a technique, he believed, that allowed an artist to focus on nature in all its local variations and that encouraged an individual and intimate response to subject matter.

As turn-of-the-century writers and commentators increasingly argued for New England as the quintessential American region, a precious repository of national culture, the work of Hassam and Metcalf helped to visualize this claim. Their paintings went beyond the efforts of Robinson, Twachtman, and Weir to portray the New England landscape as a special, if not sacred, place. In Hassam's and Metcalf's canvases, the land, the soil comes to reveal human character and human history. As one writer presented it, using Cape Ann, Massachusetts, as an example, "we see in very truth the 'stern and rock-bound coast' which so truly exemplifies the steadfast character of the early settlers."[3] For contemporary viewers, New England's Anglo-Saxon Protestant past animated the present, saturating the very earth itself. Critics responded with excitement to those artists able to capture that spirit of the land. One painting that earned great acclaim was Hassam's *Church at Old Lyme, Connecticut,* and it serves as the centerpiece of this chapter. The reception of the painting as well as its place in Hassam's body of work helps to illuminate how and why New England's heritage could prove so useful in forging a sense of American nationhood. This chapter traces the outlines of what I call an "iconography of belonging" expressed through the deployment of particular landscape motifs that explicitly signaled signs of community. It addresses the artistic project that transformed a region into a "native" landscape.

Hassam's *Church at Old Lyme, Connecticut,* 1905, "A Phase of Consecrated New England"

Hassam's interest in Old Lyme dates back to the summer of 1903, when he reportedly visited the area with several other artists. Twachtman and Weir, both close friends of his, had of course been residents of southern Connecticut for many years. What impressed Hassam was Old Lyme's colonial past and rural landscape, its salt marshes and gentle pastureland, as suggested by a letter he wrote to Weir in July 1903, calling Old Lyme "a pretty fine old town."[4] Over the next several years, he became a regular visitor at Florence Griswold's house, where members of the Old Lyme art colony found their home away from home. Here, Hassam was honored with his own special studio and painted scores of pictures. His arrival helped to transform Ranger's art colony there into a renowned American Impressionist site, affirming Hamlin Garland's belief in Impressionism as a promising mode for American painters. A host of artists, including Willard Metcalf, flocked to Old Lyme, inspired like Ranger and Hassam with the area's blend of history and scenic nature. For Hassam, and indeed for art audiences, the fascination with Old Lyme and its past crystallized in a single image—the town's old church. Under its spell, Hassam executed three oils, a pastel sketch, and an etching. Of these, the 1905 version, a close-up view of the simple white church with its stately ionic columns, garnered the most public attention and was exhibited widely (Plate 3). On display in March 1907 at the National Academy of Design show in New York, the painting was lauded for its modern way of "seeing." *The Nation's* reviewer described Hassam's work as "a phase of consecrated New England," which became art "through a sustained and intelligent presentation of 'the splendor of the true.'" Later that year, Hassam included the work in an exhibition at the Montross Gallery in New York, and the *New York Sun* in its review assigned the "place of honor" to *Church at Old Lyme,* calling it a masterpiece. Hassam succeeded not only in putting Old Lyme on the map, but also in fixing a potent image of New England in the cultural imagination. A measure of his success is apparent in a comment that Lorado Taft, a lecturer and sculptor, made years later during a 13 April 1932 airing of the "Art Broadcast" radio series, a program of the Columbia Broadcasting System's American School of the Air. Taft, speaking of *Church at Old Lyme,* declared that there was "nothing more American on all the continent."[5]

Situated near the Connecticut River and Long Island Sound, Old Lyme and its Congregational church had deep American roots. The town was first settled by descendants of a Sir Humphrey Griswold of England, who came to the area in the 1640s. A host of other English families followed, and Old Lyme developed into an active shipping port. Fertile soil and well-stocked waterways also supported fisheries and the raising of cattle and horses. Over the centuries, the area prospered and came to boast of many prominent public figures among them Superior and Supreme Court judges, congressmen, and, as one publication from 1906 put it, "many other sterling and blue-blooded men and women, who formed an intellectual aristocracy as it were, and gave to the town a distinctive character which it retains to this day."[6] The white Congregational church gave architectural expression to the town's continuous local religious tradition. Although erected in 1817 after a fire had destroyed its predecessor, the building served a congregation that stretched back to the seventeenth century. Contemporary

descriptions of the area repeatedly held up Old Lyme's tradition of a distinguished and ho-
mogenous population. As one turn-of-the-century guidebook proclaimed, "Unattractive to
the emigrating refuse of Europe, it [Old Lyme] remains an old-fashioned gem in an old-fash-
ioned setting."[7]

Graced with a variety of scenery, the town retained through the twentieth century not only
its picturesqueness but also a visible historical legacy. Buildings dating back to the days when
Old Lyme had been an active shipping port still stood. Venerable elms and old family mansions
lined the main street. In their search for painting grounds, Ranger and other Old Lyme art
colony members had found their home away from home in one of these stately residences,
Florence Griswold's family home. Like many of the others in the area, her house possessed its
share of lineage. Samuel Belcher, the architect and master builder of the Old Lyme church, had
designed it. Florence herself was descended from a long line of distinguished Griswolds, in-
cluding Old Lyme's founder, and the house, inherited from her father, still contained in 1900
many old furnishings and relics, giving what one journalist described as a "genuine 'old fam-
ily' air about the place."[8]

It was Old Lyme's natural beauty as well as its Anglo-Saxon history that drew Hassam to
the little Connecticut village. Royal Cortissoz seems to have sensed this in the late 1930s when
he reviewed Hassam's work—particularly the art with a New England focus. "Yet it was from
the countryside," he noted, "that he [Hassam] gathered most of his impressions, especially where
it made what I can only describe as a kind of native, racial appeal to him."[9] The personal writ-
ings of Hassam support Cortissoz's interpretation, hinting as they do at the artist's abiding in-
terest in issues of home and origin, at the native and the racial. Hassam took special pride in
his English ancestry. His mother's family, who were Hawthornes (or Hathornes originally) and
counted Nathaniel Hawthorne as a member, dated its arrival in America back to the seven-
teenth century. On his father's side, a William Horsham—from which the name Hassam de-
rives—came from Sussex, England, to Salem, Massachusetts, also in the seventeenth century.
The Middle Eastern sound of his surname, however, was not lost on observers. Hassam's close
artist friends jokingly referred to him as "Muley," a reference used, his biographer Adeline
Adams suggested, to describe both his stubborn nature and his "exotic" origins.[10]

Sensitive to his lineage, Hassam firmly asserted that his surname was "one of the most Saxon
names that you may come up with." His stress on his New England ancestry both in words
and in paint moved critics to label him admiringly as a "Puritan."[11] His perceived passion for
truth and his refined sensibilities were singled out as distinctive Puritan qualities. For genera-
tions, the Hassam family had maintained close ties to New England. Hassam himself grew up
in the 1860s and 1870s in Dorchester, Massachusetts, at that time an old, elite section of Boston.
In reflecting on the area years later, he admired its topographic features, its "beautiful situation
on Dorchester Bay with low hills and plains," and he commented specifically on its sense of
history, noting that "in a building here the first town meeting was held which may be said to
be the birthplace of the American commonwealth, as James Bryce might say. There were some
good sized estates with simple good colonial houses—and there were some old houses dating
from the earliest days." He recalled Dorchester not only for its familiarity and its colonial New
England architecture but also for its distinctly "native" population. But, Hassam lamented:

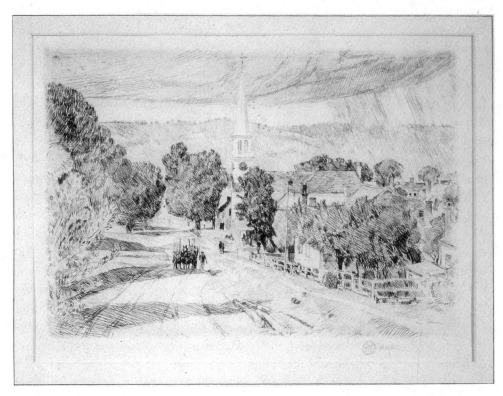

Figure 37. Childe Hassam, *Vermont Village, Peacham, Vermont,* 1923, etching. Frye Art Museum, Seattle, Gift of Harold C. Milch, 1960

> Dorchester now is merely the ugly suburb of a large city all the old estates
> have been cut up the good houses have gone and it is nothing at all like what
> it was when I knew it, that part of Boston now has anything but an Ameri-
> can population—a good many French Canadians, and a good many more
> Middle Europeans of all kinds—none of the old English names of families
> persist—where are the old Dorchester names of Capen, Hewins, Hodgman
> and Southard?[12]

Hassam's sense of loss and displacement and his understanding of an American population as one with an Anglo-Saxon background may help to account for the commentary that Adeline Adams records he wrote next to a 1923 etching entitled *Vermont Village* (Fig. 37). Identifying the place as Peacham, he noted that "our one-time Ambassador to Great Britain, George Harvey, made [Peacham] known as being one hundred per cent Anglo-Saxon."[13]

In the picture itself, Hassam emphasized the village's Anglo-Saxon quality by positioning a prominent New England church and steeple at the center. Like Peacham—and unlike the Dorchester of Hassam's adulthood—Old Lyme retained "good colonial houses" and unbro-

ken family estates. An intimate, homogenous community, it remained steeped in a sense of tradition and purpose. In his unpublished autobiography, Hassam remembered his childhood church and its "great beauty as it stood there then against one of our radiant North American clear blue skies."[14] Recalling for him Dorchester's church of yore, the Old Lyme church embodied more than anything else a Protestant Anglo-Saxon ethos and heritage.

Throughout his career, Hassam celebrated that legacy both in his choice of subject matter and in the composition of his oils, etchings, and watercolors. Despite frequent travels around the country and to Europe, images of New England scenes and historic sites repeatedly occupied his attention. The recurrent theme of heritage and community that threads through Hassam's work attests to his belief in the importance for civilized society of collective memory and palpable signs of roots. Hassam said as much in a catalog foreword to an exhibition of his art held in East Hampton, Long Island, in 1932: "It has been my lifelong aim to help retain the natural beauty and dignity of any fine old American community, and I have always felt that to spare a fine old tree and to salvage fine old houses, such as I portray in my etchings, from the hands of vandalists, constitutes one of the highest forms of a civilized peoples' [sic] aim." Hassam's thoughts should be understood less as nostalgic than as anticipatory and proactive. These kinds of familial or communal monuments, whether preserved on canvas or in situ, held out a visual model of acculturation for present and future viewers. They advertised a desired ethos or way of being. Thus could Hassam declare in a letter to Florence Griswold in 1907 that he was "very much disgusted with humanity" after he had heard of the loss of Old Lyme's Congregational church to possible arson that summer.[15] (Although he bitterly lamented that it could never be rebuilt, a new church—practically a replica of the old—was dedicated by the town in 1910.)

One of Hassam's earlier paintings, done shortly after his return to the United States from Europe, prefigures the Old Lyme church painting in its memorialization of New England rural society. *County Fair, New England (Harvest Celebration in a New England Village)* from 1890 (Fig. 38) pictures a central meeting house, square and solid, that visually reigns over the crowd. A sea of people spills from its doors. Like Hassam's much loved Dorchester church, the brilliant white facade stands out against one of those "radiant North American clear blue skies." Hassam masses the throng of villagers into a stable, broad-based pyramid whose apex marks the doorway to the building. Emphasizing community and the fellowship of local and national interests, red banners and two American flags, the uppermost extended from the bell tower, hang above the church's entrance. Hassam's citizenry appears not only well ordered, but well dressed and well bred. Men in top hats and long coats and women in fashionable dress are clearly visible. As if to underscore further community and belonging, he places a young family in the foreground. The father stands with a child in his arms, and we can see the mother's full skirts extending out from behind the line of her husband. The sturdy tree trunk that rises to the sky draws our attention to them at the same time that it associates the family as a pillar of society: Hassam's commentary on family values. The artist's exuberant colors and broken brushstrokes convey the vitality of the scene.

Hassam presented this image of strength and stability even in his paintings of New England coastal locales, to which he gravitated in the 1890s and the early 1900s. One of these—Ap-

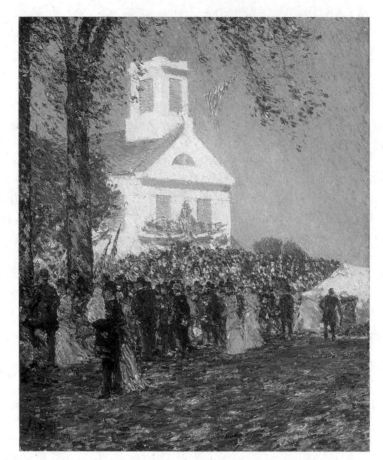

Figure 38. Childe Hassam, *County Fair, New England (Harvest Celebration in a New England Village)*, 1890, oil on canvas, 24¼ × 20 in. Private Collection

pledore Island in the Isles of Shoals just off Portsmouth, New Hampshire—Hassam discovered through the Thaxter family and spent many summers there painting. A short-lived fishing community in the colonial period, the Shoals prospered in the late nineteenth century as a summer resort. One of the earliest hotelkeepers, Thomas Laighton, had moved his family to Appledore Island in the mid-1800s. His daughter Celia Thaxter, an acclaimed Boston poet, had over the years gathered in her parlor a select group of cultural figures, many of whom, like herself, could trace their ancestry back to seventeenth-century English colonists. They included musician John Knowlton Paine, poets James Russell Lowell and Thomas Bailey Aldrich, and writers Sarah Orne Jewett and Richard Henry Dana, as well as Hassam. Returning to the island through the 1890s and even after Thaxter's death in 1894, Hassam relished both the company of Thaxter and her salon and the bracing beauty of New England's northern landscape.

In addition to his luminous pictures of Thaxter's flower garden, Hassam painted over and over again the island's irregular rock formations and the flowers and grasses overlooking the sea. He wrote to Julian Alden Weir one summer when he was visiting Appledore that "the rocks

and the sea are the few things that do not change and they are wonderfully beautiful—more so than ever!"[16] Highly structured compositions, his paintings convey that feeling of constancy and durability. Hassam uses spatial registers that define near, middle, and far distances, and in spreading across the canvas, these horizontal bands conjure nature as orderly and tranquil. The warm light and bold colors—glistening whites, sparkling blues—enhance that perception. As one critic described some of these works: "There is virile strength; and yet charm in the swirling bubbling water, and positive solidity of the rocks."[17] Toward the turn of the century, Hassam focused increasingly on the cliffs and rocks at the ocean's edge. Robust portraits of rock, sea, and sky, images such as *Isles of Shoals* from 1899 (Fig. 39), *Early Morning Calm* from 1901, and *Northeast Headlands, New England Coast* (1901) typically feature horizontal bands of rock and water as well as high horizon lines, both of which keep attention centered in the middle of the canvas, an effect that steadies the eye and reinforces a sense of calm.

Hassam enlivens scenes less through incident or object than through high-keyed tones and broad brushstrokes. Picking up on the stark, essential qualities of Hassam's work, one critic in a review of an exhibition of Hassam paintings from the early 1900s described a sea picture of

Figure 39. Childe Hassam, *Isles of Shoals,* 1899, oil on canvas, 25¼ × 30½ in. The Minneapolis Institute of Arts, Gift of the Martin B. Koon Memorial Fund

his as "a world washed clean of every impurity; an aspect of nature's keenest thrill and vitality."[18] The spareness of these compositions reinforced associations of New England's rugged coastline with hardiness and purity of character.

In his travels along the coast, Hassam found particular inspiration in the small, old New England towns such as Gloucester and Provincetown in Massachusetts; Newport, Rhode Island; and Cos Cob, Connecticut. In place of rocky shores and the solidity of the natural world, he shifted his focus more to signs of human continuity and the integration of natural and built environments. Largely harbor views, his paintings from visits to Gloucester in 1899 and Newport in 1901 nestle the towns between stretches of sky and water. Similar to the Isles of Shoals pictures, horizontal bands rather than a perspectival vanishing point tend to structure these compositions. In *Gloucester Harbor* (1899), for example, Hassam compressed the town into two thin registers at the top of the canvas. Even with his inclusion of fishing wharves and commercial boats, this scene, too, conveys an air of stillness and peace generated not only by the striated organization but also by the absence of figures and the suffusion of warm light. In the words of one critic, the work was "a brilliant little piece of sunlight with the most radiant of summer atmospheres enveloping the town and harbor."[19] A prominently placed house, isolated in the lower half of the painting, accents the domestic and familiar. In other scenes such as those from Newport, including *Cat Boats, Newport* and *Newport*, Hassam gave prominence to notable architecture, especially the town's old and dignified Trinity Church. The vertical boat masts and steeple in *Cat Boats* (Fig. 40) are interwoven with the horizontal bands of water, land, and sky to produce a gridlike pattern and a sense of stability and order even more pronounced than in his Gloucester images.

Historic associations fueled Hassam's interest, and old New England buildings and churches emerge as a leitmotif in his work. His images of Provincetown and Cos Cob, which he visited in the early 1900s, typically depict local buildings as well as the trades they housed. *Building a Schooner, Provincetown, Rigger's Shop,* and *Provincetown Grocery Store,* all from 1900, highlight the more artisanal side of village life, while such paintings as *Tidal Dam and Bridge, Cos Cob* (c. 1902) and *November, Cos Cob* (1902) present views of houses lining village streets. Among a variety of early American buildings in southern Connecticut, he portrayed in two separate paintings Greenwich's Putnam Cottage, built around 1690 and reputedly the headquarters of one of George Washington's generals in the Revolutionary War. Both *Sunlight on an Old House, Putnam Cottage* (1897) and *Indian Summer in Colonial Days* (1899) depict the house set in lush vegetation, while the latter painting actually includes a colonial couple reading under a tree. Hassam's etchings, which he began producing in large numbers around 1915, consistently focused on old homes, colonial doorways, and village churches. The home of John Paine, author of the famous song "Home Sweet Home," was one of several old residences in East Hampton, New York, that Hassam turned into subjects for his work. Throughout his life, New England's old Congregational churches especially appealed to him. In addition to Hassam's series of Old Lyme paintings and pastels from 1903 to 1906, he memorialized churches in the early American towns of Portsmouth, Gloucester, and Provincetown.

Hassam's visit to Old Lyme in October 1905 resulted in a depiction of the church on a brilliant autumn day; its gleaming whiteness stands out against an azure sky and the bright reds

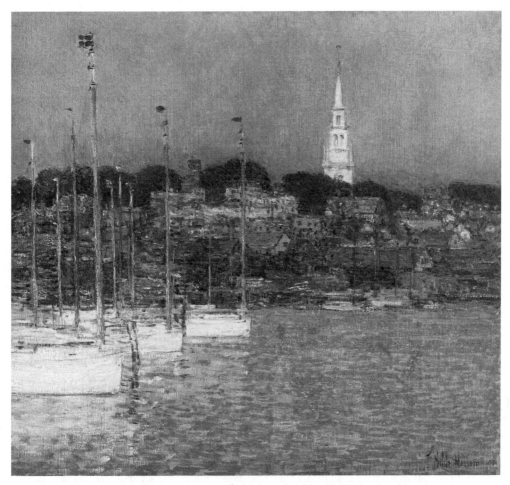

Figure 40. Childe Hassam, *Cat Boats, Newport,* 1901, oil on canvas, 24⅛ × 26⅛ in. Courtesy of the Pennsylvania Academy of the Fine Arts, Philadelphia, Joseph E. Temple Fund

and golden yellows of the leaves spread like a carpet before the entrance and frame the sides of the building. When it went on exhibition at the National Academy of Design in 1907, the painting's rich, luminous color immediately struck reviewers; the critic for *The Nation* found its color "of a quality that might be found in some rare Persian tile, or better, in the opalescent air of a late summer day with a hint of autumn stirring among the branches of immemorial elms."[20] The vitality of the image derives, however, not only from Hassam's use of color and light but also from his treatment of the church itself. Filling most of the canvas, it presses up against the picture plane, its solidity and mass emphasized by Hassam's simultaneous exposure of both the facade and the side wall.

While Hassam's *Church at Old Lyme* presents a powerful, even imposing image, the painting's effectiveness stems in large part from its intimacy and familiarity. His painting does not convey awe before things majestic and divine. Rather, he truncates the church's steeple mid-

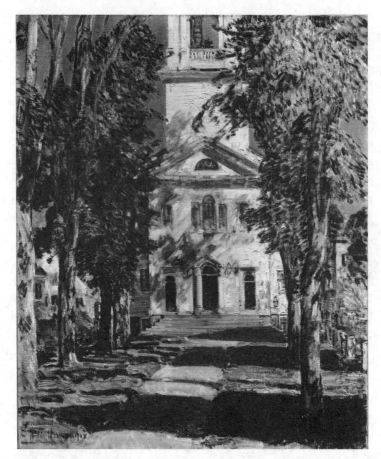

Figure 41. Childe Hassam, *The Church at Gloucester,* 1918, oil on canvas, 30 × 25 in.
All rights reserved, The Metropolitan Museum of Art, Arthur Hoppock Hearn Fund,
1925

way. This compacts the building, bringing it down to a more comfortable, human size. The composition of the painting creates for the viewer the sensation of being up close, of belonging to the scene. Hassam repeated the technique in another painting of a historic New England church, *The Church at Gloucester,* from 1918 (Fig. 41). Here too, Hassam's abbreviated steeple focused attention on the entrance to the church. The viewer is further propelled toward the doors of the church not only by an avenue of trees that leads to the building but also by the deep green of the foreground grass that is echoed in the doors of the white church.

In *Church at Old Lyme,* Hassam worked to draw viewers to the entrance as well. That he intended to accent the doorway becomes clear when compared to another painting of the same building that he executed in 1903 (Fig. 42). In the earlier version, the church stands out less distinctly. Hassam allowed a column to obscure the doorway and added a story to the church tower, thus drawing the eye upward rather than focusing it in the middle. His 1905 rendition changed all that. By making the front and side of the church meet at an angle greater than

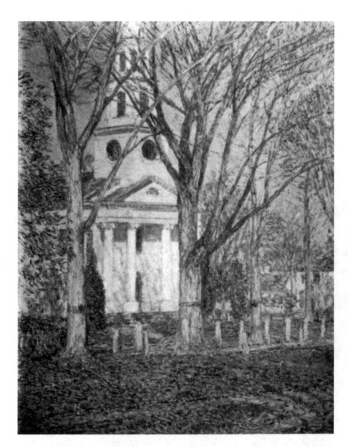

Figure 42. Childe Hassam, *Church at Old Lyme, Connecticut,* 1903. Photograph from the Pennsylvania Academy of the Fine Arts 73rd Annual Exhibition Catalogue, 1904. Pennsylvania Academy of the Fine Arts, Philadelphia, Archives

ninety degrees, he heightened the building's depth and presence, while preserving the impact of a fully frontal encounter. Hassam dramatically draws the viewer in by emphasizing the central doorway. The hefty tree to the right of the church in the 1903 version slims down to a sapling and pairs off with the column on the other side of the center door. Using two stone posts in the foreground to lock in attention, Hassam creates a visual aisle straight to the entrance of the church. Within lies the heart of the community, a community united by common social, political, and religious ideals. Although an outdoor scene, Hassam's composition invokes that inner sanctum. The rich, warm tones of the surrounding foliage, as well as the diaphanous brushstrokes that blend into one another, encircle the church and keep the viewer's gaze on the whiteness at the center of the painting. Hassam thereby reinforced a sense of access, intimacy, and connection.

Like the images of Julian Alden Weir, Hassam's vision integrates nature and human enterprise, asserting a harmony between the natural and social orders. Photographs of the church from the turn of the century suggest just how much Hassam emphasized their union (Fig. 43). Although elms ringed the perimeter of the church's lawn, in the painting the church nestles within interlocking screens of foliage, the result of Hassam's collapse of a distant perspective with an up-close one. Hassam balances the church's whiteness with brilliantly colored leaves;

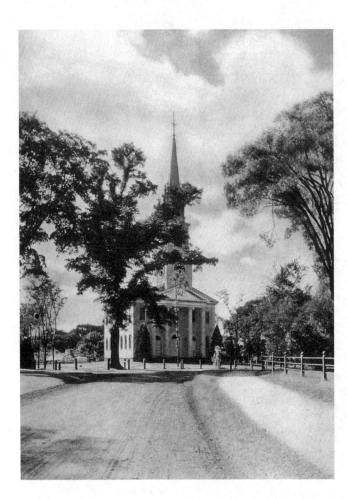

Figure 43. Period photograph of the
church at Old Lyme, Connecticut, from
Country Life in America 25 (April 1914)

its weightiness with the lightness and fracture of the trees. These compositional strategies
blended light, color, and form into a rhythmic, consistent whole.

The sense of order and things being in the right place characterized Hassam's New England
work from *Church at Old Lyme* to his scenes of Gloucester and the Isles of Shoals, and critics
picked up on and responded to these visual cues. In 1909, for example, Hassam showed *The
Old Elm* (1903) at a Montross Gallery exhibit. A review described the painting as depicting a
country road with two men cutting up a felled elm. Houses dotted the background. The re-
viewer singled them out, identifying them as having "no special character, unless it be the char-
acter of home. That is what we find so interesting in the picture, the savor of a sensitive intimacy
with the true physiognomy of our landscape." Hassam's work, according to the reviewer, dis-
tinguished itself as an example of fine painting because it captured the "very spirit of the soil."[21]

This turn-of-the-century interplay among history, home, or belonging and the region of
New England transcends Hassam's personal biography. Willard Metcalf was equally celebrated
for his pursuit of the spirit of place. He established his reputation in the early twentieth cen-
tury with depictions of New England hillsides and neatly laid-out villages characterized by

meetinghouse steeples piercing the horizon. Similar to Hassam's experience, a trip to Old Lyme, Connecticut, in 1905 also helped launch his career. His 1906 *May Night,* a moonlight painting of Florence Griswold's house, won a gold medal from the Corcoran Gallery and another from the Society of American Artists in 1907. Over the next decade, Metcalf showed in exhibitions throughout the country, and private collectors and major museums eagerly sought out his vibrant images of the region's landscape. By the time of his death in 1925, he was hailed as the "poet Laureate of these [New England's] homely hills," and the writer went on to say that Metcalf "sings their virtue and their grace with a loyalty which has not been misapplied."[22]

Like Childe Hassam, Metcalf claimed New England ancestry and turned to an old New England church to express his identification with its associated Anglo-Saxon values. Painted in 1920, *Benediction* (Fig. 44) evoked a response similar to the reception of Hassam's *Church at Old Lyme.* A number of reviewers even mistook the scene, which he painted in Maine, for the one in Connecticut. As in Hassam's meetinghouse, audiences saw in *Benediction* a sacred peace, an emblem of stability. Writing to Metcalf shortly before the painting was finished, the critic and

Figure 44. Willard Metcalf, *Benediction,* 1920. Photograph courtesy Peter A. Juley & Son Collection (J0024199), Smithsonian American Art Museum

playwright Booth Tarkington enthusiastically declared: "I'm convinced you've got a great picture. In any picture the gazer can see only what he has in himself to see; but I seem to feel that you painted your New England into this one: your forebears, your mother, and what you want your children to see in New England. The frame church, so noble and simple, stands there forever, as if it were of something imperishable, not of wood. It is of the spirit, is the reason; and it has a kind of ineffable benevolence in its dignity." The Corcoran's director, C. Powell Minnigerode, voiced similar sentiments in a later letter to Metcalf.[23]

Benediction, like *Church at Old Lyme,* struck a responsive chord with viewers: both concentrated in a single image the "humanized" quality of New England, that air of history and lineage Henry Ward Ranger and others found so appealing. In doing so, these paintings established an iconography of belonging evocative enough, as D. W. Meinig has argued, "to conjure an instant mental image of a special kind of place in a very famous region."[24] Such snapshots helped to create categories of place, capturing the essence of a particular locale or at this point an entire region. They thus worked similarly to the expressions of state/regional rivalries that resulted in the idiosyncratic and singular exhibits at the 1893 Chicago World's Fair. If organizers of the New England state exhibits had pitched their region as a model for spiritual and cultural achievement, an alternative to territorial expansion and natural wealth as represented by the West or Midwest, for example, *Benediction* and *Church at Old Lyme* now served to translate that ideal into visual icons. Their work extended the earlier efforts of landscapists Twachtman and Weir but effectively solidified an aesthetic vocabulary that secured New England as a site of belonging.

History and Belonging

By the turn of the century, American Impressionist landscape painters were among a growing number of Americans captivated by the themes of community and roots. A fascination with the region came to permeate the fine arts and the cultural imagination generally; while the colonial revival style became a popular choice for architects, collectors eagerly sought out early American antiques and organizations devoted to New England heritage rapidly multiplied. The common feature was the promotion of Anglo-Saxon values as represented by New England tradition and history. Simplicity, purity, and order became frequently used adjectives to describe the region's qualities. Interest in New England's simple but hardy ancestors spawned a host of genealogical societies. The larger and better known included the Daughters of the American Revolution, founded in 1890, the General Society of Mayflower Descendants in 1897, and the Society for the Preservation of New England Antiquities in 1910. The National Society for New England Women was inaugurated in 1895. Dedicated to, in the words of one chapter's president, "a clean, wholesome, social atmosphere, founded on loyalty to the city of our home, that shall be ruled by the steadfast purpose that emanated from our New England ancestry which we reverence," the organization sponsored so-called colonies in states outside the region, among them New York and New Jersey. Popular also in major cities across the country were the New England Societies, which, like the Philadelphia chapter that had com-

missioned a copy of Saint-Gaudens's *Puritan,* venerated New England and the Anglo-Saxon heritage it embodied.[25] Although in existence in the antebellum years, by the 1890s these societies sprang up in numerous major cities and boasted sizable memberships.

The appeal of historical associations matched the fervor for objects and architecture that recalled the country's beginnings. Homeowners in the late nineteenth and early twentieth centuries clamored not only for residences designed in the loosely defined colonial revival style but for furnishings and decorations as well. A flurry of literature from books to journals acquainted readers with features of the style, popularizing colonial heritage in general. One of the more prolific antiquarians, Alice Morse Earle, penned a series of books on colonial life starting in the mid-1890s with such titles as *Customs and Fashion in Old New England* (1893 and 1894) and *Home Life in Colonial Days* (1898, 1899, and 1900). In the following years, writers on interior design such as Candace Wheeler and Mary Northend steered readers' taste to, in Northend's words, the "dignity and refinement that is unmistakable" in colonial doorways, and to the simplicity and elegance of colonial-style furnishings and ornaments.[26] Popular journals routinely highlighted the ins and outs of colonial home decoration, often with detailed illustrations.

Around 1902, *Harper's Monthly, Country Life in America,* and *Ladies Home Journal* in particular started including the work of Wallace Nutting, a Congregational minister turned photographer, who excelled in colonial homelife scenes complete with period antiques and costumed figures. Nutting found a ready market for his photographs and by 1906 had set up a business in Southbury, Connecticut, producing black and white as well as hand-tinted photographs of New England landscapes (Fig. 45) and colonial vignettes (Fig. 46).

Nutting exercised a passion for New England and its colonial past, exemplified for him in old homes and furnishings. Old homes, he maintained, "will never lose their allurement. They are drawing us back to primal sod and the early hearth."[27] His landscape photographs featured winding roads, bucolic glens, and apple trees in bloom—Nutting quoted Henry James's description of the apple as "the olive of New England." Images such as apple blossom scenes or those of winding country roads like *A New England Road in May* proved especially popular.[28] Nutting's success and his continued admiration for the so-called pilgrim century led him over the years into ever more varied colonial-inspired ventures; in addition to publishing numerous books and articles, he started a colonial furniture reproduction firm and an old-homes restoration venture, on top of amassing an extensive collection of original seventeenth-century furnishings, later purchased by J. Pierpont Morgan (who also happened to be a member of the New England Society in the City of New York).[29] In the early 1920s, Nutting began organizing his massive photographic inventory by state, launching the publication of his States Beautiful series, in all eight volumes, with an additional two on England and Ireland. Not surprisingly, the series focused on New England; *Vermont Beautiful* appeared in 1922, *Massachusetts Beautiful, Connecticut Beautiful,* and *New Hampshire Beautiful* in 1923, and *Maine Beautiful* in 1924. Like the state exhibits at the 1893 Fair, they armed readers with an intimate sense of the local landscape.

A taste for things colonial, while manifested at the Philadelphia Centennial, was more fully indulged at the Chicago World's Columbian Exposition. Although fair organizers heralded

Figure 45. Wallace Nutting, *A New England Road in May* from *Wallace Nutting Pictures,* 1912. Courtesy of Historic New England/SPNEA

modern advances, they also traced the beginnings of that progress. An array of colonial relics and replicas punctuated the grand displays of American resources. Many of the main exhibition halls featured collections of colonial antiques, from articles and documents of the country's early leaders in the Government Building to lace exhibits in the Women's Building. Even in the Fine Arts Department, colonial themes animated paintings in the American section, as in Douglas Volk's *A Puritan Girl* or Charles Turner's *Courtship of Miles Standish* and *John Alden's Letter.* Individual states presented viewers as well with displays of local history and life in their state buildings. Many of the structures themselves, as Susan Prendergast Schoelwer has discussed, either represented actual colonial residences or incorporated significant colonial elements into their designs.[30] Massachusetts, for example, constructed its state building as a version of John Hancock's home and included in it an extensive historical exhibit of the state's colonial heritage.

By the turn of the century, the colonial seemed to denote a more straightforward, easier time. Critics praised colonial revival architecture for its simplicity, purity, and harmony of form and appreciated simple decorative designs. Objects that were handcrafted (as in colonial times) signaled diligence and the fruit of hard, honest work. Writing in 1912, Mary Northend in her book *Colonial Homes and Their Furnishings* hailed the colonial as "free from the disturbing elements of latter-day life," and concluded that it "is synonymous of the best."[31] For examples of colonial artifacts, she drew heavily on examples from New England, as did other proponents of the colonial revival, including the journal *Country Life in America,* which regularly ran articles on colonial doorways in Salem and Newport as well as on old gardens of Connecticut and

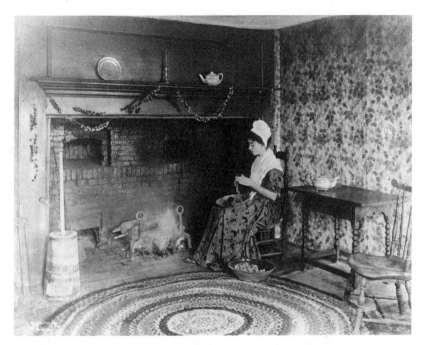

Figure 46. Wallace Nutting, *A Pilgrim Housewife*, c. 1911. Courtesy of Historic New England/ SPNEA

of New England farmhouses in general. Not only was the region rich in antiquities and well-known historical sites, but an active Anglo-Saxon elite there also helped to keep alive a view of colonial New England society as stable and orderly. With its strong historical roots and es-tablished traditions, New England appeared to be, and its promoters presented it as, the repos-itory of the nation's precious past.

Contemporary writers made explicit the ideals latent in colonial revival architecture and decorative designs: that New England, its heritage and its values, played a crucial role in the continued moral and civic well-being of the nation. An article published in 1912 as part of a series known as "Beautiful America" in *Country Life in America* exemplified this perspective. Entitled "New England—Mother of America," the piece, richly illustrated with images of the landscape, extolled the region's rugged splendor, its ineffable charm, and, above all, its sacred antiquity: "New England means more than mere natural beauty, she is backgrounded by a wonderful history, which rises higher than her rocky hills. We see the grandeur and beauty of the past as well as the present, through all the land of dead heroes of the flesh and the spirit, and of their descendants who, thank God, have still something of their lordly blood in their veins." It was upon these descendants, a caption to one of the accompanying photographs de-clared, "that the highest beauty of the land depends, for the present and for the future."[32] The photograph (Fig. 47) depicted amidst pastures and woods a New England village marked by a prominent white, spare church and steeple, an image by now emblematic of civic ideals and reminiscent of Hassam's *Church at Old Lyme*.

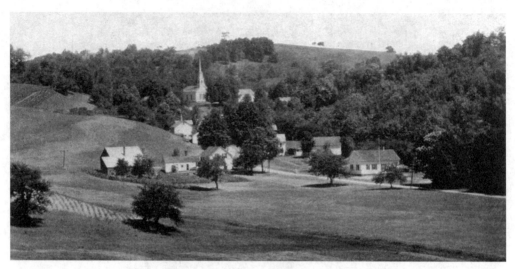

Figure 47. Period photograph of a New England hamlet, from *Country Life in America* 22 (1 July 1912).

The almost apocalyptic tone of the article and its identification of New England as an agent of salvation need to be understood in the context of the wrenching social transformations of the period. Beyond the changes wrought by the shift from an agricultural to an industrial economy, the overwhelming influx of alien immigrant groups dramatically altered the urban landscape. Not only was the number of new arrivals at its highest between about 1905 and 1915, but immigration from southern and eastern Europe also surged. The presence of religiously and ethnically distinct immigrants such as Italians, Slavs, and Jews sparked concerns over the racial composition of the country. Magazines and newspapers regularly discussed the subject in articles like "Immigration and Degradation," "Our Threatening Race Muddle," and "European Peasants as Immigrants" that grappled with the issue of assimilation. Theodore Roosevelt anxiously commented in the late 1890s on the declining birth rate of the old stock in the Northeast.[33] Social scientists and civic leaders questioned not only the country's ability to absorb so many newcomers, but the future of American democratic principles, considered by the late nineteenth century a hallmark of an Anglo-Saxon heritage.

Apprehension over the waves of immigrants entering the United States and their impact on the nation's economic and political stability mounted in the 1890s. Economists such as Francis A. Walker and Richmond Mayo-Smith questioned the economic advantages of foreign laborers. Other scientists, among them the Harvard geologist Nathaniel Shaler, argued that the new arrivals from southern and eastern Europe historically lacked the traits suitable for American citizenship. Agitation about both the quality and quantity of immigrants materialized in 1894 with the founding in Boston of the Immigration Restriction League. By the early 1900s the League held national sway. Steered largely by men who traced their roots back to English settlers, the League helped promulgate a belief in Anglo-Saxon and Teutonic superiority; members grew increasingly alarmed as census counts showed ever-higher percentages of foreign-

born in the country. Suggesting as their studies often did the dire consequences of mixing diverse and unequal populations, the work of social and political scientists allied with biological theories of race and heredity to buttress further the League's restrictionist position. Immigration, as the historian Barbara Solomon has noted, "became a matter of the survival of the Anglo-Saxon stock."[34]

From the perspective of public figures such as Theodore Roosevelt, leaders of the Immigration Restriction League, and writers in the popular press, the outnumbering or decline of so-called native Americans, that is, Anglo-Saxon Protestants, meant the decline of America and its founding principles. "Race suicide," a term coined by the social scientist Edward Ross, became the topic of the day. As one journal reported as late as 1917, "If we are ever to ripen and perfect our civilization we must not depend upon the pauperized villages of Europe, the deserts of Asia, and the jungles of Africa for our population. We must determine to rear our own population from our own best stock."[35] Against the hardy and heroic image of the early Puritan and Pilgrim settlers, the non-Nordic "racial" types—Italian, Slavic, and Russian immigrants who were typically Catholic or Jewish—appeared degraded by a supposed history of poverty, subservience, and illiteracy.

The "lordly blood," as the *Country Life in America* article put it, that would ensure America's future was Anglo-Saxon and Protestant. In the words of another author publishing in *Atlantic Monthly,* it stood "for the best yet reached in ideas and institutions, the highest type of civilization, the fairest chance for every man yet offered in the world."[36] The preservation of a Protestant Anglo-Saxon heritage, deemed paramount to the nation's social order, seemed possible through a host of efforts: legal barriers to the immigrant flood, awareness among the old stock of the racial stakes, and Americanization efforts, all measures enacted to varying degrees at the beginning of the twentieth century. The assertion of an Anglo-Saxon standard to guide citizens was summed up in an article entitled "The Immigration Peril: Are the Aliens Alienizing America?"[37] The author, Gino Speranza, stated his understanding of the responsibility of the so-called New Stock. The test of allegiance was not how much they gave of themselves but how much they denied. He demanded deference to an Anglo-Saxon Protestant ethos because it constituted the heart of American political and social institutions. His point took visual form: The front cover of the magazine in which Speranza's article appeared featured nothing other than a reproduction of Childe Hassam's *Church at Old Lyme* (Fig. 48). Although besieged itself, New England, its institutions, and its traditions appeared to preserve more than any other region the purest form of Anglo-Saxon culture.

Turn-of-the-century efforts to build American nationhood called for a seemingly secure cultural foundation, a mooring strong enough to withstand the turbulent societal changes of the times. As one *New England Magazine* author reflected in 1909: "Among the social problems before our modern American civilization, the one which will undoubtedly bulk the largest in the retrospect of future centuries is the problem of assimilation. We are in a state of flux, seething, absorbing, changing, we know not where we are going."[38] Many knew, however, whence they had come. Artists and audiences, largely upper class, turned to New England and its Anglo-Saxon Protestant heritage for a point of origin. They found in the region a source for national cohesion. Celia Applegate, writing about Germany, illuminates the resonance of a

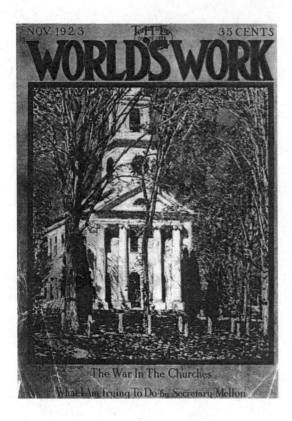

NOV. 1923 35 CENTS

WORLD'S WORK

The War In The Churches
What I Am Trying To Do by Secretary Mellon

Figure 48. Front cover, *World's Work,* November 1923.

work of art such as Hassam's *Church at Old Lyme* for contemporary viewers. In addressing the processes of nation building, Applegate focuses on the notion of *Heimat,* a word meaning "homeland" or "native place." In her book *A Nation of Provincials,* she argues that home and nation do not contradict each other. Rather, *Heimat* forms a bridge between the abstract concept of the nation and local, face-to-face associations. It offers, in Applegate's words, "a way to reconcile a heritage of localized political traditions with the ideal of a single, transcendent national entity."[39]

Writers, artists, and patrons at the turn of the century located in New England the qualities of home. Writing for *New England Magazine,* one author recalled his return to New England's countryside. Foreshadowing Frank Baum's *Wizard of Oz,* the author wrote: "There's no place like New England." Citing the diverse geography of the United States (from a midwestern prairie to a southern plantation to a far western ranch), he continued, "the New England environment, taken altogether, in its adaptation to the realization of the best ideals of *home,* is unmatched anywhere else in the world."[40] For those both inside and outside New England, the region as a whole was imagined as an adaptation of the hometown. This turn-of-the-century characterization was less a nostalgic longing for the past than an attempt to establish a foundation for the future.

As rendered by Childe Hassam and Willard Metcalf, in particular, New England offered what the raw, newly settled West and other regions could not: a sense of historical process, of

long-term habitation and time-tested values. In the historicized, or "humanized" quality of this landscape, artists and audiences grasped a fragile treasure: fragile because of the threats of industrialization and immigration, precious for the vision of belonging.

A "Native" Landscape

Hassam and Metcalf excelled in creating images that bespoke ancestry and roots, a sense of the familiar and the constant. Their interest in colonial homes and historic buildings, subjects that proved equally as popular as their landscapes, offered, like the church at Old Lyme, immediately recognizable emblems of origins and continuity. Visible signs of tradition reinforced communal principles, Charles Eliot Norton maintained in an 1889 article published in *Scribner's Magazine*. Addressing the stimulating effect of material objects such as old homes, he cited Wordworth's description of family property as a site of memory, "a kind of rallying point for their [proprietors'] domestic feelings," and declared that an old home becomes "the memorial of happiness and an incentive to excellence. The older it is the sweeter and richer garden does it become of human charities and affections." Nathaniel Shaler echoed those sentiments nine years later in an article entitled "The Landscape as a Means of Culture," in which he identified the most appealing and uplifting landscape scenes as ones which appeared domesticated: "Now those of well-trained eye find satisfaction in the wilderness, though all alike will confess that the scenes which yield the most pleasure are those which are at once humanized and historic."[41] New England towns steeped in colonial history provided just such settings, and given the sustained attraction of Metcalf and Hassam to these types of subjects, rich artistic sources as well. Their paintings and etchings from the early twentieth century affirmed secure links between the past and present, between natural and social orders.

Hassam's appreciation for colonial homesteads and communities found full expression when in 1915 he turned seriously to etching and produced in that year alone over fifty New England scenes, among them a group of old homes and buildings from Portsmouth, New Hampshire, and Cos Cob, Connecticut. Portsmouth had been settled in the 1630s, and many of its early structures still stood. In works such as *The Old Custom House, Portsmouth,* and *The Athenaeum, Portsmouth,* as well as *Portsmouth Doorway,* all from around 1916, Hassam highlighted colonial facades; the central doorway of the building orients each image. Open doors and windows, nearby figures (as is the case in the first two etchings) and the contrast of light and shadow (in *Portsmouth Doorway,* for example) lend an air of intimacy and accessibility to the image. His more distant views of the town—*Old Warehouse, Portsmouth* and *The Chimneys, Portsmouth* (Fig. 49)—recall the balanced compositions of his Isles of Shoals and Gloucester paintings. Similar to the organization of *Church at Old Lyme,* Hassam pictured his colonial homes amidst sheltering trees; his two views of the Holley House in Cos Cob and his etchings of "Home Sweet Home" Cottage of 1921 and the Lion Gardiner House of 1920 (Fig. 50) both in East Hampton, New York, feature, for example, screens of foliage and are enlivened by the play of shadows cast by the surrounding trees.[42]

The residences Hassam selected for his scenes all carried historic import; they typically

Figure 49. Childe Hassam, *The Chimneys, Portsmouth,* 1915, etching. All rights reserved, The Metropolitan Museum of Art, Gift of Mrs. Childe Hassam, 1940

marked revered sites dating back to the colonial period. One of the earliest English settlers, Lion Gardiner landed in Massachusetts in 1635 and settled his family in East Hampton in 1653. "Home Sweet Home" Cottage, named in honor of one of the works of John Howard Paine, a dramatist as well as a descendant of Plymouth colony settlers, dated back to the late seventeenth century, while the Holley House, the locus of a vibrant artists' colony beginning around 1900, was also associated with early colonists although built in the eighteenth century.

Like Hassam, Metcalf in his travels through New England also sought out old homes with distinguished lineages to transcribe in paint. *May Night* of 1906, which won him early renown, portrayed, for example, the Griswold home in Old Lyme. Built in the early 1800s, the home belonged to the descendants of some of the most prominent early settlers of Connecticut. Metcalf painted a moonlit scene. Setting the house in the middle ground at an angle, he focused on the imposing Georgian facade, framing the illuminated pillars with large leafy trees. Another Connecticut homestead, Peletiah Leete's, became the subject of *October,* a work from 1908 (Fig. 51). Leete, who lived in the early eighteenth century, was related to Governor William Leete, a seventeenth-century English settler and one of the founders of Guilford, Connecticut. In Maine, Metcalf painted several captains' houses, including the Lord mansion, built in 1812, as well as the Daniel Gerrish house, the focus of *White Lilacs,* painted in 1912 (and purchased by Charles Lang Freer). Daniel Gerrish was a fifth-generation descendant of Captain William Gerrish, who had come to Massachusetts in 1639. His home in Kittery, Maine,

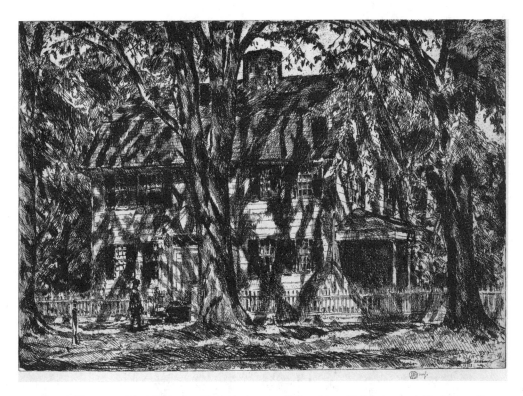

Figure 50. Childe Hassam, *The Lion Gardiner House, Easthampton,* 1920, etching.

was described in 1903 as "a storehouse of old furniture and heirlooms of many families and generations, a visit to which will well repay the lover of the antique."[43]

Metcalf's artistic renderings of these monuments to the past endow them with an aura of specialness and sanctity. Both *White Lilacs* and *May Night* are warmly painted scenes. Moonlight bathes the facades of the houses and illuminates several of the windows. The deep blue starry night of *White Lilacs* with its clumps of trees cushion the edges of the house, effecting an air of stillness. In *May Night,* Metcalf achieved a similar effect through blankets of foliage that wrap around the house and the white pillars of the facade aglow from both a light emanating from within and the reflected moonlight.

His daytime images, while energized by brilliant contrasting colors and the play of sunlight, remain sheltered and embraced by the surrounding vegetation. Two autumn trees, one red and one gold, screen the roof and sides of the bright white Leete house in Metcalf's *October.* As with other comparable pictures such as *Captain Lord House, Kennebunkport, Maine* (1920) and *Little White House* (1919), Metcalf creates a balanced composition anchored by the house in the center (and in the case of the Leete house a prominent boulder in the foreground) and foliage that either hugs the edges or forms a gridlike screen. As objects of history and architecture in general, old homes represented, in the words of one contemporary writer, "the life of

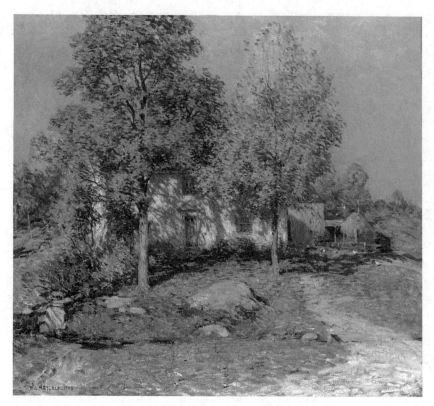

Figure 51. Willard Metcalf, *October,* 1908, oil on canvas, 26 × 29 in. Gift of the grandchildren of Frederick Harris, Museum of Fine Arts, Springfield, Massachusetts

the past in visible and enduring form."[44] Paintings like *October* presented these architectural relics in the most characteristic of seasons in New England—autumn. Through their vibrant canvases (and in Hassam's case etchings as well), Metcalf and Hassam joined preservationists in grounding American national consciousness in a colonial New England heritage.

Generating images of community, or what D. W. Meinig has called "symbolic landscapes," occurred simultaneously on canvas and on actual village streets. Interest in historic landmarks and patriotic sites such as Paul Revere's home in Boston or George Washington's at Mount Vernon intensified after the Civil War. In New England, efforts to preserve and restore old buildings resulted in 1910 in the founding of the Society for the Preservation of New England Antiquities (SPNEA) by William Sumner Appleton. The society's stated mission was to save colonial structures for the benefit of future generations. Appleton, like other antiquarians affiliated with SPNEA, among them the organization's first president, Charles Knowles Bolton, and architect, Joseph Everett Chandler, saw in the character and craftsmanship of old buildings standards worthy of respect and emulation, confident that their very physical presence could mold a public spirit and inculcate a reverence for American (Anglo-Saxon) traditions. As Wallace Nutting, Appleton's friend and fellow preservationist, somewhat effusively declared: "We cannot deny that in cherishing these old homesteads, in lighting again the old hearth fires, in

opening their doors and letting them stand for all that is strong and sweet, we shall best complete and enrich and crown our own twentieth-century civilization."[45] A passionate antiquarian as well as a keen entrepreneur, Nutting had purchased in the mid-teens five colonial homesteads in New England, including property in Saugus, Massachusetts, in Wethersfield, Connecticut, and in Portsmouth, New Hampshire. He carefully restored them, furnished them from his own extensive colonial furniture collection, and for a number of years opened them to the public for a small fee.

One of the most ambitious projects to solidify a sense of the past and community roots was undertaken in the old town of Litchfield, Connecticut. In 1913, the local Village Improvement Society set about remodeling in a colonial style public sites including the village green, the courthouse, and later the Congregational church. Architects and landscapists reconfigured spaces and building fronts, rounding out the green, replacing brick facades with wooden clapboards, and painting buildings white. Like other colonial makeovers of the period, however, Litchfield's attempt, as the decorative arts scholar William Butler has argued, represented less an authentic recreation of an old-time village than a late nineteenth/early twentieth-century vision of what a colonial New England community should have looked like. Nonetheless, a viewer could find such a scene inspiring because, in the words of a contemporary commentator, colonial architecture "smack[ed] of the manly vigor and robust hardihood of the pioneers who had the courage and the initiative to forsake their wonted paths of comfort."[46] By the turn of the century, the colonial signaled a social stability and order as well as moral virtues (such as determination, diligence, and integrity), all qualities seemingly under attack. Its revitalization offered a potential benchmark, a baseline to measure Americanness.

In the search for a pure Americanness, artists and audiences celebrated as much as what the colonists seemed to stand for as the soil they sprang from. Willard Metcalf, more than any other American Impressionist, seemed to capture for critics the essence of New England's landscape, a natural beauty and order as well as a hardy ruggedness. In his compact scenes of rural New England villages, he gave concrete form to the link between environment and personal character proclaimed at the Chicago World's Fair—that New England grew sturdy crops of men. Metcalf's status as one of the country's foremost landscape painters further secured a vision of New England as a template for American culture; his paintings, as the *Washington Post* reported, quoting the Corcoran Gallery director, "are known the length and breadth of the land, from the Atlantic to the Pacific, from Maine to Texas." Specifically addressing the relationship between the regional and the national, a review of Metcalf's work at the Montross Galleries in 1909 enthusiastically described several paintings and then observed: "A French critic recently has said—with reference to German art—that no one should expect a great National culture without preliminary 'regional culture,' and this attention to regional characteristics . . . is one of the most promising signs of the time of our own art."[47] In the unmistakable local flavor of Metcalf's scenes, contemporary critics located the source of a distinctly American art.

The perception of Metcalf's work as somehow digging down to ancestral roots succeeded in eliding the regional with the national. Through Metcalf, features of the New England landscape became metaphors for a genuine American spirit. A reviewer in the early 1920s expressed as much when he commended Metcalf's paintings for being "so native in feeling, so strong and

yet so exquisite, so purely and wholly American." Metcalf's paintings, for reviewers, not only brilliantly captured nature but also made its earthiness palpable such that his work seemed to "exhale the very spirit of the land."[48] Royal Cortissoz declared in his 1927 tribute: "He would do more than paint the portrait of a place. He would so interpret it that it disclosed the essence of our countryside everywhere." As early as 1905, when he was painting the river shores of Maine, critics read Metcalf's work as though it laid bare the essential vitality of the land itself. A *New York Tribune* review, for example, said of his Maine river scenes that they had "a raciness which is most emphatically of the soil," and another in 1907 praised *May Night* as "peculiarly freighted with that savor of the American soil which has always marked this painter's work."[49] This implied revelation of origins was echoed by later critics who spoke of Metcalf's paintings as sparking "old memories" and relieving a sense of homesickness; Catherine Beach Ely concluded her 1925 essay on Metcalf with a stanza from Walt Whitman's "Song of Joy" that began "O to go back to the place where I was born."[50]

Metcalf's "wholly American" pictures succeeded in capturing the essence of what an Anglo-Saxon Protestant community could be. His country villages amidst dense foliage or snow-covered hillsides in particular achieved iconic status. With *White Mantle* of 1906 Metcalf ushered in a long succession of village scenes that depicted clusters of buildings in the middle ground encircled by meadows and forests. *New England Afternoon* from 1919 (Fig. 52), *Buttercup Time* (1920), and *The North Country* (1923) are typical examples.

Paintings such as *Cornish Hills* (1911), *The Village—September Morning* (1911), and *October Morning, Deerfield* (1917) perfected the village/countryside scene; the latter two in particular feature the familiar church or meetinghouse nestled protectively in nature. Diagonal lines typically serve to immediately draw the viewer into the scene. In *Cornish Hills* (Fig. 53), for instance, the artist invites the viewer to traverse the landscape starting with a sentinel-like sapling in the left foreground that forms part of a receding line of trees and bushes leading to a snowy ridge in the middle of the painting and a group of rectangular rooftops there. Shielded by the trees, these homes blend into the natural scene, part of the organic order. Like Julian Alden Weir, Metcalf asserts a harmony between the natural and human worlds. The inclusion in many of these scenes of a prominent church steeple enhances that aura of equanimity as well as divine sanction; the colonial church, as one reviewer of Metcalf's *Benediction* remarked, bespoke "a sense of things sacred—'God's in His heaven, all's well with the world.'"[51] Metcalf's village scenes, like many of Hassam's paintings including those of the Isles of Shoals and *Church at Old Lyme,* were highly structured compositions and in many cases often painted on square canvases. Their artistic balance projected social order, of things being in the right place.

Although Metcalf rarely peopled his canvases, his dynamic brushwork and vibrant colors worked to bring them alive. In *Buttercup Time* (Fig. 54), a foreground of golds and greens leads back to the band of whitewashed buildings in the middle and the azure sky beyond, while in *Cornish Hills,* Metcalf juxtaposed the dazzling white of sunlit snow with the purple-gray hues of a shadowed meadow. Descriptions such as "a delightfully vitalized interpretation of sunshine and air, of birches that are truly as blithe as the June in which they were painted" characterized the response to his work. Catherine Beach Ely described his interpretations of New En-

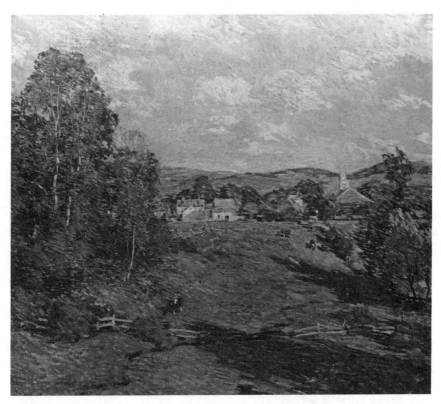

Figure 52. Willard Metcalf, *New England Afternoon,* 1919, oil on canvas, 36 × 38½ in. The Washington County Museum of Fine Arts, Hagerstown, Maryland, Gift of Mrs. Anna Brugh Singer, Olden, Norway

gland in spring as "an allegro movement played on a clear-toned spinet." Eager to convey as well the painterly vigor of Metcalf's autumn scenes, she noted that the season was "a favorite season of his—Autumn at the crescendo when New England trees quiver in tongues of flame against a pellucid blue sky, when the land of Puritan descent throws off its cloak of reticence and glows in febrile intensity."[52] Occasionally, Metcalf heightened the impression of liveliness with the inclusion of figures; pairs of children holding hands amble down a main street lined with sturdy trees and old houses in both *Morning Shadows* (1908) and *October Morning, Deerfield* (1917), another painting Charles Lang Freer purchased (Fig. 55). Elsewhere, as in *October Morning* of 1910 and *Village in Late Spring* (1920), Metcalf depicted pairs of figures at work in a field.

Equally admired by critics were Metcalf's images of hillsides and distant villages under snow. In their appeal, they struck a social as well as aesthetic chord. His paintings celebrated not only an American as opposed to European setting; they reiterated the notion of New England itself as an exceptional region, the preserve of a valuable northern heritage and thus a source of spiritual sustenance. Reviewers thrilled to the poetic yet robust qualities they found in paintings such as *The White Veil* (1909) and *Icebound* (1909), shown in 1909 and 1910 respectively.

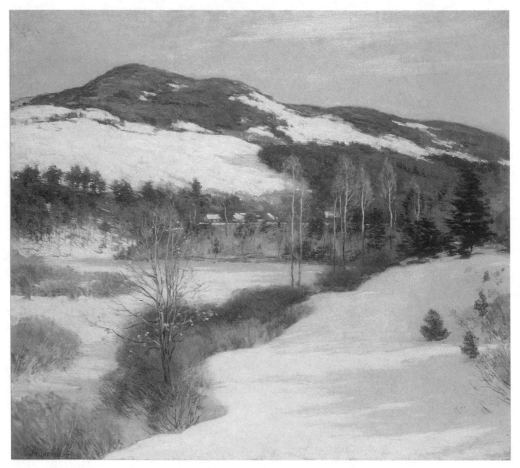

Figure 53. Willard Metcalf, *Cornish Hills,* 1911, oil on canvas, 35¼ × 40 in. Tom and Ann Barwick Family Collection

On the square canvas of *The White Veil,* Metcalf portrayed the fall of snowflakes over an un-dulating ground (Fig. 56), and as in others of his paintings draws the viewer into the still and quiet snowscape through traversing diagonals that lead to the background.

In *Icebound,* Metcalf concentrated on a partially frozen brook and a thick stand of pines ris-ing on one of its banks. Awarded the Chicago Art Institute's Norman Waite Harris prize, the painting, as one paper exclaimed, "fairly scintillates with frostiness." The *Chicago Inter-Ocean* found it a wonderful and powerful picture because, despite the scene's initial sense of loneli-ness and lost hope, the small block of ice breaking loose in the foreground appeared a promise of coming warmth. Gripping the viewer in this way, the painting, the review concluded, "preaches its overwhelming sermon of immortality." The scene's cleanness and clarity was also a subject of note. The *New York American,* for example, described the picture as having "a pre-cise and decisive air, one that cuts clear patterns as with a razor-edge and performs nothing that is not in praise of purity."[53] Like the 1909 paintings, the snow scenes that followed over

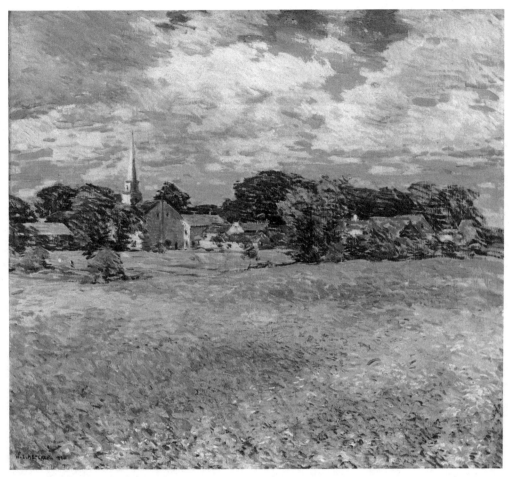

Figure 54. Willard Metcalf, *Buttercup Time,* 1920, oil on canvas, 26¼ × 29 in. Telfair Museum of Art, Savannah, Georgia, Museum Purchase, 1926

the years, among them *Hush of Winter* (1911), *Willows in March* (1911), and *The Thawing Brook* (1917), presented the inviolate, tranquil side of the season. In capitalizing on contemporary notions about winter's redemptive properties, they more firmly associated the region of New England with the season and its revitalizing powers.

Tributes to winter flavor the work of a host of mid-nineteenth-century American poets and writers, among them Henry David Thoreau, James Russell Lowell, and John Greenleaf Whittier, and the forced clarity winter imposed emerged as a common theme. For Thoreau and Lowell in particular, winter's spareness exposed essentials, cleansed and purified: a winter's icy wind, wrote Thoreau, "drives away all contagion," and what remains "we respect for a sort of sturdy innocence, a Puritan toughness."[54] Late nineteenth-century writers continued to elaborate on this view of winter, further reinforcing in the minds of readers the association of a snow-covered countryside with purity and spiritual strength. In *Nature for Its Own Sake,* John

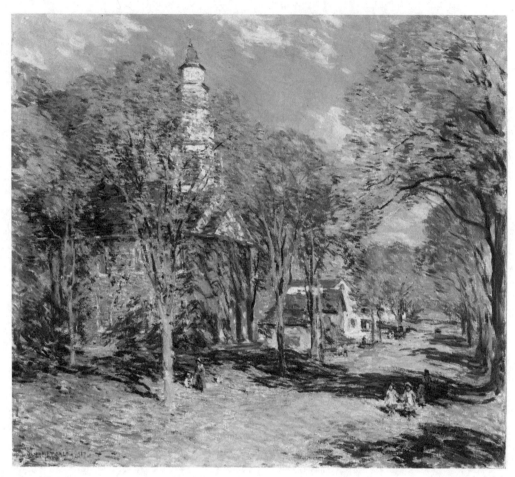

Figure 55. Willard Metcalf, *October Morning, Deerfield, Massachusetts,* 1917, oil on canvas, 26 × 29 in. Freer Gallery of Art and Arthur M. Sackler Gallery, Smithsonian Institution, Washington, DC, Gift of Charles Lang Freer, F1918.154

Van Dyke expounded on the aesthetic glories of snow, seeing in the white snowy landscape a purity, serenity, and calmness.[55] Popular magazines also picked up on the theme of winter although they tended to emphasize less its artistic qualities and more its practical rewards, urging the pursuit of winter's therapeutic effects. An article entitled "Winter in the Country" published in *Harper's Monthly Magazine* encouraged readers to get out into the snow-covered countryside of the East when "the great business of life is just to live and invite your soul." Speaking of the beneficial influences of snow, the author wrote: "The most material mind can hardly help being soothed and rested by it, and the contemplative spirit sees earth, for once, sweet, pure, and millennial." The naturalist John Burroughs writing for *Country Life in America* stressed the stimulation of the season; in place of the sun's warmth, winter offered "a heat of a more bracing and exhilarating kind."[56] It had the power to invigorate and renew both mind and body. In its austerity, most writers agreed, contact with winter, whether contemplative or more active, molded character.

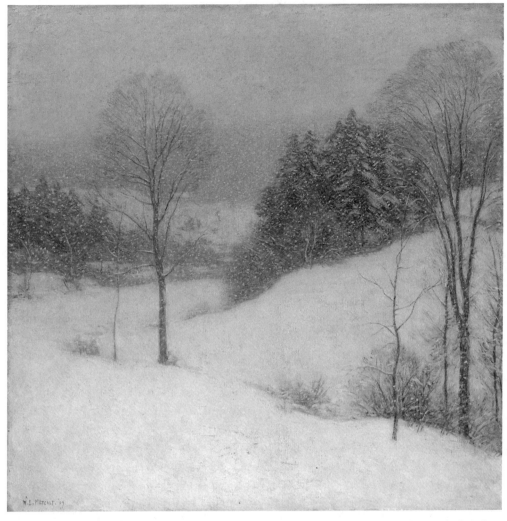

Figure 56. Willard Metcalf, *The White Veil,* 1909, oil on canvas, 36 × 36 in. The Detroit Institute of Arts, Gift of Charles Willis Ward

To confront nature's frozen forces required courage and strength of the sort most writers associated with an Anglo-Saxon racial stock best represented by the early New England settlers. As Burroughs put it in his *Country Life* article, "Our pure Northern winters," by which he meant those of New York and New England, "are of heroic cast; they make demands, they try the stuff you are made of." Echoing racial theories of the day, which posited the superiority of northern over southern peoples, Burroughs went on to maintain that although man may have first evolved in the warmer regions, it is winter that "hardens and toughens the race," and the snows that "have helped clinch his [man's] manhood—the Northern races lead." In his unpublished notes, Wallace Nutting also commented on the waywardness of southern climes in general, although he went on to apply this notion directly to regions in the United States. He mentions that for a short period of time he had toyed with the idea of doing a book on Florida

for his State Beautiful series, but that he had ultimately dismissed the project. Determining that the trend of Florida life was toward "total depravity," he remarked that "there is more stimulation in one March blast in New England than in a whole year of Florida."[57] Nutting and Burroughs illustrate the degree to which winter had come to suggest not just a climatic condition but an enlightened state of being, one distinctly associated with northern Anglo-Saxon attributes. As another author more directly asserted, the climate of New England made "hardy, clear-headed, robust, tolerant, active, virile, men and women; and no better product can be hoped for in any climate."[58] In his elegant paintings of snow-covered hillsides and woodlands of both coniferous and deciduous trees, Metcalf celebrated the northern climate and the Anglo-Saxon legacy associated with it.

By the early twentieth century, Metcalf's pictures offered a basic vocabulary to articulate a New England identity. They converted the region of New England into a set of iconic elements—old homes and churches, winterscapes, winding brooks, and verdant pastures, and these topographic features became inseparable from the region's history of human achievement. Landscape scenes solidified that link between soil and character proclaimed at the Chicago World's Fair and also encouraged by Charles Eliot Norton. Perhaps the most compelling, certainly graphic expression of this link appeared in 1909, about the same time that Metcalf started enjoying significant critical success. *New England Magazine* initiated a series entitled "Beautiful New England: Studies of the Distinctive Features of New England Landscape." By 1912 the series included photographs of the highlighted feature, which ranged from second-growth timber to country homes, accompanied by several richly descriptive paragraphs. Not only did the series offer a breakdown of the landscape into its iconographic parts, it also helped explicitly to conjoin environment and character, as for example in July 1912, the month of the waterfall. Identifying the gentle waterfall as a distinctive local subject, the commentary stated that it is "vitally linked with the pleasures and toils of the New England people . . . an epitome of the New England character. It tells us that thrift and quiet beauty, grace rather than abundance, charm rather than power, shall characterize our art and letters as in the slow evolution of the race the soil asserts its full influence."[59]

Aesthetic regard for the region was indistinguishably bound up with an appreciation of the history of those who had settled in New England; the landscape stood as a record of their fortitude and achievements. *New England Magazine* as well as other contemporary publications, among them Wallace Nutting's *State Beautiful* volumes, suggested that it was impossible to look at the New England landscape without seeing a human panorama. Speaking directly and dramatically to this point, Nutting began his book *Massachusetts Beautiful:* "Small in area, great in influence, there is not a hill within her borders but calls to memory an action which dignifies human nature; not a stream but carries to the sea the moral and mental current of truth embellished by learning."[60] The esteemed qualities of New England's manhood were revealed in the lay of the land itself.

Critics similarly read Metcalf's portraits of the landscape as full of vigor and life. Another of his early paintings, *The Golden Screen* of 1906, met instant acclaim when it was shown, winning the Temple gold medal from the Pennsylvania Academy of the Fine Arts in 1907 and an-

other gold medal at the 1910 International Fine Arts Exposition. A view over a meadow screened off by the fall foliage of three slender foreground trees, the painting caught the eyes of critics who admired its elegance and energy; in it they found, for example, "the joy of an American fall . . . not the November of the elegiac poetlings. Old gold and coppery red, the leaves piled on the road deaden the footfall. The air is brisk. One thinks of brave sublunary matters rather than the decay of nature."[61] Shows of Metcalf's pictures at the Montross Gallery in 1910 and 1911 again elicited appreciation for the artist's intense and exquisite vision. Critics praised "his exceptional vitality," and his canvases were lauded for being sweet but not "oversweet"; they had "the virility and force characteristic of American landscape painting . . . but hidden—hidden behind the strokes of a suave and graceful brush."[62] Metcalf's work seemed to keep painterly forces, that is, color, light, and form, not only vital but in balance. His work was read as dynamic without being wild.

Throughout his career, reviewers responded to the composure expressed on his canvases, many of which were in fact square or almost so. Already in 1905, the New York Tribune singled out his use of color and form as "the basis of a delightful harmony." Royal Cortissoz in a 1908 review found in Metcalf's work a "certain rightness of form. The balance is true." He also talked about Metcalf's "uncanny mastery of his motive and his brush." "A perfection of balance" was used to describe one of his later works shown at the Milch Gallery around 1920.[63] Two years before his death, Metcalf completed a large autumnal landscape while in Vermont. Purchased by the Metropolitan Museum of Art, The North Country (1923) manifests many of the qualities cherished by reviewers (Fig. 57). As in Cornish Hills from 1911, a thin line of buildings (including a steepled white church) that spans the painting centers the image. Stretching before the village is the placid water of a meandering brook, and rising above it Hawks Mountain, its bulk seemingly reflected in the water below, an impression enhanced by the bulge of the brook to the left. The balance of the top and bottom portions of the canvas occurs as well on either side in the dwellings that mass to the right and left of the painting. In the upper half of the painting, Metcalf employs a strategy similar to Hassam's. He breaks the view into scenic bands; a strip of sky, a strip of mountaintop, a strip defined by the shadow of a ridge and the line of the village. That horizontal solidity caps the diagonal thrust of the foreground stream and in combination with the warm, rich tones and the mini-scene of peacefully grazing cows establishes a sense of stability and equilibrium.

Metcalf offered viewers images of repose and dignity. Thus could the director of the Corcoran Gallery in Washington, C. Powell Minnigerode, declare in 1925 that Metcalf's work was "the very essence of refinement, the last word of a highly cultivated intellect, the product of a keen mind."[64] In the harmony and balance of their parts, his paintings, like those of Hassam, and Twachtman and Weir before them, spoke of a civilized world, a world they located in New England. As the site for many of the original settlements of the country, the region was imagined to preserve the democratic ideals of the nation and as such appeared to possess a unique cultural purity. In a way reminiscent of other writers' association of environment and character, John Van Dyke curiously alluded to this regional distinction in a section on water in Nature for Its Own Sake. He noted there that purity was the essence of

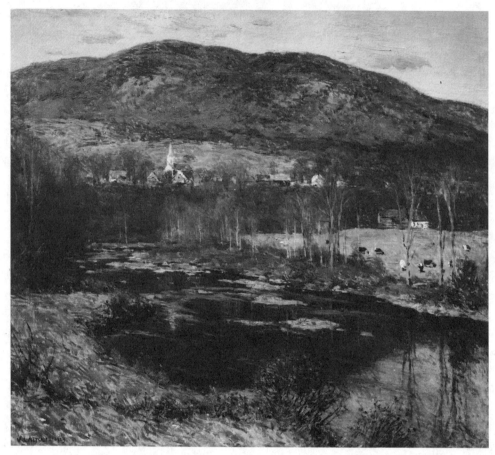

Figure 57. Willard Metcalf, *The North Country*, 1923, oil on canvas, 40 × 45¼ in. All rights reserved, The Metropolitan Museum of Art, George A. Hearn Fund, 1924

the small stream and singled out the New England brook as its best example. Elsewhere, namely in the West and "in the many streams emptying into the Mississippi and the Ohio," one found only "muddiness."[65]

Metcalf's paintings culminated the development of a New England image initiated at the Chicago World's Fair. Eager to assert its position in contrast to other parts of the country, notably the resource-rich West, organizers of the New England exhibits had staked out cultural territory and strenuously cultivated a vision of the region as the metaphoric hearth of the American home. In a review of a Metcalf show at the Montross Gallery in 1908, one commentator vividly addressed Metcalf's ability to capture a sense of place: "Here is sweetness of spirit, an abounding and almost dazzling array of color—the wholesome spirit of outdoors in the New England States gathered up and offered to the spectator as a lovely bouquet of the finest flowers."[66] Throughout Metcalf's career, critics fastened on the quality of his paintings as portraits of place. His work, a reviewer for the *Evening Globe* opined in February 1905, "is an epitome of the American landscape, essentially of the place, of the characteristics of the soil."

Twenty years later, a *New York Tribune* reviewer described his paintings as carrying "you into the heart of some individualized spot in pastoral America. It wakes old memories. The very spirit of our soil is in it."[67] In the vitality of his brushstrokes and the rendering of his luminescent color, Metcalf employed an impressionist technique. But he, like Hassam, used it to different ends than Monet and his followers, eschewing an optical, scientific approach to seeing and painting. Impressionism, translated into an American idiom as Hamlin Garland had argued already in 1894, allowed for an intimate and personal evocation of locality through a deep sinking into nature. As represented by Metcalf and Hassam, such a style of painting provided a unique means to register the value of the land and a belief in the connection between soil and character.

New England as Home

In its project to present the United States to the world and particularly to its own citizens, the 1893 Chicago World's Fair had formalized categories of distinction, breaking down the nation's assets by state and region. The West, for instance, was distinguished for its significant agricultural and mineral resources. Debates about viability heated up as New England jockeyed with other sections of the country, and the West in particular, to define its specialness. Volleys of booster reports accumulated in the pages of magazines and newspapers. Typical of the ongoing exchange, *New England Magazine* published in 1911 a pointed article asserting the vigor of the region. "We are sure," the author wrote, "that, while we may not be able to boast of producing potatoes that will wreck a house if allowed to roll against one, or melons the juice from which will drown the unfortunate person who is so foolhardy as to break one open, as is said to be the fact in some of the publicity-favored states of the Northwest, we may yet hope to vie with authenticated reports of actual product and actual progress made by any of the trumpeted regions of the country."[68] In its sarcastic edge, the article picked up on a theme sounded by a host of eastern writers; the West's natural bounty and overabundance—even excess— needed to be tempered by eastern culture and breeding.

Such distinctions between the two halves of the country were to be found in the appearance of the land itself, in the contrast between the West's unbounded, almost unwieldy expanses and the tidy spaces at the other end of the country. When an article in *Country Life in America* surveyed so-called abandoned farms, it offered just this point of comparison. Although citing the higher incidence of these farms in New England, the author reported on the region's resourcefulness and efforts at rejuvenation. Stepping back to a national perspective, he went on to comment: "The man on the rich lands of the prairies or on the Pacific coast who has a feeling of commiseration for the farmer of New England is nursing only a pleasant egoism. The New Englander will take care of himself. One never sees better farms than he finds in many parts of New England. . . . They are clean and frugal. There is no trace of the weedy carelessness of the West. The buildings are tight, and the thick sward grows to their foundations."[69] In the compactness and order of eastern landscapes, the author located an aesthetic, if not moral, standard, one reiterated in the writings of John Burroughs and John Van Dyke

among others. Liberty Hyde Bailey similarly spoke of "the weary landscapes of the West" when he addressed the subject of New England farms in an article from 1904, while a writer for *New England Magazine* raised the subject of aesthetic quality more directly. The charming style of New England's farm gates immediately struck him upon his return to the region after a long absence. Those out West, he noted, "are built on a very different pattern and, while admittedly more convenient to handle, are dreadfully prosaic and commonplace. What artist would ever think of putting a swinging board gate or a barbed wire fence into his picture?" A poem in the same issue of the magazine brought home the point about the artistic refinement of the New England landscape. Entitled "The Hills of Home," it opposed the far and wide horizon of the West with the "hooded" comfort of the hills and valleys back East, "the land of mist and memories."[70] More than just geographic zones, the regions of New England and the West embodied alternate cultural values. The ensuing dialectic juxtaposed modesty with expansiveness, refinement with the untamed, purity with admixture, and cultivation with wildness.

Apologists for New England employed these contrasts to position the region within the nation. While not denying the West's grandeur and agricultural lushness, they stressed the importance of refinement, restraint, and breeding to civilized society; without a vigorous manhood what use were material riches? New England's harsh soil and climate could be hailed as a boon rather than a burden inasmuch as it forged the mettle of men and generated strength of character. The idea of New England as a grower of men had been played out in the kinds of displays set up by the New England states in 1893 at the Chicago World's Fair, where organizers emphasized historical figures and traditions as well as educational and industrial achievements. And by the 1890s, writers, too, had self-consciously presented the region as the master builder of citizenry. Throwing New England into relief by considering its polar opposite, California, a *New England Magazine* author declared:

> After all, with your sunshine, with your beauty and productiveness, can you bring forth the nobler types of manhood? Are you equal to the high achievements of civilization? If not, then better acres in Massachusetts than ranchios in California. If not, then tell your children of the incalculable gain to life from a land where meagre harvests are the reward of laborious toil. Say what you will, the advantages of soils and climates are relative, not absolute; and the very best is not that which will produce the most potatoes, but the noblest men.[71]

A number of years later William Giles, the president of the New England Society of Chicago, reiterated that point: "If New England has not always produced great crops she has produced great men and these have ever been better empire builders than fertile lands."[72] Whatever their basis in reality, these perspectives presented New England as the nation's cultural bedrock and the source of a sturdy and productive citizenry.

Through the turn of the century, boosters repeatedly posed the region as the keeper of civilized values, such as high ideals and, in the words of one *New England Magazine* writer, "a sense of duty." The region's Anglo-Saxon lineage, embodied in the New Englander (whom the same

author identified as a "native white of native parents"), and its long and distinguished history were used to buttress such claims and demonstrate the region's uniqueness.[73] New England's re-presentation, if not reinvention, came at a time when, as the president of the New England Society of Chicago noted, reports of the region's supposed "decadence" widely circulated. For the most pessimistic of critics, the region appeared spent; abandoned farms, declining industries such as fishing and textile manufacturing, western emigration, and the inundation of non-Anglo-Saxon immigrants spelled stagnation. But the more optimistic viewed these circumstances rather as challenges to be met and overcome, believing that the region's unswerving sense of purpose, its political and cultural legacy, assured its future viability and its value to the nation as a whole. In anticipation of the presidential and congressional elections of 1912, a *New England Magazine* author, Edwin Shivell, thus reminded readers: "If there is such a thing as gratitude in the heart of a nation, it is a thousand times due to New England. If there is a section of the United States of which all may be proud that section is New England. She has excelled in all that contributes to make a people and a nation great. Her purposes have ever been righteous, her ideals high, and her spirit indomitable." As William Giles, the president of the New England Society of Chicago, and other New England promoters saw it, the region's response to economic and social dilemmas, from industrial retooling to the assimilation of foreigners, should serve as inspiration for other sections of the country.[74]

The supposed strength of the region, and what marked it as special, grew out of its abiding sense of stability and continuity. As the contributors to *New England: What It Is and What It Is to Be* noted, New England was "in some respects the most finished section of the country." Its landscape proved charming as well as meaningful precisely because of the absence of "the raw, the unfinished, the temporary, the experimental, the transitory."[75] A sense of permanence, of history and memory, instead defined the topography. Town greens, old homes and buildings, stone walls, and well-worn byways connected those of the present with the achievements and lessons of the past. Historic relics, these structures served as tokens of the industriousness and diligence of earlier generations. New Englanders, identified as heirs to this lineage, assumed the role of cultural caretakers, guardians of the principles on which the country was originally founded. The region of New England emerged as the nation's mythic home. Publications, such as a turn-of-the-century series known as "American Historic Towns," illustrated as well as fostered this myth of cultural identity. In the volume on New England, the author of the introduction reflected on the hold of the region over Americans: "But in due time the yearning for the hills, valleys and seacoast of rocky and rigorous New England, for the established institutions, the generally diffused intelligence, the equality of opportunity, the sane standards of worth, and the inspiring historical traditions of the early home becomes too strong to be resisted longer, and back to the homestead they come."[76] Envisioning the region as the original national home allowed everyone in a sense to become a child of New England.

At a time when critics were eager to locate national subjects, New England promoters made a bid for the region as a vital source of artistic and cultural inspiration. The 1893 Fair helped galvanize both artists and critics, preparing the way for the reception of artists such as Childe Hassam and Willard Metcalf. Resilience, rectitude, purposefulness, and zeal—these were the

qualities that viewers felt when they saw its artistic representation and that seemingly registered on the landscape itself. The 1911 volume *New England: What It Is and What It Is to Be* suggests a final turn of the wheel in which the local was collapsed into the national:

> The charm of New England lies in the fact that New England continues to be New England. Sentiment, romance, the halo of youthful memories, the sacred aspirations of patriotism, the roots of innumerable families, the tremulous first breath of universal political freedom, the motherings of a new continent . . . all of these sentiments and memories come and clamor when New England gets into the minds and hearts of the people of America, and it is then that we know that New England is a section of the land that is not to be permitted to live for and unto itself, but that it belongs to all the land and all the people of the land, and will always live in the hearts of all the people.[77]

By the early twentieth century, the region had been reinvented as more than just a geographic place. As the *New England Magazine* author suggested in 1908, New England represented "the constant flame of a spirit, the fulfilment of a great principle." New England, in short, he claimed "is not a place at all; it is a state of mind."[78] It was through their elegantly rendered work that Childe Hassam and Willard Metcalf transformed the region into a sacred space. Their visualization of a "native" landscape remains our legacy.

United States

E Pluribus Unum

With his seminal work on the significance of the frontier in American history, delivered at the 1893 Chicago World's Columbian Exposition, Frederick Jackson Turner had riveted attention on the subject of national identity and the development of national character. Nearly thirty years later, Turner took up the topic of nationhood again, but this time from an entirely new angle. By the early twentieth century, the historian had to consider a country that had exploded in population from east to west, absorbing thousands of immigrants, that had rallied citizens and entered a World War with an alliance of European nations, and, perhaps most important, that had endured as a balance of federal and state interests. In the 1920s, Turner wrote a number of essays that grappled with the conundrum of America as a union of radically diverse physical, economic, cultural, and social elements. Concerned specifically with the relationship of the parts to the whole, this new work considered the region or section as a key unit of analysis, and Turner addressed its role in national life both as a vitalizing force and as a potentially disruptive one.

In taking the region as a point of departure, Turner identified a subject that resonated not just in politics and the economy but also within the creative arts. Artists and critics through the first half of the twentieth century increasingly fastened on the importance of place as a way to make real and tangible an abstract concept like America. The work of Childe Hassam and Willard Metcalf had presented the region of New England as an incomparably American place and the source of a native landscape, but particularly during the 1920s and the 1930s, a new generation of artists turned for subject matter to multiple regions and locales across the country in an effort to further a national American art. If earlier chapters have explored the formulation of the region of New England as an exemplar for the nation, this chapter considers its unraveling and the ultimate reweaving into a different pattern.

By the mid-twentieth century, the cultural perspective on New England had shifted, se-

curing it more firmly as simply one region among many others. The expanded visual expression of American identity can be seen in the tremendous appeal, for example, of New Mexico and the Southwest among artists and audiences in the first two decades of the century along with the rise to prominence in the 1930s of the self-styled Midwestern Regionalists, Thomas Hart Benton, John Steuart Curry, and Grant Wood, who featured the rural landscapes and figures of their home states (Missouri, Kansas, and Iowa, respectively) in their work. The art and writings of the modernist Marsden Hartley, in particular, offer insight into the region-to-nation dialectic of the period and its emphasis on the regional and the local. As polarized as early twentieth-century art might seem between advocates of modernism and proponents of narrative realism, a conviction in the genuine attachment to place united artists as diverse as Hartley and the Midwestern Regionalists and critics as dissimilar as Alfred Stieglitz and Thomas Craven.

In his essays of the 1920s, Frederick Jackson Turner urged a balance between the unifying force of nationalism and regional/local distinctions, seeing that balance as vital to the continued success of the American polity. If Turner's work on the frontier from 1893 had addressed the important influences on a developing national sensibility, his essays from the twenties stood further back and directly confronted the political experiment of "united states"; how should one understand the function of geographic regions, or, as Turner called them, "sections"? In "Sections and Nation," published in 1922, and "The Significance of the Section in American History," which followed in 1925, Turner searchingly probed the constitution of American nationhood and the nature of the relationship between different parts of the country. The issue of federation loomed large in light of world war and the breakdown of European stability. In the course of his 1922 essay, Turner compared and contrasted the situation of Europe, with its nation-states along with recent attempts to found a League of Nations, to the American union of states and sections. He discussed at length regional interests in American society, showing through particular examples how those interests manifested themselves. Toward the end, Turner theorized more generally about the role of sections, concluding that:

> At the same time that we realize the danger of provincialism and sectional self-ishness, we must also recognize that the sections serve as restraints upon a deadly uniformity. They are breakwaters against overwhelming surges of national emotion. They are fields for experiment in the growth of different types of society, political institutions, and ideals. They constitute an impelling force for progress along the diagonal of contending varieties; they issue a challenge to each section to prove the virtue of its own culture; and they cross-fertilize each other. They promote that reasonable competition and coöperation which is the way of a richer life. A national vision must take account of the existence of these varied sections; otherwise the national vision will be only a sectional mirage.[1]

Turner elaborated upon the evocative notion of "a sectional mirage" when he wrote in 1925 "that there is always the danger that the province or section shall think of itself naively as the nation, that New England shall think that America is merely New England writ large,

or the Middle West shall think that America is really the Middle West writ large, and then proceed to denounce the sections that do not perceive the accuracy of this view as wicked or ignorant and un-American."[2] That position, which would try to elevate one region at the expense of the others, was a kind of nationalism, Turner maintained, that could never be viable.

The historian was not alone in this conviction. The idea of a national vision that looked to all parts of the country reverberated in the 1920s and 1930s among a host of literary critics, sociologists, and social commentators, in addition to artists and critics. Capturing, as one author put it, the "many Americas" that extended from coast to coast increasingly occupied the country's writers and artists.[3] This recasting of the relationship between region and nation, with its emphasis on multiplicity and diversity, made it increasingly difficult to sustain the claims for cultural hegemony that New England's leaders had attempted to assert particularly through the turn of the century, and that painters such as Hassam and Metcalf had persuasively rendered on their canvases. Never secure in the first place (despite the protestations of their authors), such claims by the second decade of the century could be more readily denounced as "a sectional mirage." The critic Martha Davidson spoke to this altered state of the country's cultural universe in a 1937 article that took stock of developments in American art. Noting the explosion of museums across the country, she remarked that their wide distribution "is rapidly replacing the earlier domination of the Northeast with a national system that is nurtured by vital sectors of regionalism."[4] Echoing Turner, Davidson applauded the diffusion of artistic resources and power, and the healthy challenge to any kind of geographical superiority. "Special" and "unique" could still characterize New England, but the region could no longer be considered the nation's only hearth and home. Other regions such as the South, the Midwest, and the Southwest—and the local practices, types, and approaches they sustained— equally offered a special sense of place and belonging. After the war, artists and critics (and ultimately the federal government) increasingly cultivated attachments to place across the country, eschewing any hegemonic model.

The Search for New Ground: The Example of Marsden Hartley

In 1918/1919, Marsden Hartley, the early twentieth-century writer, poet, and painter whom Alfred Stieglitz supported and exhibited, worked on a canvas entitled *The Last of New England—The Beginning of New Mexico* (Plate 4).[5] It is a curious work of art in that it conjures two different places simultaneously; two landscapes occupy a single canvas. Hartley visually compresses the geographical distance between New England and the Southwest so that in the painting the regions directly abut each other, separated only by a fence of scraggly cedar posts. The viewer is positioned just at the edge of the lush green embankment of New England in the foreground, looking out beyond into the vast expanse of the mountainous, semi-arid southwestern terrain. As the title suggests, the painting acts as something of a portal, made literal by the central gap in the fence. In following the passage over the path of logs that lead from the viewer's space, we can reach the red-roofed adobe house of New Mexico awaiting us below, its door beckoning.

Figure 58. A detail view from Marsden Hartley's, *The Last of New England—The Beginning of New Mexico,* 1918/1919, oil on cardboard, 24 × 30 in. Alfred Stieglitz Collection, The Art Institute of Chicago

Hartley's title speaks of the promise of beginnings. In this vision, the Southwest stretches out across the picture plane like an animate body, its voluptuous curves enlivened by the artist's undulating lines of paint. The seeming life force that emanates from the land of New Mexico stands in contrast to the desiccated, skeletal structure of the fence, which, like the bones of some great mastodon, extends into the air (Fig. 58). This is, as Hartley terms it, the last of New England, represented more as a historic monument, a relic of the past. While the fence in filling the foreground of Hartley's composition remains a formidable part of the landscape, another kind of place distinct from New England equally asserts itself. The northeastern region is after all largely hidden from view.

In presenting East and West together, Hartley's work captures an emerging interest in the diversity of regional experiences, and the painting proposes value in both of the regions depicted. At one level, the composition, with New England suddenly a neighbor to New Mexico, recalls the proposal of *New England Magazine* in April 1890 to redraw the map of America with New England in the center contiguous to all areas, a clear sign of its psychic and cultural potency.[6] At another more pointed level, Hartley attacks that authority, giving most of the canvas over to the Southwest and reducing New England literally to bare bones. The painting as a whole seems poised between these two sensibilities: an awe and acknowledgment of the sig-

nificance of New England and a determination to move on and discover new and seemingly more vibrant horizons.

This magnetic tension played out in Hartley's peripatetic life itself. He had been born in Maine and spent summers there through his twenties. After several years traveling and painting in Europe, he set off in June 1918 for Taos, New Mexico, lured by both the pragmatic (inexpensive lodgings, the promise of a private teaching position, and the presence of transplanted salon doyenne Mabel Dodge) and the idealistic (immersion in an exotic, native locale and contact with its indigenous Indian inhabitants). Native American traditions had already attracted Hartley's attention in 1914; during his stay in Berlin and on trips through France and Germany he saw not only ethnographic exhibitions of so-called primitive peoples from Africa, Polynesia, and Micronesia, but also displays of Native American artifacts. In November 1914, Hartley wrote to Alfred Stieglitz from Berlin in despair over the war and its human cost. His thoughts turned to a non-European, antimodern people for comfort, and he declared to Stieglitz his desire "to be an Indian—to paint my face with the symbols of the race I adore[,] to go to the West and face the sun forever—That would seem the true expression of human dignity."[7] At the end of the war, once finally in New Mexico, Hartley stayed for roughly a year and a half in both Taos and Santa Fe, then left and spent the next ten years variously in Gloucester, Massachusetts, France, and Germany.

Back in New York in 1930, he soon took flight again, spending time in Mexico and Bermuda as well as visiting Massachusetts, Maine, and Nova Scotia. After nearly a lifetime of constant travel, Hartley would in fact return to New England permanently in 1937 to establish himself as a New England artist and revel in his self-proclaimed identity as "the painter from Maine." Hartley took on this title in the essay "On the Subject of Nativeness—A Tribute to Maine" that he wrote for the exhibition catalog of his show at Stieglitz's gallery, An American Place, in 1937.[8] Later that same year, he also penned "The Six Greatest New England Painters," an article that marked out a New England tradition in painting initiated by John Singleton Copley and enlarged by Albert Pinkham Ryder and Winslow Homer. It would seem to have also functioned as a way for Hartley to set up an eminent artistic lineage to which he could be heir. The editorial note that preceded the essay implicitly made that connection in its comment that the worthy New England tradition was one "our present day schools might do well to contemplate."[9] Ultimately, Hartley, in choosing to become a New England artist, stepped back over to the other side of the fence he had depicted in his 1918/1919 canvas.

In presenting a synoptic image, *The Last of New England—The Beginning of New Mexico* transcends a conception of American identity rooted in a single region. Whether it be to New England or to a setting elsewhere in the country, an attachment to place and the sense of identity it secured proved a powerful force for Hartley as well as for a surprising range of artists in this period. Unlike many of his fellow painters, however, Hartley relied on the verbal as well as the visual to articulate these attachments. Throughout his life he wrote both poetry and prose, much of which reflected on not only his personal experiences as an artist but also the state of American painting in general. From his early essays of 1918 focusing on New Mexico to his unpublished commentaries dating to the late 1930s, Hartley's writings repeatedly take up the subject of nativeness and regional identity. Hartley asserts the importance of establishing a con-

nection to place at the same time he refuses to privilege any particular locale. Revealed in both text and paint, his experiences serve as a pathway for us into the evolving dynamic between region and nation in this period.

In one of his very early essays, "America as Landscape," Hartley stepped back to contemplate the American terrain and, like a surveyor, opened with the statement that he was "an American discovering America." Written after the end of World War I and just after Hartley had gone west, the essay reads as a combination of personal epiphany and public exhortation. The discovery he outlines is that America has its own painterly material for artists to make into something profound. While fully conversant with European modernism, having spent extended stays in France and especially Germany, Hartley expressed in his essay a determination to appreciate and render American landscape in a stylistic mode of its own. He notes that the name America can stir contemporary artists as the name Greece had once done for its poets, and he exulted: "We have come to feel the beauty of the names Kennebec, Androscoggin, Rio Grande, Atlantic, Pacific, and all the other names as meaning just as much in general and more than the names Thermopylae, Athens, etc., to our own esthetic sense. We are becoming native, and it is because these names represent our own American outlines and boundaries."[10] Hartley takes here a distinctly egalitarian approach to the American landscape. In citing two rivers in the far northeast of the country, another river in the far southwest and the two major bodies of water on either coast, he clearly stresses that painterly material in America ranges over the whole country, from north to south and east to west.

Where an artist would choose ultimately to concentrate his or her vision would, Hartley suggests in his later writings, be a result of personal experience. In a short unpublished essay, entitled "This Country of Maine," written in the late 1930s and included in what he thought of as a collection of "dissertations," he wrote that "regional response is a perfectly natural matter, everyone feels his Vermont, or his Dakota, his Texas, or whatever" and added in the next paragraph: "In any case we like our regional emotions."[11] Certainly, Hartley's sensitivity to and abiding interest in place grew out of his own personal and artistic struggles for a sense of belonging. But they also made him sympathetic and open to others' attachments to place and the importance of staying true to those attachments. Even if he didn't necessarily like the realistic form of their art, Hartley recognized a spiritual kinship with Thomas Hart Benton, John Steuart Curry, and Grant Wood, who had returned in the 1930s to their native homes in the Midwest to paint the region's subject matter and heavily promoted its representation in art. In "The Education of an American Artist," an unpublished essay from the late 1930s, Hartley lauded what he saw as their similar impulse to represent the origins of one's experience: "I believe in that movement basically however as I believe in my own return to the salt smitten rocks and the thunder-driven forests of my native Maine—as well as those majestic rivers that come down from the North Katahdin country and empty out their impressive volumes into the sea."[12] As powerful a force as Maine and the region of New England ended up being for Hartley, "The Education of an American Artist" in particular underscores that what really mattered was not the glorification of a specific locale but the genuine and authentic connection of the artist to some place.

Having found his native center, Hartley championed the idea of a local or regional identity

as the basis for great art in America as well as in Europe. Renoir, Monet, Rembrandt, Munty, Masaccio, and Piero della Francesca, he declared, "were all regionalists expressing vital regional essences." Hartley singled out Cézanne too, who had returned later in life to his birthplace in Provence and in Hartley's estimation was "its best interpreter as it was the source of his basic natal and prenatal experience." The art of these artists, Hartley implied, was profound not because of its local subject matter but because these artists recognized an authentic local emotion and stayed true to it. At the end of "The Education of an American Artist," he offered a prescription for contemporary Americans: "It is naturally up to every artist to refrain from fashionable eclecticism and strike out for the valleys and the mountains of his own private originations—and when that is done we shall have something."[13] An artist's pursuit of "originations" or a sense of nativeness, in the way Hartley used the term, did not mean cultivating some kind of provincial exclusivity, however. A recognition and embrace of one's felt roots were only the starting point for any meaningful creativity, and not an endpoint in any sense.

Hartley argued throughout his work that an artist needs to be aware of his or her local origin yet produce work that is not reducible to it. As the Hartley scholar Gail Scott remarked in her commentary on a late essay of Hartley's: "Although he was proud of being recognized in Maine as a genuine regional artist, he accepted the honor gratuitously and did not want his paintings to be classed as merely a local expression."[14] In an odd way, Hartley's belief in local attachments meant he had to face a strikingly similar issue to the one Frederick Jackson Turner confronted in his examination of national identity, that of the relationship of the part to the whole. For Hartley the question in artistic terms concerned the relationship of the particular to the universal, how to paint local subject matter with universal significance. Hartley tried rhetorically to tease out this tension in his essay "Is There an American Art?" in which he posed the idea: "Art itself is without a country in the strict sense. It is only localized when the artist has arisen in whatever locality, proving his unquestionable localism."[15] In his phrasing of the last sentence with its focus on emergence and development, Hartley points to the role of the local as simply a source of artistic inspiration and grounding. As if to insist that it cannot be any more than that, he concluded the essay by firmly deemphasizing the importance of the particular: "No one need be victim of place, for any place is all there is—it being the world where all life lives, and no American, not any real one, can be anything but American no matter where he is" (200).

Hartley implies in "Is There an American Art?" that there are two roads to failure for an artist: the first is to begin and remain local without ever transcending the particular; and the second is either to forget or to deny one's origins in the pursuit of great art and lose a sense of who one is, that is, where one is from. Success depended on striking a balance between these two extremes. For Hartley, truly meaningful art grew out of an artist's authentic and sincere connection to place, and that genuine encounter was the path to balance. Cultural worlds apart, the artist and the historian shared a difficult problem: how to integrate the personal, the regional, into a larger universe, be it aesthetic, national, or a combination of both.

Through both his writings and his continuous traveling, Hartley worked to come to terms with his aspirations for art and to find those places that represented for him a sincere engagement. In a piece from the 1920s, which he included in an unpublished collection of essays en-

titled *Varied Patterns,* he named the three sections in the world that he was most in love with: Provence in France, Maine/New England, and New Mexico and the Arizona country.[16] Though a seemingly eclectic assortment, each place speaks to the notion of an origin of experience, as Hartley called it in "The Education of an American Artist." Hartley arrived at Provence by way of Cézanne, whom he greatly admired not only for his aesthetic sensibility but also for the French artist's affirmation of and commitment to his regional identity. Hartley located his own nativeness in Maine and New England, the place of his birth and his formative experiences. Whatever role financial and social pressures may have played in getting him back there in the 1930s, his return launched an especially productive and successful creative period, fulfilling the critic Paul Rosenfeld's 1924 prophecy that until Hartley went back to the down east country, he would not truly find his own artistic soul.[17]

Hartley's attachment to the American Southwest might seem less obvious, since he was there for only a brief period and clearly expressed in letters to Stieglitz and others his discomfort and frustration with the Anglo community he encountered.[18] But the centuries of settlement in the region and its non-European population seized his imagination. For Hartley, as well as for a whole generation of American artists particularly after the First World War, the Southwest alluringly held out the promise of a profound connection, a local experience that seemed to have national import. In conveying both a strong sense of rootedness and a tangible indigenous history, the region offered an alternative sense of home from the one posited by New England.

The Lure of the American Southwest

In 1912 New Mexico became a state, attaining full and official status in the Union. Two major art colonies, one in Taos and the other in Santa Fe, sprang into existence and the heady list of artists who eventually made their way southwest included Marsden Hartley, Robert Henri, Andrew Dasburg, Victor Higgins, John Sloan, Dorothy Brett, Ward Lockwood, Georgia O'Keeffe, and John Marin. Many, particularly those individuals leaning toward abstraction, were encouraged by Mabel Dodge (Luhan), who, with her move to Taos in 1916, established a southwestern literary and artistic salon there. By 1920, artists of all aesthetic persuasions clamored for access to what appeared, and was effectively promoted as, a kind of mythic site, an idyll of pristine landscape and preserved native peoples and traditions. Reflecting on the pull of Taos for artists in this period, Kenneth Adams, who was the last member to join the Taos Society of Artists before its dissolution in 1927, commented: "I think I might say it was love: love that had in it elements of reverence for the awe-inspiring grandeur of the mountains, expanse of cultivated fields and desert, and that simple 'rightness' of belonging that characterizes the Indians and the Spanish-American inhabitants of the Valley."[19]

It is this notion of a "rightness of belonging" that merits special attention not only because artists and writers repeatedly talked about the region and its inhabitants in terms that evoked this idea but also because the emerging vision of the Southwest as a source of origins helped to loosen the claim of New England as the only national home. The consistent pattern to the

descriptions of New Mexico suggests just how much the Southwest offered a renewed sense of origin, especially one that seemed to match up to the place of the country's founding, the region of New England. A counterpoint to New England's early Puritan/Pilgrim founders—commemorated so enthusiastically in late nineteenth-/early twentieth-century art and in the Colonial Revival movement—one could find in New Mexico, another set of "original" Americans, but in this case living.

The founding of the Taos art colony had itself something of a mythic aura to it. Ernest L. Blumenschein (1874–1960), the painter who was one of the colony's founders, told a story that emphasized a longer, more continuous history than facts suggest. Only in the mid-teens with the establishment of the Taos Society of Artists, for example, did the colony gain official recognition. Before that, most of its members were not even regularly in the area and only loosely affiliated with each other. Nonetheless, Blumenschein's narrative dates back to 1898, when he and Bert Phillips (1868–1956), friends from the Académie Julien in Paris, reconnected in America. Desiring "fresh material" and "ennuied with the hackneyed subject matter of thousands of painters," as Blumenschein put it in "Origin of the Taos Art Colony," they arrived out West and set off on a journey to Mexico traveling through Colorado and the Rockies.[20] After some time they made it to New Mexico, where a broken wagon wheel interrupted their progress and led them to Taos to make the necessary repairs. They were awestruck by the landscape. "Never," Blumenschein recounted, "shall I forget the first powerful impressions; my own impressions direct from a new land through my own eyes. Not another man's picture this, not another's adventure" (191). At that point, they decided that they "had found what [they] had traveled long to reach" (192). Phillips immediately established residence in Taos. Blumenschein, however, returned to commitments in Paris and New York, and only around 1910 started spending the summers partly in Taos. In 1919 he finally moved there year-round, although, as he told it in "Origin of the Taos Art Colony," he and Phillips back in 1898 "abandoned the idea of going to Mexico, sold the horses and wagons, moved into an adobe house—and then and there began the Taos Art Colony" (192).

In fact, the colony started out with six members, most of whom slowly worked their way to Taos. Joseph H. Sharp, Oscar E. Berninghaus, and E. Irving Couse summered regularly in the area starting in the early 1900s before they permanently settled there, Sharp in 1912, Berninghaus and Couse by the mid-1920s. W. Herbert Dunton arrived in 1912. As the Taos Society of Artists, they wouldn't really all come together until at least 1912 and would only have their first official exhibition in 1915. In his "Origin of the Taos Art Colony," Blumenschein compressed time (and people) again when he somewhat proprietarily insisted: "it doesn't matter if five or six artists had visited Taos before our arrival. They had nothing to do with this colony" (192). Blumenschein's story played up the "discovery" of Taos. It also cast Blumenschein and Phillips and the critical mass of artists they helped bring together in the role of pioneers, a description actually used at the time.[21] That identification allied them with earlier discoverers and colonizers of New England, notably the Pilgrims and the Puritans. It updated for the early twentieth century that original story of stalwart settlers.

Taos and Santa Fe, in many ways in this period, constituted a pilgrimage site. Artists and writers came to partake of the sublime landscape and the ancient native culture it sustained.

In what appeared as the region's deep American roots, they sought creative inspiration and a rejuvenating contact with nature. In Mabel Dodge Luhan's estimation, "the poets have sensed already its [the Southwest's] positive psychic polarity and have called Santa Fé 'the spiritual centre of America.'"[22] Dodge Luhan, after arriving in Taos in 1916 (marrying shortly thereafter Tony Luhan, a Pueblo Indian), drew in her wake a coterie of artists and prominent poets and authors, including Mary Austin, D. H. Lawrence, Willa Cather, and Jean Toomer. Their presence and their promotion of the area eventually inspired Paul Rosenfeld, the art and music critic and close friend of Alfred Stieglitz, to venture west in 1926. He traveled by train to New Mexico from New York and wrote about his journey in "Turning to America: The Corn Dance," a version of which was originally published in *The Dial*. His dramatic, almost histrionic, prose conveys the kind of transfigurative experience the region could produce. Leaving the plains, he wrote of how his imagination had entered into the unknown: "The span it leaped in the mountainy desert was wider, more comprehensive, and more robustly affirmative; starting with fantastically strange sensations and finding a profoundly germane core." Marveling at the colors and formations of the landscape before him, he suddenly grasped the significance of this southwestern vista: "Midmost the continent, New Mexico lay about me, its penetralia; at once the sacred essential point of the land, where it was most itself; and the mysterious projection of a long dormant idea. I kept repeating, 'The most American place,' knowing nothing precisely through the words and yet finding expression in them."[23] In Rosenfeld's essay, the land and its inhabitants are revealed as the true heart and soul of the country, offering the promise of redemption for a postwar, spiritually enervated generation. The essay closes with Rosenfeld watching the corn dance of the Pueblo Indians, his anxiety about the modern condition—its hyper-individualism, over-industrialization, and materialism—swept away by an affirming spirit, "summoning joy of certainty and offering [one] life and a prime criterion" (235).

Despite his somewhat hyperbolic prose, Rosenfeld expressed a typical response to the southwestern environment, and his description articulated some of the basic ideals imagined and promulgated by white Americans about Pueblo Indian society and what the region and its native inhabitants seemed able to offer American culture. Chief among these were that the Pueblos preserved a certain timelessness and primordial connection, that their way of life produced a natural and communal harmony, and that the culture itself represented an original and authentic American source. (Of course, the need to believe in these romanticized ideals often tragically occluded the grim economic and social realities of Native American life.)

With the establishment in 1907 of the School of American Archaeology at Santa Fe and continually new archaeological finds, the region's ancient beginnings had come into striking relief. The discovery of prehistoric dwellings and primitive art effectively provided an indigenous, non-European cultural heritage for Americans, one to which artists and writers could lay claim. As one writer observed: "It is here, in one of the richest archaeological regions of the United States, that American art had its beginnings a thousand and more years ago, and where was evolved an indigenous American architecture." Earlier the author had quoted Walter Ufer, a member of the Taos Society of Artists, describing the Southwest as "rooted in aeons of time," a perception advanced by Mabel Dodge Luhan in her comment about the region's possession of "an archaic past. Still alive there and ruling the ether."[24] This sense of the pres-

ent infused with a rich and vibrant past, a commingling of modern and traditional elements, was enormously seductive to cultural figures of this period. Robert Henri, the New York-based realist painter and nominal leader of the Ashcan School whose visit to Taos in 1916 proved so inspirational that he persuaded fellow painters John Sloan and George Bellows to visit also, perhaps summarized best this almost magical power of the Southwest when he wrote: "There in the pueblos of New Mexico the Indians still make beautiful pottery and rugs, works which are mysterious and at the same time revealing of some great life principle which the old race had. Although some hands lead, the whole pueblo seems responsible for the work and stands for their communal greatness."[25] With its active preservation of tradition, Pueblo culture, I suggest, not only filled a vacuum left by what was increasingly perceived on the part of a white cultural elite as a bankrupt Puritan legacy, but it also, as Henri admiringly noted, seemed to offer a model for the enhancement of community spirit.

The notion of communal harmony resonated for a generation disillusioned by the calamity of world war. None was more effusive in this regard about the Pueblo Indians than the writer Mary Austin, who proclaimed: "This is the only society in the world in which culture exists as an expression of the whole, unaffected by schisms of class and caste, incapable of being rated in terms of power or property."[26] When Ernest Blumenschein first wrote about Taos in 1917, around the time of the United States' entry into the war, he made a point of mentioning that the Pueblo Indians had over the centuries developed a democratic political system. Edgar L. Hewett, the director of the School of American Archaeology at Santa Fe (later the School of American Research) and the Museum of New Mexico, similarly pointed this out in his influential volume on the American Southwest. In language reminiscent of what New England leaders had earlier claimed about their region's soil producing worthy men and women, he stated that American Indian government was "always of a representative type. The race took its character from the soil."[27] Pueblo Indian social organization was held up as a model of an ideal communal structure, and ceremonial dances like the corn dance appeared to viewers as perfect embodiments of the relationship between the individual and the collective. Marsden Hartley, who was entranced by these rituals and devoted four essays to analyzing them, captured this ideal when he summarized the Indian dancer as "the leading soloist and auxiliary in one."[28]

Hartley's comment could apply to the regional/national configuration of the United States itself. If one took Pueblo ritual dances as a model, then communal stability and, at the broader level, national harmony were achievable through the balance of parts. Mabel Dodge Luhan suggested as much when she posited that the Southwest would yield "the synthetic American culture we have all desired."[29] Characterized as one with nature and each other, linked to a prehistoric past, and grounded in democratic principles and a sense of beauty, Pueblo Indians seemed to correspond perfectly to the needs and concerns of leading early twentieth-century cultural figures. Hardly surprising then to find the Pueblos and other of the Indian tribes of New Mexico acclaimed in this period as the "first Americans." Raymond Jonson echoed Edgar Hewett among others in his defense of Santa Fe as a site of origins. Responding to a Chicago critic's objection to his more abstract painting style and to the problem of Chicago artists "running away" to Santa Fe or other "even more romantic and un-American" places, Jonson declared: "In truth, this is the site of the real American—the original one."[30] With its compelling

art, its history and rituals, what better culture than that of the Pueblo Indians to take the place of the worn-out, tired Puritan/Pilgrim legacy?

Like Hamlin Garland, who had called on American artists to find local subject matter, Hartley, in his 1918 essay "America as Landscape" rallied his generation to truly engage with American subject matter. He urged them to get beyond not just the faddish but also the traditional, and in this regard, he, unlike Garland, specifically exhorted fellow artists to look beyond New England: "Something must take the place of the America, of New England, in all our ways, esthetically speaking. . . . America is growing up and the artists are slow in recognizing it."[31] The Southwest appeared as one of those new places. And it could assume that position because Hartley and so many other artists imagined the region as a pristine, original place, whose unspoiled landscape and pure inhabitants would in turn stimulate an original creativity on the part of the artist. This conviction depended of course on a rather superficial and selective awareness of the region's history, its relations with Spain and present-day Mexico, and its multi-ethnic background. In addition to the Taos Pueblo Indians, there were the Hopi and Zuni Indians, as well as a non-Indian, Spanish-speaking population, and these cultures intermingled. The Pueblo Indian corn dance, for example, which inspired so many artists and writers, was itself a mix of Christian and Indian practices.[32]

That the reality of the Indians' history and circumstance had such little bearing on the perception of the region suggests the power of the Taos/Santa Fe mystique. To the outsider, the Indians went about their work, in the words of a *Scribner's Magazine* author, "in their old accustomed ways, unchanged and practically untouched by centuries of contact with the white man."[33] Like that author, artists found the idea of native peoples in a pristine state thrilling, particularly in what they could offer aesthetically. As Victor Higgins, one of the members of the Taos Society of Artists, maintained in a 1917 newspaper article: "The Taos are a people living in an absolutely natural state, entirely independent of all the world. . . . Being so completely the product of their surroundings, they give the painter a host of fresh and original ideas."[34] In the Anglo myth of the Southwest, contact produced two desirable results: freedom from undue European influence and American originality. If, as Hartley argued, the Indian was "the one truly indigenous religionist and esthete of America," then he could deliver contemporary American art to new heights.[35] In the Southwest, another "native" landscape came into view, an alternative to the one pictured on the canvases of Childe Hassam and Willard Metcalf.

By 1920, the Taos Society of Artists—which counted the six founders Berninghaus, Blumenschein, Couse, Dunton, Phillips, and Sharp, along with Victor Higgins, Julius Rolshoven, and Walter Ufer among its active members—played an important role both in attracting artists to the region and in presenting New Mexico–focused artwork to a national audience. Having come together to support and promote their artwork, the members organized every year, from 1915 until the society's dispersal in 1927, exhibitions that toured coast to coast. The Secretary and Treasurer's Report for 1917, for example, mentioned two shows that had made a tour of American cities such as New York, Boston, Chicago, St. Louis, Des Moines, Denver, Pasadena, and Salt Lake City. It also stated that the pictures in these shows had met with warm appreciation and that it was impossible, given all the advertising, that there could be a person in the whole country who had not heard of Taos and its painters.[36] In 1924 Dallas was on the

exhibition circuit, and the *Dallas Morning News* reported that the Taos Society of Artists had brought "an encouraging message . . . to those loyal supporters of American art who have been watching the 'swinging pendulum' and speeding the day that would find a great national spirit surging on this side of the Atlantic."[37] In addition to organizing annual traveling shows, the Taos Society of Artists participated in national expositions such as the Panama-Pacific of 1912 and regularly sent members' work to juried exhibitions sponsored by major museums and art institutions like the National Academy of Design in New York.

Much of their work met with great success and often garnered prestigious prizes; Ernest Blumenschein, Martin Hennings, and Walter Ufer, for example, all received major National Academy of Design awards. Ufer was also awarded the Pennsylvania Academy's Temple Gold Medal in 1923; Irving Couse won the Lippincott Prize in 1921. Taos artists showed frequently at the Academy and, as the institution's archivist has noted, "seem to have been more popular at least with local critics and the public than other regional artists."[38] Prolific and committed painters, society members succeeded in generating broad appeal for New Mexico's landscape and peoples. Although Blumenschein, Higgins, and Ufer experimented with abstract techniques, on the whole the Taos Society artists leaned toward figuration and realistic scenes with Indian figures and depictions of Indian customs and practices making up most of their subject matter. In *Sangre de Cristo Mountains,* for example, Blumenschein depicts a local ritual in a clearly defined setting. But he also concentrates attention on the painting's overall geometric pattern, the rounded forms of adobe buildings, the arched massing of figures in the foreground, and the soft, undulating mountain ridges that roll away into the distance (Fig. 59).

The attention to portraiture, and to realistic depiction in general, no doubt contributed to making their art accessible to a broad public and appealing to more conservative art institutions. Mabel Dodge Luhan in her 1947 book, which detailed the life and work of about thiry-four Taos artists, including those of the Taos Society, pointed out how many of them had their art hanging in numerous museums across the country and in private collections and that their names had become familiar to all.[39] While perhaps less well known now, given the dominance of abstraction through the second half of the twentieth century, the work of society members and those loosely affiliated with them was as important in bringing New Mexico more directly into sight as the celebrated modernist paintings of Marsden Hartley, John Marin, and Georgia O'Keeffe, artists of Stieglitz's circle who were equally drawn to the landscape of the Southwest.

Of the three, it was O'Keeffe who succeeded brilliantly in translating the region's spirit of place into a national image. By the time O'Keeffe settled permanently in New Mexico in 1949 after years of visiting in the summers, she had attained legendary status as an American painter. What Hartley outlined in his writings—and particularly in his c. 1938 essay "Is There an American Art?"—about the simultaneous importance of origins of experience and the need to rise above the local, O'Keeffe managed to achieve on canvas. To use Hartley's formulation, precisely because of O'Keeffe's authentic encounter with the Southwest, her art transcended geography, while retaining a local essence. Hartley addressed this almost alchemic process in his 1936 piece "Georgia O'Keeffe: A Second Outline in Portraiture." Inspired by an exhibition of O'Keeffe's southwestern bone pictures, he used the example of a ram skull painting to describe what he

Figure 59. Ernest Blumenschein, *Sangre de Cristo Mountains,* 1925, oil on canvas, 50 × 60 in. The Anschutz Collection; photo by James O. Milmoe

saw as "a transfiguration—as if the bone, divested of its physical usages—had suddenly learned of its own esoteric significance, had discovered the meaning of its own integration through the processes of disintegration, ascending to the sphere of its own reality, in the presence of skies that are not troubled, being accustomed to superior spectacles—and of hills that are ready to receive."[40] O'Keeffe transformed her canvases into "superior spectacles," striking that fine balance between the particular and the grand through, significantly, the departure from a literal transcription of place. Neither completely abstract nor entirely representational, her images occupy a border zone where forms correspond to identifiable objects such as bones or bodies but at the same time create, as Hartley observed, their own reality.

O'Keeffe's pictures simultaneously engage external representational content and internal formal design. In *Ram's Head, White Hollyhock-Hills (Ram's Head and White Hollyhock, New Mexico)* from 1935 (Fig. 60), a clearly rendered ram's skull confronts the viewer, challenging perspective as well as gravity; not only is the skull pressed up against the picture plane, stretched across the surface, but it hangs, along with a stemless flower, freely suspended above small tufts of earth that seem both faraway and close by.

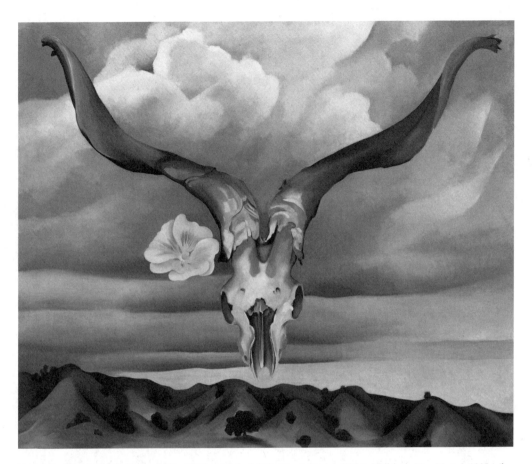

Figure 60. Georgia O'Keeffe, *Ram's Head, White Hollyhock-Hills (Ram's Head and White Hollyhock, New Mexico),* 1935, oil on canvas, 30 × 36 in. Brooklyn Museum. 1992. 11.28. Bequest of Edith and Milton Lowenthal

One of the ways O'Keeffe destabilized representational content was often to eliminate recognizable context, for instance, of figure/ground relationships or perspective. Unmoored from the familiar or expected, forms took on a life of their own in her paintings in such a way that they could be read in abstract terms or in figurative terms, easily oscillating between both. In the use of biomorphic shapes, *Grey Hill Forms* (Fig. 61), for example, seems to metamorphose from arid landscape to supine body, the viewer positioned at the base of a huge, sprawling torso. By contrast, both Marin and Hartley stayed much more securely bound to a traditional landscape format. In O'Keeffe's work, enough details—a skull, a red-earth hill—signal locality, but her images focus on a dialogue among forms.

O'Keeffe's tremendous success is instructive next to Hartley's more modest acclaim. Following the warm reception of his 1932 show, "Pictures of New England by a New Englander," Hartley made the decision to fashion himself as the painter from Maine, and his canvases until his death in 1943 concentrated on the landscape and figures of that environment rendered

Figure 61. Georgia O'Keeffe, *Grey Hill Forms,* 1936, oil on canvas, 20 × 30 in. Gift of the Estate of Georgia O'Keeffe, University of New Mexico Art Museum, Albuquerque

in an expressionistic style. Unlike Hartley, O'Keeffe never pushed to identify herself as the painter from New Mexico despite her profound identification with the region. If anything, so successful was she in transcending the local that New Mexico became associated with O'Keeffe rather than the other way around. O'Keeffe's triumph derived in part from the unique aesthetic she employed. It was a kind of abstraction that, while it relied on an integrity of form, conjured the spirit of place more than it depicted it. Her work pointed the way to a new vision of American identity in art, one that no longer depended on the literal representation of the specific locale but aimed to evoke it symbolically instead. Hartley and Turner had both addressed the tension inherent in the relationship of the part and the whole, the individual and the collective, the region and the nation. By moving almost effortlessly between the realistic and the non-representational, O'Keeffe's southwestern paintings promised for the first time a resolution of those inherent tensions. They did so by emphasizing American nationhood as fundamentally inclusive.

Region to Nation

The interest among artists and writers in regions outside of New England and the Northeast, as illustrated by the prominence of the Southwest in the art world, gained increasing mo-

mentum through the thirties. Initiated most avidly in literature and the social sciences, the concept of regionalism identified regional diversity as an essential component of American nationhood. Although loosely organized and operating with disparate methodologies (much like the multi-varied local and regional experiences they championed), regionalist proponents shared a fundamental conviction in the importance of a local or regional consciousness for modern life. The regionalism of the twentieth century, Lewis Mumford explained, "in contrast to the belligerent nationalism of the nineteenth century, is not only compatible with a general culture, but an essential element of it. . . . It is precisely because no region can live to itself that each must have a firm center of its own, since intercourse and reciprocity can take place only between equals," and he concluded, regionalism "is a contemporary issue, not a matter for pious antiquarianism; or rather, all that is legitimate in folklore, historical curiosity and regional pride will thrive best when they are taken not as escapes from contemporary fact, but as contributions to a living culture."[41] Promoters found in the local and the regional an animating force for individuals and communities and envisioned a dynamic relationship between region and nation. A concrete sense of place could give tangible feel to an elusive American identity. Like Turner, advocates stressed regional awareness not as an end unto itself but as a conduit to a more profound national sensibility: regionalism endorsed cooperation over exclusivity, unity over separateness. Howard Odum, one of the foremost regionalist voices in sociology, talked about the culture of the United States as being more than the sum of its parts and asserted that "the organic union of the nation is found in the continuing rediscovery and reintegration of its regions."[42]

A diverse array of cultural figures in the interwar years tackled the question of what exactly was to be rediscovered and how. As Robert Dorman has shown, the regionalist enterprise ranged from folklorists such as B. A. Botkin, who edited a number of volumes entitled *Folk-Say: A Regional Miscellany,* to urban planners like Lewis Mumford, to environmentalists and economists, and to writers and poets, including Allen Tate and Donald Davidson of the Southern Agrarian circle. On the art scene, Benton, Curry, and Wood were the group most closely identified with the movement and the most nationally visible. Regional advocates across this spectrum of disciplines and interests all sought a counter-force to the modern drive toward centralization, standardization, and urbanization. In the words of Dorman, the region was "programmatically envisioned to be the utopian means for reconstructing the nationalizing, homogenizing urban-industrial complex, redirecting it toward an accommodation with local folkways and local environments."[43] In the aftermath of the First World War and the extreme dislocation wrought by the stock market crash of 1929 and the ensuing years of the Depression, the regionalist proposal for a genuine attachment to place and a building of local solidarity resonated deeply. By the 1930s, intellectuals, writers, and artists were finding America all over the place.

In de-centering a singular notion of American nationhood, regionalism effectively made every locale part of the larger collective. In the art world, regional exhibitions proliferated. As one arts editor mused in 1934, "critics and even museum directors are talking about 'regionalism' instead of 'periods.'"[44] The *Art Digest* called attention to this new phenomenon by devoting its entire February 1937 issue to the topic, a novel occurrence as Peyton Boswell made

clear in his editorial comment; the magazine had never before focused an issue on one theme. Ten years ago, he said, such a thing would have been impossible but at the moment, regional exhibitions were at "their zenith," and were something to support and encourage since, in Boswell's opinion, a mature national art depended on the "intense cultivation" of every region.[45] Three years earlier in 1934, the Whitney Museum of American Art had inaugurated an exhibition series to highlight different parts of the country, although the museum tended to identify regions with major cities and their environs. The first show featured Chicago artists, the second, in November 1934, Philadelphia artists. Reporting on the November opening, the *Art Digest* had described the series as "presenting, one by one, concise statements of the various tendencies of contemporary painting as produced in different localities throughout the country." The article went on to quote the Whitney's director, Juliana Force, who underscored the importance of showing living local artists because they were, regardless of their stylistic modes or European influences, "an integral part of the artistic life of their community."[46]

Force's series and the interest in regional exhibitions in general registered not only a growing interest across the country in art—including the establishment and growth of new art museums such as those in Kansas City, Seattle, and Dallas—but also an energetic pursuit of American subject matter and art that conveyed an indigenous sense of place. Critics such as F. A. Whiting, Jr., applauded this self-determination, which in Whiting's blunt view was spurred on by the Depression: "Apparently the depression that relieved us of our commercial and financial cockiness relieved us also of our spiritual dependence."[47] Forced away from European models and influences, American artists could stay focused on the unique and compelling features of their own locales. The impulse that looked to all parts of the country for artistic inspiration transcended genres and styles. In attempting to make sense of the vast variety of artwork being produced, Martha Davidson could only conclude in 1937 that the "one great national motivation" was a "turn to Americanisms."[48] To demonstrate this new and expansive interest in the diversity of American subject matter, she went on to describe artists ranging from anecdotal realists to formal abstractionists, aesthetic approaches as different as those practiced by Thomas Hart Benton and Georgia O'Keeffe.

In the context of this broad regional renaisssance, it is hardly surprising to find Alfred Stieglitz opening a new gallery, An American Place, in 1929, which was the third and last of his exhibition spaces; the first, "291," ran from 1905 to 1917, his Intimate Gallery from 1925 until 1929. In its very name, An American Place embraced the entire country. It could be anywhere, or indeed everywhere, and stand for any place in America. Even the physical design of the gallery corresponded to the regionalist ideal of the whole made up of equal parts to form a harmonious organic union. Dorothy Norman, author and eventual gallery manager for Stieglitz, described An American Place as "divided into well-proportioned rooms of varying sizes, each almost square in shape. There are thresholds without doors, the rooms leading one into the other without barrier."[49] She also remarked on the fluid medium of light, which, coming in from the windows and reflecting off the gray and white walls, unified the space. Stieglitz, a dedicated New Yorker, located An American Place, like all of his galleries, in Manhattan, but the artists he chose to promote represented a range of locales and sites.

An American Place extended the purpose of Stieglitz's Intimate Gallery to nurture and pre-

sent to the American public American artists, artists who, one might say, had the ability to convey a "passionate yearning for spontaneous union with the quick of livingness," to use the writer Edna Bryner's description of Stieglitz himself.[50] In practice, that ended up being a very small group. In March 1925, just prior to opening the Intimate Gallery, Stieglitz singled out seven. The exhibition, *Seven Americans*—"159 Paintings Photographs and Things recent and never before publicly shown," featured the work of Arthur Dove, Marsden Hartley, John Marin, Charles Demuth, Paul Strand, Georgia O'Keeffe, and Stieglitz himself. Through the 1930s, An American Place would continue to highlight this small band of artists. Characteristic of their work, and what seemed to have drawn Stieglitz to them, was a devoted attempt to transmit to paper or canvas the experience of an authentic encounter with a specifically American place or subject, wherever or whatever that might be. Stylistically, the work of these artists varied dramatically, but a focus on abstracted forms and landscape elements often typified their attempts to express visually the felt experience of place.

In taking on a small circle of artists, Stieglitz conjoined focus with grand vision, and his mission to cultivate an independent American art swept along a set of evangelizing critics, among them Paul Rosenfeld and Waldo Frank. Through their essays and reviews, they amplified Stieglitz's aims, elaborating on and publicizing the importance of indigenous artistic expression. Rather obsessively, Stieglitz and his circle promoted their art as being rooted in America. To that end, as Wanda Corn has shown, their rhetoric was rich in words like "soil," "spirit," and "place," used, however, quite loosely and without any specific referent.[51] The contemporary art critic Elizabeth McCausland most eloquently expressed the essence of this "spirit of America" fervor in her contribution to an essay collection in honor of Stieglitz entitled *America and Alfred Stieglitz: A Collective Portrait,* published in 1934 and which, according to the editors, stood less as a tribute to Stieglitz than a testament to what was possible in the development of American art. Using Marin, Dove, and O'Keeffe as examples, McCausland dilated on Stieglitz's belief in the principles of beauty and freedom and argued that it was the support of these ideals that allowed an original and indigenous American art to flourish:

> Here freedom does not produce anarchy or lawless self-indulgence; it does not lump three diverse lives under one subhead: *homo americanus;* it does not sacrifice universal or human truth for an easy nationalistic imprint. It does, however, permit these splendid workers to live under the American sun, sucking up strength from the American soil, rooted in the American earth, beating in time with the American tempo, each achieving that special and individual happiness for which in the American mind liberty is the antecedent condition.[52]

McCausland's paean echoed the view of many of Stieglitz's enthusiasts that he above all promoted American creativity and originality.

An American Place, however, while it certainly asserted the importance of America, left the specific geography purposefully vague. Thus, while Stieglitz and his coterie of artists and writers may have favored the non-narrative and abstract in art, their emphasis on native experi-

ences and genuine encounters did not dictate a specific or predetermined regional focus or locale. Stieglitz himself relied on Manhattan and Lake George, New York, for artistic material. Georgia O'Keeffe turned increasingly to the Southwest having worked in New York City and painted its architecture. Dove moved to his family farm in upstate New York while Demuth came to focus on his hometown of Lancaster, Pennsylvania. Although the Southwest repeatedly called to Hartley and he wrote about wanting to return, he ended up in his native Maine. Marin gravitated to New England by way of New Jersey.

Of Stieglitz's group, Marin and O'Keeffe in particular enjoyed steady critical acclaim. Reviewers responded with excitement to the way both these artists conjured a spirit of place without resorting to literal transcription. As Martha Davidson declared of John Marin in her 1937 article "New Directions in Native Painting," his genius lay "in his ability to abbreviate nature and yet maintain its inherent character and peculiar identity."[53] Paul Strand had earlier identified Marin as an artist who "transports us veritably into his places," while Paul Rosenfeld in *Port of New York* had characterized Marin as "fast in American life like a tough and fibrous apple tree lodged and rooted in good ground."[54] Even the critic Thomas Craven, who later violently opposed Stieglitz and his circle of artists, had admired Marin's work, writing in a 1924 review for *The Nation* how the artist's "poetical concern with trees, waves, and skies is charged with solid conviction, with the desire to project meanings into his pictures." In his 1934 volume of *Men of Art,* Craven had cited both Marin and O'Keeffe as significant and important American artists.[55]

Despite the common aspirations among artists and critics for a nationally meaningful art, tensions about its representation and its organization did erupt. In 1934, a heated debate broke out between Stieglitz, a leading proponent of modernism, on the one hand, and Craven, an advocate of narrative realism, and Thomas Hart Benton, a muralist and Midwestern realist painter, on the other. Like Stieglitz, Craven and Benton (along with fellow Midwestern artists Wood and Curry) championed artwork that engaged notions of rootedness, community, and authentic expression. But unlike Stieglitz and his circle, they strenuously promoted a representational, narrative art over modern abstract idioms, and strongly encouraged decentralized artistic networks. In the mid-1930s both sides of the debate produced publications asserting their points of view; the edited volume by Waldo Frank, Paul Rosenfeld, and Lewis Mumford among others, entitled *America and Stieglitz: A Collective Portrait* (1934), essentially valorized his art world prominence and his aesthetic convictions, while Craven in *Modern Art* (1934) specifically attacked Stieglitz's modernist preferences and absolutist leadership in the arts. In early 1935 Benton wrote a review further excoriating the Stieglitz volume for its unjustifiably elitist tone and adulatory rhetoric.[56] While the flare-up between Stieglitz and Craven and Benton involved serious disagreement about stylistic approach, it also brought into play the potent issues of aesthetic hierarchy and hegemonic authority, both of which were antithetical to regionalist ideals of the 1930s. Above all else, regionalism, as pursued by social scientists and writers as well as by the Midwestern artists, stressed equality among parts and the diffusion of power.

Opposed to what they perceived as Stieglitz's New York–based authority and his overly European influences, Benton, Curry, and Wood held up the midwestern landscape as particularly native and worthy of serious attention, and they advocated a realistic, figurative approach to

subject matter. By the early 1930s, they had major, well-received exhibitions throughout the country; Curry, for example, showed his *Baptism in Kansas* at the Corcoran in 1928, while Wood showed *American Gothic* at the Art Institute of Chicago in 1930. Benton had embarked on several major mural projects including panels for the Whitney Museum of Art and the New School of Social Research. In December 1934 he landed on the cover of *Time* magazine as part of a feature article entitled "U.S. Scene." The magazine highlighted Benton, Curry, and Wood along with Charles Burchfield and Reginald Marsh, celebrating all of their artwork as indigenous and liberated from French art movements. It affirmed the art dealer Maynard Walker's assessment in 1933 when he enthused: "One of the most significant things in the art world today is the increasing importance of real American art. I mean an art which really springs from American soil and seeks to interpret American life. . . . And very noticeably much of the most vital modern art in America is coming out of our long backward Middle West."[57] Both articles, along with the writings of critics like Thomas Craven and Peyton Boswell, Jr., that forcefully called for the development of native traditions in American art, further reinforced regional expression as essential to a national artistic identity. Equally important, it spotlighted another region of the United States, the Midwest, underscoring further the receding importance of New England.

New England was seen in fact to pose somewhat of a cultural liability. Earlier in the century, as we saw in chapter 2, critics including Van Wyck Brooks, reacting to the long-running spiritual hegemony of the Puritan tradition, had deemed New England's heritage ill equipped to meet the needs of a large nation, unable, as it was, to offer a "usable past."[58] In the mid-1930s Benton and Wood both articulated that part of the problem with an older, entrenched region like New England was its strong connection to Europe and European traditions. The Midwest's relative youth, its remove from Europe and a colonial past, elevated all the more the contributions this region could make to American art. The Midwest, as Benton remarked in an interview, "never had a colonial psychology, that dependent attitude of mind which acts as a check on cultural experiments motivated in the environment."[59] Wood elaborated on this point in "Revolt Against the City," an essay he wrote in 1935 laying out his convictions that a real American art needed to come from a widespread focus on local material and "the development of regional art centers." To that end, he asserted that the contemporary American artist had to resist not just French influence in particular but "the whole colonial influence which is so deep-seated in the New England states."[60] With Craven as their tireless promoter, Benton, Curry, and Wood reproduced in paint dynamic scenes of an agrarian and rural Midwest, determined to identify the region as a vibrant cultural resource for the nation. But in Wood's "Revolt Against the City" he was also careful to give other regional painters their due: "I shall not quarrel with the painter from New Mexico, from further West, or from quaint New England, if he differs with me; for if he does so honestly, he doubtless has the same basic feeling for his material that I have for mine—he believes in its genuineness" (232). Wood made clear that he championed the regionalist movement in arts and letters but not its narrow interpretation. A commitment to regional subject matter, Wood maintained, should not translate to cultish provincialism (232). Rather, it should enable a broader awareness of America and independence from any sole aesthetic authority either within or outside of the country.

It was the federal government in the end who offered the grandest and most comprehensive regionalist vision, however, and in its concentrated support of artists throughout the country it truly turned New England into merely one of many regions. In response to the worsening economic conditions during the early 1930s, the American government launched a host of federal art programs to support struggling artists. The first, the Public Works of Art Project (PWAP), was established in 1933 and replaced in 1934 with the Section of Painting and Sculpture in the Treasury Department, which provided art funds for new federal buildings. The Federal Art Project of the Works Progress Administration (FAP/WPA), which dispersed funds for art in state and municipal institutions, came into existence in 1935. That same year the Farm Security Administration (FSA) offered another avenue of support through its creation of a project that sent photographers out into rural areas and into small towns to document American conditions. Also initiated in 1935 were the Index of American Design—a project that employed graphic artists to produce drawings and watercolor sketches of early American handicrafts such as Shaker crafts, weather vanes, textiles, basket weavings, woodcarvings, and toys—and the Federal Writers' Project. The latter sponsored "An American Guide Series," employing writers to portray the cultural and physical features of the states, cities, and towns where they lived. Guides to each of the forty-eight states of the Union were completed as well as one for Alaska.

Although federally funded, these programs favored decentralization and were maintained largely at the local level. The Treasury Department's Section of Painting and Sculpture, for example, sought out local artists to employ for work on federal buildings such as post offices from Maine to Alabama, from Massachusetts to Montana. In Portland, Connecticut, for example, Austin Mecklem enlivened the interior of the town's new post office in 1942 with *Shade Grown Tobacco,* a realistically rendered scene of local agriculture; the area was an important producer of tobacco leaves for cigar wrappers (Fig. 62). Not only did eleven hundred new post offices come into being through the Treasury's program but every state in the Union as well as Alaska and Hawaii had, in multiple cities and towns, artwork created under the Section's auspices, and while the Section did have final approval and stepped in to arbitrate disputes or controversies, it was through local and regional juries that commissions to local artists were granted. For the early American material culture project that constituted the Index of American Design, the national directors appointed regional and state administrators to oversee the selection and reproduction of materials as well as to guarantee the coverage of artifacts throughout the country.[61]

Federal patronage ensured in theory that no region or state could be elevated over any other. It de-emphasized a hierarchical ordering of states and regions in favor of equal representation to diffuse cultural authority. Such an approach advanced an egalitarian spirit over the promotion of any one dominating source. Holger Cahill, the national director of the Federal Art Project, summed up this new attitude when he maintained that the project "proceeded on the principle that it is not the solitary genius but a sound general movement which maintains art as a vital, functioning part of any cultural scheme."[62]

Under the government's innovative system of the 1930s, the region of New England came to be revitalized and re-presented, but now less as a singular place than as one part of the Amer-

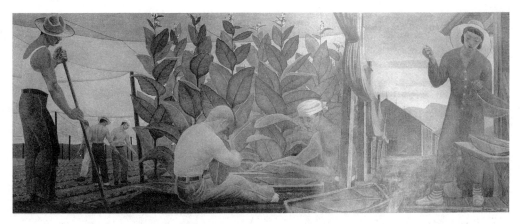

Figure 62. Austin Mecklem, *Shade Grown Tobacco*, 1942, oil on canvas, 139 × 58 in. United States Post Office, Portland, Connecticut. Courtesy Portland Historical Society

ican landscape. The federal art programs of the New Deal, by engendering a sense of belonging all over the country, worked out a fundamentally new way of transmuting the regional into the national. They enabled each and every locale to both celebrate its uniqueness and rise above its particularity, essentially democratizing the country. In the early twentieth century, the regional and the local provided American artists and critics a way to make tangible the abstract, and constantly evolving, notion of nationhood. The generation that followed, inheritors of an artistic legacy centered on the regional, would, in extending or reacting to this legacy, propose new ways to imagine American national identity.

Notes

Introduction

1. Yi-Fu Tuan, "Place: An Experiential Perspective," *Geographical Review* 65 (April 1975): 159.

2. For Miller's discussion, see *The Empire of the Eye: Landscape Representation and American Cultural Politics, 1825–1875* (Ithaca: Cornell University Press, 1993), chap. 5, particularly p. 199.

3. Sara Norton and M. A. De Wolfe Howe, eds., *Letters of Charles Eliot Norton,* 2 vols. (Boston: Houghton Mifflin, 1913), 2:278 n. 2

4. Benedict Anderson, *Imagined Communities: Reflections on the Origin and Spread of Nationalism* (London: Verso, 1991), E. J. Hobsbawm, *Nations and Nationalism since 1870: Programme, Myth, Reality,* 2nd ed. (Cambridge: Cambridge University Press, 1992), D. W. Meinig, ed., *The Interpretation of Ordinary Landscapes: Geographical Essays* (Oxford: Oxford University Press, 1979), and W. J. T. Mitchell, ed., *Landscape and Power* (Chicago: University of Chicago Press, 1994), have been especially influential here, as have a number of recent studies in American art including Wanda Corn, *The Great American Thing: Modern Art and National Identity, 1915–1935* (Berkeley: University of California Press, 1999); Elizabeth Johns, *New Worlds from Old: 19th-Century Australian and American Landscapes* (London: Thames and Hudson, 1998); Miller, *The Empire of the Eye;* and William Truettner and Roger Stein, eds., *Picturing Old New England: Image and Memory* (Washington, DC: National Museum of American Art, Smithsonian Museum, and New Haven: Yale University Press, 1999). From the European perspective, two notable contributions are Elizabeth K. Helsinger, *Rural Scenes and National Representation: Britain, 1815–1850* (Princeton: Princeton University Press, 1997), and June Hargrove and Neil McWilliam, eds., *Nationalism and French Visual Culture, 1870–1914,* Studies in the History of Art, Center for Advanced Study in the Visual Arts, Symposium Papers 45 (Washington, DC: National Gallery of Art, distributed by Yale University Press, 2005).

5. Important early twentieth-century histories of the region include James Truslow Adams, *The Founding of New England* (Boston: Atlantic Monthly Press, 1921), and Charles M. Andrews, *The Colonial Period of American History,* 2 vols. (New Haven: Yale University Press, 1936). For a condensed history of the region, see the eleventh edition of the *Encyclopaedia Britannica,* 1911, s.v. "New England," vol. 19, as well as Burt Feintuch and David H. Watters, eds., *The Encyclopedia of New England* (New Haven: Yale University Press, 2005), 635–40, 656–57. David Cressy addresses perceptions of New England in the 1600s in *Coming Over: Migration and Communication between England and New England in the Seventeenth Century* (Cambridge: Cambridge University Press, 1987).

6. Joseph A. Conforti, *Imagining New England: Explorations of Regional Identity from the Pilgrims to the Mid-Twentieth Century* (Chapel Hill: University of North Carolina Press, 2001), esp. 110–11; chap. 3 discusses the works of Morse and Dwight in detail.

7. John Warner Barber, *Connecticut Historical Collections,* 2nd ed. (New Haven, CT: Durrie & Peck and J. W. Barber, 1838).

8. "Marsden Hartley: Exhibition of Recent Paintings, 1936," Elizabeth McCausland Papers, Archives of American Art, roll D273, fr. 84.

Chapter 1. America on Display

1. Henry Adams, *The Education of Henry Adams: An Autobiography* (Boston: Houghton Mifflin, 1918), 343.

2. The main analytical works on the fair include Reid Badger, *The Great American Fair: The World's Columbian and American Culture* (Chicago: N. Hall, 1979), Robert Muccigrosso, *Celebrating the New World* (Chicago: Ivan R. Dee, 1993), Robert Rydell, *All the World's a Fair: Visions of Empire at American International Expositions, 1876–1916* (Chicago: University of Chicago Press, 1984), and Allan Trachtenberg, *The Incorporation of America: Culture and Society in the Gilded Age* (New York: Hill and Wang, 1982). Rydell and Trachtenberg focus on the hegemonic ideals the fair promoted, while Muccigrosso addresses the sense of collectivity the fair generated and its mediation of high and low culture. James Gilbert, *Perfect Cities: Chicago's Utopias of 1893* (Chicago: University of Chicago Press, 1991), considers the fair in the context of Chicago's social and economic circumstances. See also John E. Findling, *Chicago's Great World's Fairs* (Manchester: Manchester University Press, 1994).

3. M. H. De Young, "The Columbia World's Fair," *Cosmopolitan* 12 (March 1892): 599.

4. F. S. Skiff, "Mines and Metallurgy," *Cosmopolitan* 15 (September 1893): 597.

5. "Topics of the Time," *Century Magazine* 44 (October 1892): 955. For discussions of American art at the fair, see *Revisiting the White City: American Art at the 1893 World's Fair* (Washington, DC: National Museum of American Art, Smithsonian Institution, 1993), and Margaretta Lovell, "Picturing 'A City for a Single Summer': Paintings of the World's Columbian Exposition," *Art Bulletin* 78:1 (March 1996): 40–55.

6. Henry Van Brunt, "The Columbian Exposition and American Civilization," *Atlantic Monthly* 71 (May 1893): 579.

7. Carl Degler, "Northern and Southern Ways of Life and the Civil War," in *The Development of an American Culture,* ed. Stanley Coben and Lorman Ratner, 2nd ed. (New York: St. Martin's Press, 1983), 128. See pages 125–28 for his discussion of the doctrine of states' rights and conceptions of the Union.

8. See, for example, Sven Beckert, *The Monied Metropolis: New York City and the Consolidation of the Bourgeoisie 1850–1900* (New York: Cambridge University Press, 2001).

9. Dimensions are cited in Benjamin Truman's *History of the World's Fair* (Chicago, 1893; New York: Arno Press, 1976), 439.

10. Ibid., 444. For a reading of the gendered visual rhetoric at the fair, see Judy Sund, "Columbus and Columbia" *Art Bulletin* 75:3 (September 1993), revised and reprinted in *Critical Issues in American Art,* ed. Mary Ann Calo (Boulder, CO: Westview Press, 1998), 221–42.

11. "Columbus Day," *The Youth's Companion* 65 (19 May 1892): 256. The official program was published later that year on September 8, 1892. Anderson, *Imagined Communities,* 5–7. For a history of the "Pledge of Allegiance," see Margarette Miller's *I Pledge Allegiance* (Boston: Christopher, 1946). Robert Knutson first noted the Flag/Fair connection in "The White City: The World's Columbian Exposition of 1893," Diss., Columbia University, 1956.

12. In the 1920s, the words "my Flag" were amended to "the Flag of the United States of America." The phrase "under God" was added only in the 1950s.

13. Robert Goldstein, *Burning the Flag: The Great 1989–1990 American Flag Desecration Controversy* (Kent, OH: Kent State University Press, 1996), 2–3.

14. 10 February 1894, *The Letters of Theodore Roosevelt,* ed. Elting E. Morison et al. (Cambridge: Harvard University Press, 1951), 1: 363. For the importance of Turner's work, see Martin Ridge, "Turner the Historian: A Long Shadow," *Journal of the Early Republic* 13 (Summer 1993): 133–44. David Potter has discussed the issue of national foundations and the need for "a common commitment to shared values" at the time in "The Quest for National Character" in *The Reconstruction of American History,* ed. John Higham (1962; Westport, CT: Greenwood Press, 1980), 197.

15. Hubert Howe Bancroft, *The Book of the Fair* II (Chicago: Bancroft, 1893), 630.

16. Ibid.

17. Graeme Davison, "Exhibitions," *Australian Cultural History* 2 (1982/3): 6–8. See also John Allwood, *The Great Exhibitions* (London: Studio Vista, 1977).

18. Report on the Classification Presented at the May Meeting of the Commission, 1874, by the Committee on Classification, 3, quoted in Rydell, *All the World's a Fair,* 20.

19. "The Centennial," *New York Times,* 4 March 1876, 2. For the departments, see James D. McCabe, *The Illustrated History of the Centennial Exhibition* (Philadelphia: National Publishing Company, 1876), 217; and the United States Centennial Commission, *Report of the Director-General,* vol. 2 (Philadelphia: J. B. Lippincott, 1879), 634.

20. Benjamin Harrison, "Points of Interest," *Cosmopolitan* 15 (September 1893): 611. A complete list of depart-

ments appears in *World's Columbian Exposition Illustrated* 1 (June 1891): 20. For a general discussion on the scale and grandeur of the 1893 Fair compared to others, see especially John Cawelti, "America on Display: The World's Fairs of 1876, 1893, 1933," in *The Age of Industrialism,* ed. Frederic Cople Jaher (New York: Free Press, 1968), 317–63.

21. Bancroft, *The Book of the Fair* II, 799.

22. Ibid. See also *World's Columbian Exposition Illustrated* (June 1891): 6–7, which published a preliminary list of state appropriations for both fairs to demonstrate increased interest in 1893. Sources for both fairs yield somewhat inconsistent information about the exact number of state buildings. For example, for the Centennial, Rydell, *All the World's a Fair,* p. 11, notes that there were 17 buildings, while a primary source, McCabe, *Illustrated History,* details 22. Similarly, for 1893, Bancroft lists 39 on his map, whereas Norman Bolotin and Christine Laing, *The World's Columbian Exposition* (Washington, DC: Preservation Press, 1992), provides descriptions for 43 state buildings.

23. According to Cawelti, in 1893, businesses erected 9 of about 137 buildings at the fair. In 1933, the number jumped to 20 of about 137. See "America on Display," 323 and 348. The other big expositions held in the early 1900s such as the 1904 Louisiana Purchase Exposition in St. Louis and the 1915 Panama Pacific in San Francisco largely followed the model of the 1893 Fair.

24. Montgomery Schuyler, "State Buildings at the Fair," *Architectural Record* 3 (July-September 1893): 56, 58. Schuyler uses the word "racy" in the sense of a genuine or original quality, a defining characteristic.

25. Bancroft, *The Book of the Fair* II, 801. For detailed descriptions of the state buildings, see especially Bancroft, chap. 22; John J. Flinn, comp., *Official Guide to the World's Columbian Exposition* (Chicago: The Columbian Guide Company, 1893), 147 ff.; as well as *Handbook of the World's Columbian Exposition* (Chicago: Rand, McNally, 1893), 182–211.

26. H. H. Boyesen, "A New World Fable," *Cosmopolitan* 16 (December 1893): 182. Boyesen records his impressions of many other state buildings here as well.

27. "State Exhibits at the Fair," *World's Columbian Exposition Illustrated* 1 (April 1891): 28.

28. Thomas C. Quinn, ed., *Massachusetts of To-day: A Memorial of the State, Historical and Biographical* (Boston: Columbia Publishing, 1892), 9.

29. *Final Report of the California World's Fair Commission* (Sacramento: State Office, 1894), 4.

30. Rossiter Johnson, ed., *A History of the World's Columbian Exposition* II (New York: D. Appleton, 1897), 35.

31. Bancroft, *The Book of the Fair* I, 349.

32. Flinn, comp. *Official Guide to the World's Columbian Exposition,* 51. For descriptions of the agricultural exhibits, see *Handbook of the World's Columbian Exposition,* 103–5; Bancroft, *The Book of the Fair* I, 347–62.

33. For descriptions of state pavilions, see *Handbook of the World's Columbian Exposition,* 44–47; Stuart C. Wade and Walter S. Wren, "The Nut Shell," *The Ideal Pocket Guide to the World's Fair and What to See There* (Chicago, 1893): 18–25, as well as Bolotin and Laing, *The World's Columbian Exposition,* 94.

34. *Report of the Board of General Managers of the Exhibit of the State of New York at the World's Columbian Exposition* (Albany: James B. Lyon, State Printer, 1894), 114.

35. Herbert Gregg, *Idaho, Gem of the Mountains* (St. Paul: Pioneer Press, 1893): unpaginated.

36. *Pennsylvania and the World's Columbian Exposition* (Harrisburg: E. K. Meyers, State Printer, 1893), 11. For Massachusetts, see E. C. Hovey, "Massachusetts at the World's Fair," *New England Magazine* n.s. 9 (February 1894): 741–42, and Quinn, ed., *Massachusetts of To-day,* 24 and 7. G. L. Dybwad and Joy Bliss list numerous state publications in *Annotated Bibliography of the World's Columbian Exposition, Chicago 1893* (Albuquerque: The Book Stops Here, 1992.)

37. *Final Report of the California World's Fair Commission,* 53, 1.

38. *Connecticut at the World's Fair. Report of the Commissioners from Connecticut of the Columbian Exhibition of 1893 at Chicago* (Hartford, CT: Case, Lockwood and Brainard, 1898), 17. See also F. Vaill, "Connecticut at the World's Fair," *New England Magazine* n.s. 10 (July 1894): 561–63.

39. *Report of the Massachusetts Board of World's Fair Managers* (Boston: Wright & Potter, State Printers, 1894), 67.

40. "The South at the Fair," *World's Columbian Exposition Illustrated* (March 1891): 3. See also "What the Southern States are Doing for the World's Columbian," *World's Columbian Exposition Illustrated* (July 1892): 100–101.

41. "States to be Grouped," *World's Columbian Exposition Illustrated* (July 1891): 18. See also "Vermont at the Exposition," *World's Columbian Exposition Illustrated* (November 1892): 219.

42. Bancroft, *The Book of the Fair* II, 353. Bancroft details the state exhibits in the Mines and Mining Building on pages 471–88.

43. Vermont was referred to as a state "rich in patriotic achievement, replete in brave, historic incident" and Maine as the site for "solid and substantial men." For the individual statements, see James Taft Hatfield, "In the Massachusetts Building," *New England Magazine* n.s. 9 (February 1894): 750; Alonzo Williams, ed., *Rhode Island at the World's Columbian Exposition* (n.p., 1894), 58–59; Charles P. Mattocks, "Maine at the World's Fair," *New England Magazine* n.s. 10 (May 1894): 295. H. H. McIntyre, "Vermont at the World's Fair," *New England Magazine* n.s. 10 (March 1894): 6.

44. Deborah Poole, *Vision, Race, and Modernity: A Visual Economy of the Andean Image World* (Princeton: Princeton University Press, 1997), 76.

45. Martin Green, *The Problem of Boston: Some Readings in Cultural History* (New York: W. W. Norton, 1966), 176–77.

46. Quinn, ed., *Massachusetts of To-day,* 9, as well as page 14 for a statement to the same effect.

47. John C. Van Dyke, "Painting at the Fair," *Century Magazine* 48 (July 1894): 446. See also Lucy Monroe, "Chicago Letter," *The Critic* 23 (5 August 1893): 92.

48. "The Fine Arts. Massachusetts Art and Artists and the World's Fair in Chicago," *Boston Evening Transcript,* 14 November 1892, 6.

49. "Boston Art at Chicago," *Boston Evening Transcript,* 14 January 1893, 12. Carolyn Carr discusses the inclusion of Homer paintings at the Fair in "Prejudice and Pride: Presenting American Art at the 1893 World's Columbian Exposition," in *Revisiting the White City,* 88 and n. 136.

50. Van Dyke, "Painting at the Fair," 446. See also Monroe, "Chicago Letter," *The Critic* 23 (5 August 1893): 92.

51. Van Dyke, "Painting at the Fair," 446, and Bancroft, *The Book of the Fair* II, 673. For less dramatic but similar responses, see also Lucy Monroe, "Chicago Letter," *The Critic* 23 (12 August 1893): 115; as well as *Chicago Herald* reports from 15 and 18 June 1893, cited in Carr, "Prejudice and Pride," 100; and "The Fine Arts," *Boston Evening Transcript,* 24 May 1893, 6.

52. Carr, "Prejudice and Pride," 93–96. World's Columbian Exposition, *Revised Catalogue, Department of Fine Arts* (Chicago: W. B. Conkey, 1893), details the location of specific artworks.

53. William Howe Downes, "New England at the Fair," *New England Magazine* n.s. 8 (May 1893): 359. "Boston Art at Chicago," *Boston Evening Transcript,* 14 January 1893, 12.

54. *Inter-Ocean,* 12 November 1893. Thomas Hovenden Papers, Archives of American Art (cited hereafter as AAA) roll P13, fr. 100.

55. *Philadelphia Telegraph,* 31 January 1891. Hovenden Papers, AAA roll P13, fr. 100.

56. Ibid. A critic in 1893 similarly found the painting "honestly and wholesomely American." Unidentified clipping, Hovenden Papers, AAA roll P13, fr. 101.

57. Both the *Chicago Tribune,* 11 May 1893, Hovenden Papers, AAA roll P13, fr. 105 and Benjamin Truman, *History of the World's Fair,* 382, printed this interpretation. For Bancroft's statement, see *The Book of the Fair* II, 681. "World's Fair Art Notes," *Chicago Record,* 17 June 1893, Hovenden Papers, AAA roll P13, fr. 113, and *Art Amateur* 30 (February 1894): 72 also read the painting as a New England scene. For Bancroft's biography, see *National Cyclopaedia of American Biography,* vol. 5 (New York: J. T. White, 1907), 112.

58. Unidentified clipping from April 1886, Hovenden Papers, AAA roll P13, fr. 28. For Corson's background, see an unidentified clipping from 26 May 1884, Hovenden Papers, AAA roll P13, fr. 27, as well as the *Philadelphia Times,* 22 October 1893, Hovenden Papers, AAA roll P13, fr. 109.

59. "Hovenden at Home," *Philadelphia Times,* 23 February 1891, Hovenden Papers, AAA roll P13, fr. 64. Both the *Philadelphia Record,* 9 May 1893 and the *Times,* presumably of Philadelphia, undated, Hovenden Papers, AAA roll P13, fr. 100 and fr. 105, for example, specifically located the scene in Pennsylvania.

60. See "Beautifying the Home," *Prairie Farmer* 44 (10 July 1875): 219, as well as Sally McMurry, *Families and Farmhouses in Nineteenth-Century America: Vernacular Design and Social Change* (Oxford: Oxford University Press, 1988).

61. Nancy Goyne-Evans, "American Windsor Chairs: A Style Survey," *Magazine Antiques* 95 (April 1969): 530–43, and *American Windsor Chairs* (New York: Hudson Hills Press in association with The Henry Francis du Pont Winterthur Museum, 1996). Ralph Kovel and Terry Kovel, in *American Country Furniture, 1780–1875* (New York: Crown, 1965), 116, note that while regional variation existed during the eighteenth century, by 1840 differences had disappeared and Windsor styles were universal.

62. See especially the images reproduced in William Truettner, ed., *The West as America: Reinterpreting Images of the Frontier, 1820–1920* (Washington, DC: National Museum of American Art, 1991).

63. "When Hope was Darkest," unidentified pamphlet, Hovenden Papers, AAA roll P13, fr. 126. Sarah Burns, in "The Country Boy Goes to the City: Thomas Hovenden's Breaking Home Ties in American Popular Culture," *American Art Journal* 20:4 (1988): 60, reads the picture strictly in terms of city/country tensions.

64. *New England Magazine* n.s. 2 (April 1890): 233. See also "New England in New York," *New England Magazine* n.s. 4 (April 1891): 128–31. For the New England Societies in general, see Pershing Vartanian, "The Puritan as a Symbol in American Thought: A Study of the New England Societies, 1820–1920," Diss., University of Michigan, 1971.

65. McIntyre, "Vermont at the World's Fair," 5.

66. *Boston Journal,* 21 February 1891, Hovenden Papers, AAA roll P13, fr. 113.

67. Quinn, ed., *Massachusetts of To-day,* 17, as well as pages 16 and 24.

68. Bancroft, *The Book of the Fair* II, 681. Diane Dillon, "'The Fair as Spectacle': American Art and Culture at the 1893 World's Fair," Diss., Yale University, 1994. The country's colonial Puritan/Pilgrim past was celebrated in other

venues of the fair, including the Woman's Building, where Lucia Fairchild Fuller's *The Women of Plymouth* was one of six murals on display. See Charlene G. Garfinkle, "Lucia Fairchild Fuller's 'Lost' Woman's Building Mural," *American Art* 7 (Winter 1993): 2–7.

69. "Editor's Table," *New England Magazine* n.s. 8 (June 1893): 539.

70. "The Fine Arts. American Subjects for American Artists," *Boston Evening Transcript,* 24 May 1893, 6.

Chapter 2. New England in the Public Eye

1. "High Treason," *Boston Globe,* 23 November 1896, 5. The story was reported also in the *Newark Advertiser,* November 1896, exact date unclear, Frederick MacMonnies Papers, Archives of American Art (hereafter AAA) roll D245, fr. 130.

2. Thomas Russell Sullivan, *Passages from the Journal of Thomas Sullivan, 1891–1903* (Boston: Houghton Mifflin, 1917), 188–89.

3. The remarks by the president of the library trustees, Frederick Prince, are quoted in Walter Muir Whitehill, "The Vicissitudes of *Bacchante* in Boston," *New England Quarterly* 27 (December 1954): 449. For McKim's letter to the library trustees of 6 July 1896, see Art Correspondence File, Trustees Library, Boston Public Library. See also "At Intervals," *Boston Evening Transcript,* 22 October 1896, 6, and the letter of H. L. Warren, 1 August 1896, Correspondence File of the Boston Art Commission, Boston City Hall. The seven-stanza poem "The *Bacchante*'s Plaint" appeared in *New York Town Topics,* 10 June 1897, Frederick MacMonnies Papers, AAA roll D245, fr. 80.

4. Records of the Boston Art Commission for July, October, and November 1896, Boston City Hall. The committee of experts appointed by the commission included among others Charles A. Cummings, a Boston architect; Edward Robinson, a curator at the Museum of Fine Arts; Charles Eliot Norton, a professor at Harvard University; and C. Howard Walker, also a Boston architect.

5. Letter of 1 June 1897 to Frederic W. Rhinelander, Charles McKim file, Metropolitan Museum of Art Archives.

6. Quoted in Whitehill, "The Vicissitudes of *Bacchante* in Boston," 440.

7. See *Boston Evening Transcript* of 24 October 1896, 16. For current scholarship, see Tom Armstrong et al., *200 Years of American Sculpture* (New York: Whitney Museum of Art, 1976); Albert TenEyck Gardner, *American Sculpture: A Catalogue of the Collection of the Metropolitan Museum of Art* (Greenwich, CT: New York Graphic Society, 1965); Hildegard Cummings, "Chasing a Bronze *Bacchante*," *Bulletin of the William Benton Museum of Art, The University of Connecticut* 12 (1984): 3–19, as well as Mary Smart, *A Flight with Fame: The Life and Art of Frederick MacMonnies* (Madison, CT: Sound View Press, 1996). Joy Kasson in *Marble Queens and Captives: Women in Nineteenth-Century Sculpture* (New Haven: Yale University Press, 1990) addresses the fraught attitudes of nineteenth-century audiences toward nudity.

8. Royal Cortissoz, "Some Imaginative Types in American Art," *Harper's New Monthly Magazine* 91 (July 1895): 174. Cummings in "Chasing a Bronze *Bacchante*" details the various reproductions and reductions made of the statue.

9. Saint-Gaudens's letter to Paul Bion is cited in C. Meltzer, "Frederick MacMonnies—Sculptor," *Cosmopolitan* 53 (July 1912): 210. Similar compliments from the sculptors appear in letters to the Art Commission, 21 July 1896 and 26 June 1896, Correspondence File of the Boston Art Commission, Boston City Hall.

10. Joint letter from Daniel Chester French and Augustus Saint-Gaudens, 26 October 1896, Correspondence File of the Boston Art Commission, Boston City Hall.

11. Kathryn Greenthal in *Augustus Saint-Gaudens: Master Sculptor* (New York: Metropolitan Museum of Art, 1985), 42, makes the specific comparison between Moulin's work and MacMonnies's. Interestingly, Moulin had found inspiration in an antique sculpture from Pompeii known as *Dancing Faun;* see Peter Fusco and H. W. Janson, eds., *The Romantics to Rodin* (Los Angeles County Museum of Art in association with George Braziller, 1980), 308.

12. W. T. Parker, cited in Whitehill, "The Vicissitudes of *Bacchante* in Boston," 438.

13. Sullivan, *Passages from the Journal of Thomas Sullivan,* 185–86.

14. "Not Bad," *Boston Record,* 16 November 1896, scrapbook of newspaper clippings, 3 January 1895 to 25 January 1897, Trustees Library, Boston Public Library.

15. "The Bacchante on Exhibition," *Boston Herald,* 16 November 1896, scrapbook of newspaper clippings, 3 January 1895 to 25 January 1897, Trustees Library, Boston Public Library.

16. See Whitehill, "The Vicissitudes of *Bacchante* in Boston," 445, and the *Boston Traveller* clipping from 11 December 1896 in MacMonnies Papers, AAA roll D245, fr. 64.

17. These figures are cited in Ronald Story, *The Forging of an Aristocracy: Harvard and the Boston Upper Class, 1800–1870* (Middletown, CT: Wesleyan University Press, 1980), 177.

18. Ibid., 181.

19. Cleveland Amory, *The Proper Bostonians* (New York: E. P. Dutton, 1947), 298. See also 297.

20. Ibid., 24.

21. Library Trustee Henry Bowditch is the one possible exception. He earned both a B.A. and an M.D. degree from Harvard and held a professorship at the Harvard Medical School. The medical school, however, did not play the role in Boston that the college or even the law school did. For the backgrounds of all these men, see the *National Cyclopaedia of American Biography*.

22. Robert Grant, *Fourscore: An Autobiography* (Boston: Houghton Mifflin, 1934), 292.

23. Grant had his protagonist make this comment in his novel *The Chippendales* (New York: Scribner's, 1909), 365.

24. *Boston Evening Record,* 16 November 1896, Frederick MacMonnies Papers, AAA roll D245, fr. 125. See also the *Boston Post,* 16 November 1896, 5.

25. I draw on Stuart Blumin's definition of the middle class in this period as urban, salaried, and non-manual employees. See *The Emergence of the Middle Class* (Cambridge: Cambridge University Press, 1989). Both Ruth Bordin, *Woman and Temperance: The Quest for Power and Liberty, 1873–1900* (Philadelphia: Temple University Press, 1981), 163–75, and Jack S. Blocker, Jr., *American Temperance Movements: Cycles of Reform* (Boston: Twayne, 1989), 81, discuss the class composition of the WCTU and other temperance groups. As Nicola Beisel has shown, upper-class individuals typically organized and led anti-vice movements such as Boston's Watch and Ward Society, while members came from the middle to upper classes: "Class, Culture, and Campaigns against Vice in Three American Cities, 1872–1892," *American Sociological Review* 55:1 (February 1990): 44–62.

26. "Attacked by S. B. Capen," *Boston Globe,* 30 November 1896, 7.

27. See the *Boston Evening Transcript,* 10 December 1896, 6, and the *Boston Post,* 13 November 1896, 6.

28. *Boston Globe,* 24 November 1896, 5.

29. *Evening Sun,* 12 December 1896, MacMonnies Papers, AAA roll D245, fr. 63, as well as unidentified clipping, fr. 64.

30. Concerning the model's identity, see Cummings, "Chasing a Bronze *Bacchante,*" 6–8.

31. Barbara Epstein, *The Politics of Domesticity: Women, Evangelism, and Temperance* (Middletown, CT: Wesleyan University Press, 1981), 127. On the subject of home values, see also Nicola Beisel, *Imperiled Innocents: Anthony Comstock and Family Reproduction in Victorian America* (Princeton: Princeton University Press, 1997).

32. Paul Dimaggio, "Cultural Entrepreneurship in Nineteenth-Century Boston: The Creation of an Organizational Base for High Culture in America," *Media, Culture and Society* 4 (1982): 40. On the broader topic of the "sacralization of culture," see Lawrence Levine, *Highbrow, Lowbrow: The Emergence of Cultural Hierarchy in America* (Cambridge: Harvard University Press, 1988), and Pierre Bourdieu, *Distinction: A Social Critique of the Judgment of Taste* (Cambridge: Harvard University Press, 1984).

33. "The Foreign Elements in Our Population," *Century Illustrated Monthly Magazine* n.s. 6 (September 1884): 765, and H. C. Merwin, "The Irish in American Life," *Atlantic Monthly* 77 (March 1896): 289–99. While in Boston the Irish did not tend to translate their political power into economic or occupational achievement, statistics suggest that second-generation Irish did do better than their parents: Stephan Thernstrom, *The Other Bostonians* (Cambridge: Harvard University Press, 1973), 130–35.

34. "Influence of the Liquor Traffic," *Boston Evening Transcript,* 18 November 1896, 6.

35. Geoffrey Blodgett, *The Gentle Reformers: Massachusetts Democrats in the Cleveland Era* (Cambridge: Harvard University Press, 1966), 149. As James Connolly notes in *The Triumph of Ethnic Progressivism: Urban Political Culture in Boston, 1900–1925* (Cambridge: Harvard University Press, 1998), 217, n. 4, census data from the period show that the number of first- and second-generation Irish alone totaled 41.7 percent of the city's population in 1885; adding third and fourth generations to that would greatly increase the percentage.

36. Letter to Samuel Ward, 14 July 1897, *Letters of Charles Eliot Norton,* ed. Norton and Howe, 2: 254.

37. Adams, *The Education of Henry Adams,* 419.

38. *Boston Globe,* 1 January 1892, quoted in Walter Muir Whitehill, *Boston Public Library: A Centennial History* (Cambridge: Harvard University Press, 1956), 153.

39. Frederick Crunden, "The Public Library and Civic Improvement," *The Chautauquan* (June 1906): 338–39. For useful histories on the development of public libraries, see Dee Garrison, *Apostles of Culture: The Public Librarian and American Society, 1876–1920* (New York: Free Press, 1979), and Rosemary Ruhig Du Mont, *Reform and Reaction: The Big City Public Library in American Public Life* (Westport, CT: Greenwood Press, 1977). In addition, see Richard Sennett, *The Conscience of the Eye: The Design and Social Life of Cities* (New York: Alfred Knopf, 1990), and Jeff Weintraub, "The Theory and Politics of the Public/Private Distinction," in *Public and Private in Thought and Practice: Perspectives on a Grand Dichotomy,* ed. Jeff Weintraub and Krishan Kumar (Chicago: University of Chicago Press, 1997).

40. Frederick Crunden, "The Value of a Free Library," *Library Journal* 15 (March 1890): 79–80. Josephus N. Larned, "The Freedom of Books," in *Why Do We Need a Public Library,* Library Tract, no. 1 (American Library Association, 1902): 18. For the connection of libraries and a healthier society, see also "The Editor's Table," *New England Magazine* n.s. 2 (April 1890): 237–38; Joseph L. Harrison, "The Public Library Movement in the United States," *New England Magazine* n.s. 10 (August 1894): 709–22; and A. Peck, "Workingmen's Clubs and the Public Library," *Library Journal* 23 (November 1898): 612–14.

41. Sally Promey, *Painting Religion in Public: John Singer Sargent's Triumph of Religion at the Boston Public Library* (Princeton: Princeton University Press, 1999).

42. Crunden, "The Public Library and Civic Improvement," 336. M[ariana] G. Van Rensselaer, "The New Public Library in Boston, *Century Magazine* 50 (June 1895): 262.

43. Roy Rosenzweig, *Eight Hours for What We Will: Workers and Leisure in an Industrial City, 1870–1920* (Cambridge: Cambridge University Press, 1983), 95.

44. Crunden, "The Value of a Free Library," 80.

45. "Rev. S. H. Roblin Objects to *Bacchante*," *Boston Globe*, 30 November 1896, 7.

46. "The Listener," *Boston Evening Transcript*, 28 October 1896, 4. See also the *Boston Post*, 16 November 1896, front page.

47. *Boston Evening Transcript*, 5 December 1896, 17.

48. Letter of 26 October 1896, Correspondence Folder, Boston Art Commission.

49. Charles Eliot Norton, "Some Aspects of Civilization in America," *The Forum* 20 (February 1896): 650.

50. Ibid., 644.

51. Frederick Jackson Turner, *The Significance of the Frontier in American History*, ed. Harold P. Simonson (New York: Frederick Ungar, 1963), 57.

52. "James Russell Lowell," *Harper's Magazine* 86 (May 1893): 846. Several of Norton's letters to Samuel Ward reiterated this position. See those from 26 April 1896 and 14 July 1897, *Letters of Charles Eliot Norton* 2: 244, 254.

53. Letter to Colonel Robert Thomson, 3 February 1893, in Mark Anthony De Wolfe Howe, *Barrett Wendell and His Letters* (Boston: Atlantic Monthly Press, 1924), 107–8 (ellipsis in original).

54. Letter of 2 March 1902, in ibid., 145.

55. Norton, "James Russell Lowell," 846. Wendell expressed similar sentiments. See Howe, *Barrett Wendell and His Letters*, 197–98.

56. Letter to Samuel Ward, 26 April 1896, and letter to Leslie Stephen, 8 January 1896, *Letters of Charles Eliot Norton* 2: 244 and 237.

57. Letter to Leslie Stephen, 20 March 1896, ibid., 241, and letter from Barrett Wendell to Sir Robert White-Thomson, 22 November 1908, in Howe, *Barrett Wendell and His Letters*, 198.

58. *Literary World*, quoted in a clipping from the *Minneapolis Tribune*, 20 December 1896, Frederick MacMonnies Papers, AAA roll D245, fr. 64.

59. Homer Saint-Gaudens, ed., *The Reminiscences of Augustus Saint-Gaudens* (New York: Century, 1913), 1: 353.

60. *Springfield Republican*, 25 November 1887, 4.

61. Russell Sturgis, "The Works of J. Q. A. Ward," *Scribner's Magazine* 32 (October 1902): 389. See also Lewis Sharp, *John Quincy Adams Ward: Dean of American Sculpture* (London: Associated University Presses, 1985), 216.

62. John Dryfhout, *The Work of Augustus Saint-Gaudens* (Hanover, NH: University Press of New England, 1982), 166, lists these reductions and their current locations. In 1899 Saint-Gaudens wrote to his brother stating that he had sold two small statues: Augustus Saint-Gaudens Papers, Dartmouth College Special Collections, Box 32.

63. "The Mission of Saint-Gaudens," *Literary Digest* 35 (17 August 1907): 237. Charles Lewis Hind, *Augustus Saint-Gaudens* (New York: John Lane, 1908), xxviii. See also Charles Caffin, "The Work of Augustus Saint-Gaudens," *World's Work* 7: 4 (February 1904): 4410.

64. *Springfield Republican*, 25 November 1887, 4.

65. *Municipal Register of the City of Springfield of 1888*, 328. The statue itself was referred to as "that history-telling work of art." A column in the *Springfield Republican*, 16 January 1898, 9, provides a description of the fountain.

66. *Springfield Republican*, 16 January 1898, 9. For reports of damage to Stearns Park, see 23 January 1898, 9.

67. *Springfield Republican*, 23 January 1898, 9. See also 1 July 1899, 8, as well as 16 January 1898, 9, for articles concerned with the statue reaching the widest possible audience.

68. Frederick Crunden's article "The Value of a Free Library," quotes the *Springfield Republican's* comments. "The Editors' Table," *New England Magazine* n.s. 2 (April 1890): 237–38.

69. Quoted in Chalmers Hadley, *John Cotton Dana: A Sketch* (Chicago: American Library Association, 1943), 43.

70. See Michael Frisch, *Town into City: Springfield, Massachusetts, and the Meaning of Community, 1840–1880* (Cambridge: Harvard University Press, 1972), 124–27, 194–97, 238–50, and Guy A. McLain, *Pioneer Valley: A Pictorial History* (Virginia Beach, VA: The Donning Company, 1991), chap. 11.

71. Unidentified clipping, John Cotton Dana Papers, Connecticut Valley Historical Museum and Library, Box 8:7. Letters suggest that Dana and other library officials were involved with the statue's relocation. See ibid., Box 1:11.

72. Ibid., Box 8: 4.

73. Pershing Vartanian traces their growth and development in "The Puritan as a Symbol of American Thought," particularly pp. 13–15, 47.

74. "New England and the West," *New England Magazine* n.s. 2 (April 1890): 233, and "New England in New

York," *New England Magazine* n.s. 4 (April 1891): 128. See Vartanian, "The Puritan as a Symbol of American Thought," 114 and 191, n. 5, for the range of newspapers that publicized the societies' festivals.

75. *Philadelphia Evening Bulletin,* 23 December 1885, quoted in Vartanian, "The Puritan as a Symbol of American Thought," 115. See ibid., 108–9 for the growth in numbers.

76. Miscellaneous pamphlets and Forefathers' Day Yearbooks of the New England Society of Pennsylvania, Historical Society of Pennsylvania, Boxes Wj54, Wj541, Wj542. The 1902 dinner featured, for example, nine senators, one congressman, and an admiral. See also the Anniversary Celebration publications for the New England Society in the City of New York.

77. See Vartanian, "The Puritan as a Symbol of American Thought," 140, n. 43. In 1891, the New York Society was noted as having 1,500 members. See "New England in New York," 129.

78. 12 August 1902 letter from James Beck, Saint-Gaudens Papers, Dartmouth College Special Collections, Box 16. New England Society of Pennsylvania, *25th Annual Festival,* 1905, 19, notes the background of the eventual commission.

79. See *The Reminiscences of Augustus Saint-Gaudens* 1: 354, as well as the 26 January 1905 letter from the society's president, Theodore Frothingham: Saint-Gaudens Papers, Dartmouth College Special Collections, Box 16.

80. Fairmount Park Association Archives, Historical Society of Pennsylvania, Box 16.

81. Records of the New England Society do not make clear who decided on the City Hall location. See, for example, New England Society of Pennsylvania, *Tercentenary of the Landing of the Pilgrims, 1620–1920,* Historical Society of Pennsylvania, Box Wj541.

82. New England Society of Pennsylvania, *25th Annual Festival,* 1905, 19, 24–25.

83. Theodore Clarke Smith, "The Scientific Historian and Our Colonial Period," *Atlantic Monthly* 98 (November 1906): 709–10. Jan Dawson's *The Unusable Past: America's Puritan Tradition, 1830–1930* (Chico, CA: Scholar's Press, 1984), chap. 7, provides an in-depth discussion of the scientific historians' position in this period. See also Vartanian, "The Puritan as a Symbol of American Thought," chap. 9.

84. Dawson, *The Unusable Past,* 92.

85. See Claire Sprague, ed., *Van Wyck Brooks: The Early Years* (New York: Harper and Row, 1968), 38. In later years, Brooks called on Americans to reinvigorate their society and turn to a past other than the Puritan. See his 1918 essay "On Creating a Usable Past" in the same volume.

86. Caffin, "The Work of Augustus Saint-Gaudens," 4410. Kenyon Cox, "Augustus Saint-Gaudens," *Century Illustrated Monthly Magazine* n.s. 13 (November 1887): 30.

87. *Reminiscences* 1: 354.

88. Dryfhout also notes that Saint-Gaudens had the medallion sent in grand style, as if it were a diplomatic message: *The Work of Augustus Saint-Gaudens,* 265. See pp. 266–67 for the bronze caricatures of Finn and also Charles Adams Platt.

89. *Reminiscences* 1: 316. For a discussion of the colony, see Deborah Van Buren, "The Cornish Colony: Expressions of Attachment to Place, 1885–1915," Diss., George Washington University, 1987.

90. Saint-Gaudens Papers, Dartmouth College Special Collections, Box 68.

91. "Saint-Gaudens and His Work," *Art World* 1 (February 1917): 302.

92. New England Society of Pennsylvania, *17th Annual Festival,* 1897, 21 and 55.

93. Ibid., 18.

94. New England Society of Pennsylvania, *22nd Annual Festival,* 1902, 66–67.

95. Excerpt from an address made at the 1890 dinner of the New England Society in the City of New York reprinted in "New England in New York," 129.

96. New England Society of Pennsylvania, *Annual Report,* 1895, 16–17, quoted in Vartanian, "The Puritan as a Symbol of American Thought," 125.

97. Excerpt from an address made at the 1889 dinner of the New England Society of St. Louis, quoted in "New England and the West," 236. See also "New England in New York," 129, for the address given at New York's dinner.

98. "The Ills of Pennsylvania," *Atlantic Monthly* 88 (October 1901): 565–66.

99. "The Causes of Pennsylvania's Ills," *Atlantic Monthly* 89 (January 1902): 124–29.

100. New England Society of Pennsylvania, *21st Annual Festival,* 1901, 108.

101. Clipping from the *New York World,* 31 May 1897, Frederick MacMonnies Papers, AAA roll D245, fr. 71.

102. Blumin, *The Emergence of the Middle Class,* 296.

103. See 9 October 1903 letter from James Beck and the 19 March 1913 letter from Joseph Mumford, Fairmount Park Art Association Archives, Historical Society of Pennsylvania, Box 16. See also a 1904 New England Society of Pennsylvania pamphlet, p. 17, Historical Society of Pennsylvania, Box Wj54.

104. Greg Reibman, "The *Bacchante* That Got Left Behind," *Artnews* (May 1992): 40.

Chapter 3. The Aestheticization of Rural New England and the Spirit of Place

1. Will Low, *A Chronicle of Friendships, 1873–1900* (New York: Scribner and Sons, 1908), 477.

2. *Letters of Charles Eliot Norton,* 2: 278.

3. Lewis Mumford, *The Brown Decades: A Study of the Arts in America, 1865–1895* (1931; 2nd ed., New York: Dover, 1955), 59.

4. Parke Godwin, ed., *Prose Writings of William Cullen Bryant* (New York: D. Appleton, 1884), 2: 232. On the development of landscape appreciation in the United States, see especially Earl A. Powell III, "Thomas Cole and the American Landscape Tradition: The Naturalist Controversy," *Arts Magazine* 52 (February 1978): 114–23, as well as Kenneth Myers, "On the Cultural Construction of Landscape Experience: Contact to 1830," in *American Iconology,* ed. David Miller (New Haven: Yale University Press, 1993), 58–79.

5. John McCoubrey, *American Art: Sources and Documents* (Englewood Cliffs, NJ: Prentice-Hall, 1965), 108–9.

6. Angela Miller discusses in detail this image in *The Empire of the Eye,* 39–49. See also Matthew Baigell and Allen Kaufman, "Thomas Cole's 'The Oxbow': A Critique of American Civilization," *Arts Magazine* 55:5 (January 1981): 136–39. Alan Wallach addresses further Cole's artistic response to the pressures of settlement in "Thomas Cole's *River in the Catskills* as Antipastoral," *Art Bulletin* 84:2 (June 2002): 334–50.

7. Letter II (17 January 1855), *The Crayon* 1, in McCoubrey, *American Art: Sources and Documents,* 112, and Letter III (31 January 1855), quoted in John Czestochowski, *The American Landscape Tradition* (New York: E. P. Dutton, 1982), 16. Thomas Cole, "Essay on American Scenery," in McCoubrey, *American Art: Sources and Documents,* 102.

8. For the rise of tourism in the nineteenth century and its relationship to class and cultural identity, see John Sears, *Sacred Places: American Tourist Attractions in the Nineteenth Century* (New York: Oxford University Press, 1989), and Kenneth Myers, *The Catskills: Painters, Writers, and Tourists in the Mountains, 1820–1895* (Yonkers, NY: Hudson River Museum of Westchester, 1987), as well as Dona Brown, *Inventing New England: Regional Tourism in the Nineteenth Century* (Washington, DC: Smithsonian Institution Press, 1995).

9. Miller, *The Empire of the Eye,* 9. For the relationship of the panoramic view and American expansionism, see Henry Sayre, "Surveying the Vast Profound: The Panoramic Landscape in American Consciousness," *Massachusetts Review* 24 (Winter 1983): 723–42.

10. The appeal of the wilderness also found literary expression, for example, in the works of James Fenimore Cooper, William Cullen Bryant, and Henry David Thoreau. Roderick Nash discusses evolving nineteenth-century attitudes toward the wilderness in *Wilderness and the American Mind* (New Haven: Yale University Press, 1967), especially chap. 4. For an artistic context, see Franklin Kelly, *Frederic Edwin Church and the National Landscape* (Washington, DC: Smithsonian Institution Press, 1988), 82–83.

11. Adam Badeau, *The Vagabond* (New York: Rudd & Carleton, 1859), 124. For Niagara's iconic status and a comparison of Church's depiction with others, see Jeremy Adamson, *Niagara: Two Centuries of Changing Attitudes, 1697–1901* (Washington, DC: The Corcoran Gallery of Art, 1985).

12. Kelly, *Frederic Edwin Church and the National Landscape,* 114–15.

13. Quoted in Joni Kinsey, *Thomas Moran and the Surveying of the American West* (Washington, DC: Smithsonian Institution Press, 1992), 23.

14. Tuckerman used the phrase in describing Bierstadt's *The Rocky Mountains* in *Book of the Artists* (New York: G. P. Putnam & Sons, 1867), 395. A review in *Harper's Weekly* 8 (26 March 1864): 194–95, also referred to the painting as "purely an American scene."

15. Bancroft's comment appeared in a daily publication during the fair and is quoted in Gordon Hendricks, "Bierstadt and Church at the New York Sanitary Fair," *The Magazine Antiques* 102 (November 1972): 897. William Cullen Bryant, *Picturesque America; or the Land We Live in* (New York: D. Appleton, 1872), preface.

16. For Bierstadt's illustrious career, see Nancy Anderson and Linda Ferber, *Albert Bierstadt, Art and Enterprise* (New York: Brooklyn Museum, 1990).

17. In *Revisiting the White City,* 135, it is noted that seasonal landscapes made up a quarter of the total number of American paintings exhibited. For a discussion of the tonal approach to art, see Wanda Corn, *The Color of Mood: American Tonalism, 1880–1910* (San Francisco: M. H. de Young Memorial Museum, 1972).

18. See Jane Hancock, "French Academic and Barbizon Painting in American Collecting, 1870s–1890s," in *Homecoming: The Art Collection of James J. Hill* (St. Paul: Minnesota Historical Society Press, 1991), 16.

19. For the decline of Bierstadt's career, see Anderson and Ferber, *Albert Bierstadt,* 246–48.

20. George William Sheldon's review, "How One Landscape-Painter Paints," *Art Journal* 3 (1877): 284–85, is quoted at length in Ila Weiss, *Poetic Landscape: The Art and Experience of Sanford R. Gifford* (Newark: University of Delaware Press in association with Associated University Presses, 1987), 152–53. See Miller's final chapter, "Domesticating the Sublime," in *The Empire of the Eye.*

21. "A Painter on Painting," *Harper's Magazine* 56 (February 1878): 461.

22. Charles Caffin, *The Story of American Painting* (New York: Frederick A. Stokes, 1907), 81–82. See p. 125 for

Caffin's reference to nature-poets. Sadakichi Hartmann, *A History of American Art* (Boston: L. C. Page, 1902), 1: 78–79, similarly speaks of the new focus by American artists on nature's moods.

23. Birge Harrison, *Landscape Painting* (New York: Charles Scribner's Sons, 1909), 155, 156.

24. Caffin, *The Story of American Painting,* 281.

25. Ibid., 233. For extended discussion of Homer's work at Prout's Neck, Maine, see Elizabeth Johns, *Winslow Homer: The Nature of Observation* (Berkeley: University of California Press, 2002), especially chap. 4, as well as Bruce Robertson, *Reckoning with Homer: His Late Paintings and Their Influence* (Cleveland: Cleveland Museum of Art in association with Indiana University Press, 1990).

26. John C. Van Dyke, *Nature for Its Own Sake: First Studies in Natural Appearances* (New York: Charles Scribner's Sons, 1908), 170.

27. John Burroughs, *Far and Near,* vol. 11, *The Writings of John Burroughs,* Riverby edition (Boston: Houghton Mifflin, 1904), 3.

28. Ibid., 5, 6, 7, 8, my emphasis.

29. Van Dyke, *Nature for Its Own Sake,* 224.

30. Hamilton Wright Mabie, *Essays on Nature and Culture* (New York: Dodd, Mead, 1896), 243.

31. See, for example, Theodore Roosevelt, *Ranch Life and the Hunting Trail* (1896; New York: St Martin's Press, 1985), as well as Sarah Burns, *Pastoral Inventions: Rural Life in 19th-century American Art and Culture* (Philadelphia: Temple University Press, 1989), and Sarah Burns, "The Country Boy Goes to the City: Thomas Hovenden's *Breaking Home Ties* in American Popular Culture," *American Art Journal* 20 (1988): 59–73.

32. Harvey W. Wiley, "Plow and Pitchfork versus Pills and Powders," *Country Life in America* 20:8 (15 August 1911): 21.

33. "What This Magazine Stands For," *Country Life in America* 1:1 (November 1901): 24, as well as "The Spread of the Country Life Idea," 21:12 (15 April 1912): 19. For references to other articles about the return to nature, see Peter Schmitt, *Back to Nature: The Arcadian Myth in Urban America* (1969; rpt. Baltimore: Johns Hopkins University Press, 1990), as well as David Shi, *The Simple Life: Plain Living and High Thinking in American Culture* (London: Oxford University Press, 1985).

34. On Homer, see especially Sarah Burns, "Revitalizing the 'Painted-Out' North: Winslow Homer, Manly Health, and New England Regionalism in Turn-of-the-Century America," *American Art* 9 (Summer 1995): 20–37.

35. E. P. Powell, *How to Live in the Country* (New York: Outing Publishers, 1911). President Roosevelt voiced similar ideas in a special address in 1909 printed in the *Report of the Country Life Commission,* Senate Document #705 (New York: Sturgis and Walton, 1911): 9. See also Liberty Hyde Bailey, *The Country Life Movement in the United States* (New York: Macmillan, 1911). For a discussion of the movement and its participants, see William Bowers, *The Country Life Movement in America, 1900–1920* (Port Washington, NY: Kennikat Press, 1974).

36. Bailey, *The Country Life Movement in the United States,* 17.

37. "The New Romance of the Road," *The Craftsman* 17:1 (October 1909): 50. See also Josiah Strong, *The New Era* (New York: Baker & Taylor, 1893), 177. On New England in particular, see Hal S. Barron, *Those Who Stayed Behind: Rural Society in Nineteenth-Century New England* (Cambridge: Cambridge University Press, 1984).

38. *New England Magazine* n.s. 3 (January 1891): 674, reprinted the London article in its section "The Editors' Table." For country stories, see, for example, W. H. Bishop, "Hunting an Abandoned Farm," *Century Magazine* 26 (1894): 30–43, and Frank French, "A New England Farm," *Scribner's Monthly Magazine* 13 (April 1893): 426–36, as well as "The Abandoned Farms," *Country Life in America* (November 1901): 3–8. On the subject of rural decline, see Harold Wilson, *The Hill Country of Northern New England: Its Social and Economic History, 1790–1930* (New York: Columbia University Press, 1936).

39. Henry U. Fletcher, "The Doom of the Small Town," *Forum* 19 (1895): 215; Clarence Deming, "Broken Shadows on the New England Farm," *The Independent* 55 (30 April 1903): 1018–20; Edward Vallandigham, "What Ails New England?" *Putnam's Magazine* 6 (September 1909): 719–24; and George S. Boutwell, "The Decadence of New England," *Forum* 10 (September 1890): 142–51.

40. Herbert Wendell Gleason, "The Old Farm Revisited," *New England Magazine* 22 (August 1900): 678. See also Nathaniel Shaler, "European Peasants as Immigrants," *Atlantic Monthly* 71 (May 1893): 646–55; Philip Edward Sherman, "Immigration from Abroad into Massachusetts," *New England Magazine* 29 (February 1904): 671–81; and "The Regeneration of Rural New England," *Outlook* 64 (3 March 1900): 506. For a more positive view, see William A. Giles, "Is New England Decadent?" *The World Today* 9 (September 1905): 991–95.

41. See R. Douglas Hurt, "Northern Agriculture after the Civil War, 1865–1900," in *Agriculture and National Development: Views on the Nineteenth Century,* ed. Lou Ferleger (Ames: Iowa State University Press, 1990), 53–73.

42. "The Editor's Table," *New England Magazine* 4 (June 1891): 539, describes the start of this practice. See also the following articles published in *Country Life in America:* Liberty Hyde Bailey, "Going Back to the Old Farm," 6:5 (September 1904): 435–37; Wilhelm Miller, "A New Solution to the Summer Home Problem," 8:5 (September 1905): 530–31; Arthur H. Gleason "New Hampshire—A State for Sale at $10 an Acre," 9:1 (November 1905): 51–54; and E. H. Brainerd, "The Joyous Sport of Farm Hunting," 18:2 (June 1910): 193–96.

43. William Burnham, "Old Home Week in New Hampshire," *New England Magazine* 22 (August 1900): 648. For details of Old Home Week events, see Thomas F. Anderson, "'Old Home Week' in New England," *New England Magazine* 34 (August 1906): 673–85.

44. Gleason, "The Old Farm Revisited," 678, and Burnham, "Old Home Week in New Hampshire," 649–50.

45. Brown, *Inventing New England,* 141.

46. Anderson, "'Old Home Week' in New England," 685.

47. *Old Lyme, the American Barbizon* (Old Lyme, CT: Old Lyme Historical Society, Florence Griswold Museum, 1982), 6.

48. "Academy Notes," April 1913 in Edwin Coupland Shaw Papers, AAA roll 1125, fr. 862, as well as Caffin's remarks (fr. 817) and De Kay's (fr. 830). See also John Cournos, "John Twachtman," *Forum* 52 (August 1914): 246. For Weir, see "The Ten Americans," *Boston Evening Transcript,* 1909, Julian Alden Weir Papers, AAA roll 70, fr. 294.

49. Theodore Robinson, "Claude Monet," *Century Magazine* 44 (September 1892): 701. Earlier in the article, Robinson had written: "Beauty of line, of light and shade, of arrangement, above all, of color, it is but a truism to say that nowhere except in nature can their secrets be discovered" (698). For the details of Robinson's initial visit to Giverny, see Eliot Clark, *Theodore Robinson: His Life and Art* (Chicago: R. H. Love Galleries, 1979), appendix.

50. Theodore Robinson diary, Frick Art Reference Library, New York City, 30 October 1895 and 25 October 1895. See also Harrison Morris, *Confessions in Art* (New York: Sears, 1930), 173.

51. Hamlin Garland, "Theodore Robinson," *Brush and Pencil* 4 (September 1899): 285, 286. For a discussion of the relationship of American Impressionists to nature, see H. Barbara Weinberg, Doreen Bolger, and David Park Curry, *American Impressionism and Realism: The Painting of Modern Life, 1885–1915* (New York: Metropolitan Museum of Art, 1994).

52. Theodore Robinson diary, 29 October 1893 and 27 December 1893.

53. Ibid., 26 March 1894 and 9 June 1894. For his comments on New Jersey, see 8 and 10 October 1894.

54. Ibid., 10 April 1895. See also 17 May 1895; 6 June 1895; 26 July 1895; 23 August 1895; 7 September 1895.

55. Ibid., 9 September 1895.

56. Ibid., 1 October 1895. For his comments about Stowe's novel, see 25 October 1895.

57. Ibid., 2 September 1895. Townshend, Vermont, and its church very much appealed to him. See his entries for 7 September 1895 and 7 October 1895 for his interest in motifs of hillsides and winding roads.

58. Ibid., 4 February 1896 (emphasis Robinson's).

59. Letter postmarked 16 December 1891, Dorothy Young, *The Life and Letters of J. Alden Weir* (New Haven: Yale University Press, 1960), 189–90.

60. "Art Notes," *New York Times,* 13 April 1891, 12. Eliot Clark, *John Twachtman* (New York: Frederic F. Sherman, 1924), 42. For his comments about "a feeling of home," see Eliot Clark, "The Art of John Twachtman," *International Studio* 72 (January 1921): 82.

61. Kathleen Pyne, "John Twachtman and the Therapeutic Landscape," in *John Twachtman: Connecticut Landscapes* (Washington, DC: National Gallery of Art, 1989), 54–55.

62. Cournos, "John Twachtman," 246.

63. Alfred Henry Goodwin, "An Artist's Unspoiled Country Home," *Country Life in America* 8 (October 1905): 628.

64. See, for example, Caffin, *The Story of American Painting,* 281–82. John Cournos, "John Twachtman," 245–47, speaks of the tranquility, serenity, and delicacy of Twachtman's work as does Eliot Clark, *John Twachtman,* 42.

65. Julian Alden Weir et al., "John H. Twachtman: An Estimation," *North American Review* 176 (April 1903): 562.

66. Young, *The Life and Letters of J. Alden Weir,* 161. According to Young, Weir's brother came up with the phrase in a letter to Weir that he headed with these words.

67. Ibid., 211 (ellipsis in the original), 217.

68. Ibid., 162 (ellipsis in the original).

69. *Newark News* clipping of June 1911, Julian Alden Weir Papers, AAA roll 70, fr. 277. See also the clipping "Art at the Pan-American," *New York Sun,* 21 July 1901, Julian Alden Weir Papers, AAA roll 70, fr. 182, and Howard Russell Butler, "The Field of Art," *Scribner's Monthly* 59 (January 1916): 132.

70. Duncan Phillips, "Julian Alden Weir," in *Julian Alden Weir: An Appreciation of His Life and Works* (New York: Century Club, 1921), 38, as well as a newspaper clipping possibly from 1901 or earlier, Julian Alden Weir Papers, AAA roll 70, fr. 181.

71. Guy Pène du Bois, "The Idyllic Optimism of J. Alden Weir," *Arts and Decoration* 2 (December 1911): 78 and 56. See also Butler, "The Field of Art," 132, as well as "Julian Alden Weir," *Mentor* 8 (December 1920): 22. Concerning Weir's refinement, see clipping from the *Newark News,* June 1911; unidentified clipping from 1906, Julian Alden Weir Papers, AAA roll 70, fr. 276; and Caroline Ely, "J. Alden Weir," *Art in America* 12 (April 1924): 116.

72. Eliot Clark, "J. Alden Weir," *Art in America* 8 (August 1920): 242. Newlin Price, "Weir—the Great Observer," *International Studio* 75 (April 1922): 131.

73. Van Dyke, *Nature for Its Own Sake,* 292.

74. Royal Cortissoz, "Weir," in *Julian Alden Weir: An Appreciation of His Life and Works,* 64. Giles Edgerton, "Is America Selling Her Birthright for a Mess of Pottage?" *The Craftsman* 11 (March 1907): 664.

Chapter 4. Childe Hassam, Willard Metcalf

1. Ralcy Bell, *Art Talks with Ranger* (New York: G. P. Putnam & Sons, 1914), 80–81 (italics in the original). See also his comments in the *New Haven Morning Journal and Courier,* 5 July 1907, cited in *Old Lyme, the American Barbizon,* 6.

2. Celia Applegate, *A Nation of Provincials: The German Idea of Heimat* (Berkeley: University of California Press, 1990), 11. Hamlin Garland, *Crumbling Idols: Twelve Essays on Art and Literature* [1894] (Cambridge: Harvard University Press, 1960), 104. The chapter "Impressionism" addresses in general Garland's interest in this style.

3. Mary E. Wilkins Freeman, "New England, 'Mother of America,'" Beautiful America series, *Country Life in America* 22:5 (1 July 1912): 30.

4. Letter to Julian Alden Weir, 17 July 1903, Hassam Papers, AAA roll NAA2, fr. 67.

5. Hassam Papers, AAA roll NAA1, fr. 772, typescript of the American School of the Air broadcast. *New York Sun,* 19 December 1907, NAA1, fr. 545; Frank Fowler, "Impressions of the Spring Academy," *Nation* 84 (28 March 1907): 298.

6. Grace Slocum, "An American Barbizon," *New England Magazine* 34 (July 1906): 570.

7. George S. Roberts, *Historic Towns of the Connecticut River Valley* (Schenectady, NY: Robson & Adee, 1906), 57. See also Frank Vincent Du Mond, "The Lyme Summer School and Its Theory of Art," *The Lamp* 27 (August 1903): 1, which discussed the town as still possessing "the characteristics expressive of the quiet dignity of other days."

8. H. S. Adams, "Lyme—A Country Life Community," *Country Life in America* 25:6 (April 1914): 47.

9. "The Life and Art of Childe Hassam," *New York Herald Tribune,* 1 January 1939, Hassam Papers, AAA roll NAA1, fr. 633. Charles Lewis Hind comments similarly in *Landscape Painting from Giotto to the Present Day* (New York: Scribner's Sons, 1923–24), 2: 234.

10. Adeline Adams, *Childe Hassam* (New York: American Academy of Arts and Letters, 1938), 5. Elizabeth Broun details Hassam's family history in "Hassam's Pride in Ancestry" in *Childe Hassam: American Impressionist,* ed. H. Barbara Weinberg (Metropolitan Museum of Art in association with Yale University Press, 2004): 285–94.

11. Autobiographical statement, Hassam Papers, AAA roll NAA1, fr. 741. He also identified "Childe" as the Saxon word for "shield or knight" (fr. 739). For critics' use of the term, see Israel L. White, "Childe Hassam—A Puritan," *International Studio* 45 (December 1911): xxix–xxxiii; "A Modern Master, Childe Hassam," *Newark Evening News,* 4 February 1911, Hassam Papers, AAA roll NAA1, fr. 558; and Frederic Newlin Price, "Childe Hassam—Puritan," *International Studio* 77 (April 1923): 3–7.

12. Autobiographical statement, Hassam Papers, AAA roll NAA1, fr. 740 and 739.

13. Adams, *Childe Hassam,* 88.

14. Autobiographical statement, Hassam Papers, AAA roll NAA1, fr. 742.

15. Letter of 4 July 1907, Florence Griswold Papers, Lyme Historical Society. For the 1932 show, see "Exhibition of Paintings, Etchings, Drawings and Lithographs by Childe Hassam," Hassam Papers, AAA roll NAA2, fr. 414. Even in his cityscapes, Hassam addressed the progress of American civilization, as Kathleen Pyne has argued in *Art and the Higher Life: Painting and Evolutionary Thought in Late Nineteenth-Century America* (Austin: University of Texas, 1996), 254–66.

16. Letter dated 20 July 1911, Hassam Papers, AAA roll NAA2, fr. 66.

17. *New York American,* 13 December 1907, Hassam Papers, AAA roll NAA1, fr. 543.

18. *New York Evening Mail,* 18 December 1907, in Hassam Papers, AAA roll NAA1, fr. 543.

19. "Art Notes," *Sun,* 20 March 1900, 6, quoted in William Gerdts, *Masterworks of American Impressionism* (New York: H. N. Abrams; Milan: Thyssen-Bornemisza Foundation, 1990), 62.

20. Fowler, "Impressions of the Spring Academy," 298.

21. "New Pictures by Two American Painters," *New York Tribune,* 7 December 1909. Hassam Papers, AAA roll NAA1, fr. 546.

22. Walter Jack Duncan, *Paintings by Willard L. Metcalf,* exhibition pamphlet (Washington, DC: The Corcoran Gallery of Art [1925]), foreword. For general overviews of Metcalf's connection to New England in both his life and art, see Barbara J. MacAdam, *Winter's Promise: Willard Metcalf in Cornish, New Hampshire, 1909–1920* (Hanover, NH: Hood Museum of Art, Dartmouth College, 1999) and Richard J. Boyle, Bruce W. Chambers, and William H. Gerdts, *Willard Metcalf: Yankee Impressionist* (New York: Spanierman Gallery, 2003). Metcalf's life and work are discussed in Elizabeth de Veer and Richard J. Boyle, *Sunlight and Shadow: The Life and Art of Willard L. Metcalf* (New York: Abbeville Press in association with Boston University, 1987).

23. Excerpt of a letter dated 6 August 1921 from Tarkington to Metcalf, The Corcoran Gallery and School of Art Archives, Director's Correspondence. See also Minnigerode's letter from 12 January 1922 in the same file.

24. D[onald] W. Meinig, "Symbolic Landscapes: Some Idealizations of American Communities," in *The Interpretation of Ordinary Landscapes,* ed. D. W. Meinig (Oxford: Oxford University Press, 1979), 165.

25. E. Marguerite Lindley and Juanita Leland, "The National Society of New England Women," *New England Magazine* 34 (July 1906): 634. For the revival of New England Societies, see Vartanian, "The Puritan as a Symbol of American Thought," especially chaps. 5 and 6.

26. Mary Northend, *Colonial Homes and Their Furnishings* (Boston: Little, Brown, 1912), 20. See also Candace Wheeler, *Principles of Home Decoration* (New York: Doubleday, 1903), and J. W. Dow, *American Renaissance* (New York: The William T. Comstock Co., 1904). For an analysis of turn-of-the-century colonial interest, see William Rhoads, *The Colonial Revival* (New York: Garland, 1977); Alan Axelrod, ed., *The Colonial Revival in America* (New York: W. W. Norton, 1985); and Michael Kammen, *Mystic Chords of Memory: The Transformation of Tradition in American Culture* (New York: Knopf, 1991).

27. Wallace Nutting, *Old New England Pictures* (privately printed, 1913), 18.

28. Nutting cites James in his trade list *Wallace Nutting Pictures* (privately printed, 1912), 8, and lists 84 available apple blossom images.

29. In 1925, Morgan donated the collection to the Wadsworth Atheneum. For comprehensive discussions of Nutting's life and work, see Joyce Barendsen, "Wallace Nutting, an American Tastemaker," *Winterthur Portfolio* 18 (Summer/Autumn 1983): 187–212, and Thomas Andrew Denenberg, *Wallace Nutting and the Invention of Old America* (New Haven: Yale University Press, 2003).

30. Susan Prendergast Schoelwer, "Curious Relics and Quaint Scenes: The Colonial Revival at Chicago's Great Fair," in *The Colonial Revival in America,* ed. Axelrod, 184–216.

31. Northend, *Colonial Homes and Their Furnishings,* 20 and 236.

32. Freeman, "New England, 'Mother of America,'" 29 and 70.

33. See, for example, Francis A. Walker, "Restriction of Immigration," *Atlantic Monthly* 77 (June 1896): 822–29, which reiterates many of his arguments from "Immigration and Degradation," *Forum* 11 (1891): 634–44; Nathaniel Shaler, "European Peasants as Immigrants," *Atlantic Monthly* 71 (May 1893): 646–55; William Z. Ripley, "Our Threatening Race Muddle," *Boston Evening Transcript,* 21 June 1913, pt. 3, 3 and 8; and Amy Woods, "Italians of New England," *New England Magazine* 30 (July 1904): 626–32. For Roosevelt's comment, see *The Letters of Theodore Roosevelt,* ed. Morison, 2: 1053. For a general overview of nativism, see Dale Knobel, *"America for Americans": The Nativist Movement in the United States* (New York: Twayne, 1996), as well as Matthew Frye Jacobson, *Whiteness of a Different Color: European Immigrants and the Alchemy of Race* (Cambridge: Harvard University Press, 1998).

34. Barbara Solomon, *Ancestors and Immigrants: A Changing New England Tradition* (Chicago: University of Chicago Press, 1956), 135. Her book describes in detail the League and its work.

35. "Birth Control and Race Suicide," *Literary Digest* 54 (3 February 1917): 245. For the term "race suicide," see Edward A. Ross, "The Causes of Race Superiority," *Annals of the American Academy of Political and Social Science* 18 (1901): 88, as well as his *Old World in the New* (New York: Century, 1914).

36. G. B. Adams, "The United States and the Anglo-Saxon Future," *Atlantic Monthly* 78 (July 1896): 36.

37. Speranza published his article in *World's Work* 47 (November 1923): 57–65. See also Madison Grant, *The Passing of the Great Race* (New York: Charles Scribner's Sons, 1921), first published in 1916; Daniel Chauncey Brewer, *The Conquest of New England by the Immigrant* (New York: G. P. Putnam, 1926); and William Rhoads, "The Colonial Revival and the Americanization of Immigrants," in *The Colonial Revival in America,* ed. Axelrod, 341–61.

38. Caroline MacGill, "The New England Type: A Study in Psychological Sociology," *New England Magazine* 40 (August 1909): 668.

39. Applegate, *A Nation of Provincials,* 11.

40. Herbert Wendell Gleason, "The Old Farm Revisited," *New England Magazine* 22 (August 1900): 680, italics in the original.

41. Charles Eliot Norton, "The Lack of Old Homes in America," *Scribner's Magazine* 5 (May 1889): 638. Nathaniel Shaler, "The Landscape as a Means of Culture," *Atlantic Monthly* 82 (December 1898): 782.

42. For Hassam's prints, see Royal Cortissoz and the Leonard Clayton Gallery, *Catalogue of the Etchings and Dry-Points of Childe Hassam,* rev. ed. (San Francisco: Alan Wofsy Fine Arts, 1989), #13–16, #104, #39, #53, #159, #172. Elizabeth E. Barker provides an overview of Hassam's print work in "'A truly learned weaving of light and dark': Hassam's Prints," in *Childe Hassam: American Impressionist,* ed. Weinberg, 267–84.

43. Everett S. Stackpole, *Old Kittery and Her Families* (Lewiston, ME: Press of Lewiston Journal Co., 1903), 57. *Dictionary of American Biography,* s.v. "Leete, William."

44. Harold D. Eberlein, *The Architecture of Colonial America* (Boston: Little, Brown, 1915), 1.

45. Wallace Nutting, *Old New England Pictures* (Norwood, MA: Plimpton Press, 1913), 18. On SPNEA, see James M. Lindgren, *Preserving Historic New England: Preservation, Progressivism, and the Remaking of Memory* (Oxford: Oxford University Press, 1995).

46. Eberlein, *The Architecture of Colonial America,* 8–9. For the history of Litchfield, see William Butler, "Another City upon a Hill: Litchfield, Connecticut and the Colonial Revival," in *The Colonial Revival in America,* ed. Axelrod,

15–51. See also J. S. Wood and M. Steinitz, "A World We Have Gained: House, Community, and Village in New England," *Journal of Historical Geography* 18 (1992): 105–20.

47. "Exhibition of Metcalf's Work," *New York Times,* 5 January 1909, AAA roll N70–13, fr. 516. For the Corcoran director's remark, see Aida Rainey, "Metcalf Paintings in the Corcoran Provide Notable Art Exhibition," *Washington Post* clipping [1925], Metcalf Papers, AAA N70–13, fr. 557.

48. "Landscapes by Mr. Willard L. Metcalf," *New York Tribune,* 6 February 1906, Metcalf Papers, AAA roll N70–13, fr. 506 (this review focuses on Metcalf's Connecticut landscapes), and William B. McCormick, "19 Paintings by Metcalf on Exhibit," Metcalf Papers, AAA roll N70–13, fr. 561.

49. *New York Tribune,* 13 February 1907, and *New York Tribune,* 4 February 1905, Metcalf Papers, AAA roll N70–13, fr. 508, 505. Royal Cortissoz, *Commemorative Tribute to Metcalf* (New York: American Academy of Arts and Letters, 1927), 4. See also *New York Evening Globe,* 6 February 1905, Metcalf Papers, AAA roll N70–13, fr. 505.

50. Catherine Beach Ely, "Willard L. Metcalf," *Art in America* 13 (October 1925): 336.

51. Washington newspaper clipping [1925], AAA, Metcalf Papers, N70–13, fr. 548.

52. Ely, "Willard L. Metcalf," 332. *New York Tribune,* 17 April [1920], AAA, Metcalf Papers, N70–13, fr. 548.

53. *New York American,* 24 October 1910; *Chicago Inter-Ocean,* 15 October 1910; *Examiner,* 15 October 1910, all from Metcalf Papers, AAA roll N70–13, fr. 522. The *White Veil* also received adulatory reviews; see the *New York Times,* 22 March 1909, 7, and the *Boston Evening Transcript,* 24 March 1909, 21.

54. Quoted in Tim Armstrong, "'A Good Word for Winter': The Poetics of a Season," *New England Quarterly* 60 (December 1987): 571–72, which addresses the response of American poets to winter.

55. Van Dyke, *Nature for Its Own Sake,* 107–9. See also Birge Harrison, "The Appeal of the Winter Landscape," *Fine Arts Journal* 30 (March 1914): 191–96.

56. John Burroughs, "The Tonic of Winter," *Country Life in America* 19 (December, mid-month 1910): 179; Edward S. Martin, "Winter in the Country," *Harper's Monthly Magazine* 107 (November 1903): 852, 846.

57. Notes for the unpublished Florida manuscript, Wallace Nutting file, Framingham Public Library. For Burroughs, see "The Tonic of Winter," 177, 179.

58. George French, ed., *New England: What It Is and What It Is to Be* (Boston: Boston Chamber of Commerce, 1911), 37.

59. *New England Magazine* 47 (July 1912): 202 (the original contains a typesetting error and reads "grace rather that abundance").

60. Wallace Nutting, *Massachusetts Beautiful* (Framingham, MA: Old America Co., 1923), 7.

61. *Sun,* January 1908, Metcalf Papers, AAA roll N70–13, fr. 512.

62. *New York American,* 10 January 1910, and *New York Tribune* 8 January [1911], both from Metcalf Papers, AAA roll N70–13, fr. 520 and 522. See also the Sunday *Sun,* 8 January [1911], Metcalf Papers, AAA roll N70–13, fr. 522, which found in his work an "increasing virility."

63. *New York Tribune,* 17 April [1920]; Royal Cortissoz, "New Landscapes by Mr. Willard L. Metcalf," [1908] clipping; and *New York Tribune,* 4 February 1905; all from Metcalf Papers, AAA roll N70–13, fr. 548, 511, and 505.

64. Reported in Rainey, "Metcalf Paintings in the Corcoran Provide Notable Art Exhibition."

65. Van Dyke, *Nature for Its Own Sake,* 170–71.

66. Unidentified review of the Montross Gallery exhibition, Metcalf Papers, AAA roll N70–13, fr. 512.

67. *New York Tribune,* 10 March 1925, Metcalf Papers, AAA roll N70–13, fr. 544, and *Evening Globe,* 6 February 1905, Metcalf Papers, AAA roll N70–13, fr. 505. Royal Cortissoz's review of the 1908 Montross Gallery show, "New Landscapes by Mr. Willard L. Metcalf," in an unidentified newspaper addresses Metcalf's brand of Impressionism: Metcalf Papers, AAA roll N70–13, fr. 511.

68. George French, "The Land of the New England," *New England Magazine* 43 (February 1911): 637.

69. "The Abandoned Farms," *Country Life in America* 1 (November 1901): 6.

70. Herbert Wendell Gleason, "The Old Farm Revisited," *New England Magazine* 22 (August 1900): 668, as well as p. 653 for the poem. For the Bailey article, see "Going Back to the Old Farm," *Country Life in America* 6 (September 1904): 435.

71. Rev. A. W. Jackson, "New England and California," *New England Magazine* 1 (February 1890): 694.

72. William A. Giles, "Is New England Decadent?," *The World Today* 9 (September 1905): 994.

73. MacGill, "The New England Type," 670 and 668. For a similar position, see also W. Harshaw, "A Public Library in a Small Town," *Outlook* 68 (29 June 1901): 492.

74. Giles, "Is New England Decadent?" as well as French, ed., *New England: What It Is and What It Is to Be,* 31. Edwin Shivell, "Will the Nation Repudiate Her Debt to New England?," *New England Magazine* (September 1911): 39. See also A. Phenis, *Yankee Thrift: The Story of New England's Marvelous Industrial Development* (How "Clear Grit," Ingenuity and Ceaseless Activity Have Transformed a Semi-Barren Corner of the Country into One of the Most Prosperous Regions of the Globe. An Inspiration for Other Sections, Particularly the South) (Baltimore: Manufacturers' Record Publishing Co., 1905).

75. French, ed., *New England: What It Is and What It Is to Be,* 45, 47.

76. Lyman P. Powell, ed., *Historic Towns of New England,* 2nd ed. (New York: G. P. Putnam's Sons, The Knicker-bocker Press, 1899), 51.

77. French, ed., *New England: What It Is and What It Is to Be,* 47.

78. Winthrop Packard, "The New England Society in the City of New York," *New England Magazine* 37 (January 1908): 523.

Chapter 5. United States: *E Pluribus Unum*

1. Frederick Jackson Turner, "Sections and Nation," in *Frontier and Section: Selected Essays of Frederick Jackson Turner,* with an introduction by Ray Allen Billington (Englewood Cliffs, NJ: Prentice-Hall, 1961), 152. Turner's late work tends to be overlooked. For its connection to his historical perspective in general, see Michael Steiner, "Frederick Jackson Turner and Western Regionalism," in *Writing Western History: Essays on Major Western Historians,* ed. Richard W. Etulain (Albuquerque: University of New Mexico Press, 1991), 103–35.

2. Frederick Jackson Turner, "The Significance of the Section in American History," in *Frontier and Section,* 131. Turner cites here Josiah Royce's eloquent definition of a section as "any one part of a national domain which is geographically and socially sufficiently unified to have a true consciousness of its own ideals and customs and to possess a sense of its distinction from other parts of the country" (131).

3. The phrase comes from Thomas Craven, who tenaciously advocated for an American art that reflected American experience, and whose often-extreme opinions and bold remarks have tended to overshadow his many astute observations. In *Modern Art: The Men, the Movements, the Meaning* (1934; rev. ed., New York: Simon and Schuster, 1940), 258, he commented: "It [America] is a country of endless variations, and no one man shall know them all. There are many Americas which, in time, I trust, shall all be revealed to us in art."

4. Martha Davidson, "New Directions in Native Painting," *Art News* 35 (1 May 1937): 139.

5. Scholarly discussion of this painting has been minimal. See Sharyn Rohlsen Udall, *Modernist Painting in New Mexico, 1913–1935* (Albuquerque: University of New Mexico, 1984), 41; Steven Henry Madoff, "Marsden Hartley: Painter in Motion," *Art News* 88 (November 1989): 81–82; and Judith A. Barter, *Window on the West: Chicago and the Art of the New Frontier, 1890–1940* (Chicago: Art Institute of Chicago, 2003), 137.

6. "New England and the West," *New England Magazine* n.s. 2 (April 1890): 233.

7. Letter to Alfred Stieglitz, 12 November 1914, Alfred Stieglitz Papers, Yale Collection of American Literature, Beinecke Rare Books and Manuscript Library, Yale University (hereafter YCAL).

8. Reprinted in Donna M. Cassidy, *Marsden Hartley: Race, Region, and Nation* (Durham: University of New Hampshire; published by University Press of New England, 2005), appendix c, as well as in *On Art by Marsden Hartley,* ed. Gail Scott (New York: Horizon Press, 1982), 112–15. General biographical treatments of Hartley include Townsend Ludington, *Marsden Hartley: The Biography of an American Artist* (1992; rev. ed., Ithaca: Cornell University Press, 1998); Barbara Haskell, *Marsden Hartley* (New York: Whitney Museum of American Art, 1980); Jeanne Hokin, *Pinnacles and Pyramids: The Art of Marsden Hartley* (Albuquerque: University of New Mexico Press, 1993), and Elizabeth M. Kornhauser, ed., *Marsden Hartley* (Hartford/New Haven, CT: Wadsworth Atheneum Museum of Art in association with Yale University Press, 2003).

9. Marsden Hartley, "The Six Greatest New England Painters," *Yankee* (August 1937): 14–16.

10. Marsden Hartley, "America as Landscape," *El Palacio* 5 (December 1918): 340–42, quotations from 340 and 341.

11. Marsden Hartley, "This Country of Maine" (1937/1938), Marsden Hartley Papers, YCAL, microfilm in Archives of American Art (hereafter AAA), reel 1371, fr. 3440.

12. Marsden Hartley, "The Education of an American Artist," Hartley Papers, YCAL, AAA, reel 1369, fr. 1250.

13. Ibid., fr. 1256 and 1253.

14. Scott was commenting on Hartley's "Is There an American Art?" See *On Art by Marsden Hartley,* 167.

15. Ibid., 198.

16. "Impressions of Provence from an American's Point of View," in ibid., 143.

17. Paul Rosenfeld, *Port of New York* (1924; rpt., University of Illinois Press, 1961), 99–100. For Hartley's self-construction as a regional artist, see especially Cassidy's compelling and extended analysis, *Marsden Hartley: Race, Region, and Nation.* Cézanne's regional identity is explored in Nina Maria Athanassoglou-Kallmyer, *Cézanne and Provence: The Painter in His Culture* (Chicago: University of Chicago Press, 2003).

18. See Haskell, *Marsden Hartley,* 57–60, as well as letters such as those to Stieglitz from 20 June 1918, 20 July 1918, 1 August 1918, 9 September 1918, 16 October 1918, 20 November 1918, and 20 July 1926 in Alfred Stieglitz Papers, YCAL.

19. Quoted in "The Pioneer Artists of Taos," *American Scene* 3:3 (Fall 1960): n.p., The Harwood Foundation, AAA, reel 3242, fr. 756.

20. "Origin of the Taos Art Colony," *El Palacio* (15 May 1926): 190. See also Ernest L. Blumenschein, "The Taos

Society of Artists," *American Magazine of Art* 8 (September 1917): 445–51, as well as Mabel Dodge Luhan, who also told this story in "Taos—A Eulogy," *Creative Art* 9:4 (October 1931): 289–95. Blumenschein relayed a more detailed version published in Laura M. Bickerstaff, *Pioneer Artists of Taos* (c. 1955; rev. and expanded ed., Denver: Old West Publishing, 1983), 30–31.

21. See, for example, Paul A. F. Walter, "The Santa Fe–Taos Art Movement," *Art and Archaeology* 4 (December 1916): 330, 337, and Fred Hamilton Rindge, "Taos—A Unique Colony of Artists," *American Magazine of Art* 17:9 (September 1926): 449.

22. Mabel Dodge Luhan, "A Bridge between Cultures," *Theatre Arts Monthly* 9 (1925): 299. For a full account of Luhan in Taos, see Lois Palken Rudnick, *Utopian Vistas: The Mabel Dodge Luhan House and the American Counterculture* (Albuquerque: University of New Mexico, 1996).

23. Paul Rosenfeld included "Turning to America" in *By Way of Art: Criticisms of Music, Literature, Painting, Sculpture, and the Dance* (New York: Coward-McCann, 1928), 219, 221–22.

24. Walter, "The Santa Fe–Taos Art Movement," 335, 330. Mabel Dodge Luhan, "Native Air," *New Republic* 42 (4 March 1925): 41.

25. Robert Henri, *The Art Spirit* ([c. 1923] New York: Harper & Row, 1984), 187.

26. Mary Austin, "Cults of the Pueblos: An Interpretation of Some Native Ceremonials," *Century Magazine* 109 (November 1924): 35.

27. Edgar L. Hewett, *Ancient Life in the American Southwest* (Indianapolis: Bobbs-Merrill, 1930), 23–24. Blumenschein, "The Taos Society of Artists," 448.

28. Marsden Hartley, "Red Man Ceremonial: An American Plea for American Esthetics," *Art and Archaeology* 9:1 (January 1920): 9. See also "Tribal Esthetics," *The Dial* (16 November 1918): 399–401; "The Scientific Esthetic of the Redman, Part I: The Great Corn Ceremony at Santo Domingo," *Art and Archaeology* 13:3 (March 1922): 113–19; and "The Scientific Esthetic of the Redman, Part II: The Fiesta of San Geronimo at Taos," *Art and Archaeology* 14:3 (September 1922): 137–39.

29. Luhan, "A Bridge between Cultures," 299.

30. Samuel Putnam, "Lost: One America; Provincetown to Santa Fe," *Chicago Evening Post Magazine of the Art World,* 23 March 1926, 3. For the term "first Americans," see Hewett, *Ancient Life in the American Southwest,* xiv, as well as Celeste Connor, *Democratic Visions: Art and Theory of the Stieglitz Circle, 1924–1934* (Berkeley: University of California Press, 2001), 175, who cites its use in *Clason's New Mexico Green Guide,* a popular guidebook of the 1920s.

31. Hartley, "America as Landscape," 342.

32. Arrell Morgan Gibson, *The Santa Fe and Taos Colonies: Age of the Muses, 1900–1942* (Norman: University of Oklahoma Press, 1983), 15. For Mabel Dodge Luhan's promotion of a mythic New Mexico, see Lois P. Rudnick, "Mabel Dodge Luhan and the Myth of the Southwest," *Southwest Review* 68 (1983): 205–21. See also Leah Dilworth, *Imagining Indians in the Southwest: Persistent Visions of a Primitive Past* (Washington, D.C.: Smithsonian Institution Press, 1996).

33. Ernest Peixotto, "The Taos Society of Artists," *Scribner's Magazine* 60 (August 1916): 258.

34. Quoted in Dean A. Porter, *Victor Higgins: An American Master* (Salt Lake City: Peregrine Smith Books, 1991), 49.

35. Hartley, "Red Man Ceremonials," 7, 14.

36. The Museum of Fine Arts, Museum of New Mexico Papers, AAA, reel 3292, fr. 217.

37. Idalea Andrews Hunt, "Taos Art Exhibit Shows Indian Life," *Dallas Morning News,* 7 December 1924, 16, in the Museum of Fine Arts, Museum of New Mexico Papers, AAA, reel 3292, fr. 505.

38. Cheryl Leibold quoted in Dean A. Porter, Teresa Hayes Ebie, and Suzan Campbell, *Taos Artists and Their Patrons, 1898–1950* (Snite Museum of Art, University of Notre Dame, 1999), 54. The section on "Juried Exhibitions" details the successes of Taos artists with prizes and awards.

39. Mabel Dodge Luhan, *Taos and Its Artists* (New York: Duell, Sloan, and Pearce, 1947), 11–12.

40. In *On Art by Marsden Hartley,* 106–7.

41. Lewis Mumford, "Toward a New Regionalism," *New Republic* 66 (25 March 1931): 158. See also B. A. Botkin, "We Talk About Regionalism—North, East, South, and West," *Frontier* 13:4 (May 1933): 286–96.

42. Howard Odum and Harry Moore, *American Regionalism: A Cultural-Historical Approach to National Integration* (New York: Henry Holt, 1938), 423.

43. Robert Dorman, *Revolt of the Provinces: The Regionalist Movement in America, 1920–1945* (Chapel Hill: University of North Carolina Press, 1993), xii. See also Michael Steiner, "Regionalism in the Great Depression," *Geographical Review* 73 (October 1983): 430–46. For its artistic expression, see especially Matthew Baigell, *The American Scene: American Painting of the 1930's* (New York: Praeger, 1974), Nancy Heller and Julia Williams, *The Regionalists* (New York: Watson-Guptill, 1976), and Donna M. Cassidy, "'On the Subject of Nativeness': Marsden Hartley and New England Regionalism," *Winterthur Portfolio* 29 (1994): 227–45. For modernist elements in the work of the three Midwestern regionalists, see James M. Dennis, *Renegade Regionalists: The Modern Independence of Grant Wood, Thomas Hart Benton, and John Steuart Curry* (Madison: University of Wisconsin Press, 1998).

44. F. A. Whiting, Jr. (unsigned editorial), "The Americana School," *American Magazine of Art* 27 (August 1934): 409.

45. Peyton Boswell, "Peyton Boswell Comments: Regional Exhibitions," *Art Digest* 11 (15 February 1937): 3.

46. "Whitney Museum Shows the 'Regional Art' of Philadelphia," *Art Digest* 9 (1 November 1934): 32.

47. Whiting, "The Americana School," 409.

48. Davidson, "New Directions in Native Painting," 141.

49. Dorothy Norman, "An American Place," in *America and Alfred Stieglitz: A Collective Portrait,* ed. Waldo Frank et al. (New York: Literary Guild/Doubleday, Doran, 1934), 126. On page 144, she compares the gallery to "a living cell out of the body entire." The art historian Celeste Connor speaks of the gallery as "a metonym for America" in *Democratic Visions,* 73. See also Wanda Corn's discussion of the gallery's name in response to the opening of the Museum of Modern Art in 1929, *The Great American Thing: Modern Art and National Identity, 1915–1935* (Berkeley: University of California Press, 1999), 40. For Norman's personal relationship with Stieglitz, see Vivien Green Fryd, *Art and the Crisis of Marriage: Edward Hopper and Georgia O'Keeffe* (Chicago: University of Chicago Press, 2003).

50. Edna Bryner, "An American Experience," in *America and Alfred Stieglitz,* 256.

51. Corn, *The Great American Thing,* 31–33, 249.

52. Elizabeth McCausland, "Stieglitz and the American Tradition," in *America and Alfred Stieglitz,* 229.

53. Davidson, "New Directions in Native Painting," 145–46.

54. Paul Strand, "American Watercolors at the Brooklyn Museum," *The Arts* 2 (December 1921): 152. Rosenfeld, *Port of New York,* 153. Rosenfeld made a similar comment again in 1937 in "John Marin's Career," *New Republic* 90 (14 April 1937): 292.

55. Thomas Craven, "John Marin," *Nation* 118 (19 March 1924): 321. See also *Men of Art* (New York: Simon and Schuster, 1934), 512.

56. Benton's review, originally published in *Common Sense* 4 (January 1935): 22–25, is reprinted in *A Thomas Hart Benton Miscellany,* ed. Matthew Baigell (Wichita: University Press of Kansas, 1971), 65–74. Interestingly, Stieglitz took on Benton and continued the debate primarily through private correspondence, as Marcia Brennan has noted in *Painting Gender, Constructing Theory: The Alfred Stieglitz Circle and American Formalist Aesthetics* (Cambridge: MIT Press, 2001), 204–7.

57. Walker's comment is quoted in "Mid-West Is Producing an Indigenous Art," *Art Digest* 7 (1 September 1933): 10. "U.S. Scene," *Time* 24 (24 December 1934): 24–27.

58. See, for example, Van Wyck Brooks, "The Wine of the Puritans" (1908), "The Culture of Industrialism" (1917), and "On Creating a Usable Past" (1918), in *Van Wyck Brooks: The Early Years,* ed. Claire Sprague (New York: Harper & Row, 1968). For a comprehensive discussion of American intellectuals and their relationship to the Puritan tradition, see Dawson, *The Unusable Past.* Warren Susman provides a more general overview in *Culture as History* (New York: Pantheon, 1973), 39–49.

59. From an interview in *Art Front* 1 (April 1935): 2, reprinted in *A Thomas Hart Benton Miscellany,* 64.

60. Grant Wood, "Revolt Against the City" reprinted in James M. Dennis, *Grant Wood: A Study in American Art and Culture* (New York: Viking, 1975), 230, 235. For Wood's general interest in regionalism, see Wanda Corn, *Grant Wood: The Regionalist Vision* (New Haven: Yale University Press in association with The Minneapolis Institute of Arts, 1983).

61. For the federal art programs in general, see especially Marlene Park and Gerald E. Markowitz, *Democratic Vistas: Post Offices and Public Art in the New Deal* (Philadelphia: Temple University Press, 1984), 6–8, 11–15, appendix (Section Murals and Sculptures by State), and Jonathan Harris, *Federal Art and National Culture: The Politics of Identity in New Deal America* (Cambridge: Cambridge University Press, 1995). To administer its program effectively, Harris notes, the Federal Art Project under the WPA divided the country into forty-two administrative units corresponding to individual states, small regions, and in some cases large municipalities (28).

62. *New Horizons in American Art,* with an introduction by Holger Cahill (New York: Museum of Modern Art, 1936), 18.

Selected Bibliography

Archival Collections

Archives of American Art, Smithsonian Institution, Washington, DC.
Boston City Hall. Records of the Boston Art Commission, Correspondence Folder.
Boston Public Library. Trustees Archives, Art Correspondence files; Trustees Scrapbook.
Connecticut Valley Historical Museum and Library, Springfield, Massachusetts.
Corcoran Gallery of Art, Washington, DC.
Dartmouth College, Hanover, New Hampshire, Special Collections.
Florence Griswold Museum / Lyme Historical Society, Old Lyme, Connecticut.
Frick Art Library, New York City.
Historical Society of Pennsylvania, Philadelphia.
Yale Collection of American Literature, Beinecke Rare Book Library, Yale University, New Haven, Connecticut.

Published Sources

Adams, Henry. *The Education of Henry Adams: An Autobiography.* Boston: Houghton Mifflin, 1918.
The American Renaissance, 1876–1917. New York: The Brooklyn Museum of Art in association with Pantheon Books, 1979.
Anderson, Benedict. *Imagined Communities: Reflections on the Origin and Spread of Nationalism.* London: Verso, 1991.
Applegate, Celia. *A Nation of Provincials: The German Idea of Heimat.* Berkeley: University of California Press, 1990.
Axelrod, Alan, ed. *The Colonial Revival in America.* New York: W. W. Norton. Published for The Henry Francis du Pont Winterthur Museum, 1985.
Ayers, Edward, Patricia Limerick, Stephen Nissenbaum, and Peter Onuf. *All Over the Map: Rethinking American Regions.* Baltimore: Johns Hopkins University Press, 1996.
Baigell, Matthew. *The American Scene: American Painting of the 1930s.* New York: Praeger, 1974.
———. *Artist and Identity in Twentieth-Century America.* Cambridge: Cambridge University Press, 2001.
Bailey, Liberty Hyde. *The Country Life Movement in the United States.* New York: Macmillan, 1911.
Baltzell, E. Digby. *Puritan Boston and Quaker Philadelphia.* Boston: Beacon Press, 1979.
Bancroft, Hubert. *The Book of the Fair.* Volumes I and II. Chicago: The Bancroft Company, 1893.
Barron, Hal. *Those Who Stayed Behind: Rural Society in Nineteenth-Century New England.* Cambridge: Cambridge University Press, 1984.
Beisel, Nicola. "Class, Culture, and Campaigns against Vice in Three American Cities, 1872–1892." *American Sociological Review* 55:1 (February 1990): 44–62.

Bhabha, Homi K. "DissemiNation: Time, Narrative, and the Margins of the Modern Nation." In *Nation and Narration,* ed. Homi K. Bhabha. London: Routledge, 1990.

Bickerstaff, Laura M. *Pioneer Artists of Taos.* Revised and Expanded Edition. Denver: Old West Publishing, 1983.

Blocker, Jack S. *American Temperance Movements: Cycles of Reform.* Boston: Twayne, 1989.

Bogart, Michele H. *Public Sculpture and the Civic Ideal in New York City, 1890–1930.* Chicago: University of Chicago Press, 1989.

Bourdieu, Pierre. *Distinction: A Social Critique of the Judgment of Taste.* Cambridge: Harvard University Press, 1984.

Bowden, M. J. "The Invention of American Tradition." *Journal of Historical Geography* 18 (1992): 3–26.

Boyer, Paul. *Urban Masses and Moral Order in America, 1820–1920.* Cambridge: Harvard University Press, 1978.

Brown, Dona. *Inventing New England: Regional Tourism in the Nineteenth Century.* Washington, DC.: Smithsonian Institution Press, 1995.

Bunce, M. F. *The Countryside Ideal: Anglo-American Images of Landscape.* London: Routledge, 1994.

Burke, Doreen B. *J. Alden Weir: An American Impressionist.* Newark: University of Delaware Press / An American Art Journal Book, 1983.

Burns, Sarah. *Inventing the Modern Artist: Art and Culture in Gilded Age America.* New Haven: Yale University Press, 1996.

——. *Pastoral Inventions: Rural Life in Nineteenth-Century American Art and Culture.* Philadelphia: Temple University Press, 1989.

——. "Revitalizing the 'Painted-Out' North: Winslow Homer, Manly Health, and New England Regionalism in Turn-of-the-Century America." *American Art* 9 (Summer 1995): 20–37.

Cassidy, Donna. *Marsden Hartley: Race, Region, and Nation.* Lebanon, NH: University Press of New England, 2005.

Chotner, Deborah, Lisa N. Peters, and Kathleen Pyne. *John Twachtman: Connecticut Landscapes.* Washington, DC.: National Gallery of Art, distributed by Harry N. Abrams, New York, 1989.

Conforti, Joseph A. *Imagining New England: Explorations of Regional Identity from the Pilgrims to the Mid-Twentieth Century.* Chapel Hill: University of North Carolina Press, 2001.

Connor, Celeste. *Democratic Visions: Art and Theory of the Stieglitz Circle, 1924–1934.* Berkeley: University of California Press, 2001.

Corn, Wanda M. *Grant Wood: The Regionalist Vision.* New Haven: The Minneapolis Institute of Arts in association with Yale University Press, 1983.

——. *The Great American Thing: Modern Art and National Identity, 1915–1935.* Berkeley: University of California Press, 1999.

Craven, Thomas. *Modern Art.* New York: Simon and Schuster, 1934.

Cummings, Hildegard, Helen K. Fusscas, and Susan G. Larkin. *J. Alden Weir: A Place of His Own.* Storrs: The William Benton Museum of Art, The University of Connecticut, 1991.

Dainotto, Roberto Maria. "'All the Regions Do Smilingly Revolt': The Literature of Place and Region." *Critical Inquiry* 22 (Spring 1996): 486–505.

Dawson, Jan C. *The Unusable Past: America's Puritan Tradition, 1830–1930.* Chico, CA: Scholars Press, 1984.

de Veer, Elizabeth, and Richard J. Boyle. *Sunlight and Shadow: The Life and Art of Willard L. Metcalf.* New York: Abbeville Press, 1987.

Dimaggio, Paul. "Cultural Entrepreneurship in Nineteenth-Century Boston: The Creation of an Organizational Base for High Culture in America." *Media, Culture, and Society* 4 (1982): 33–50.

Dorman, Robert, *Revolt of the Provinces: The Regionalist Movement in America, 1920–1945.* Chapel Hill: University of North Carolina Press, 1993.

Eldredge, Charles C., Julie Schimmel, and William H. Truettner. *Art in New Mexico, 1900–1945: Paths to Taos and Santa Fe.* Washington, DC and New York: National Museum of American Art, Smithsonian Institution, in association with Abbeville Press, 1986.

Feintuch, Burt, and David H. Waters. *The Encyclopedia of New England.* New Haven: Yale University Press, 2005.

Ferleger, Lou, ed. *Agriculture and National Development: Views on the Nineteenth Century.* Ames: Iowa State University Press, 1990.

Garrison, Dee. *Apostles of Culture: The Public Librarian and American Society, 1876–1920.* New York: Free Press, 1979.

Gillis, John R., ed. *Commemorations: The Politics of National Identity.* Princeton: Princeton University Press, 1994.

Halttunen, Karen. "The Rust of Time, the Patina of Place: Recent Studies in New England Regionalism." *New England Quarterly* 77 (2004): 122–35.

Hancock, Jane H., Sheila Ffolliot, and Thomas O'Sullivan. *Homecoming: The Art Collection of James J. Hill.* St. Paul: Minnesota Historical Society Press, 1991.

Helsinger, Elizabeth K. *Rural Scenes and National Representation: Britain, 1815–1850.* Princeton: Princeton University Press, 1997.

Hiesinger, Ulrich. *Impressionism in America: The Ten American Painters.* Munich: Prestel-Verlag, 1991.

Higham, John. *Strangers in the Land: Patterns of American Nativism, 1860–1925.* New Brunswick: Rutgers University Press, 1994.

Hobsbawm, E. J. *Nations and Nationalism since 1870: Programme, Myth, Reality.* 2nd edition. Cambridge: Cambridge University Press, 1992.

Jacobson, Matthew Frye. *Whiteness of a Different Color: European Immigrants and the Alchemy of Race.* Cambridge: Harvard University Press, 1998.

Jaher, Frederic Cople, ed. *The Age of Industrialism in America: Essays in Social Structure and Cultural Values.* New York: Free Press, 1968.

Jordy, William H. "Four Approaches to Regionalism in the Visual Arts of the 1930s." In *The Study of American Culture: Contemporary Conflicts,* ed. Luther S. Luedtke, 19–48. Deland, FL: Everett / Edwards, c. 1977.

Kammen, Michael. *Meadows of Memory: Images of Time and Tradition in American Art and Culture.* Austin: University of Texas Press, 1992.

Keyes, Donald, and Janice Simon, eds. *Crosscurrents in American Impressionism at the Turn of the Century.* Athens: Georgia Museum of Art, University of Georgia, 1996.

Lears, T. J. Jackson. *No Place of Grace: Antimodernism and the Transformation of American Culture, 1880–1920.* New York: Pantheon, 1981.

Lowenthal, David, and Martyn Bowden, eds. *Geographies of the Mind.* Oxford: Oxford University Press, 1975.

Meinig, D. W., ed. *The Interpretation of Ordinary Landscapes: Geographical Essays.* Oxford: Oxford University Press, 1979.

Miller, Angela. *The Empire of the Eye: Landscape Representation and American Cultural Politics, 1825–1875.* Ithaca: Cornell University Press, 1993.

Mitchell, W. J. T., ed. *Landscape and Power.* Chicago: University of Chicago Press, 1994.

Odum, Howard, and Harry Moore. *American Regionalism: A Cultural-Historical Approach to National Integration.* New York: Henry Holt, 1938.

Park, Marlene, and Gerald E. Markowitz. *Democratic Vistas: Post Offices and Public Art in the New Deal.* Philadelphia: Temple University Press, 1984.

Peters, Lisa. *Visions of Home: American Impressionist Images of Suburban Leisure and Country Comfort.* Carlisle, PA: The Trout Gallery, Dickinson College, distributed by University Press of New England, Hanover, NH, 1997.

Porter, Dean A. *Taos Artists and Their Patrons, 1898–1950.* Notre Dame, IN: Snite Museum of Art, University of Notre Dame, 1999.

Powell, E. P. *How to Live in the Country.* New York: Outing Publishers, 1911.

Pyne, Kathleen. *Art and the Higher Life: Painting and Evolutionary Thought in Late Nineteenth-Century America.* Austin: University of Texas Press, 1996.

Revisiting the White City: American Art at the 1893 World's Fair. Washington, DC: National Museum of Art and National Portrait Gallery, Smithsonian Institution, 1993.

Rhoads, William. *The Colonial Revival.* New York: Garland, 1977.

Rudnick, Lois. *Utopian Vistas: The Mable Dodge Luhan House and the American Counterculture.* Albuquerque: University of New Mexico Press, 1996.

Rydell, Robert W. *All the World's a Fair: Visions of Empire at American International Expositions, 1876–1916.* Chicago: University of Chicago Press, 1984.

Schmitt, Peter. *Back to Nature: The Arcadian Myth in Urban America.* 1969; rpt Baltimore: Johns Hopkins University Press, 1990.

Scott, Gail, ed. *On Art by Marsden Hartley.* New York: Horizon Press, 1982.

Sears, John F. *Sacred Places: American Tourist Attractions in the Nineteenth Century.* Oxford: Oxford University Press, 1989.

Shipp, Steve. *American Art Colonies, 1850–1930: A Historical Guide to America's Original Art Colonies and Their Artists.* Westport, CT: Greenwood Press, 1993.

Solomon, Barbara Miller. *Ancestors and Immigrants: A Changing New England Tradition.* Chicago: University of Chicago Press, 1972.

Susman, Warren. *Culture as History: The Transformation of American Society in the Twentieth Century.* New York: Pantheon, 1973.

Tager, Jack, ed. *Massachusetts in the Gilded Age.* Amherst: University of Massachusetts Press, 1985.

Theodore Robinson, 1852–1896. With an introduction and commentary by Sona Johnston. Baltimore: The Baltimore Museum of Art, 1973.

Trachtenberg, Alan. *The Incorporation of America: Culture and Society in the Gilded Age.* New York: Hill and Wang, 1982.

Truettner, William H., and Roger B. Stein, eds. *Picturing Old New England: Image and Memory.* Washington, DC: National Museum of American Art, Smithsonian Museum, and New Haven: Yale University Press, 1999.

Turner, Frederick Jackson. *Frontier and Section: Selected Essays of Frederick Jackson Turner.* With an Introduction by Ray Allen Billington. Englewood Cliffs, NJ: Prentice-Hall, 1961.

Udall, Sharyn R. *Contested Terrain: Myth and Meanings in Southwest Art*. Albuquerque: University of New Mexico Press, 1996.

——. *Modernist Painting in New Mexico, 1913–1935*. Albuquerque: University of New Mexico Press, 1984.

Vartanian, Pershing. "The Puritan as a Symbol in American Thought: A Study of the New England Societies, 1820–1920." Diss., University of Michigan, 1971.

Weinberg, H. Barbara, Doreen Bolger, and David Park Curry. *American Impressionism and Realism: The Painting of Modern Life, 1885–1915*. New York: Metropolitan Museum of Art, 1994.

Index